**Re-Situating
Folklore**

Re-Situating Folklore

Folk Contexts and Twentieth-Century Literature and Art

Frank de Caro
and
Rosan Augusta Jordan

The University of Tennessee Press / Knoxville

Library of Congress Cataloging-in-Publication Data

De Caro, F. A.
Re-situating folklore: folk contexts and twentieth-century literature
and art / Frank de Caro and Rosan Augusta Jordan.— 1st ed.
 p. cm.
Includes bibliographical references and index.

ISBN 1-57233-248-4 (cl.: alk. paper)

1. American literature—20th century—History and criticism.
2. Literature and folklore—United States—History—20th century.
3. Folklore—United States—History—20th century.
4. Art, American—20th century.
5. Folklore in literature.
6. Folklore in art.
I. Jordan, R. A. (Rosan A.)
II. Title.

PS228.F64 D4 2004
810.9'357–dc22 2003018424

Contents

Illustrations

Acknowledgments

We would like to express our appreciation to David Estes and Elliott Oring, both of whom offered very helpful suggestions on aspects of this book; to the anonymous reader who offered other valuable perspectives; to Robin Roberts for good advice and support; to Susan Roach for collaborating with us on one chapter; and to Scot Danforth at the University of Tennessee Press for his encouragement and excellent assistance. Joyce Harrison of the University of Tennessee Press was kindly encouraging at a much earlier stage. And Louisiana State University generously provided us with financial assistance that enabled us to complete this study. Some of the ideas developed in the book were stimulated in the course of our teaching at LSU or were presented in public forums on campus, and we thank our students and colleagues for their feedback.

Some of our chapters are derived from material we published previously. Parts of chapter 4 appeared in the *Midwestern Journal of Language and Folklore*, *Proverbium*, and *Western Folklore* (original essay copyright 1978 California Folklore Society). Part of chapter 5 appeared in the *Journal of Popular Culture*. Part of chapter 8 appeared in the *Louisiana Folklore Miscellany*. We thank these journals and their editors for originally publishing these essays and for their gracious response to our wishing to adapt them here. Part of chapter 1 and much of chapter 9 previously appeared in *Southern Folklore* ("The Three Great Lies: Riddles of Love and Death in a Postmodern Novel," by Frank de Caro, vol. 48, copyright 1991 University Press of Kentucky;

"Not into Cold Space: Zora Neale Hurston and J. Frank Dobie as Holistic Folklorists," by Rosan Augusta Jordan, vol. 49, copyright 1992 University Press of Kentucky).

Individuals and institutions have kindly and generously agreed to allow us to reproduce a number of illustrations: the artists David Avalos and Bunny Matthews; Creekmore Fath, who compiled the excellent catalogue raisonné of Thomas Hart Benton's lithographs; art historian Laurie Beth Kalb and art collector Lynn Steuer; and the ever-resourceful Historic New Orleans Collection, where John Magill, John Lawrence, and Pamela Arceneaux were especially helpful. Joyce Ice of the Museum of International Folk Art kindly discussed the Cyber-Arte exhibition with us.

Obtaining permission to reproduce work by Frida Kahlo and Diego Rivera was a protracted and expensive process, and we wondered at the time whether museums and arts agencies always understood the needs and economics of simple scholarship. But we do thank the Mexican government agencies involved and the Phoenix Art Museum for kindly granting permissions. We heartily thank Margaret Parker, Juan Barroso VIII, Margaret Lindauer, and Jacqeline Barnitz for their assistance or advice in negotiating the Mexican permissions. At Bridgeman Art Library Marcus Morrell was unfailingly pleasant and helpful, as was Rafael Cruz Arvea at CENIDIAP. INBA.

In two chapters we quote unpublished material. Lucy Maycock has allowed us to quote from her unpublished playscript of *Gumbo Ya-Ya*. We also thank her for her generous willingness to discuss the play. Quotations in chapter 7 from Clarence John Laughlin's unpublished writings are used with the kind permission of the Historic New Orleans Collection; copyright Historic New Orleans Collection.

On Literary and Artistic Uses of Folklore

An Introduction

This book is primarily concerned with some of the ways in which two different forms of communication—literature and folklore—interrelate in the twentieth century.

Like all media, each of these two has its own unique set of characteristics. As Ruth Finnegan notes, "the whole area of 'What is literature?' is . . . a controversial and unending one."[1] Indeed, any consideration of the exact parameters of literature is apt to be complex, but we can note in brief that literature as a medium today involves a particular process of writing, editing, and printing; the distribution of the resulting printed objects; then usually private, usually silent reading. It is a chirographic/typographic medium which in the twenty-first century is perhaps evolving into an electronic one.

Folklore, on the other hand, is a medium which involves direct, face-to-face, often verbal interaction (to which extent it is like conversation and may indeed be embedded in conversation). Often folklore is an oral medium involving human speech. It differs in that what is transmitted from one person to another (or others) is "traditional" rather than original, preexisting rather than something being made up on the spot (though improvisation may also be a factor). That is, instead of saying, "We had better take precautions now to

avoid problems later," a person says, "A stitch in time saves nine," utilizing a traditional proverb, reaching into memory for an already formulated saying to express a certain value. Instead of inventing an original design for a pieced quilt top, a quilt maker sews together her fabric scraps into some rendition of an already known quilt design. Instead of wondering how to celebrate the holiday of Halloween, we resort to certain established forms of costuming and engage in such passed-on activities as carving pumpkins and bobbing for apples. (Especially in the context of such examples as quilting and holiday celebrations, it is easy to see how individual creativity and immediate circumstances interact with preexisting forms to result in ever-new, expressive variations.)

Indeed, because there is a "teller"/performer and an actively participating "audience," folkloric communication involves an element of performance and a degree of direct feedback influencing the performance in process (and is, in McLuhan's terms, a "cool" medium).[2] Because it is oral and involves memory and because it continually evolves in response to its performance context, folklore is what has been called dynamic;[3] that is, although the passing on of what is traditional—a particular joke, quilt pattern, riddle—is fundamental to folklore, those "items" performed commonly undergo change in the course of being transmitted. Such factors as creativity, culture change, and memory itself—both memory's strengths and weaknesses, as well as the different ways in which things are remembered—combine to bring about variations in the "same" folktale, the "same" riddle, the "same" quilt pattern, as it is transmitted through speech and face-to-face interaction.

Folklore can be seen as a fundamental medium, one nearly as basic as conversation itself, and it no doubt predates most other media in human cultural history. It is a medium which, in contrast to the "mass media," requires little, often virtually nothing, in the way of "artificial infrastructure,"[4] such as equipment, technicians, editors, or sales personnel for communication to occur. At its simplest it requires only two people—for example, one person telling another a story. Of course it may be more complicated—say, several singers and musicians performing for a small audience in a village. Equipment may be

called for—musical instruments, for instance—but customarily such equipment will be produced by those who are themselves using it or through local channels requiring only a rather simple infrastructure of production.

As communicative media, literature and folklore obviously have quite different characteristics: written language vs. oral (and even non-verbal); silent reading by a "public" vs. hearing/watching a perform-ance; fixed, printed text vs. a shifting, unwritten one; a physical text vs. memory; a rather complex infrastructure of editors, publishers, and booksellers vs. a simple one of a few people in direct contact with each other.[5] Yet different media do overlap and interconnect, and "there is constant interplay between oral and written forms."[6] The ways in which folklore and literature overlap and interrelate have long been of interest to scholars and others. Indeed, this rela-tionship between the two has been central to the study of folklore certainly since the eighteenth century.

For one thing, folkloric forms and genres share many charac-teristics with literary ones. Such narrative forms as fairytales and *Schwanke* tell fictional stories, as do short stories and novels. A folk ballad is a kind of poem, its words structured stanzaically and met-rically. Proverbs and riddles employ metaphor and rhyme. A folk drama like "The Dead Man Revived" is a type of play. A lyric folk-song may employ symbolism not unlike that of any lyric poem.[7] That is, oral folklore shares with written literature an aesthetic use of language. Thus Ben-Amos, in his influential definition of folk-lore, emphasizes that folklore is "*artistic* communication," and Bascom conceives of folklore as "verbal art."[8] The characteristics of folklore genres, Bascom notes, put "them squarely alongside . . . literature, as forms of aesthetic expression." He adds that the "aesthetic experi-ence of both the artist and his audience is recognized as one of the distinctive functions . . . of literature. This is equally true in verbal art. . . ."[9] Folklore is also the functional equivalent of literature in preliterate societies and for nonliterate and less literate groups within literate societies. People in such contexts get their stories from spoken tellings, their poetry from oral sources, whether recitation or song. Although the issues involved are sometimes complex, "when

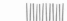

we consider what are usually assumed to be the basic characteristics of literature . . . it is difficult to maintain any clear-cut and radical distinctions between those cultures which employ the written word and those which do not."[10] As Daniel R. Barnes notes, literature can be seen as a "domain inhabited by both oral and written narrative."[11] Hence we have the fairly widely used terms *oral literature* and *folk literature* and the term recently proposed by Bruce Rosenberg, *oralature*,[12] indicating our perception that folklore has a "literary" dimension in terms of stylistics and function, and that "we must approach, as at least analogous to our literature, the unwritten forms of millions of people throughout the world, now and earlier, who do not employ writing."[13] That literature and folklore (though primarily verbal folklore) have much in common is further underscored by Susan Stewart in her groundbreaking study *Nonsense*, which limns the nature and categories of "nonsense," drawing many examples from both literary and folkloric contexts because both writers and folk tradition can utilize the same devices and operational principles. In other words, folklore and literature may have particular "affinities of intertextuality." For example, both Rabelais in *Gargantua and Pantagruel* and children in their rhymes collected by Peter and Iona Opie perform "inversions of animal and human categories" (an example of inverting classes). Both *Finnegan's Wake* and the game "Mother, May I?" engage in a similar "strategy of hesitation" which is an aspect of reversals and inversions. Furthermore, a counting-out rhyme and an avant-garde sound poem may equally engage in forms of misdirection when writers or performers of folk tradition play with boundaries.[14]

Historically the folklore/literature relationship has played itself out in a variety of ways.[15] On the one hand, literature can become folklore, a process Bascom calls "folklorization." This occurs when, for instance, poems originating in writing pass into oral tradition as recitations or songs. Examples of this process include the singing of lines from the Italian epic poetry of Torquato Tasso by eighteenth-century Venetian gondoliers; a ballad written by Matthew G. Lewis for his 1795 horror novel *Ambrosio, or The Monk*, which then circulated in American oral tradition; and the American ballad of the Civil War, "The Last, Fierce Charge" (A17 in Laws's compendium),

which is taken from a poem written by Virginia Francis Townsend. Of course there is a whole class of ballads—the broadsides—which go back to printed originals, and one might argue that many popular songs have passed into the oral tradition.[16]

Probably more commonly (or at least the process is more studied), once committed to writing and print, folklore can come to be considered literature. Perhaps the most striking example of this phenomenon[17] in the English language is what happened to certain folk ballads after eighteenth- and nineteenth-century British literary figures like Bishop Percy, Lord Hailes, and Sir Walter Scott began to take an interest in the genre, collecting and publishing ballads (partly because of their fascination with the Middle Ages, the period from which the ballads were presumed—in some ways erroneously—to come).[18] Divorced from their music and oral context, the printed ballad texts came to be thought of by many simply as poems, and certain ballads still appear in the textbook canon of English literature as examples of medieval poetry (though some of these, demonstrably, did not originate in the Middle Ages at all). Recently medieval romances also have undergone close examination by scholars who have, under the impact of the oral-formulaic theory of Parry and Lord,[19] formulated a conception of the oral origins of some of these long poems. Whether or not some of these poems were orally composed and what the precise nature of their composition and performance may have been are unresolved questions; nevertheless many of the written texts of the extant romances seem to have derived in some manner from folkloric performances.

Additionally (and more common still), writers frequently and more or less self-consciously have adapted and incorporated the forms and content of folklore in creating literary works. They have repositioned folk texts and contexts, re-framing them in literary texts. Although discussing specifically proverbs as re-used in literary works, Abrahams and Babcock provide a lucid characterization of the larger process of repositioning folk texts and folk contexts in literature. Folk *"items of performance,"* they note, may be "detached" from their usual oral performance contexts: "Detachability involves a process of de-situation and re-situation, transforming an item from an interactional exchange situation to one in which it is embodied in some medium of record

(such as the printed page or a phonograph record)."[20] We will use the terms "re-situation" and "re-situating" throughout our book, and indeed these terms have provided our very title. By "re-situating folklore" we mean—as do Babcock and Abrahams—simply the process by which folklore is somehow taken from its position in a sociocultural context (de-situation) and placed into a literary or artistic context, whether by description, textual quotation, or some other means (such as the adaptation of a plot structure) (re-situation). This process is not unlike quotation, which Susan Stewart has said involves "detachment of discourse from its context of origin." Stewart notes that art is especially "open on all sides to the influence of other domains of life" such that culture, especially culture as communication, is "constantly in process, transformable, and manipulatable" and there is frequent occasion for the "taking in and taking over of one text by another."[21] Thus we are seeing an aspect of intertextuality but an aspect which is not especially complex in its most basic form. It is the process of de-situating folklore and re-situating it in *literary* "records" in the twentieth century with which this book is principally concerned (while, as we will explain, there is also a secondary concern with visual arts "records"), but first let us look briefly at the principal modes through which writers effect their adaptations.

First, they may imitate or otherwise adapt the stylistic conventions and form of a particular genre of folklore, re-situating not a particular text but the conventions that inform a series of related texts. Thus we have, for example, the literary ballad. Not only did eighteenth- and nineteenth-century literary men and women collect and publish folk ballads, but they began to write poems in imitation of ballads (those who did so having been "influenced largely by edited and printed texts"—though not by oral performances). Indeed, the literary ballad has been so prevalent in English that G. Malcolm Laws notes: "It would be hard to find another specialized poetic type which had been so frequently produced by so many poets of diverse kinds as the literary ballad. Not only has the genre been in existence for at least four centuries, but it has assumed a role of considerable importance since the beginning of the Romantic period." "We have," he goes on to say, "a large body of English poetry which could not have existed

without the folk and broadside models which are its prototypes."[22] In creating literary ballads, poets have worked with various types of ballads, using such characteristics of style as considerable use of dialogue, meter and rhyme patterns associated with balladry, and incremental repetition, producing poems which retold actual folk ballads or were partly based on particular ballads, or which borrowed general ballad motifs or attempted to reproduce the "archaic" language of ballads. They have parodied ballads and parodied imitations of ballads, and the form has continued to appeal to modern writers, including A. E. Housman, Thomas Hardy, and W. H. Auden.[23]

Such imitation of form creates, then, a *formal* or *stylistic* framework, using a *generic structure* as a model. On the printed page a literary ballad often looks not unlike a folk ballad reduced to print (though the resemblance may be more or less superficial). In such cases the folkloric form provides a sort of "exoskeleton" for the literary work.

Other writers de- and re-situate folklore to provide an "endoskeleton" of plot, reference, or meaning, and these are other modes in which adaptation takes place. In these cases the outward, formal appearance of the work is that of a literary rather than a folkloric genre—of, say, a short story or a novel. But for a literary narrative, a plot may be adapted from that of an oral tale or based in part on an oral narrative known to the author. Elizabeth Bowen's short story "The Demon Lover"—a story in which a woman revisits her abandoned London house during the wartime Blitz; encounters memories of a mysterious, deceased lover; and is in the end carried off by him, in some literal or symbolic sense, in a taxi—clearly is based on the ballad of the same title which tells the story of a woman lured to death and hell by a lover who returns from the dead. Joyce Carol Oates works from the same ballad (perhaps also from related folk traditions) in her "Where Are You Going? Where Have You Been?". She tells the story of a vapid teenager sucked off to some fatal otherworldly destiny by a strange, hotrod-driving, demonic character who is able to enter her otherwise empty self.[24]

Folklore plots thus get adapted as literary plots, but of course in the case of such *plot adaptation* the folkloric reference usually also provides a resonance which expands the meaning, in these stories

helping to provide some of the terror in each by offering a wider and more obvious frame of reference to the supernatural. In other literary creations, aspects of folklore other than plot have been used to do the same thing: to allude to contexts, ideas, and values; to provide ironic reference; to expand thematic understandings. Take, for example, the use of proverbs in Lafcadio Hearn's neglected novella, *Chita: A Memory of Last Island*,[25] which he based on oral accounts of the great hurricane of 1856 which devastated Île Dernière off the Louisiana coast, at the time a remote seaside resort for the upper middle class of New Orleans. In Hearn's tale a very young girl, Chita or Concha, survives the terrible storm, is adopted by a family of Spanish-speaking fisherfolk, and is finally reunited with her biological father (who had thought her dead), but under tragic circumstances. The plot of the novella is really secondary, however, to Hearn's desire to write about natural forces, particularly the sea, and the book is full of extended, lyrical descriptions of the natural setting of the Louisiana coastal regions. In describing Chita's growing-up, Hearn writes: ". . . she learned the fables and sayings of the sea—the proverbs about its deafness, its avarice, its treachery, its tremendous power,—especially one that haunted her for all time thereafter: *Si quires aprender a orar, entra en el mar* (If thou wouldst learn to pray, go to the sea)" (p. 146). The Spanish proverb is repeated later in the narrative in which the girl's feelings about the sea's dangerous powers are described. Hearn is using the proverb to make a connection between the world of nature and the world of man, to invest the people in his tale with something of the reverence he himself felt for the sea as something both transcendent and powerfully threatening. That is to say, the folklore has a *referential* function in *calling attention to meaning*.

In these cases of plot use or the use of something like a proverb to add an aspect of meaning, writers are working with the detachability of folklore, taking it from its folk context (de-situation) and weaving it into the structures of their own literature (re-situation). Here folklore becomes a sort of literary fodder, being consciously de-situated from folk contexts and re-situated for literary ends, enabling the literary development of plot, characters, and themes.

However, writers adapt and incorporate folklore in another, related manner. Insofar as folklore is a part of culture and society, and

writers provide a re-creation of culture and society, so folklore will appear in literature simply as part of the life reflected there. "Literature provides a fictional lifeworld," Bruce Rosenberg writes, "which highlights lore and yet provides a natural context for its existence. . . . The number of possible examples is infinite. . . ."[26] Mary Ellen B. Lewis emphasizes the point even more strongly: "Folklore is everywhere; it is a cultural universal. Since all authors come from a culture, they inevitably reflect folkloric elements in any work of literature, because folklore is a pervasive aspect of life."[27] Sometimes a transposition of folklore occurs from its actual context in culture to a fictional context which mimics the cultural reality, the transposition in part creating literary context. Here re-situating a folk context, which may or may not embed "items of performance" (that is, folk texts) in an imagined context is *mimetic*. A writer may include folklore in a novel or short story simply because the lore exists in the real world, and folklore can be transposed to a literary narrative to thus become just part of the fictional cultural landscape, merely an aspect of setting, of background realism, of everyday human interaction fictionalized. In Agatha Christie's mystery novels, for example, characters may use proverbs simply as reflections of how people talk, that is, because people sometimes have recourse to proverbs when speaking. On different occasions, her detective, Hercule Poirot, says "it is an old maxim—*everyone has something to hide*," and "She wanted to get rid of her family because—to use a vulgarity—she had other fish to fry."[28] The significance of such usage seems not to go beyond needing language for a character to make his point in a manner in which many of us use traditional rhetorical devices in real social situations.

In point of fact, the incorporation of folklore into what Rosenberg refers to as the "fictional lifeworld" of the literary narrative is often more than part of the scenery but rather functions also referentially, to add to the meaning of the work in other ways. At the very least, Christie's giving her characters proverbs to speak may give insight into these characters, as when the Belgian Poirot's mangling of English proverbs ("And then, as you say, the dripping will be in the fire") emphasizes his status as a foreigner and his partial psychological remove from British culture.[29] In Hearn's *Chita* the young girl's adoptive father uses a proverb at one point, telling his fretful wife,

"The world is like the sea: those who do not know how to swim in it are drowned" (p. 157). Not only does this allow the character a realistic way of speaking and stress his sententiousness as a character, but it also ties together a certain attitude toward the sea, Chita's relationship to the sea, and the greater theme of the sea as metaphor for life.

The various modes by which writers incorporate folklore are interrelated, and though for convenience we have suggested such terms as *mimetic* and *referential* as descriptive of these modes, the dividing lines between them are not always sharply drawn. Indeed, something of the complexity of folklore use by writers can be seen if we look briefly at two of the most recent, book-length studies of two major British authors and their respective relationships to folk traditions.

In an important study of *The Canterbury Tales*, Carl Lindahl suggests a whole new folkloric dimension for the great medieval work.[30] Chaucer's debt to folktales has long been recognized, of course, in terms of his use of folktale plots for the plots of a number of his narrative poems, such as "The Miller's Tale." Lindahl argues that the frame story of the pilgrimage which provides the occasion for Chaucer's characters' telling the stories is likewise taken over from the folk milieu and that, far from being simply a literary device ("according to scholarly convention . . . the product of Chaucer's unique genius"), it is a realistic presentation of folk narration and of the social types who might have been narrators. Further, Lindahl argues that in creating his work, Chaucer "was strongly influenced by certain rules of folk oral delivery." He provides an extensive examination of such areas as the medieval parish gild to suggest how Chaucer's characters constitute a definable folk group; medieval festivals, from which Chaucer drew "patterns of action," particularly regarding the presentation of the oral arts on festival occasions; medieval social types, including Chaucer's occupational and class representatives and travelers who were significant tale-tellers; and the power of speech in the medieval context. By also looking at our knowledge of folk narration in the twentieth century and the possibility that Chaucer's poetry was presented in some oral/aural context, Lindahl suggests how "Chaucer drew upon the medieval . . . forms he had witnessed all his life and crafted them into a lifelike shape of performance."[31]

In the second of the recent studies, Mary Ellen Brown has examined Robert Burns's connections with folk tradition to conclude that these traditions "directly affected his own life, providing the themes, the tunes, the style, the strategy, and the subject matter of his own creative works."[32] Burns's use of folklore is complicated indeed, stemming from a variety of influences—his own rural background and participation in traditional folklife, then his later connection with Edinburgh where in nationalistic intellectual circles he was influenced to conscious collecting of folksongs and to an antiquarian perspective on folklore. His earlier work is full of the life of his traditional milieu—his poem "Halloween," for example, being "explicitly descriptive of certain elements of the calendar celebration." He also used the poetic patterns of ballads and other kinds of folksong. Later when "he turned to song [as his principal genre] with a vengeance"[33] because he saw the tunes he used as distinctly Scottish and thus in line with his nationalistic intentions, he not only wrote songs but edited and rewrote and borrowed lines from existing traditional and popular songs and did this so effectively that often it is impossible to determine whether some songs were written by Burns and passed into tradition or were originally part of the folk repertoire.

Burns, then, both transposed the subject matter of his poems from folk contexts and used formal, generic structures to model his poetry on folk originals (to the extent that his creations and the original models have become often indistinguishable). Chaucer transposed not only adapted plots but also a folk aesthetic of oral performance, and, indeed, a linguistic folk world; to the extent that his storytelling situation is realistic, he moves at least toward a mimetic of folk performance in his frame narrative. The influence of folkloric communication on both writers was profound, and the role of folklore in their oeuvre is certainly complex.

So, for that matter, is the case with Toni Morrison, Nobel Prize–winning African American novelist, whose work in relation to folklore is the subject of a recent book by Trudier Harris. In looking at Morrison, Harris tries to take us to the "cultural beliefs, which are the essence of folkloristic transmission," that are beyond the level of text or even of performance to something deeply embedded and which is hard to define or quantify, to where Morrison's "imagination

leaves off and communal memory begins." Morrison does, of course, re-situate specific, documented folk traditions, but Harris looks also for underlying patterns and oblique references and feels that Morrison "has gone beyond the mere grafting of traditional items on to her fiction." Thus, for example, she sees the well-known slave tale "Coon in the Box" as underlying the position of Milkman Dead in *Song of Solomon*, though the tale is never directly alluded to, and finds the "language of fairy tales" in elements of plot development. *The Bluest Eye* Harris sees as "the story of African-American folk culture in process" and as involving a main protagonist "who can shape and tell the community's stories," though those are not necessarily the traditional folk stories we can "document . . . in any collected sources we may consult."[34]

Once we recognize that folklore becomes incorporated into literature, however, how do we deal with the intersection, with this interactional dynamic?

Although his contribution has not always been recognized, Alan Dundes firmly established the currently accepted perspective on the study of folklore in literature in an essay he published in 1965. Dundes was writing during a time of important transitions in folklore studies, both reflecting and bringing about a shift from emphasis on folk texts to emphasis on the social and cultural contexts in which these texts communicated, and he sought to move folklorists toward considering the meanings of the folklore they collected, when previously they had often merely collected and archived and established comparative types and motifs ("identification"). He argued: "The problem is that for many folklorists identification has become an end in itself instead of a means to the end of interpretation. . . . A folklorist who limits his analysis to identification has stopped before asking any of the really important questions about his material. . . . [Therefore] interpretation must follow initial identification. . . ."[35]

This paradigm shift, signaled more fully later by Bauman and Paredes,[36] was to have a profound effect on the study of folklore generally, as folklorists looked increasingly toward understanding the cultural contexts and the messages of folkloric communication. Part of Dundes's 1965 focus was upon the interpretation of folk texts

themselves as a part of culture. This aspect of his interest was to become central to folkloristics. In addition, however, he was also partly focused on the interpretation of folklore as found in literature, insisting that the process of looking at folklore in literature be a two-step undertaking. Not only did folklorists need to interpret folklore as such; when considering folklore embedded in literature, they needed to go beyond identification here as well and to interpret the meaning the folklore brought to the literary work. "Folklorists plunge into literary sources and emerge with dry lists of motifs or proverbs lifted from the literary context," he says,[37] when they should proceed to use their knowledge of the folklore to explicate the literature. As an example of what should be done, he examines a riddle used by the character Stephen Dedalus in Joyce's *Ulysses*, showing its relationship to an international folktale and how its use illuminates our understanding of Stephen's character. This began a shift to explaining the function and meaning of folklore in those texts, and the matter of origins and sources became less central (though of course the need for identification remained, and Dundes also notes that *not* identifying folklore has undercut interpretation by literary scholars).[38]

Daniel Barnes notes that undertaking to determine literary sources of any sort is often a most difficult task. Indeed, it has often been difficult, if not impossible, to determine where or how precisely an author had obtained his knowledge of the lore in question. In earlier, influential comments on studying folklore in literature, Richard Dorson suggested biographical investigation and determination from internal evidence, and sometimes writers like Eudora Welty have made written or spoken comments upon their folklore sources,[39] but living writers rarely have even been asked about their uses of folk material.

In the present work the authors intend to look closely at the folklore in a number of written texts and to interpret those texts in terms of the folklore re-situated in them. We also expand the scope of our study to include folklore re-situated in visual and plastic arts texts, because it has seemed to us that artists in media other than literature have performed similar re-situations of folk texts and contexts which have been little examined by folklorists. However, it is necessary to

consider another question about folklore in literature which Dundes does not, and in doing so, to suggest that the examination of folklore in literature is a three-step process at least.[40]

This question is: why *is* there so much folklore in literature? Why have writers felt this urge to re-situate folkloric communication in the literary? Obviously, it is partly a matter of the realistic reflection of sociocultural realities. As we have already suggested, insofar as, say, literary fictional narratives (or, for that matter, visual arts texts) mirror the real world and insofar as folkloric communication is a part of that world, folklore inevitably appears in the literary text. The appearance "of folklore in literature," Rosenberg writes, ". . . is hardly startling," because "the more an author mimetically describes human life, the more lore is likely to appear." Or, as Lewis notes, "a creative writer may simply use folklore . . . because it is part of the known."[41] There is a fundamental human tendency toward imitation, toward mimesis, toward what Cantwell refers to as "the movement of cultural material from one order of signification to another" and as "that . . . mimicry through which we take the deposits of a particular influence, tradition, or culture to ourselves."[42] Cantwell is primarily concerned with the re-creation of folkloric performances in the context of a national folk festival—that is, the re-situating of performances away from the actual, usual venues for those performances—a process which involves a mimesis different from that which re-creates folklore in the literary realm. Yet he suggests what a complex process mimesis is, this mimicry of the real, such that "imitation" seems too pale a word to describe it, and we understand why McLuhan speaks of the various media as "translators" of each other.[43]

Folklore is "in" literature, then, because art imitates life in a variety of ways, both obvious and subtle. But to say so is not to fully explain the folkloric presence in the literary. A writer has access to a vast universe of reality which can be incorporated into written texts. Why does (s)he choose in some instances folklore, as opposed to (or, for that matter, in conjunction with) pop cultural media, culturally determined kinship systems, or aspects of utilitarian technology? As Susan Stewart says, "the transformation of one domain of meaning will have consequences for other domains of meaning." As aspects of

expressive culture, folkloric texts are already rich and ripe with meaning which can be appropriated, contradicted, affirmed, revised, and played with, and they thus have particular appeal for writers and artists. However, Stewart's description of how "the taking over of one text by another is a form of negation, of canceling out and/or transforming the meaning of the confiscated text," seems to ignore the ongoing power that even a "confiscated" text takes with it.[44]

Of course, particular folklore may in some ways relate to ideas or themes the writer wishes to convey (and these re-positionings need to be interpreted in their singularity). But in more general terms folklore may be associated with certain perspectives, orders of existence, cultural norms, and ideologies which draw writers to it in the first place. In considering folklore in literature, it seems desirable not only to go beyond identification to interpretation of particular literary works in which folklore is embedded, but also to go beyond interpretation to examine how particular literary uses of folklore fit into a larger, more fundamental concept of what folklore is and how and what folklore communicates. That is, the "third step" of the process, following identification and interpretation, would be to look also at conceptions of how folklore fits into culture and to consider how these conceptions have influenced and determined the re-situating of folklore into purely literary contexts.

In the following chapters we consider some of the reasons writers have adapted folklore in connection with particular literary works, but we want to mention here some of the reasons that folklore has interested and appealed for centuries to scholars, intellectuals, ideologues, and other commentators, as well as to writers and other artists. That is, we wish to look briefly and in very general terms at some of the emotional associations, symbolic meanings, and other connotations which folklore has acquired and which are among the larger patterns of thought and opinion which may shape why and how folklore has been re-situated into literary contexts.

Folklore has commonly been associated with the culture of particular segments of society. In sketching in our definition of folklore earlier in this chapter, we emphasized its nature as a medium of communication, not as an aspect of culture peculiar to any isolated

social segment. Contemporary folklorists largely agree that folkloric communication is virtually a cultural universal, that everyone is potentially a folkloric communicator (although it might be argued that folkloric communication is more basic in contexts where literacy and electronic media are less prevalent). However, historically, folklore often has been viewed as limited to contexts removed from those of the intellectual elites who look at folkloric communication from an outsider perspective—limited to distant times or distant places or to such groups as the peasantry, "primitives," the working class, or simply "the common people." As a result, folklore can come to seem a repository of worldview, ethos, or setting expressive of an Other, of a perspective or position reflective of a foreign, exotic, bygone, or otherwise different reality, though such different realities — and the folklore which may come to symbolize them—may be viewed either positively or negatively.

Perhaps the simplest use of folklore in literature which emphasizes folklore as coming from and marking the realm of the Other is for the creation of local color. Though many folklore texts and contexts may in fact be widely distributed through world cultures, folklore nonetheless is taken frequently to be closely associated with the local, and writers who have sought to capture the flavor of a place or region have certainly incorporated folklore into their works as indicative of place. In addition to such regionalist perspectives, folklore's long-standing association with the lower orders of the social spectrum means that writers can incorporate it to indicate something about the proletarian. Kelsie Harder, for example, suggests that William Faulkner puts so much proverbial language into the mouths of his Snopes family characters specifically to emphasize their lower-class origins (on the assumption that the common folk have greater need of traditional speech patterns).[45]

Folklore can also be used to suggest remoteness of place or time, or it can even be revised in the construction of alternate fantasy or science fiction worlds. For instance, J. R. R. Tolkien creates for his fantasy world an array of what are supposed to be orally transmitted songs which pass on the stories of past deeds and events.[46] Though these songs constitute a made-up folklore and though the

context in which they exist is purely a fantasy one, they partly serve to give an impression of their world as a place very much like what we may imagine a more ancient time in our real world to have been like, with bardic performances setting the background for heroic adventures. The fantasy world thus acquires a patina of antiquity which makes it seem more real, though also more distant. Such a process, of course, plays upon romantic notions of the past and folk-loric roles in the past.

Perhaps more complex is folklore used to signify the transcendental and the mystical. This connection, of course, goes beyond the literary and has considerable contemporary vogue in, for example, Jungian-inspired books of self-help and self-discovery, the popularity of the writings of Joseph Campbell, and the approaches sometimes found in the journal *Parabola*. Indeed, the connection is an obvious one, given not only the religious significance of myth but also fantastic plot elements in other forms of folk narrative and an association of folklore with stories about the supernatural. The connection certainly is played upon in literary narratives which seek to evoke terror, such as the demon-lover short stories discussed briefly above, in fantasy novels which borrow motifs or characters or plots from fairytales or myths, or in horror films which borrow urban legends.

Another perspective is that folklore communicates particularly fundamental messages—values, perspectives, wisdom—not found in other media. The very beginnings of European folklore study stemmed from such an idea, from Herder's belief—followed up by the Brothers Grimm, among others—that folklore held the seeds of ancient knowledge that went back to a nation's "poetic" past that had otherwise been lost.[47] Herder meant this notion to revitalize the moribund German literature of his own day. Such a conception also has bearing on the idea that folklore is a crucial means of communicating group identity, though this idea is a much broader one also stemming from the fact that folklore often becomes symbolic for groups of their sense of who they are. As was noted above, Robert Burns's interest in ballad and folksong partly resulted from his sense that these songs embodied something about being Scottish. Of course, the values communicated by folk texts may be thought fundamental merely

because they reflect common sense. Writers may adapt proverbs because they seem to express a simple and straightforward form of basic wisdom about life.

Others may feel that folklore communicates messages which are different from those communicated by other media, that the very nature and social context of folklore means that *what* folklore ordinarily communicates will differ from what a newspaper, television broadcast, or novel does. Urban legends, for example, pass on accounts of events—generally out-of-the-ordinary or bizarre or ironic events—which "really happened" in the sense that the events told about are commonly believed actually to have taken place by those doing the telling. These stories are, as Oring has suggested, a form of news.[48] Yet, though occasionally these stories are picked up by journalists, this is not the news carried by newspapers. Their oral nature is such that the actuality of the events can seldom be verified by investigation, nor do the kinds of events reported usually constitute the sort of "hard" news sought by reporters and editors. However, writers of fiction as diverse as Thomas Pynchon and Robert Coover[49] have incorporated such legends to stress—among other things—the existence of obscure, even hidden truth which comes to us only via such *sub rosa* means as legend and rumor.

We do not mean to imply that we have covered here all the broad reasons that writers have incorporated folklore. We provide this brief discussion to sketch out a broad background which indicates the desirability of thinking about the larger intellectual and aesthetic patterns which determine the literary and artistic uses of folklore, something we see as an important step in any wide-ranging study of nonfolk adaptations of the folkloric.

In the chapters which follow we do examine the place of folklore in a range of literary and artistic works of the twentieth century. With a few minor exceptions, we limit our discussion to the twentieth century (and, indeed, to some extent to literature published after the Second World War) partly to circumscribe a manageable subject and to deal with works whose creators might be assumed to share certain outlooks, conventions, and assumptions. In addition, however, we use more recent literature specifically to counter any lingering

impressions that folklore is to be found mostly in older literary traditions—the medieval, nineteenth-century American regionalism—or that modern writers working under the influences of the industrial and postindustrial worlds, mass media, and electronic communication are removed from the influences of folklore.

Certainly folklorists are well aware how folklore flourishes in modern and postmodern times, and commentators such as Lewis, Rosenberg, Bacchilega, Zipes, and Workman[50] imply or state that folklore is very much alive and well in modern literature (and popular culture). Other folklorists have written on Thomas Pynchon, Robert Coover, Vladimir Nabokov, and Angela Carter.[51] Yet, as Thigpen notes, in folklore and literature studies to date, "there has been an emphasis on antiquarian and agrarian folklore as it appears in the pastoral literary tradition," and upon older or regional literature closely tied to social contexts easily recognized as "traditional."[52] Rosenberg writes on the folkloric implications of fire symbolism in Golding's *Lord of the Flies*, but the great majority of his book deals with the literature of the Middle Ages. Brown writes on folklore in Chinua Achebe's *Arrow of God*,[53] but she devotes her major study to Robert Burns. Because folklore studies historically have emphasized rural, peasant environments and only recently looked to other milieus, there has been an emphasis upon literature that reflects or depicts some traditional, usually rural folk society or culture,[54] even in many recent studies. Folklorists know quite well that folklore exists in contemporary contexts and in contemporary literature, but the pull of the older literature and its closeness to well-established folk traditions has sometimes been irresistible.

But if folklorists do not need to be told that the twentieth century and recent literature are full of the folkloric, others may need to hear such an assertion. Popular conception has it that folklore is not of the modern world, indeed is incompatible with if not antithetical to it. Whereas literary scholars and critics once were commonly conversant with folk materials, such is no longer the case. The importance of the work of Mikhail Bakhtin to those interested in literary and cultural theory, with his emphasis on the necessity of a "deep study of . . . popular sources" and the significance of "the background

of folk tradition"[55] in his celebrated study of Rabelais, surely has made literary scholars more cognizant of the folk in the literary. Yet the very subject of that study may serve to deflect attention from recent literature in favor of that of the Renaissance and before. The role of folklore in modern literature is easily missed by critics. We seek to make them more aware of the folkloric possibilities inherent even in the work of writers whose acquaintance with folklore may seem unlikely at first glance—E. M. Forster, Walker Percy, Katherine Mansfield, and Jay McInerney, among others.

In doing so we call attention to aspects of twentieth-century intertextuality which largely have been ignored by many critics and theoreticians, namely the extent to which modern writers and other artists have found meaning in folk texts and folk contexts and have transposed and transformed those meanings into their own texts. This indicates that folklore has ongoing significance in the modern world, that clearly it is part of the communicative systems of writers and artists, and that understanding certain things about folklore is essential to understanding some modern literature and art.

In succeeding chapters we consider the artistic roles played by a range of folk genres and types, including fairytale, proverb, ritual, legend, riddle, games, song and dance, children's rhymes, and material culture and folk art. We look at their significance in a range of literary genres. Additionally, although our comments in this introduction have centered on folklore in literature and other written texts and although that remains the primary focus of our book, we also look at the re-situating of folklore in visual art, initially to expand our discussions of particular literary works, in a later chapter as a focus in itself. Since many folklorists also have backgrounds in literary scholarship, there is a long history of looking at the use of folklore in literature, while folklorists have given little attention to how folklore has been transformed for other artistic media. Yet, as Bascom notes, the nature of folk materials is such that it "places them squarely alongside the graphic and plastic arts, music and the dance [as well as literature] as forms of aesthetic expression,"[56] and it would seem that any examination of the incorporation of folklore into other aesthetic media would expand our understandings of folklore's larger role as a medium

which plays a significant interactive role with various other aspects of culture. In looking at folklore in other art forms we expand our knowledge of how artists, not only literary artists, conceptualize folklore and of how the folkloric medium broadens its ability to communicate beyond its various "natural" contexts. Our consideration of the visual arts, then, joins with our consideration of literary and other written media to comment upon the power and variety of folk messages beyond the boundaries of the oral tradition itself.

It is not our intention to provide a survey or a history of the folklore/literature/art relationship in the twentieth century but rather to present a series of studies of selected, particular literary works, studies which nonetheless are meant to demonstrate the range of literary re-situation of folk texts and folk contexts. The first three chapters of this study focus on works of literature—four novels and a play—to examine how they incorporate a *variety of folk genres,* and specific possibilities for looking also at the visual and plastic arts are introduced here as well. In chapter 1, two rather recent novels are examined to show the variety of folklore in each as well as to emphasize the importance folklore may assume in postmodern American literature; the discussion of one of these novels is supplemented by a consideration of works in the visual and plastic arts that re-situate folklore in ways that relate to some of the novel's concerns. Whereas the novels in this chapter are mimetic in transposing folklore into their fictional lifeworlds, the two novels discussed in chapter 2 are additionally informed by the plots of folk narrative adapted to shape the literary plots, though the folklore is transformed as referential to meaning as well. One of the works discussed in chapter 2 is recent and Canadian, the other older and American and to some degree representative of a work which involves formal/stylistic imitation of folk forms. Chapter 3 looks at a literary genre comparatively little examined in connection with folklore, drama,[57] and looks at a particular adaptation of a folklore collection for the stage. It also takes advantage of the playwright's willingness to discuss the adaptation.

Each of the second three chapters focuses on a *particular genre of folklore* as incorporated in different literary works, mostly works of fiction, and in visual arts works, including vernacular graphics and

murals.[58] Brunvand's placing all folklore into the three broad categories of oral folklore, customary folklore, and material folk traditions is a division most folklorists can accept at least for the sake of pedagogy and convenience, and each of these three chapters relates to one of these categories.[59] Chapter 4 looks at an oral genre, the proverb; chapter 5 at customary folklore, notably ritual public events; and chapter 6 at an area of material culture, quilts and quilting.

The final three chapters move away from the concerns of the earlier chapters in several ways. Chapter 7 looks more specifically at visual art than have earlier chapters in examining in some detail the work of a celebrated Mexican painter and an unconventional Louisiana photographer, and chapter 8 considers the visual arts as well as written texts. Chapters 8 and 9, however, also examine the folklore/literature connection from other perspectives and are meant to indicate something more of the complexities of that connection. Chapter 8 looks at how literary and artistic texts focused upon in terms of a folkloristic concept can be used to examine culture beyond the texts, in this instance cultural ideas of sense of place. Chapter 9 deals with how folkloristics can be influenced by literary works and literary conventions, looking at two books of folklore published in 1935 which utilize novelistic frameworks to present field-collected folk texts. In each instance an author has incorporated folk texts into a sort of fictional narrative, producing a sort of novel, but the purpose is not so much literary as folkloristic.

In a brief conclusion we return to the reasons writers incorporate folklore into literature and visual art, focusing our discussion of course on the works of literature considered in the book.

Riddles of Love and Death

Two American Novels

It seems obvious to a folklorist that in the late twentieth century folklore continued to have a power to communicate, to reflect cultural attitudes and ideologies, to express meanings and understandings both personal and social. And certainly some late-twentieth-century writers re-situate folklore in literary narratives in order to harness not merely the expressive power of the folklore and because the folklore lends social color or verisimilitude to the fictional lifeworld of the narrative. In undertaking such re-situations, some writers may choose to de-construct the original folk context, to question the efficacy or legitimacy of the folklore, or to invent new meanings. In many instances, however, a writer takes the folklore at face value, accepting its existence in the real world and, in imaginatively moving it to a fictional one, re-situates and validates its communicative relevance in a mimetic exposition of its power.

The two American novels examined in this chapter—Jay McInerney's *Story of My Life* and Ana Castillo's *So Far from God*—do precisely that, though they are very different from each other in a variety of ways. Published only a few years apart,[1] they examine very different worlds and very different worldviews, concentrating on segments of American society which seem almost polar opposites. *Story of My Life* is a generally realistic, first-person narration that focuses on the life of one person, the narrator, as she moves through an upper-class, urban, almost painfully sophisticated social landscape.

So Far from God plays with the fantastic and gives us the lives and deaths of several sisters born into a poor, rural, ethnic environment. McInerney's novel is a moral tale concerned with an unconventional redemption, Castillo's almost a miracle play concerned with ethnic consciousness. McInerney's is fiercely secular, Castillo's imbued with an eccentric but potent spirituality. Despite their differences, however, folklore appears very centrally in each, a significant indication of the appeal that folklore has even for contemporary writers with very different visions. In McInerney's urban moral tale a very limited range of folklore—a children's rhyme, a game, a joke—keeps reappearing in the narrator's consciousness or experience or memory. In Castillo's exuberant though tragic saga the whole environment vibrates with folk tradition. But this variance in how folklore makes its appearances is only the proof of the flexibility of its appeal for postmodern storytellers.

McInerney's novel presents folklore "in context" in the sense that the folklore is used by characters in the course of their everyday interactions and as part of their taken-for-granted cultural backgrounds. The folklore appears as one medium of communication among many for characters who move in an urban world of upper-class New York youth culture, a world of "the cursed and gilded youth of Eighties Manhattan."[2] The narrator and chief protagonist of *Story of My Life* is Alison Poole, an aspiring actress who reaches her twenty-first birthday in the course of the action. She and her friends are habitués of the in clubs and consume great quantities of alcohol and cocaine, are rich but often in need of money, and lead lives that are frantically hedonistic with little thought to future consequence.

Though she is not consciously aware of it, Alison is moving to extricate herself from this purposeless existence. In acting classes she has found something she loves doing, and, early in the narrative, refuses cocaine, despite the pressure of friends to partake, in order to get to acting class. Unfortunately, at the outset of the novel she has no money for her tuition, even though her playboy father tells her he has sent the check for it. To get the money for tuition she tells an ex-boyfriend, commodities trader Skip Pendleton, she is pregnant by him and needs funds for an abortion.

Meanwhile she enters into an affair with bond dealer Dean Chasen. Her relationship with Dean forms the central thread of the rest of the novel, as they sleep with each other and with others, though the plot has many twists and turns. Throughout we get bits and pieces of Alison's troubled relations with her divorced parents—her alcoholic, TV evangelist–watching mother, and her father, who, Alison has come to believe, poisoned her beloved horse for the insurance money years before.

Finally, Alison discovers she really is pregnant and, ironically, has to use the tuition money finally sent by her father for an abortion. Her unhappiness escalates at her wild twenty-first birthday party. Alienated from Dean because she has slept once again with old flame Skip in order to spite Dean, who had slept with one Cassie Hane, she becomes hysterical after a sudden realization of the quality of love in her life, and tries to jump out a window of the Stanhope Hotel. She manages to call a counseling agency whose business card has been passed around as a joke throughout the novel, passes into virtual unconsciousness and awakes, sedated, in an institution in Minnesota, wanting to think that 90 percent of the story of her life has been "just dreaming" (p. 188).

It is easy to see the fragmented, youth-centered environment in which Alison lives as an immature world of people who really care little for others. Alison herself rejects the rules, the "care of the social fabric," which would interfere with her spontaneity and "honesty," with her unbridled, childish self. Despite this, however, Alison has been taking steps toward order and toward centering herself, though they are small, tentative steps. When her friends try to take her away from doing a scene for class she asserts, "this is my life, I'm trying to do something constructive with it" (p. 12). Unlike her roommate, she pays her share of the rent. She at least fantasizes about a stable relationship with Dean. She wonders about leaving New York and thinks about "all this hysterical noise which is supposedly my life but it doesn't add up to anything" (p. 147).

McInerney is concerned with the time-honored American literary theme of coming of age, and he calls attention to the significance of Alison's coming of age as a rite of passage, not only through the party itself but also through the speech one character—ironically, a "prep,"

a designation that marks not only his style of dress but also his juvenile manner—makes to declare that Alison is now an adult and a woman. Her transition to adult is hardly a triumphant one, yet from the outset of the novel, maturity has been on her mind. Her father is "fifty-two going on twelve" (p. 2), she herself "twenty going on gray" (p. 3).

However, Alison's maturing is linked to her obsessive concern for honesty, and, indeed, honesty is a central theme of the novel itself. Early in the narrative Alison declares that "real life seems to be about being a liar and a hypocrite" (p. 8), though "if there's one thing I hate it's the usual bullshit" (p. 22). Part of the novel hinges on her father's apparent lying about having sent her tuition check, and her relationship with Dean becomes rocky after he has lied about a recent encounter with Cassie Hane. Her desire for honesty is a pure and fierce one, yet it is—like Holden Caulfield's obsession with phonies—too simple, an immature complex of reactions to some of the things which bedevil her life. Her own honesty is hardly as pure as she would have it, and her maturing must involve approaching the complexity of honesty, dishonesty, and truth itself.

The three pieces of folklore McInerney re-situates in his narrative, though their meanings are multivalent, are tied to these central, interconnected themes of maturity and honesty.

Not quite halfway through the novel Alison is called by her sister Rebecca, who has been trying to remember the words to a childhood nursery rhyme, "the one about Miss Mary Mack." Alison is able to supply some of it: "Oh, right, I go. Miss Mary Mack Mack Mack all dressed in black black black with silver buttons buttons buttons down her back back back . . ." (p. 85) but can't remember any more despite Rebecca's prodding for additional words. Alison is momentarily "bugged" by her inability to recall more, but Alison does not dwell for long on very much and her mind moves elsewhere, away from this concern about the parameters of her personal folklore repertoire.

It is impossible to say exactly what Alison has forgotten, for the rhyme—collected as a jump rope rhyme and as part of hand-clapping, skipping, and marching games—is found in a number of variants in tradition, and the lines she remembers are associated with a variety of

other rhymes.[3] Of course it does not matter what lines she cannot recall. What is important is that she cannot recall whatever variant she happened to know as a child, for in the forgetting itself we see the working out of her current position in her life passage. On the one hand her failure to remember suggests a dangerous fragmentation, an inability to connect, to put things together in a meaningful way and mirrors the disconnected and immature world of which she is a part. Though it may have an important personal dimension, folklore is a social connective, supportive of society, and the forgetting suggests a distancing from social cohesion, from "care of the social fabric."[4] Then too, insofar as a "nursery" rhyme reflects childhood, the partial forgetting suggests a repression of a painful childhood which the reader gets glimpses of throughout but which Alison seems unready to actually confront before the very end of the novel.

On the other hand, in a more positive vein, a moving away from the rhymes of childhood suggests a maturing process, an idea which is reinforced by the second use of "Miss Mary Mack" in the novel, as Alison undergoes her abortion. When she is told that outpatients are given only local anesthesia, she tries to distract herself from the pain but has trouble concentrating: "I try to remember that rhyme we used to say in school—Miss Mary Mack Mack Mack all dressed in black black black, but I draw a blank on the rest . . ." (p. 181).

During the abortion, she is able to remember even less of the rhyme than she could earlier. It does seem as though her immaturity is slowly slipping away here in drugless pain and confusion with the childhood lore itself. The rhyme, then, looks both ways, back toward her immature self and ahead toward a more mature self, which will perhaps forget entirely the rhymes of childhood (or perhaps remember them whole and entire once again).

There is, however, another important dimension to the folklore in the novel, a relation to riddling, a complexity which may not be immediately apparent until we realize that "Miss Mary Mack" is also found in tradition as a riddle, the answer for which is "coffin."[5] The joke which recurs through the novel as another folk element is in question-and-answer form, the genre sometimes termed a riddle joke. And Truth or Dare, a game played in the novel (a third folk element),

though not literally a riddling session, approximates the form of such traditional sessions, people posing questions and expecting answers.

To see the novel's lore against the background context of riddling suggests several things. First there is the relationship between riddling and transitional states. Several of the contexts in which traditional riddling is encountered involve transitional activities, such as courtship and initiation and death rituals, probably because riddles themselves seem to join disparate, even opposite, entities through metaphor, just as a wake, for example, joins the world of life and that of death, or courtship male and female.[6] Alison is also on a borderline, a frontier between selves, trying to pass into the world of adulthood and leave that of the child. Beyond that, however, riddling involves posing questions which have certain answers. Alison is looking for answers, though not always consciously or directly, and it is interesting that she repeatedly seeks answers to folkloric questions. In connection with the joke discussed below, she asks others what the "three great lies" are, hoping to find finally a completing answer to fill in her fragmentary one. When the answer does come, it is a dramatic revelation which pushes her toward a new life state. If that state is immediately a seemingly negative one, it can also be seen as another traumatic ritual of initiation which can lead to a more positive, more healthy, more mature life. She also asks herself what the rest of "Miss Mary Mack" is. Though probably she is literally seeking only other, complementary verses, the answer to the "Miss Mary Mack" riddle, "coffin," is in another sense the "rest" of the rhyme. She can be seen here too as seeking an answer to a riddle. If this search does not literally yield an answer, the answer does, in a sense, make itself plain. Her present way of life leads only to the coffin, to death, perhaps physical, more likely moral. Perhaps her inability to come up with the rest of the rhyme really indicates her desire to avoid death and to affirm its opposite.

Alison's transition is in part facilitated by the game called Truth or Dare,[7] which occupies two chapters. The first time the game is played, the rules are explained to Dean, who is unfamiliar with it: "Everybody has to swear at the beginning to tell the truth, because otherwise there's no point. When it's your turn you say either truth or

dare. If you say truth, you have to answer whatever question you're asked. And if you say dare, then you have to do whatever somebody dares you to do" (p. 65). The dares are invariably selected by the women when asked by the men and involve removing clothes. The questions posed when truth is selected invariably have to do with sex and romantic attachments.

Truth or Dare thus has rules and a definite structure and seems a traditional form of play for Alison's folk group, whose lives are otherwise chaotic; it provides rules, which lead to the uncovering of reasonably certain truth. Yet the group uses the game not for self-discovery but rather to find out gossip and to embarrass (in a sense greatly magnifying potentials inherent in the game). If it provides a fixity, they use it to play with dissension, perverting an activity which does promote a level of social cohesion but which falls off into the potential for ill will. The game works, at least in theory, on the honesty Alison so prizes, yet here honesty leads only to the trivial, the shallow, the hateful, so it is not surprising that a disastrous session of the game leads Alison to challenge herself and her beliefs.

Alison repeatedly makes statements like, "If there's one thing I hate it's dishonesty. Drives me crazy. I hate liars and hypocrites" (p. 68). Yet her own relationship to honesty is hardly so simple. She indulges in the same small dishonesties as most people. Her lie about needing an abortion (which comes back to haunt her as truth) is an important element in the plot. And, in a sense, she lies to the reader, hiding the fact that she has sex with Skip to spite Dean in a vague remark followed in the text by three asterisks.

It is only at the second Truth or Dare session that the truth of the asterisks—standing in for an episode, a hardly praiseworthy action, which has been left out of her narrative—emerges. It is forced out by Dean's asking whether she slept with Skip lately—Skip's presence at the session making a lie, which she does contemplate, impossible. The session has already been horrid, and now Alison sees Dean, for whom she has obviously developed strong feelings despite her stated nonchalance about men, slipping further away from her. She begins to think:

> Some impulses you should stifle, right? I never used to
> think so, I've always done whatever I felt like, I figured
> anything else and you're a hypocrite like I told Dean,
> but I don't know, here in the middle of this really ugly
> Truth or Dare session. . . . I'm beginning to wonder if
> a little stifling is such a bad thing. Right now I'd give
> my grandmother's pearls for a little white lie. The way
> this game is going, I'd give all my possessions for a dose
> of amnesia. (p. 156)

The session is interrupted finally by the arrival of Mannie, a Puerto
Rican drug dealer, who is searching for Alison's sister Rebecca to
express his love to but who winds up throwing himself from the sixth-
floor window, an event which produces another element in Alison's
transition. Just before the abortion, for reasons she cannot explain,
she goes to visit Mannie in the hospital. She explains that Rebecca
asked her to look in—"which is totally a lie, I don't know why I say
it, except maybe to make him feel better" (p. 180).

Alison, who has scorned Dean because "he'd rather be pleasant
than honest" (p. 99), has lied to be kind, to make someone happy, to
ease pain. Clearly she has learned something, if she's not sure what,
about human relations and the complexity of honesty. She has
reached for maturity by doing something selfless to help someone
else, though it has meant violating her own supposed values.

The Truth or Dare game sessions, in addition to stressing the
theme of honesty, also further suggest the immaturity of Alison's
world. In promising honesty but delivering something else, the game,
especially the second session, forces Alison to move forward, and she
does not play the game again in the novel.

The third folklore element, a joke, also ties in with questions of
honesty and trust but relates to Alison's vision of love as well.

In a chapter called "Two Lies," Alison seeks to punish Dean for
having sex with Cassie. A memory causes her to think of lying: "I've
been lied to by the best. Which reminds me, I suddenly go to Dean,
he's kind of whimpering on his side of the bed, hey, I go, what are the
three greatest lies in the world?" (p. 107). When Dean waffles, she

goes on: "You know. You're an expert on this subject. (This goes right past him.) One, the check's in the mail. Two, I promise I won't come in your mouth, and what's the third?" (p. 108). But the third cannot be recalled, nor can it be later when she asks Alex, a former boyfriend, the same thing, although his second lie differs—"I promise I'll pull it out before I come." Nor can the third lie be recalled still later when she asks her friend Francesca. It is not until the verge of Alison's breakdown that the "prep" recalls the third lie during the birthday party, and his answer plays a role in pushing Alison over the edge.

Alison is, of course, playing with a well-known joking tradition carried over from oral joke to posters, Ann Landers columns, and cartoons.[8] Like much obscene folklore, the joke itself seems to have avoided print in scholarly sources. In oral tradition it has a relatively stable structure, with, of course, the usual variations to be expected. *The check is in the mail* seems to be invariably the first lie. The *third* lie acts as punch line and may be Alison's *I promise not to come in your mouth*, Alex's *I promise I'll pull it out before I come*, or *I promise I'll respect you in the morning*, or *I promise I'll only put it in a little way*, which have also been reported. The *second* lie seems to be the most variable, and some tellers of the joke have reported that virtually anything can be put in the second slot, such as *Your car will be ready by noon*. The joke proceeds from an economic lie, to a lie about virtually anything, to a lie which involves male betrayal during sexual intercourse.

Alison has confused and mistold the joke, shifting what should be the punch line into the second slot, forgetting what is normally the second, "floating" lie. Forgetting part of a joke can be, of course, part of the normal process of joke telling, and forgetting one of the lies, usually the second, has been reported to the authors by actual tellers of the joke. In the context of the novel, however, this indicates several things. It suggests, again, Alison's disorientation in a fragmented world. As with "Miss Mary Mack" she cannot remember wholes, only bits and pieces; she has difficulty in putting things together. On one level she has difficulty recognizing the lies as a joke at all. Oral sex is so much a part of her life that it is too commonplace to provide much punch for a punch line. *The check is in the mail* lie

also closely mirrors the reality of her existence. Furthermore, the joke reflects her vision of the world as a place of painful dishonesty. Humor, of course, can be a reaction to what is most painful to us, and Alison does appreciate the humor inherent in the great lies. However, she is more interested in them as a statement of her personal worldview and thus loses sight of them as joke. Indeed, when Dean, upon hearing her ask what are the three greatest lies, asks if this is a joke, she replies, "no, not really. It's just kind of an old proverb or something" (pp. 107–108). To confuse a joke with a proverb perhaps indicates further Alison's difficulty in structuring her life, but more important is the fact that proverbs are popularly supposed to be wise statements of truth. Thus she sees the joke as a statement of the truth of male betrayal and dishonesty, of her father's lies about money, of Dean's lies about other women, of a world in which lying has given her a dark vision of love itself. "Did I say love?" Alison exclaims. "Wash my mouth out with soap" (p. 33).

At her birthday party the "prep" who announces Alison's majority also includes in his speech assertions of his love for her, though mixed in with similar assertions about her sister. As the party continues at his hotel suite, Alison asks him if he knows the third great lie: "That's easy, he says. The third lie is, I love you. And I'm thinking, wow! of course. That's it" (p. 186). This sudden realization of the quality of love in her life, of the fact that she is not loved, of a need for love, of the failure of the possibility of love with Dean hurries her to the breakdown, though also to the realization of her need for help.

Noah Richler has suggested that underneath McInerney's first novel, *Bright Lights, Big City*, "was a rather old-fashioned moral tale about a young man's fall from grace," and another English review notes that *Story of My Life* itself "has the contours of a moral tract." Such a view contrasts with those of most American reviewers, who saw in Alison only "a 20-year-old airhead," or "a dumb little New York rich girl" and in the novel only "the whine of the eternal adolescent." A closer reading of the novel than most American reviewers seem to have accorded it reveals something more akin to a moral tale and a tale of progress toward redemption. Winding up in drug abuse

therapy may be a prosaic redemption, but it suggests that finally Alison is mature enough to reach out for help, and it marks the potential for initiation into a new life beyond. Rather like the protagonist of *Bright Lights, Big City*, Alison undergoes a series of "jarring event[s]"[9] which move her toward the realization that she will "have to learn everything all over again."[10] One wonders whether the mostly male reviewers failed to perceive Alison's moral progress because they were unprepared to recognize it as a possibility for a young female protagonist.

It has been suggested that postmodern literature engages in a de-centering of moral authority and rejects the possibility for agreed-upon standards of human behavior. McInerney, however, would have Alison look beyond such uncertainty and rise from the moral fall of her world. Three times Dean refers to her as a postmodern girl (pp. 29, 53, 120), and each time her feelings about the label might be seen as ambivalent. When the term is used a fourth time, it is to make the point that Dean has had "enough of the postmodern girls, [and] now . . . wants the good old-fashioned kind" (p. 169). Alison has certainly not become a good, old-fashioned girl, but she has seen the need for a more constructive life and for love and selflessness and demonstrates that she is capable of both and that she can grow out of strongly held but immature values and into a kinder accommodation with the world. At the end she not only confronts the central issue of a painful childhood but also opens herself to the possibility at least of alternate truth.

McInerney's use of folklore is only one element of his subtly and gracefully complex novel, but it is an integral part of it, both a part of the novel's lifeworld and an element that references and amplifies elements of meaning. It is Alison's folklore and is used to emphasize Alison's liminality, through its connection to riddling, though also her fragmentation, while it emphasizes too her need for something more than she has possession of—answers, in a chaotic world. Her inability to remember all the lore suggests her failure to achieve personal wholeness or to become part of the social cohesion that folklore promotes. But her persistent asking for the missing pieces suggests a constancy in searching for a whole, for a more positive relationship with

the larger world, and indeed, for her own role in caring for the social fabric (which is, after all, the principal function of folklore). Alison has begun to find a few answers to the riddles of love and death.

McInerney's novel presents a realistic depiction of folklore in the contemporary, urban world, indeed in a part of that world far removed from roots in traditional culture. Folklore exists here as one communicative, expressive channel among many, formal and informal, popular and elite. Though it is hardly the central mode of communication in this subculture, it has considerable vitality. It stems from the needs of the subculture (Truth or Dare surely matches the need to probe into those areas, sex and romance, which fixate Alison's crowd). It communicates attitudes and values (Alison seeks the great lies to make manifest, to encapsulate in fixed form her view of male dishonesty). It is forgotten or remembered according to circumstances (the childhood rhyme being recalled in moments of extreme stress). It pops up in normal encounters of everyday life, as characters reach back into their stores of memory to find fixed forms which are relevant to the shifting moment. It provides connections, however tenuous, to tradition in a world of novelty and of unfixed values.

The novel does "provide typical situations and examples of medium,"[11] as well as of folklore "items of performance" and, in doing so, enlarges understanding of texts and how they function both socially and personally. We see something of how texts have social and personal uses and meanings, as well as how an author can manipulate texts for literary meaning (and McInerney is a skilled manipulator of various kinds of "texts"). Alison's search to discover missing pieces of folklore and to thereby reconstruct a fragmented whole is part of a search for her own role in the social fabric, suggestive of folklore's universal function of keeping the social fabric intact. The literary meaning here obviously goes beyond the folklore but it is also inextricably bound up with folklore use, the context—though a fictional one—amplifying text and vice versa, the novel using the folklore in its fictional, mimetic context to render meaning but also working to give the folklore a certain life within the fictional frame.

McInerney's use of folklore is primarily thematic, communicating certain ideas and values central to the main character's life patterns, providing a note of tradition and traditional values in an unstable world. Ana Castillo, on the other hand, employs folklore to fill in the social context of her novel and to limn the parameters of the very world in which her characters move and breathe. That context is an ethnic one—New Mexican Chicano—and the folklore serves to proclaim this context to the reader, to establish that this context is a distinctive one that stands both apart from and connected to the American mainstream.

In another sense, *So Far from God* stands in contrast to *Story of My Life*. In McInerney's novel the folklore, though important to the book's meanings and something of a fixation of the main character, seems a very small part of the larger cultural lifeworld in which that character exists. In Castillo's novel the folklore seems to pervade every corner of the book's cultural scene. The characters take part in folk religious traditions like pilgrimages and *santo* carving, are influenced by the lore of apparitions, sing folksongs to saints, engage in folk healing practices, listen to ethnic musical groups at weddings, grow up in the midst of special seasonal customs, live according to folk beliefs, and exchange strings of proverbs. Yet despite this contrast between the two books, each is using folklore as a normal part of a sociocultural context in which the action takes place, re-enforcing the idea that folklore operates within the bounds of normal human lives, however different those lives may be. In McInerney's novel the folklore re-situated in fictional context has retreated from a central social position; in Castillo's it retains a larger hold on life, but the lifeworlds of both books communicate through folklore.

Though the folklore is provided to the reader of *So Far from God* in great profusion, it does not act simply to give local color and thus establish the cultural boundaries by stressing the "exotic" differentness of the ethnic culture. On the contrary, Castillo integrates folklore in complex ways that amplify meaning and uses them to examine the very relationship between the ethnic group and the larger American culture. In doing so she sees folklore very much as folklorists have

seen it, as reflecting or even establishing what Richard Bauman has called "differential identity,"[12] that is, as seeing folklore as grounded in its possession by "special groups" whose members may in part conceptualize the folklore as "theirs" and thus as a source of group feelings of self-ness and sense of identity. Such a view of folklore does, of course, go back to earlier, nationalistic visions of folk tradition as somehow embodying the "soul" of a race or nation or of a smaller cultural group.

The novel draws its title from an expression—attributed to Mexican president Porfirio Diaz but which has become proverbial in both Mexico and among Mexican Americans: "Poor Mexico. So far from God, so close to the United States." By focusing on the first part of the expression, Castillo is suggesting several things, including a seeming absence of a beneficent God because such terrible things happen to her characters. Yet the world of the novel—whatever God's place in it—is far from devoid of the spiritual and full of alternate, otherworldly realities. The novel takes a Mexican American family— matriarch Sofi and her four daughters, three of whom are named, whether allegorically or whimsically, Esperanza, Fe, and Caridad (Hope, Faith, and Charity[13])—up to and beyond the deaths of the daughters.

Indeed, the novel opens with a miraculous event, the return to life of the fourth, youngest daughter after she has died following terrible convulsions. When her tiny coffin is placed on the ground in front of the village church while the funeral procession pauses, the child suddenly pushes up its lid and steps out alive and well. When the priest attempts to touch her, she levitates to the church roof. Ever after she is known as La Loca Santa—that is, the Holy Crazy One— or La Loca for short. But as the novel unfolds, the plot incorporates a number of happenings which may be called wondrous or remarkable, whether inherently spiritual or simply fantastic in more natural ways—from strange coincidence, from the vicissitudes of fate, or from life's extraordinary ironies.

Castillo's novel is many things—Sandra Cisneros calls it "a Chicana *telenovela* . . . roaring down Interstate 25 at one hundred and fifteen miles an hour"[14]—but certainly at its center are the tensions

between the ethnic culture and the dominant, "Anglo" culture and the contrasting, though also complementary, demands and values of each. These contrasts and tensions are found in their most concentrated forms in two subplots involving other characters who do eventually impact importantly on Sofi's family. One involves Maria, a Californian with New Age inclinations and distant New Mexico Hispanic roots who journeys to New Mexico with her estranged lover, Helena, to see something of those roots. While on their way to her ancestral village in a refurbished VW bug, these "two women with spiked hair and camping gear strapped to the top of their car" (p. 127) are mysteriously attacked by a stranger in a pickup who finally forces them to retreat back in the direction from which they have come. Though his identity and motives remain shrouded, he is clearly local and they not so. The incident emphasizes the estrangement of the local context from the larger, dominant, outside culture and, indeed, the difficulties inherent in re-establishing oneself in the ethnic context when one has been so definitively outside it. Maria is finally able to make welcoming contact with her New Mexico *tios* and *primos*, and she eventually breaks her ties with Helena and moves permanently to New Mexico, "her true native homeland." However, she is able to bring with her only one of their three cats, the one named Xochitl, after the "Aztec" goddess, leaving behind those named after Greek goddesses who "get neurotic" off their "familiar turf" (p. 123), suggesting the difficulties of bringing one culture into the heartland of the other.

The second subplot recounts the story of a local young man called only Francisco el Penitente. He grows up and goes to "'Nam" in the Army, where he is immediately cast into a Hispanic stereotype typified by the bestowal of the nickname Chico ("all 'Spanish boys' were 'Chico'" [p. 94]). When he returns home from the war he falls in love with a "privileged white college girl" (p. 100) who inspires him to enroll at the university. She takes him home and feeds him "gringo food—nothing like the blue corn tamales, posole, and green chili he was raised with, but a little closer to the Army food he was fed for two years . . . things like mashed potatoes, string beans, and steak" (p. 99). When the college girl abandons him, he loses interest in college and

women and finally picks up a piece of wood and becomes a *santero*—
a maker of holy images, a tradition which one of his uncles also fol-
lows. Later he joins his uncle's *morada*, becoming a *penitente*—a
member of the lay religious brotherhood devoted to performing peni-
tential acts and other religious rituals and who have played a key role
in the religious life of Hispanic New Mexico particularly during the
period when there were few clergy.[15] Though Francisco's story serves
to highlight aspects of the ethnic culture's traditions of spirituality, it
also gives focus to the barriers between that culture and the dominant
culture, barriers created by the dominant culture's stereotypes of oth-
erness, thus establishing those barriers. In addition, the food traditions
of each culture subtly contrast—moreso than the tone of the language
of their description might at first seem to imply. Francisco tries college
and gringas, but these are too far removed from his own heritage, and
it is only when he immerses himself in two traditions of spirituality
which are unique and important to Hispanic New Mexico that he
appears to find himself, because the larger American culture has norms
and values that are alien to him.

But the dominant "Anglo" culture is not merely different, not
merely the generator of offensive stereotyping. The novel presents
the dominant American society as potentially harmful, as a series of
forces which bring destruction and death to two of the daughters of
the family. Esperanza, the oldest, lands a job as a broadcaster at the
local TV station, then moves up to be an anchorwoman in Wash-
ington, D.C. When the Gulf War breaks out, she is sent to cover it
and disappears in the Middle East. The second sister, Fe, remains in
New Mexico, where she becomes engaged to an accountant cousin
and gets a job as an assembler at a company called Acme Inter-
national. Compulsively devoted to the American work ethic, she
quickly gets positions of increasing responsibility. But Acme is a Penta-
gon contractor for disposing of toxic materials, its workers unpro-
tected from deadly substances, and Fe sickens and dies of cancer
(and is even blamed for her own death). Thus Esperanza is sucked
into the promise of success in the larger American culture only to be
killed in a conflict engaged in by the larger society and its estab-
lishment, a conflict to which she has only a peripheral relation. Fe,

committed to the powerful work ethic of that larger society, is destroyed by its capitalism and militarism which are unheeding of the safety and well-being of its more marginal members. Both sisters are destroyed because they entered the "Anglo" world.

Although the folklore in the novel is woven throughout for a number of aesthetic purposes, it certainly serves to highlight cultural differences. Historically folklore often has been fixed upon as fundamental to the delineation of particular cultures, sometimes taking on almost mystical significance as something which reflects the underlying, defining essence of the group.[16] Such a perspective has in particular informed nationalistic uses of folklore and movements for cultural revitalization. In *So Far from God* the group's folklore is used to contrast the ethnic world with that of the dominant society.

This can be seen starkly in the life of one sister, Caridad, who develops a gift as a *curandera*, a traditional healer.[17] Ironically, she finds employment at a hospital in Albuquerque but only of the menial, low-paying sort often held by members of ethnic or racial minorities who lack formal medical training. But if the Anglo world relegates her to such a low status position, in her own she is "destined to help people as even those trained doctors and nurses down there can't do," as her landlady and mentor *doña* Felicia tells her (p. 55).

Within the ethnic culture there is a different system of healing, a folk system of disease and curing of which the doctors know little or nothing, and it serves to tell or remind the reader that the ethnic culture has its own healthcare resources quite distinct from those of the conventional, "scientific" medicine which controls healing in the dominant society. (It is interesting to note that the artists who created the amazing mural which covers the Women's Building in San Francisco chose to prominently include a traditional *curandera* as an important indication of both the powers of women and the parameters of Hispanic, especially Mexican, culture.[18]) Caridad apprentices herself to *doña* Felicia, the novel shifting to this accomplished *curandera* and her life and development as a healer to stress the depth and power of the alternative system. Castillo includes an appendix to one chapter detailing "A Brief Sampling of Doña Felicia's Remedies" which sets out such folk diseases as *empacho*, *aigre*, and *mal de ojo*

along with the theory behind them and the physical remedies, oral formulae, and *limpias* (spiritual cleansings) used to combat them. That the several pages devoted to this are only a "brief sampling" attests to the richness of the ethnic medical tradition, which may be thought mere "superstition" by the dominant group.

Folklore also plays an important role in the aftermath of Esperanza's Gulf War death, and here too it signals cultural patterns divergent from those of the world in which she died. Though the family receives only vague information from the U.S. government about what happened to her, they get a much clearer communication from La Llorona, the legendary apparition.[19] Up to the point where this happens, the family has only been told by the government that Esperanza was kidnapped when "too close to enemy lines." Loca, however, receives a more definitive message while amusing herself near an irrigation ditch where she has played since she was a child. Loca explains to her mother: "*She* came to tell me that la Esperanza is died, Mama" (p. 158). It turns out that "she" is "the lady with the long white dress" (p. 159) whom Loca has been seeing for years, without ever having been told the legend of La Llorona, which her mother summarizes as follows: "La Llorona was a bad woman who had left her husband and home, drowned her babies to run off and have a sinful life" (p. 161). According to Mexican and Mexican American folklore, her punishment is to always haunt lonely rivers and streams, searching and crying out for her lost children. Hence her presence at the ditch, but Sofi—repelled by the legend because she well knows that it is she and other women who have been abandoned by men and stayed to nurture their children, not rid themselves of them—has "refused to repeat this nightmare to her daughters" (p. 161). Castillo envisions La Llorona whimsically as a "Chicana international astral-traveler" encountered in the ether by "Esperanza's spirit-mind" (pp. 162–163) and thus sent by Esperanza to deliver the news of this daughter's death. A week later the family finally receives an "official letter" but still with "no details" (p. 159). Castillo's somewhat antic use of a figure from the folk narrative and belief systems of the ethnic group as the more effective channel of communication for the family is highly indicative of the gulf between cultures, suggesting

that the dominant culture is not even communicating with the ethnic group, which thus has to rely on its own methods of communication, whether folkloric or transcendental.

Yet the relationship between ethnic and dominant cultures is, of course, more complex than one of alienation and noncommunication. Castillo is well aware that Mexican American culture—and by extension all American ethnic cultures—is intimately a part of a larger American context and that the ethnic group cannot presume or pretend to live apart from that larger context. The circumstances of the end of the third daughter, Caridad, make that clear.

Francisco el Penitente conceives an overwhelming desire for Caridad, whom he encountered while she spent a year in a cave as a holy hermit and his *penitente* brotherhood approached her. He pines for her, stalks her—or, as he thinks of it, keeps a vigil outside her trailer every night—while she has fallen in love with Esmeralda, now the lover of California Maria. Caridad keeps a vigil every night outside their house and Francisco eventually follows her and keeps his vigil there while she keeps hers. At one point he abducts Esmeralda— ironically taking her by "the power of words" (p. 207), not by physical force—in front of the rape crisis center where she works. Finally Caridad, followed by Francisco, goes to Acoma Pueblo with Esmeralda, who is part Pueblo Indian and has family there. When she suddenly sees Francisco, Esmeralda, though not frightened, begins to run, and she and Caridad, holding hands, leap off the Acoma mesa, not precisely to their deaths but to disappear, apparently swept up by the Pueblo spirit deity Tsichtinako, also known as Thought Woman. Later that night Francisco is found "like a crow-picked pear [on] a tall pinon" (p. 212), having called out Caridad's name before hanging himself.

Francisco's motivation is both unclear and multivalent. His Viet Nam experience played a role in shaping the self which commits his "hideous crime," and his intense religiosity has moved him toward irrational behavior including a suppression of the sensual which seems to create the virtual eruption of desire for Caridad. His religious orientation is closely tied by Castillo, however, to folk tradition. Not only does he participate in the religious observances of a folk cult,

the *penitentes*, but he has chosen as his profession that of *santero*, carver and painter of the traditional *bultos* which have been virtually emblematic of Hispanic New Mexican folk art. That is, his religion is bound up in his attempt to virtually withdraw from the dominant culture into the ethnic one. The attempt is certainly part of the madness which overcomes him, and Castillo is implying that the extremes of ethnicity can be as destructive as the problems created by the power of the dominant culture and that in the American context ethnic cultures are inevitably hybrids whose members must successfully negotiate between disparate worlds. If assimilation killed Fe, failure to assimilate kills Francisco. This theme is reinforced by Francisco's death by hanging—a sort of symbolic crucifixion such as is at the heart of *penitente* folk belief and ceremonialism—and by the site of his final, fateful encounter with Caridad: Acoma, noted as a bastion of Pueblo tradition which deliberately rejects many influences of the dominant culture and its things. The theme is reinforced also by another character who figures importantly in the chapter which tells the story of Caridad's and Francisco's end. This is Francisco's uncle's friend Sullivan, an Isleta Indian whose belief that he will become a Cloud Spirit if struck by lightning and whose singing of a Pueblo song indicate his ease with his own tradition, while his name, which comes from his mother's love of early TV and Ed Sullivan's show, suggests a more graceful straddling of cultures than Francisco can manage. Caridad herself has been a straddler of cultures, working in the health delivery systems of both—an area which, as Américo Paredes has pointed out, is one of particular sensitivity for assimilated Mexican Americans, one particularly infused for them with loyalties to both cultures.[20]

Indeed, Castillo's whole novel, though it does draw out the destructive power of the dominant culture, is about the complex relationship between the dominant and the ethnic cultures, which of course are intricately intertwined and which exist in some exquisite tension with each other. In fact, the novel projects an even more inclusive approach to defining Chicano identity than we have suggested thus far. The negative depiction of the religious zealot Francisco el Penitente and the fact that Caridad becomes a traditional

healer yet does not emulate her *curandera* mentor's Catholic orientation are both elements that undercut the oft-cited characterization of Hispanic cultures as Catholic in nature. Sofi's rejection of the La Llorona legend is a feminist revision of traditional knowledge, and her political activism and leadership roles run counter to the characterization of the culture as passive and patriarchal. Caridad at one point is identified by the masses with an Apache mystic woman warrior, linking her to a non-Mexican Indian identity. And when Caridad and Esmeralda, *mestizas* with different indigenous backgrounds, leap hand-in-hand from the mesa at Acoma, summoned by the Keres deity Tsichtinako/Thought Woman, they represent the blending of two indigenous traditions, arguing for the recognition of the non–Meso American indigenous roots of many Chicanos.[21] Even Fe, who embraced Anglo culture so enthusiastically and fatally, is reclaimed later in the novel as she is hailed as a martyr in the demonstrations against the evils of industrial pollution. Castillo's vision of Chicano tradition and identity thus allows for the inclusion of non-Catholics, *mestizos* from northern indigenous groups, feminist activists, and it even makes room for those who, like Fe, favor assimilation.

In part the novel is cast as a *telenovela*, the Latin American version of the TV soap opera, yet it parodies that form, suggesting both the ethnic culture's connection to the larger world of Latin America and, as a culture of the United States, its ironic distance from it. Castillo's very language—English but with liberal use of Spanish, Spanglish, and local ethnic terminology and slang, and a tone which suggests the cadences of Mexican American speech—places the book itself as a cultural hybrid, like the world it describes. So does Castillo's obvious debt to magic realism—in literature, the hard-to-define genre which is "a mingling and juxtaposition of the realistic and the fantastic"[22]— and which in part accounts for Castillo's use of folklore, some of which lends itself to the fantasy elements magic realism strives for. Magic realism is particularly associated with certain Latin American writers, and Castillo is tying her book to the larger world of Latin American culture. Yet magic realism as a term has earlier uses in reference to American painting and has been noted in the work of African American writers and thus straddles the

cultural matrix. Even the book's proverbial title suggests—among its other meanings—cultural fusion. However far from—or close to—God the world of the novel may be, it is closer to the United States, far closer than the Mexico of the saying. Indeed it is part and parcel of the United States, however uneasy that unity of identity may sometimes seem, however much the ethnic group draws from Hispanic cultural sources.

That is, the novel is talking precisely about the American ethnic situation which juxtaposes and intermingles different cultural realities, bringing about interrelations, both smooth and uneasy. It is precisely in focusing upon both the complexity of ethnic identity and the interrelations of Hispanic New Mexico with the dominant society that Castillo uses folklore (though the folklore, central to the fictional lifeworld in the novel, is a dimension which has other ramifications and references other meanings as well). Folklore has been conceived as a marker of "racial" or "national" difference since the eighteenth century at least, and in So Far from God it serves to mark ethnic territory. However, Castillo presents it in such a way that it also comments upon its hybrid nature as well as its connection to the larger society to which the ethnic group is inextricably bound.

In doing so she works with cultural tensions that have been important to other Latina and Latino writers and artists in the United States, and it is noteworthy that some of them have likewise looked to re-situations of the folkloric in their work. To look briefly at some of that work in the visual arts amplifies the cultural context of Castillo's work and her balancing of mainstream and ethnic cultures and also moves our consideration of folkloric re-situations into art forms beyond the literary.

The images and objects produced by Latina and Latino artists which re-situate folklore may be playful or, in the wider spirit of Latin American art, highly satirical and full of social criticism. José Antonio Burciaga's *Amor Indocumentado/Undocumented Love* (acrylic on canvas, 1986),[23] for example, parallels Castillo's focus on the pain and dislocation experienced by ethnic Americans who feel alienated by the larger American culture. Central to this painting is a bleeding Sacred Heart—a religious symbol with a long history in

both fine arts and vernacular renderings and in popular devotions and rituals. However, here the Heart is confined by a chain-link fence surmounted by barbed wire (which also winds into a Crown of Thorns around the Heart). Blood drips onto an American flag, also behind the fence to indicate that the United States is there, while above the Heart and against the floating cross that is traditionally a part of the Sacred Heart a man wearing only the white, loose trousers of the Mexican *campesino* stretches out his arms as if to reach out and over and across the fence, clearly reaching toward his Mexican heritage on the other side. The title of the painting suggests that, just as he may be an "undocumented alien," so his love for his Mexican culture is undocumented, that is, unrecognized. The traditional symbol of the Sacred Heart takes on nonreligious meaning, bleeding for his suffering in a cultural imprisonment which involves Hispanic culture's being trapped within the dominant American.

Playful in their satire and social consciousness and more in keeping with Castillo's recognition of the bi-cultural reality of Hispanics in the United States are such works as *McMuertos, Inc.*, a mixed media installation (2000) by a group of eight artists, and Ester Hernandez's *Sun Mad* (serigraph, 1981) and *Sun Mad—the Installation* (mixed media, 1989), all three of which play with *calavera* images from Mexican Days of the Dead rituals juxtaposed with commercial icons of American popular culture. The Days of the Dead complex of customs, ritual, and beliefs is a blending of European Catholic beliefs and ceremonies associated with All Saints' Day and All Souls Day (November 1 and 2 in the calendar of the Roman Catholic Church) and pre-Columbian practices and beliefs. In Mexico, the Days of the Dead celebrations constitute one of the most important holiday events. The days leading up to the event are dedicated to preparations—buying supplies, building altars in homes, preparation of special foods, and grave cleaning. Finally, on November 1 and 2, the reunion of living and dead family members and friends occurs when the spirits are supposed to return to their former homes, where they will find altars containing food and drink prepared for them. The term *calavera* refers to the skeletal figures and especially the skulls which are important foci of the holiday as toys,

food objects (candy skulls or wax skulls which contain sweet liquids), and ritual pieces that are placed on family or more public altars (*ofrendas*). This syncretic Mexican celebration offers a time and place (whether the cemetery or home altars) for renewed contact between the living and the dead, who together constitute a spiritual community. In this way each year the continued well-being of family and community is assured, through the renewed commitment to mutual care and support of living and dead.

Since at least the early 1970s art galleries and Chicano cultural centers in the United States have been featuring Days of the Dead altars and exhibits. Chicanos had begun to organize politically in the 1960s to bring about economic and social changes which would benefit their community. In this context highlighting elements of Mexican cultural heritage served as an expression of group identity and unity. The customs and traditions surrounding the Days of the Dead were particularly effective as a marker of common roots, because they focused on honoring Mexican ancestors. Moving the altars into public arenas, on the other hand, has made them accessible to a larger, non-ethnic audience and created a broader appreciation of Mexican culture among the general public. Insofar as death and the impulse to honor the dead are universal human experiences, the rituals promote feelings of kinship among all the participants.[24]

Tere Romo, Curator of Exhibitions at the Mexican Museum in San Francisco, notes the adaptive nature of this "very distinct Mexican tradition" which has allowed it "to evolve and maintain its relevance through hundreds of years," even "incorporating American cultural references, such as the use of English and . . . electronic technology," while retaining "its core concepts of duality and the inherent union of life and death, of the spirit and corporal worlds." Moreover, as Chicano artists began to incorporate images, motifs, and ideas associated with the celebration into their work, they re-situated the traditions in an American context, using it to express ideas and values rooted in their own cultural heritage. In Romo's words, the tradition was transformed "within a *mestizo* sensibility, one of syncretism that emphasized its spiritual role, had a sense of humor and irony, yet was still very much rooted in the political agenda of *Chicanismo*."[25]

McMuertos, Inc.[26] (the souls who are believed to return during the Mexican rituals are referred to as *los muertos*, or the dead ones) works from the advertising and corporate symbols of the McDonald's fast-food chain, here presenting a mock advertising poster that pretends to offer a corporate venue for providing for "*all* of your Dia de los Muerto's needs," thus poking fun at the omnipresence and power of such chains as McDonald's, which can even impose cultural, culinary hegemony. In the poster, Days of the Dead altars vie with a *calavera* Ronald McDonald (the clown figure who is central to the company's public relations) and an employee who is a luminous-eyed *calavera* in a peaked cap which bears a satirical rendering of McDonald's "golden arches" trademark. A mock press release which was part of the installation further develops the idea that even sacred rituals may have to endure corporatization in modern America.

Hernandez's more overtly political works stem from the artist's discovery that the water table beneath her home town in California had been contaminated by pesticides used for spraying local grape crops, including those used to make Sun Maid brand raisins. *Sun Mad* provides a serigraph rendering of the well-known box in which Sun Maid raisins have long been marketed but which replaces the usual sunny maid with a *calavera* and also replaces the usual language of the box with alternatives ("Naturally Grown" becoming "Unnaturally Grown," for example). The installation expands on the print by repeating the image on panels that display different figures when viewed from different angles. From one direction one sees, instead of the *calavera* maid, a human *bracero* (field laborer) and from another angle a *calavera bracero* to suggest the dangers of pesticides for agricultural workers. The installation also adds sand and votive candles to suggest a Days of the Dead *ofrenda* and objects, such as a canteen, associated with field labor. Hernandez also appears in a short performance-art video, *Sun Mad—the Movie/Sun Mad—la Pelicula*, directed by Renée Moreno (2000), in which she is herself dressed as a comedic *calavera* in the fields of Sun Mad Vineyards and at one point stretches out like a *calavera* corpse figure laid out traditionally on a *petate* mat with flowers.[27]

Both Hernandez and the McMuertos artists, then, work within the hybridity of the ethnic American context, merging folk elements

of ethnic culture with major manifestations of American mass culture. Though their satire and politics show their affinity with some of the darker aspects of Castillo's vision (Hernandez's concerns with pollution, for example, mirroring Fe's death by contamination and the protest which makes Fe an environmental martyr), the artists place their ethnicity firmly in the larger orbit of American society through intimate acquaintance with some of its mass symbols (not to mention their use of English rather than Spanish in expressing aspects of their ethnic identity), which they intermix with ethnic folk elements. As Castillo creates a narrative world which emphasizes hybridity, so they create images which draw upon both ethnic and mainstream images to which they have equal access. In essence they create new images out of old, both popular and folk.

Other Mexican American artists, however, express the connection through the very materials of their art. In *Hubcap Milagro # 1* (mixed media, 1984) (fig. 1) David Avalos takes an artifact from American mass culture, an automobile hubcap, and joins it both artistically and conceptually to ethnic folk religion. A metal-work Sacred Heart (with a picture of Jesus in the center) superimposed on to the hubcap not only resembles a traditional *milagro* (one of the small, metal objects ritually presented to Christ, the Virgin Mary, or a saint in connection with a request for a miraculous intervention) but transforms the whole piece into a symbolic *milagro*, hubcap and all. The mainstream, industrial artifact is fused with ethnic sensibilities to reflect an inextricable connection. Contemporary New Mexican *santero* Luis Tapia has expressed this hybridity in another way, by using the traditional folk art methods of *santo* making to include nontraditional subject matter which expresses the contemporary context as one in which ethnic culture is interwoven with the greater American one. Not only has he produced Noah's ark assemblages (which can be marketed to non-Catholics and even non-Christians historically outside the tradition of the *santo*) but he also has made *bultos* (carved figures, traditionally of holy personages) which depict entirely secular subjects, including one called *Folk Art Collectors* (1992) (fig. 2). Here two figures are mounted to a base, a man in flowered shorts and a T-shirt that bears the state symbol of New Mexico, holding a tiny *santo* of the

traditionally rendered San Rafael, and a woman wearing a squash-blossom necklace and with money in one hand and a *bulto* of the Virgin of Guadalupe in the other. In terms of materials and style the piece is much in the folk art and ethnic traditions. It is also a witty and brilliant acknowledgment of how in the late twentieth century the ethnic arts tradition is part and parcel of the tourism and art-collecting trends of American society.[28]

Figure 1 *Hubcap Milagro # 1,* by David Avalos; mixed media: hubcap, circular saw blade, tin funnel, colored tin strips, wood, plastic sheeting, nails and color Xerox; 15" diameter, 4" deep; 1984. Reproduction courtesy of the artist; photograph by Manuel "Memo" Cavada.

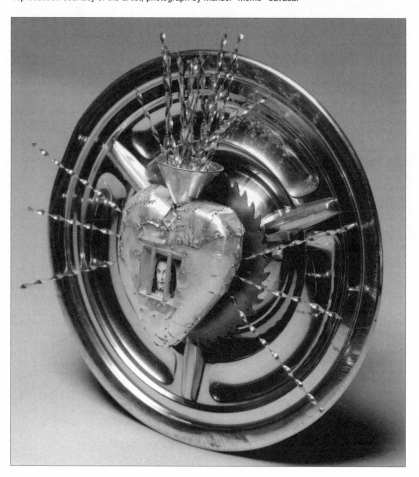

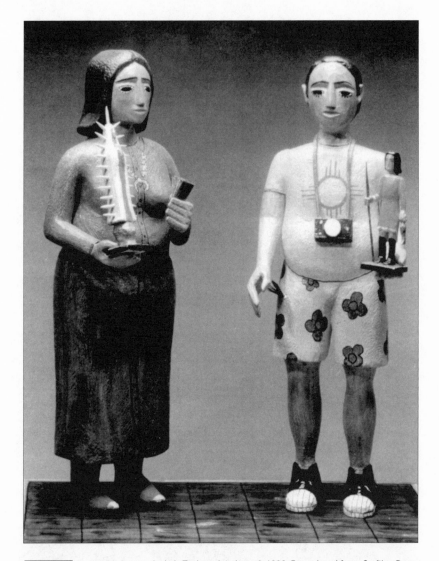

Figure 2 *Folk Art Collectors,* by Luis Tapia; painted wood; 1992. Reproduced from *Crafting Devotions: Tradition in Contemporary New Mexico Santos,* by Laurie Beth Kalb with the permission of Laurie Beth Kalb and Lynn Steuer.

Such a sense of hybridity reached an interesting level in the controversial "Cyber Arte" exhibition which opened at the Museum of International Folk Art in Santa Fe in 2000. An exhibition which

continued the museum's interest in ongoing development of New Mexican Hispanic arts, it included such works as a rendering of a *matachines* costume (*matachines* perform a traditional dance) made of computer boards. The controversy that enveloped the exhibition, however, swirled around a painting in which artist Alma Lopez depicted herself in a bikini as the Virgin of Guadalupe, a sacred figure of legend and popular devotion especially important to Mexicans and Mexican Americans (and thus a figure played with in a variety of ways by other Latino and Latina artists[29]). The painting outraged some local Hispanics and other conservative Catholics, who mounted a campaign against it. The resulting controversy raises questions about who "owns" folk traditions and what can happen when artists appropriate folk traditions, perhaps especially sacred ones, but the fact that a sophisticated artist member of the ethnic group mixed together ethnic tradition and American modernity so completely underscores the recognition of hybridity and explores the artist's relationships to both cultures.

Castillo and McInerney present mimetic cultural contexts for folklore which are very different and in which folklore functions very differently, both in terms of its pervasiveness and its cultural specifics. For McInerney the folklore—one communicative medium among many in a sophisticated environment—serves to put his main character and her progress in the world into perspective. McInerney takes the folklore which informs his characters' everyday lives and foregrounds it to comment on a character's personality, moral state, and progress in life. Alison's use of folklore is in part a personal one, and McInerney recognizes that we have personal repertoires of lore. For Castillo the folklore—a cultural constant in an environment which is in some measure a folk society—serves to comment on the expanding boundaries of the novel's cultural world. Castillo takes the folklore which suffuses her characters' lives like light fills a room and uses it to draw a complex picture of social and cultural relations in American society (complexity which is mirrored in the work of Mexican American visual and plastic artists who also re-situate folk materials to explore the same cultural hybridity that she does). Each

novel works closely with the social reality of folklore, re-situating it mimetically into a fictional reality (though in *So Far from God* reality is often fantastic, the folklore sometimes amplifying the fantastic), seeing it as a part of culture which communicates and has meaning within a novelistic lifeworld, but each also heightens those internal meanings to provide new ones for the reader.

2

Somebody Always Gets Boiled

Reworking "The Robber Bridegroom"

The folklore that animates McInerney's and Castillo's novels appears as an element of the fictional lifeworld of each book. That is, these novelists incorporate the folklore into their work by transposing it from an actual cultural context into a fictive one. This approach is mimetic, and the folklore is presented as the cultural possession of fictional characters. We have meant to suggest that the prominence of folklore in two such postmodern novels is indicative of the ongoing appeal of folklore to writers and is a recognition by writers of the continuing significance of folklore in late-twentieth-century society. Nor are these two novels unique in recent literature.

However, twentieth-century writers also used folklore by adapting folk plots—notably from myth and fairytale (Märchen)—as literary plots or as important reference points which structure meaning. One need only think of Joyce's *Ulysses* and Kazantzakis's *The Odyssey: A Modern Sequel* (both based on the Odysseus story, a narrative which of course also has a long literary lineage), or such lesser-known landmarks as Donald Bathelme's *Snow White* or the short stories in Angela Carter's collection *The Bloody Chamber* (the titles for both of which are the conventional titles for well-known fairytales).[1]

In this chapter we consider two novels, one Canadian and recent, one American and published over fifty years before the other. Interestingly, though the novels are probably as different from each other as is *Story of My Life* from *So Far from God*, each works from the same folk narrative, the Märchen widely known as "The Robber Bridegroom." This tale is designated Type 955 in the Aarne-Thompson international index of folktales;[2] Aarne and Thompson note also that it is closely allied with Type 311, "Rescue by the Sister." It also has features in common with Type 312, "The Giant-killer and His Dog (Bluebeard)." The story is most widely known from its inclusion in the Grimms' *Kinder- und Haus-Märchen*, where it is number 40, and in fact the Grimm version has influenced oral as well as literary tellings of the tale.

In the Grimms' version of Type 955,[3] a young maiden is promised by her father, a poor miller, to a suitor. When she goes to his house "in the dark forest," she is warned by a bird in a cage not to enter:

> "Turn back, turn back, young maiden dear,
> 'Tis a murderer's house you enter here."

An old woman she finds in the cellar warns her, "You think you are a bride soon to be married, but you will keep your wedding with death." Sure enough, from a hiding place she witnesses the murder and dismemberment of another young girl at the hands of her bridegroom and his band of robbers. The murdered girl's little finger, chopped off by a robber wanting her gold ring, flies through the air and lands in the maiden's bosom. With the old woman's help, however, the maiden escapes home and tells her father exactly what happened. On the wedding day, in front of all the guests, she repeats her story as if telling about a dream, interspersing after each new detail, "My darling, I only dreamt this," until the point where she exclaims, "And there is the finger with the ring!" showing it to all present. She thus exposes the "gentleman's" robber identity and murderous nature, and "he and his whole troop were executed for their infamous deeds." The tale is thus full of mirror images and double exposures: We hear the story twice, as it happens *to* the miller's daughter, and again when told *by* her. She sees her own fate as bride mirrored

in the scene of murder she witnesses. And of course the title of the story points to the double identity of the "robber bridegroom," the rich gentleman with a monstrous dark side.

Cristina Bacchilega has written at length on recent literary and filmic re-situations of "Bluebeard" and its related tales, including "The Robber Bridegroom," noting aspects of doubling and duality but emphasizing the initiatory aspects of the tales whereby women venture and thus gain important knowledge.[4] The two modern women novelists discussed here have used this tale for exploring questions of identity and the psychological process of personality integration: Eudora Welty in *The Robber Bridegroom* in 1942, and Margaret Atwood, who turns the paradigm inside out in *The Robber Bride*, in 1993.[5]

In her novel Welty imitates the style and mood of the Märchen (so that there is an element of formal/stylistic imitation in her re-situation of folklore) because the history of the Natchez country setting of her plot seemed to her, like the Märchen, to be characterized by innocence, fantasy, and wonder on the one hand and violence, danger, and terror on the other. After poring over primary documents relating to the history of the Natchez Trace, she said, "I thought how much like fairy tales all of those things were. And so I just sat down and wrote *The Robber Bridegroom* in a great spurt of pleasure."[6] Discussing the novel in a talk given before the Mississippi Historical Society, published under the title, "Fairy Tale of the Natchez Trace," Welty called the book a historical novel, but "not a *historical* historical novel."[7] Indeed, many fairytale elements appear in the story, ranging from obvious plot elements from other well-known tales (notably "Cinderella," "Snow White," and "Beauty and the Beast"/"Cupid and Psyche") to the appearance of motifs such as a magical locket and a disembodied, talking head, a wicked stepmother and a literal-minded fool. There is the sort of plot repetition common to folktales as when the planter Clement Musgrove goes from inn to inn trying three times to find an honest landlord, and Welty gives her characters the simple motivations of tale protagonists.

The robber/bridegroom character in Welty's novel, Jamie Lockhart, is based on both the folktale and on the outlaws who figure

in the history and legends of the Natchez Trace.[8] Thus Welty in part looks to folklore to invoke a vision of the frontier, much as her near-contemporary Thomas Hart Benton sometimes looked to folk songs to do the same in his visual art, whether the Western frontier in lithographs or murals like *Jesse James* in which the James gang is depicted simultaneously holding up railroad men and shooting it out in front of a small-town bank; or the Southern mountain frontier in such depictions as *She'll Be Driving Six White Horses* (fig. 3) in which folk musicians play in front of log buildings while a scene from the song is set behind them, emphasizing the rough and craggy terrain of the Ozarks and the interconnection of folk song and environment.[9] The frontier wilderness in Welty's novel, however, is portrayed as both Eden and inferno, folktale motifs being used to create both an atmosphere of enchantment and also a sense of horror. Welty's heroine Rosamund, the daughter of a wealthy planter, meets Jamie in the woods, where he robs her without knowing who she really is, and on their second encounter, he kidnaps and rapes her. After that encounter, Rosamund, like the miller's daughter in the folktale, sets out to find her lover's house deep in the forest, without knowing that he is Jamie Lockhart, a gentleman who has befriended her father. As in the tale, she ignores the advice of a talking bird and enters. Finding no one at home, she begins organizing the household, and instead of killing her, the robbers allow her to stay and cook for them, like Snow White keeping house for the dwarfs. "And at first," Welty tells us, "the life was like fairyland" (p. 82). Rosamund and Jamie spend the nights together, the robbers spend the days robbing, and Rosamund keeps house. But when she tries "to lead [Jamie] to his bed," Welty tells us, "he would knock her down and out of her senses, and drag her there." However, "if Jamie was a thief after Rosamond's love, she was his first assistant in the deed, and rejoiced equally in his good success" (p. 84).

Both Jamie and Rosamund, then, have double identities, and neither realizes this truth about the other. When Jamie Lockhart had dined with Rosamund's father Clement Musgrove, he had not of course been wearing his robber's disguise, a mask of berry stains (which like Bluebeard's beard are "the visible clue to his otherness"[10]),

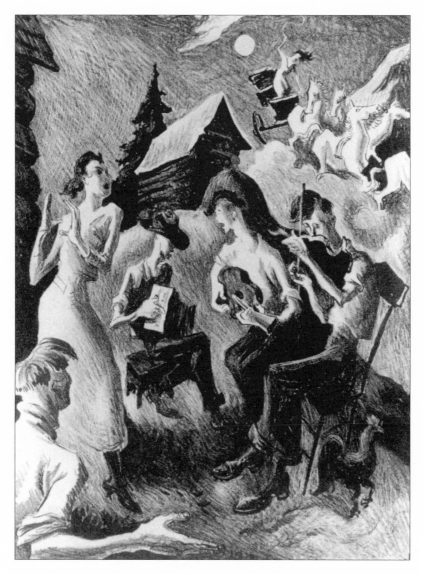

Figure 3 *She'll Be Driving Six Whie Horses,* by Thomas Hart Benton; black and white lithograph; 1931. Reproduced by permission of Creekmore Fath.

and Rosamund had scarcely looked at him. Stunned by her encounter with the robber that very morning, and forced by her stepmother to work all afternoon cleaning house and cooking, she had appeared

"with ashes all in her hair and soot on either cheek and her poor tongue all but hanging out, and her dress burned to a fringe all around from the coals, and altogether looking like a poor bewitched creature that could only go in circles" (p. 68). When Clement Musgrove promised his daughter to Jamie if he will save her from the bandit who robbed her, Jamie lamented to himself, "Why the devil could she not have been beautiful, like that little piece of sugar cane I found for myself in the woods?" Jamie did not recognize Rosamund as the beautiful girl he robbed and raped, and Rosamund does not recognize "her dark lover" (p. 68) in her father's dinner guest. Later, living with Jamie in the robber's den, Rosamund longs to see her lover's face beneath the berry stain disguise but she avoids the unpleasant truths about their relationship. Jamie, meanwhile, never allows anyone who knows him as a robber, not even Rosamund, to know him as Jamie Lockhart the gentleman.

Before either character can grow up, and before they can establish a relationship built on true knowledge of each other's identity, each must develop a more realistic sense of his or her *own* identity. This new self-knowledge for each of them is accomplished partly through encounters with an alter-ego character in whom they see a mirror reflection of aspects of themselves. When Jamie meets the Little Harp, a cruel and ruthless bandit who serves as a projection of the darkest parts of his personality, he is appalled. Little Harp recognizes both halves of Jamie's identity, but somehow Jamie can't quite bring himself to kill off this threat to his dual existence, although he afterwards wonders why he let the Little Harp go. Rosamund, approaching the robbers' den after a visit to her parents, finds Little Harp in her husband's place and she hides in fright behind the barrel out of sight, where, like the bride in the Grimm tale, she witnesses the murder of an innocent Indian maiden at the hands of her bridegroom's band of robbers, and the maiden's finger ends up in Rosamund's lap. Little Harp had asked for Jamie Lockhart's bride, and the robbers swore that the Indian maiden was her. Thus, despite her love for Jamie, Rosamund sees reflected in this event the dark side of their relationship and her role in it. That night, using a formula given her by her stepmother, Rosamund cleans the berry juice

mask off of her lover's face and recognizes him as Jamie Lockhart, while he finally realizes that she is the planter's daughter. Thus each, in gaining self-knowledge, is led to a recognition of the other's full identity. Rosamund later laments:

> "My husband was a robber and not a bridegroom," she said. "He brought me his love under a mask, and kept all the truth hidden from me, and never called any-thing by its true name, even his name or mine, and what I would have given him he liked better to steal. And if I had no faith, he had little honor, to deprive a woman of giving her love freely." (p. 146)

As in the story of Cupid and Psyche (Type 425), Rosamond's lover flees when she discovers the gentleman under the monster's mask, and like Psyche Rosamund must undergo ordeals before the two are reunited. Only then can a relationship between two mature, whole individuals develop.

Nevertheless, the duality of all things permeates the novel. As Welty herself told the Mississippi Historical Society:

> There's a doubleness in respect to identity that runs in a strong thread through all the wild happenings—indeed, this thread is their connection, and everything that happens hangs upon it. I spun that thread out of the times. Life was so full, so excessively charged with energy in those days, when nothing seemed impossible in the Natchez country, that leading one life hardly provided scope enough for it all. In the doubleness there was narrative truth that I felt the times themselves had justified.[11]

What Welty is coming to terms with in *The Robber Bridegroom* is the problem of self-identity and the integration of the individual personality as an aspect of finding one's self. It is not coincidence that the narrative practically begins with a quarrel between Jamie Lockhart and Mike Fink in which each asserts his own identity while disparaging that of the other—a boasting match in the spirit of the

ring-tailed roarers of the Frontier humor traditions. In contrast, some of the main characters in the short novel are consumed by their dark, destructive side or are engaged in a struggle to assert the more positive side of their personality, to determine who they really are despite the disguises and lies they use to hide parts of themselves.

Salome, Rosamund's stepmother (called "satanic" by one critic[12]), is lost in the compulsions of greed and of never being satisfied with what she has or with what is. There is "no longer anything but ambition left in her destroyed heart" (p. 24), and her desire to possess all leads her to send Rosamund out into the wilderness, hoping she will be kidnapped by Indians or carried off by a leopard. If there is anything good and praiseworthy in her, it never emerges (or perhaps has disappeared before we meet her), and in the end she perishes in a terrible isolation.

Jamie Lockhart of course is more obviously the divided self, the man of dual natures, who works to establish his more positive side as dominant. In his early incarnation he lacks the restraint of self-control and says, in first robbing Rosamund, "I am determined to have all" (p. 49). Later he says, "all things come to him who waits, but that is not my motto," so of course he merely takes what he wants, his id virtually unbridled. That he insists on taking Rosamund by force when she would freely give herself shows that he is obsessively given to thievery, and indeed his role as a robber indicates his inclination to simply take whatever he wants. He is thus not unlike Salome, but unlike her he is capable of changing, of becoming the gentleman he appears to be when Clement first meets him. He becomes transformed by compassion when he is moved by Clement's suffering and by the love he feels for Rosamund, once he realizes who she is. In the end he has made the "transfer from bandit to merchant" (p. 184) and is living in New Orleans, the civilized city which is the presumed opposite of the wilderness which is the place of darkness where dark sides get played out. "All his wild ways had been shed like a skin," Welty writes, "and he could not be kinder to her than he was" (p. 183).

Yet Welty ultimately suggests that an excursion into our own duality and our dark sides is a necessary step in establishing self-identity and understanding who we are. Clement Musgrove, like his wife

Salome, seems to be limited to only one side of himself, though in his case it is the light side, not the dark. At the very outset of the novel he is described as "an *innocent* planter" (p. 1, emphasis added) and we are told near the end that "he was an innocent of the wilderness" (p. 182). He goes through life with an inner goodness, despite many trials, and comes out at the end safe and sound. Welty implies that he has ignored something important in himself and, though this is not self-destructive, it limits his relationship with the world and with others. When in the end he arrives in New Orleans himself, he is oblivious to the life it offers as "the most marvelous city in the Spanish country or anywhere else on the river. . . . Clement Musgrove was a man who could have walked the streets of Bagdad without sending a second glance overhead at the Magic Carpet, or heard the tambourines of the angels in Paradise without dancing a step, or had his choice of fruits of the Garden of Eden without making up his mind" (p. 182). And in the end he is unable to be truly reunited with his daughter.

Jamie Lockhart, however, is a success precisely because he knew his other side: "But now, in his heart Jamie knew that he was a hero and had always been one, only with the power to look both ways and to see a thing from all sides" (p. 185). That is, he enjoys a more subtle, more complex, more exquisite vision of himself and others. Likewise Rosamund finds happiness in the end because she knows something of her own duality. Though never as dark as Jamie, though seemingly a good young woman in many ways, she is depicted as an inveterate liar, and she shares the blame for the perpetuation of a relationship based on dishonesty. She too needs to realize her self, through a series of symbolic and real revelations (as when she stands naked after Jamie robs her of all she has or when she watches the robbers murder a young girl they claim is she herself) and through finally putting her trust in Lockhart, once his true self is revealed. Thus the lovers are like Ada and Baines in Jane Campion's film *The Piano*, a rendering of the "Bluebeard" tale discussed by Bacchilega; like Jamie and Rosamund, Ada and Baines also ultimately unite successfully in love after learning and maturing in the course of the film's narrative. It is noteworthy that unlike Bluebeard or the Robber Bridegroom, both of whom must be killed in the folktales, both Jamie and Baines live to

share in a knowledge learned through initiation, and one might argue that Baines and Ada like Jamie and Rosamund explore dark sides of their selves before moving on.[13]

While Atwood does not simulate a Märchen style in *The Robber Bride* (which is much more a conventional novel than Welty's, though indeed a much more complex one), she does explore the theme of duality and the need to integrate light and dark facets of the personality to achieve one's true identity, important elements in the original folktale. The title character, however, is not bridegroom but bride and refers to Zenia, the femme fatale who destroys men in order to wound the women who love them. The novel's three chief protagonists, Tony, Charis, and Roz, share a history of such wounds. Indeed, Zenia steals a man from each, leaving heartache and destruction in her wake. When Tony, an academic historian, is in graduate school, she forms a friendship with West, who is living with Zenia. When Zenia abandons him he becomes an emotional cripple, so Tony takes him in and comes to love him, only to have Zenia return, take him back, then cast him away again. Later, Charis, a devotee of yoga, vegetarian food, and New Age philosophies, takes as her lover Billy, an American draft dodger in Canada fleeing the Viet Nam War and active in antiwar circles. Charis takes in and tries to heal Zenia, who claims to be suffering from cancer. Zenia winds up not only taking Billy away as a lover but apparently also betraying him to the American authorities. Charis, pregnant with his child, last sees him on a ferry pulling away from the island where they live, Zenia with him along with some shadowy men. Charis remains haunted by his mysterious, utter, and sudden disappearance from her life. Later still, Zenia entices away Mitch, Roz's husband and the father of her children. Mitch may have gone through numerous dalliances with other women, but with Zenia he falls madly in love. He finds himself crushed when she dumps him, chases her unsuccessfully to Europe, and finally kills himself in despair.

Zenia as the Robber Bride is not a dualistic character in need of personality integration herself; instead she is the alter ego projected by each of the three women in turn. And just as Jamie cannot bring himself to kill off Little Harp even when he moves in and

takes over, because Little Harp knows the secret of his dual identity, these women create and sustain Zenia through their psychological projections. "My own monster, thinks Roz. I thought I could control her. Then she broke loose" (p. 95). Charis worries that, once Zenia is dead, the "mere absence of a body would not stop Zenia; she would just take someone else's. The dead return in other forms . . . because we will them to" (p. 525); that is, Zenia inhabits others, and those others welcome her in. Zenia knows the three women's strengths and weaknesses so intimately that she becomes the embodiment of their fears and desires, a reflection of aspects of their selves, a mirror in which their own identities linger. When the police inquire about their relationships to Zenia (after she has plunged to her death from a hotel balcony into a fountain), Charis blurts out, "We were her best friends," a statement which flies in the face of the hatred they had of her for what she did to them, the fear they have of her ongoing potential for harm. Yet it is a strangely true statement suggestive of how closely intertwined they all are. When they had visited her individually in her hotel room just before her death, the room had seemed to change to suit the self of each, as Zenia had adapted to their shadow selves.

The significance of the book's title which plays on the folktale title is explored in an episode involving Roz's twin daughters, Erin and Paula. Roz remembers that the twins went through a phase where "They'd decided that all the characters in every story had to be female" (p. 291). At one point Roz is looking at a collection of fairytales given the twins by Tony, their godmother, and recalls:

> There on the cover is the dark forest, where lost children wander and foxes lurk, and anything can happen; there is the castle turret, poking through the knobbly trees. *The Three Little Pigs*, she read. The first little pig built his house of straw. *Her* house, *her* house, shout the small voices in her head. The Big Bad Wolf fell down the chimney, right into the cauldron of boiling water, and got his fur all burned off. *Her* fur! It's odd what a difference it makes, changing the pronoun. (p. 330)

The twins also fought for control of the story, changing the bits they didn't like, although they wouldn't allow the stories to be altogether sanitized. When Roz suggested "that maybe the pigs and the wolf could forget about the boiling water and make friends, the twins were scornful. Somebody had to be boiled" (p. 292). Roz is amazed at their bloodthirstiness. Her friend Tony, whose historical specialty is wars and battles, gives them what Roz calls "those authentic fairy tales in the gnarly-tree editions," with all the gory, violent details retained, insisting that this is more true to life. When Tony reads them "The Robber Bridegroom," they insist she refer to the suitor as "she."

> "We could change it to *The Robber Bride*," says Tony. "Would that be adequate?"
>
> The twins give it some thought, and say it will do. . . .
>
> "In that case," says Tony, "who do you want her to murder? Men victims, or women victims? Or maybe an assortment?"
>
> The twins remain true to their principles, they do not flinch. They opt for women, in every single role. . . .

Looking back, Roz considers the implications of changing the villain's gender, and she explicitly links the tale's malevolent character to Zenia. Then, thinking over her own efforts "to be kind and nurturing, to do the best thing," she concludes: "Tony and the twins were right: no matter what you do, somebody always gets boiled" (pp. 292–293).

Zenia's power over each of these women comes from their projections onto her of shadowy parts of themselves, a factor which of course relates to the duality of the Robber Bridegroom of the original tale, both murderer and respectable suitor, carried over to his reincarnation by Tony and the twins as Robber Bride (when the folktale does make its fleeting appearance in the lifeworld of the novel, though Atwood places it there only so that we may reference its meaning to aspects of the novel more broadly). When Zenia insinuates herself into their lives, she embodies their related fears, insecurities, and

fantasies. Tony feels her mother abandoned her, leaving her with a helpless father who eventually committed suicide. But Zenia's story is much more dramatic than Tony's: her mother sold her to men when she was only five or six years old, so that the two of them, refugees, could eat. Tony is horrified and gives Zenia the sympathy that she denies herself. After this point, Tony gives Zenia whatever she needs — money at first, and then a plagiarized term paper which Zenia later uses to blackmail her.

Zenia insinuates her way into Charis's life by telling her that she has cancer and is being mistreated by the man she is living with, West, who eventually becomes Tony's husband. Charis gradually assumes responsibility for Zenia, feeding her homegrown organic vegetables from her garden, encouraging her to meditate, do yoga, beat the cancer. Charis was also abandoned by her mother, who deteriorated into mental and emotional collapse before dying in an institution, and she cherishes the short time she spent with her grandmother, an independent farm woman, a bloodstopper[14] with other psychic powers as well. Zenia, with her cancer (in fact, a fabrication), plays upon Charis's need to be a healer and a harmonizer.

But Zenia reawakens in Charis a frightening, other side of herself that she had abandoned many years before, her childhood self, named Karen. Karen's mother had abused her physically, and later an uncle abused her sexually. In order to survive, Charis split off from the helpless Karen and tried to forget her and everything that happened to her. Her memories of the events precipitating the emergence of Charis now resurface:

> Then [Uncle Vern] falls on top of Karen and puts his slabby hand over her mouth and splits her in two. He splits her in two right up the middle and her skin comes open like the dry skin of a cocoon, and Charis flies out. . . .
>
> When she was twenty-six she dumped her old name. A lot of people were changing names, then, because names were not just labels, they were also

> containers. . . . She threw away as many of the old
> wounds and poisons as she could.
> That was the end of Karen. Karen was gone.
>
> (pp. 294–298)

But of course shadowy parts of ourselves are not killed off so easily, and Charis finds Karen fighting to come back, brimming over with anger, retribution, and shame. And Charis realizes, "She no longer looks like Karen. She looks like Zenia" (p. 263). Meanwhile Zenia has begun sleeping with Charis's lover, the draft dodger to whom she is giving sanctuary, and just when Charis is about to have his baby, Zenia apparently turns him in.

Zenia has yet another story for Roz, who has already seen how Zenia has wounded her two friends. Zenia convinces Roz that she has straightened out her life, which has not been an easy one, and she hints at both inspirational, courageous adventures, and vulnerability. Roz's own past as an outsider and her present life as a successful businesswoman of means make her sympathetic, though Zenia gains entrance into Roz's life by again exploiting issues concerning parents, Roz's father. In Europe during the war he may have been a hero or a crook or both, and Roz yearns to know more about his life. Zenia claims to be able to fill in some blanks and even credits him with her very survival when a distant Jewish past destroyed her family and threatened her life. Roz sees herself in the fantasy she projects into Zenia as, underneath her successful and beautiful exterior, "a waif, a homeless wandering waif" (p. 362), and she extends her sympathy.

Zenia also expresses Roz's shadow self in another way. Roz accepts the responsibility that her wealth and position imply, but she experiences the requests of the needy as demands which activate strong guilt feelings. Also, knowing that the recipients of her generosity may resent her gifts or even despise her makes her uncomfortable. The part of her that would like to get rid of responsibility and guilt and wallow in self-indulgence and luxury finds expression in the Zenia who announces, *"Fuck the Third World! I'm tired of it!"* Roz "although shocked . . . , had felt an answering beat, in herself" (p. 97).

Roz's husband goes off the deep end trying to hang on to Zenia after their affair is over, losing everything, and so Roz becomes Zenia's

third casualty. The other two now help her pick up the pieces of her life when she breaks down, as they each have done for each other. Even after they attend what they think is Zenia's funeral, however, they do not rest easy, and sure enough, Zenia returns and once more tries to get each one of them to resume their relationship. But this time, they are stronger, and Zenia fails. They have gone through what Bacchilega calls "a profoundly transforming initiation process,"[15] though the robbers' house they entered is that of their complex relationship with Zenia, and now they know better how to deal with her.

The novel explores the interesting issue of how reversing the sex of the title character of the fairytale affects the story—a change which takes place because of how characters relate to the tale in the fictional context of the plot but a change which compellingly amplifies important thematic concerns. The Robber Bride, true to the twins' vision, destroys women, insinuating her way into their lives by exploiting their weaknesses; her power over them comes from their own projections onto her of parts of themselves which they do not wish to own. She *is* their own shadow selves. But one of the book's epigraphs is a quote from Jessamyn West, "A rattlesnake that doesn't bite teaches you nothing." In other words, the fairytale's propensity for making sure "somebody gets boiled" is a reference to the impossibility of learning without pain, and, indeed, Atwood reaffirms the power of fairytales to point to how to survive and make one's way in the world. When Zenia devours their men, the women are forced to confront psychological issues which threaten to destroy them unless they are reconciled with suppressed elements of their own personalities. This is the lesson of Atwood's Robber Bride figure.

As in Welty's novel, however, duality as a theme emerges in many ways. From her early years Tony has developed the habit of reading things both backward and forward.[16] She amused her dorm mates in college by singing "Oh, my darling Clementine" backward, each word turned inside out, but continues throughout life to reverse words, sometimes half joking about the final product. Her reverse language is, she thinks, "her seam . . . where she's sewn together . . . where she could split apart" (p. 21), and she sometimes invokes it when threatening or negative words appear in her consciousness. Hence it is obviously a survival mechanism comparable to Charis's own splitting off of

the helpless Karen. But Tony also has a secret, double, fantasy self—invented in childhood, whom she thinks of as a twin and as "herself turned inside out" (p. 188) and who has her own reverse language war cry, who is daring and strong, and taller than the petite Tony. She is named not Tony Fremont but Ynot Tnomerf, and Tony writes this name with her left hand, her naturally dominant hand she is not supposed to write with. Her task is to release this stronger self.

Charis we know has a suppressed, dual self, an inner child named Karen. Her daughter changes her name from August to Augusta. And her boyfriend the American draft dodger has a second name, a code name in the antiwar movement; he was also a double agent, buying amnesty by betraying his friends. Tony thinks of Zenia herself as a double agent in the war of the sexes, while Zenia hints at her own double agency in the mysterious involvements that lead to her death. Zenia has other names or at least claims to have published under them. Roz was raised during World War II as Rosalind Greenwood and sent to Catholic school. Later, after her father becomes rich, her name is restored to Roz Grunwald, and she is sent to a school where Jewish is the thing to be. But she was not Catholic enough for the first school, and not Jewish enough for the second. We are told, "She's an oddity, a hybrid, a strange half-person" (p. 340). Later she has twin daughters who operate as a single persona. And these are only the most obvious examples of duality.

Duality, however, may imply a failure to integrate the parts of self and to thus find and possess one's true and complete identity. It implies a state of psychic marginality and hybridity, and indeed the three women friends are depicted as marginalized. Probably Roz feels this most acutely, coming out of a "foreign" background, and she sees herself as an "immigrant," a "hybrid," a "pastiche" and in part bonds with Zenia as "a mixture like herself" (p. 406). But Tony too sees herself as "a foreigner" (to her parents) and as someone who has gone through life in disguise. Charis literally dwells on an island cut off from the mainland of the action and is also socially marginal in terms of her employment and her obvious connection to a bohemian subculture.

Atwood also depicts the women as each especially embodying one of the attributes which together compose a complete human

being. Tony, the rational scholar who replays ancient battles and publishes weighty volumes, is mind. Charis, with her (gently lampooned) New Age philosophies and her considerable psychic abilities is spirit. Roz with her consciousness of her own overweight physical form and of her appearance generally is body. By emphasizing such separation Atwood implies a lack of integration for her characters; none of them then is truly a whole person. Through the action of the plot, however, the three women find integration for themselves both literally and symbolically, as the divided Robber Bridegroom of the folktale finds integration (to his detriment, of course, though to the advantage of society) through the story told by his intended victim.

In their final encounter with Zenia, each woman goes first to face her alone and each thinks that she will do battle in terms of her own attribute. It is, however, because the women, who in their earlier lives encountered Zenia serially and individually, are now united as friends and confederates that Zenia fails, and it is no coincidence that they find her dead when they return to the hotel together—integrated finally as one. Zenia's final threats—in part invented by the women themselves—prove impotent.

And, though she once told Roz, "I know who I am" (p. 410), it is Zenia who turns out to be lacking an identity. The police are unable to determine which of her three passports, if any, is real (a number which of course mirrors the three women into whose lives she has intruded, as well as three alternate stories of her own paternity which she once told). This factor further calls into question the conflicting stories she has told about her past and about other matters affecting Tony, Charis, and Roz. In the end Tony calls Zenia's very name into question, suggesting that it may have no real existence in terms of the history of names and their meanings.

Thus both Eudora Welty and Margaret Atwood use the same folktale for exploring questions of duality, the nature of identity, and the necessity of developing an integrated personality which leads to wholeness. In both novels, characters seek integration when they face great adversity. Of course each writer re-situates the tale differently. In Atwood's novel the tale is introduced, albeit briefly, as part of the fictional lifeworld, whereas in Welty's it makes no such appearance but

structures the plot (and the overall form) of the book. Although Welty's novel is not simply a retelling of the tale, it does follow the plot of the tale with some closeness, reproducing at least episodes from the folk narrative (though also introducing elements from other folk sources[17]). Atwood's plot is more in tune with the tale indirectly and symbolically, offering background reference which frames meanings for the novel. In both instances characters learn from their adversity and, indeed, from their duality, however problematic it may also be and however much they may need to go beyond dualities.

Clearly Jamie Lockhart is the knowing gentleman he becomes at the end because he once knew his other, dark side, and Rosamund is what she is at the end because she too has known her lying, disguised, shadow self. Atwood suggests something similar in relation to her characters, for the three women friends are surely stronger because of their encounters with Zenia and what she represents. If Atwood secondarily has in mind the Grimm tale "Fichter's Bird," a variant of Type 311 which she has referenced in other contexts,[18] the lesson is even more clear. In that tale the youngest of *three* sisters rescues her older siblings partly through a process of disguise, first by setting a skull in a window to look like herself, then arraying herself in feathers to look like a bird. That is, the tale suggests the positive value of having contact with other, "disguised" selves, so long as we also integrate ourselves by going beyond them. Zenia, powerful though she is, never moves beyond her dark side (lacking her own full self, she needs others to inhabit), never integrates her own selves. In that respect she is like Welty's Salome. And West, Tony's husband, seems rather like Clement Musgrove in that, at least at the end of *The Robber Bride*, he seems a sort of innocent, someone then forgetful of the dark side of his own past and thus lost in the trivial pursuits of the present.

What Welty and Atwood both do is to look to a well-known folk narrative for what it may fundamentally suggest about human existence and human psychology, about how we develop or fail to develop as individual people. In doing so, they work with the modern conception—certainly of interest to Jungians in particular—that Märchen are eloquently expressive of basic human situations and

archetypes. In writing their novels they may have had many purposes (Atwood, for example, being concerned with matters of truth, history, and memory, as well as with the larger issue of changing gender expectations[19]). But the tale they adapt clearly lends itself to an appreciation of the divisions and the secrets of human identity, and both writers re-situate the tale in ways which forcefully call our attention as readers to basic truths about the human soul.

3

Falling in Love with All Its Lore

Adapting "A Collection of Louisiana Folk Tales" for the Stage

During the American Folklore Society symposium on folklore and literature in 1954, Richard M. Dorson argued strongly that folklorists interested in folklore in literature had to establish authors' direct connections to the lore in oral tradition. The folklorist/critic who would approach folklore that had been re-situated in a literary work, he said, must first look for evidence of that direct connection in an author's life or "in the literary composition itself."[1] He goes on to say that "once we can prove that authors have directly dipped into the flowing stream of folk tradition, we are then in a position to discuss whether or not this folklore contributes to a given literary work in any important way,"[2] but not before.

As we noted in the introduction, however, subsequent students of folklore in literature have been less concerned with the precise origins of an author's folklore, whether it be tradition directly or published sources such as folklore studies. It often has proven difficult, if not impossible, to pinpoint how precisely an author had obtained his knowledge of folklore, and as the focus shifted from the identification

of folklore in literary texts to explaining the function and meaning of folklore in those texts, the matter of origins became less central. Few living authors were even asked.

In this chapter we look at a literary re-situating of folk materials whose author deliberately used a single, particular collection of folk materials, a published volume somewhat known to American folklorists and well-known generally in the region from which the materials were collected. Thus the nature of the author's folklore source is both limited and abundantly clear, and we can consider with some precision the process by which folklore—albeit "static," already-collected folklore—became part of a literary work. In addition, the author in question, Lucy Maycock, was willing to discuss the motives for and the process of re-situation. Of considerable interest is that the play she wrote ends up being itself a dialogue about folklore collecting, re-situating folklore, and the representation of culture.

At the time she wrote her play, the English-born Maycock was resident dramaturge of a Baton Rouge, Louisiana–based professional theatre company, Swine Palace Productions, which put on a regular annual season of plays. In 1999, Maycock created for Swine Palace *Gumbo Ya-Ya*, a play adapted from *Gumbo Ya-Ya: A Collection of Louisiana Folk Tales*,[3] one of the few books to come out of the Depression-era Federal Writers' Project folklore-collecting endeavors. Originally published in 1945, its compilers were Lyle Saxon, Edward Dreyer, and Robert Tallant. As a book it has enjoyed considerable popularity among Louisiana readers and is still in print nearly sixty years after its first publication.[4]

The original book was in many ways a unique contribution to folklore studies, though one not without problems in its presentation of folk materials.

The Federal Writers' Project was part of the larger agency called the Works Progress Administration, which was established as one of Franklin Roosevelt's New Deal agencies for combating the economic devastation of the Depression. Its function was to put unemployed people to work while also making contributions to localities through projects of various kinds, such as those which erected public buildings and even swimming pools. To employ out-of-work white-collar

and cultural workers, several national cultural endeavors also came into existence under the WPA, including the Federal Art Project and the Federal Writers' Project. The Writers' Project adopted as its principal goal the compiling and publishing of a series of American travel guidebooks which would include a great variety of information, including information on customs and folklore. Chosen to head the Louisiana Writers' Project was Lyle Saxon, the most prominent literary interpreter of the state in his day. In October 1935 he assumed his duties as director. Initially assigned sixty-three employees, he set about hiring personnel, not only writers but also historians, teachers, and unemployed lawyers.

The primary job of the Project was to gather information not only for the anticipated guidebook, and a complex system was devised to provide a steady and systematic flow of data. At one end of the flow were field-workers, who undertook research using documentary sources, personal observation, and interviews. Some of the field-workers were detailed to find folklore,[5] partly because folklore had been included in the national plan, although the Louisiana Project may have been the most zealous in this regard. Saxon was himself something of a romantic, and the exotic cultural mix of the state and of New Orleans in particular intrigued him and led him to an intense interest in folklore which he was able to indulge. The Project amassed a great deal of folklore, filing cabinets bulging with field interviews and collected texts. Some of this material ended up in folklore chapters of the state guide and New Orleans city guide, and it was the source of material for *Gumbo Ya-Ya.*[6]

Although the Louisiana Writers' Project field-workers were not trained ethnographers—nor were the directors of the project—they were doing ethnography, and doing it in fact on the grand scale made possible by government funding and the employment of a team of researchers. As one part of the larger endeavor, they collected folk texts. However, when it came to pulling together *Gumbo Ya-Ya* itself, the compilers of the volume—Saxon, Dreyer, and Tallant—produced neither a conventional folklore collection nor an ethnographic study.

Although they subtitled the book "A Collection of Louisiana Folk Tales," Saxon, Dreyer, and Tallant probably had little acquaintance with scholarly or even semi-scholarly collections or with

scholarly standards for collecting. By background they were news-papermen and magazine writers, who had even less awareness of ethnographic writing, and they sought a wide audience for the end-product of their labors. In addition, some of the material gathered was not folklore at all (but rather local history or local color, though perhaps some of it was "lore" in a broad sense of that term), and some of the field reports were accounts of cultural contexts not nor-mally presented in standard folklore volumes of the day.

Thus much of *Gumbo Ya-Ya* presents its materials journalisti-cally through a series of somewhat impressionistic chapters. Though as a group the chapters might be seen as presenting an extended impression of the folk culture of Louisiana—though primarily of New Orleans, where the Writers' Project was centered—each chap-ter tends to be discrete, and there is no obvious progression through a thesis about Louisiana culture or even a really unified conception of that culture. Though it is an exaggeration to say that *Gumbo Ya-Ya* contains a hodgepodge of information, clearly there was a heady and loosely organized mixture of materials in it: social history, leg-ends and other oral narratives, accounts of local customs, rituals and folklife, written documents of various kinds, information meant to be humorous or to evoke a sense of the bizarre, information containing sober facts, description of artifacts, and historical anecdotes. Thus it is hardly surprising that folklorists have been ambivalent at best about *Gumbo Ya-Ya*, an attitude solidified by the book's journalistic tone of presentation, which makes folklorists suspicious about how the originally recorded information may have been transformed in the process. Additionally, the tone of presentation sometimes is one which emphasizes the otherness of the subjects or is condescending to the folk who transmit the lore and toward their ways of life.

The condescension is particularly problematic in terms of how African Americans are presented, and aspects of the book can be seen as racist, in that white racial attitudes of the time period of the book's creation permeate parts of the volume. Blacks are presented as prosti-tutes and menials, as ignorant and prone to misbehavior (though they may also be rather charming in their inferior way). When quoted, they speak in the heavy dialect assigned to them in literary sources

since the nineteenth century.[7] The deceased Mother Catherine, for example, whose significance as a presence in the religious life of New Orleans is today well-recognized,[8] becomes, for example—though perhaps interesting—ignorant and deluded, and her successor, Mother Rita, a dilapidated joke. The middle-class, white authors of the book find it impossible to see much beyond their own cultural perspectives and can only be dismissive and patronizing.

However, despite its being such a problematic book, *Gumbo Ya-Ya* does contain much valuable folkloric information. There are appendices which include a wide selection of folk beliefs as well as information on customs and folk language. The "Songs" chapter includes a number of texts from the Creole, Anglo-American, children's, blues, spirituals, and work song traditions. Even in the more journalistic chapters, many aspects of custom and folklife are detailed and informants are extensively quoted verbatim (though of course the field researchers did not employ sound recording equipment, and it is difficult to judge how accurately they recorded what they heard).

In adapting *Gumbo Ya-Ya* for the stage Lucy Maycock had a potential wealth of material but material previously presented in highly problematic ways, making an adaptation a tempting but difficult undertaking.[9] Though the original book might itself be seen as a sort of literary use of folklore, in a more profound sense it *is* a collection, if not a conventional one, of folklore and other materials. It is a highly amorphous work, lacking any sort of plot to be worked into a drama or any characters central enough to unify a play. The book "refuses to settle on a form," Maycock has commented. What is interesting about Maycock's adaptation is what she does with the folk materials the book contains, and how she creates a dramatic structure which gives some unity to the haphazardly assembled folklore. In creating that unity she does what was essential to have a play at all, but the end result is also very revealing of her personal motives in dealing with Louisiana folklore and culture.

In order to find her dramatic structure Maycock had to look outside the collection itself to its creation and its creators. She decided to frame the folklore in the context of the Federal Writers'

Project, an undertaking which clearly intrigued her ("Once upon a time, ladies and gentlemen, the U.S. Government hired writers to be writers," the character Jean Loftis announces in the second scene of act 1 with some sense of wonder [p. 4]). Maycock introduces as the play's principal character none other than Lyle Saxon—charming bon vivant, tormented artist, bisexual—the real director of the Louisiana project and a person who fascinated Maycock.[10] The Saxon character provides the much-needed unity by commenting on the project which put together the folklore, although also by revealing (and not revealing) various things about himself through the course of the play.

Whereas the Saxon character is based on a real, historical person, Maycock also felt the need for a countervoice, a voice to speak from a contemporary perspective. Thus she introduced the purely fictitious character of Jean Loftis, a modern-day graduate student who is about to defend her thesis, "*Gumbo Ya-Ya:* Fact, Fiction, or Folklore? An Examination of *Gumbo Ya-Ya*, Lyle Saxon, and the Federal Writers' Project." Particularly in act 2 Jean and Saxon discuss and, indeed, wrangle over *Gumbo Ya-Ya*, making the play in part a dialogue about folklore collecting and the representation of culture. In doing so Maycock manages to wrestle with many of the problems of the original book and thus avoid some of its pitfalls by the very act of reflecting on them.

The play Maycock constructed—she speaks of it as "half a play, half an adaptation"—necessarily retains some of the original loose structure of the book, running through a series of scenes in which selected aspects of the folklore from the original are presented (although much folk and other material from the book of course never finds its way into the play). As produced in Baton Rouge and New Orleans in 1999, slides of Louisiana subjects—mostly of the past but some from the present—were projected onto a backdrop to help "guide" the audience and "locate them" in the action of what was essentially a nonnarrative play.[11]

Each act has a rather different feel. Whereas the first act introduces Saxon and Jean and something of how they conceptualize themselves and the work of collecting and presenting folklore, their

dialogue does not fully develop until act 2. Act 1 is more concerned with the dramatic presentation of the folklore. Indeed, Maycock felt that she had to "give the gumbo" in the first half and then "take the risk of dissecting" it in the second—that is, putting the folklore out front before talking about its meaning or the meaning of how it has been presented.

Though such an arrangement seems conceptually sound, it was a conception of the play which Maycock has since suggested she would change,[12] mixing together more the material from both acts. Nonetheless, it is impossible not to see this arrangement as also reflecting the playwright's personal relationship to the material adapted for the play. The first act presents a "gumbo" of Louisiana folk cultural forms and contexts such as she encountered, if not literally, by coming to Louisiana. In fact the play does begin with a song called "Sweet Gumbo," which invokes the culinary meaning of the word "gumbo" as a quintessential Louisiana food (a use largely eschewed by the original book) while also playing with the obvious symbolism of a gumbo's containing a mixture of ingredients, and a mixture from different cultural traditions at that, to suggest Louisiana cultural diversity and richness.

In a sense the cultural gumbo of act 1 is presenting Louisiana, of course a limited vision of the state but one which nonetheless stands in for a larger whole. One has to see this as one phase of Maycock's own coming to terms with the place to which she has come, dropping from a very different part of the world into a context she hardly can have imagined before circumstances brought her to it from Britain.[13] Indeed, she acknowledges this connection to her own life and her own difficulties in trying to understand this new place with which she had become inextricably involved. Folklore, the essence of *Gumbo Ya-Ya*, had particular appeal for her because, though she had her doubts as to what extent the particular "stories" in the book were collective among Louisianians, folklore did seem to be something which is a communal possession and thus especially representative of a place (a time-honored view of folklore). It is no accident that when Jean Loftis, the outsider character (though obviously American) trying to come to terms with Lyle Saxon and what he did

and what he represents, is asked by Saxon where she comes from, she says "England" before correcting herself and saying "New England." In the first act Louisiana cultures spread out before the author as well as Jean Loftis and the audience, and it is interesting to look at the progression within this act of the folk materials, which Maycock selected from the various possibilities in the book with a somewhat instinctive sense of what would be the strongest material dramatically.

After introductions to Saxon and Jean and the "Sweet Gumbo" song in the first three scenes, scene 4 (through the device of Saxon's giving a supposed lecture) takes the audience into the world of Louisiana buried treasure. Chapter 13 in the book quotes several treasure hunters on the beliefs, rituals, and work of their craft. For dramatic effect Maycock puts what was said by several treasure hunters (sometimes taking verbatim from the text, sometimes adapting it more freely and rearranging it) into the mouth of the character Tom Plimpton (Pimpton in the book); he is an African American who, as a "spirit controller," talks about dealing with the spirits who guard treasure and the magical rituals involved in recovering it:

> There sure is plenty of treasure buried in Louisiana, but you gotta be careful of them spirits.
>
> [As he names the kinds of spirits, the chorus, one after another, visibly straighten] There's land spirits and there's water spirits, and you gotta know how to talk to both kinds. The land spirits is bad and the water spirits is good. They got seven kinds of land spirits; that's part of the trouble. There is bulls, lions, dogs, babies, snakes, persons and pearls. When you see a cat, that's a bad one and if you ain't careful your hole's gonna lap up water right as you dig.
>
> ▪ ▪ ▪ ▪
>
> I don't dig. Anybody can do that. I'm a spirit controller. I am one of the best in the state. I fight the spirits. I master the spirits. There's none of them can mess with me. All buried treasure has got spirits watching over it.

■ ■ ■ ■

If something is wrong you knows it right away. You can't ever fool a spirit. Your treasure is sure to start sinking and slipping and once it sinks it ain't coming up again for seven years.

(pp. 6–7)

When Tom speaks of how Jean Lafitte would kill a man to become the spirit guardian of his treasure, Lafitte speaks as a character, and when Tom talks of making the circle that marks a treasure spot, this is acted out on stage with other actors.

Although the "Buried Treasure" chapter of the book includes information on nonfolkloric material, Maycock sticks with the folkloric aspects of treasure hunting, and as the play's folkloric introduction to a wide range of Louisiana culture the buried treasure material functions in several ways. The idea of treasure suggests the Louisiana cultural riches which Lyle Saxon says are coming and which the play begins to set out. And treasure lore straddles the world of the real and practical (it involves finding material wealth and the means for doing so) and that of the supernatural (the guardian spirits, the magical rituals). That might be read as suggestive of the position of Jean Loftis or Maycock herself or of the audience, moving from the "real" of the familiar into something stranger and murkier to outsiders: Louisiana itself.

Nor is finding the cultural treasure of this place necessarily easy. The pitfalls inherent in discovering buried treasure are set out by Tom Plimpton. The play is suggesting that uncovering Louisiana's cultural wealth is no simple matter either—for the author, for Jean, for anyone, even Saxon—for this is a complex place where the true nature of things is guarded.

The rest of act 1 takes the audience through a range of cultural treasure. From buried treasure itself we shift to Theophile and Marie Polite (who appear in chapter 9, "The Cajuns"), then to scenes featuring New Orleans street life, the first of which uses street cries until the action morphs into "Preparation for Zulu," a scene which begins with Saxon introducing Mardi Gras Day, 1940, and continues with

the King of Zulu (Zulu being an African American Mardi Gras organ-
ization) bantering with bystanders and then the singing of the Mardi
Gras Indian song "Tu-Wa-Pak-a-Way."[14] Then a chimney sweep talks
about his life and work, and Baby Dolls, the black prostitutes who
dressed up as outlandish babies for Mardi Gras, make an appearance.
Thus there has been a shifting interchange between the everyday and
occupational on the one hand, the festive and carnivalesque on the
other, all worked out in terms of life on the streets. The act as a whole
has moved from the private worlds of the individual treasure hunter
and the Cajun family to the public world of street characters and
communal festivals. There has also been a progression from rural to
urban. And very near the end of the act is St. Joseph's Day and the St.
Rosalia procession (chapters 5 and 6 in the book), maintaining the
public face of folk tradition, taking the audience back to the spiritual,
though here the spirituality is not only more public than the neces-
sarily hidden world of the ghosts who guard treasure, but more main-
stream as well—folk Catholicism perhaps, but church-sanctioned
nonetheless.

Although the act literally presents a limited selection of Louis-
iana folklore and Louisiana culture, the folklore's ranging from private
to public, rural to urban, individual to collective, secular to religious
suggests a much fuller picture, a symbolic if not literal whole.
Maycock throughout makes effective use of one of the book's great
strengths, the willingness of the compilers to include long quotations
from informant interviews. For example, in the scene involving the
Santa Rosalia procession she is able to use as a character Mrs. Zito,
owner of a grocery store who in the book makes a traditional speech
about the saint, though Maycock's version again also includes the
saint's origin legend, which in the book is narrated by another person.
In the play subsidiary characters act as a kind of chorus to give the leg-
end the more dramatic, more communal quality that legends often
enjoy in oral tradition. The scene ends with an enactment of the pro-
cession, providing an element of spectacle and mass involvement.

Maycock has said that in presenting material from the original
Gumbo Ya-Ya, she wanted to make it "edgy" and not "folksy." There
is a degree of edginess in act 1—the palpable dangers of treasure

hunting, tension between the uptown and downtown prostitutes in the Baby Dolls segment, the chimney sweep's complaints about his white customers, a doll thrown on to the stage at the end of the Baby Doll scene which causes the women to remember "childhood, lost childhood, lost innocence" (p. 29). But the edginess accelerates in act 2, where Jean and Saxon begin to spar with each other and where images of death and dying abound.

In act 1 the Santa Rosalia scene ends with an explosion of fire-works (achieved by lighting effects and sounds made by the chorus) which produces—at least in the eyes of the devout beholders—an image of the saint in the sky. One actor intones, "She's on fire," another adds, "On fire in the sky!" and the chorus cries out "Viva, Santa Rosalia. Viva!" Thus the scene ends (p. 35) on a note of reverence and awe and life. In the next scene, Saxon appears and provides what at first sounds like a reaffirmation of his earlier promise to show the audience a Louisiana "gumbo": "This is my gumbo," he says. But he goes on to define gumbo further: "A native Louisiana dish made of poverty, hot sauce, and spirit" (p. 36), introducing a disquieting note. The audience has seen both spirit and spirits, and hot sauce could be a metaphor for the lively cultural mix, but the slipping in of poverty as an ingredient is potentially jarring.

This is immediately followed up by a song called "Salvation Everywhere," which includes the recurring lines:

> I guarantee salvation
> I guarantee salvation
> I guarantee salvation's everywhere.
>
> (p. 37)

But an actor vigorously objects to the song's message: "No! This is wrong! And I'm going to tell you why. Salvation? I'll tell you what is in the air. Death and money. There's your gumbo, a sweet meal of death and money." And the actor playing Saxon speaks the last line of the act: "In 1946, Lyle Saxon died. I never wrote a great novel" (pp. 36–37).

Thus despite the rich gumbo, the audience goes into act 2 remembering notes of doubt, denial of the possibilities for salvation,

intimations of materialism, and announcement of the death of the main character. The second act develops with a collision between Jean and Saxon—over who each of them is and what each represents—as Saxon ostensibly lectures and Jean engages in her thesis defense. In effect Jean sets about deconstructing Saxon—who resists the process—as well as the original *Gumbo Ya-Ya*, its presentation of Louisiana culture, and Louisiana itself.

In act 2 Saxon begins a rather exuberant speech about Mardi Gras, and Maycock blends with other biographical details an account of a childhood Mardi Gras the real Saxon had recounted in an earlier book, *Fabulous New Orleans*.[15] "After that day," says the Saxon character, "the plantation—my boyhood home—seemed dull by comparison" (p. 42). Jean takes his plantation reference as the occasion to begin an attack upon him, with Maycock drawing upon Saxon's penchant for writing about his plantation boyhood, though the family plantation seems in fact to never have existed.

Saxon becomes defensive, noting his role in historic preservation in the French Quarter; Jean accuses him of pricing out the poor former residents through gentrification. He notes the famous writers who came to his New Orleans house; she derides them as "more dead white males." Then she accuses him of being merely a local colorist. "You and your kind have mythologised Louisiana," she says, "turned it into a huge white cathedral to Dixie. The old South of Belles and Beaux, the charming quadroon, the faithful black servant with his grin." She accuses him of "falling in love with all its lore," suggesting superficial romanticism on his part. When his manservant Joe Gilmore[16] is brought into the conversation, she accuses Saxon of having been patronizing and manipulative. Later she says, "Look at *Gumbo Ya-Ya*. Your description of African-Americans limits itself to stereotypes; drunkenness, sexual excess." And "You were a thief. You stole other people's stories." She calls his chapter on slavery "apology." Instead of faithfully recording folklore for *Gumbo Ya-Ya*, "you got in the way," she tells him. "With your voice, your skewed vision, your fumbling imaginings . . ." (pp. 43–44).

But Saxon fights back. He insists upon the complexity of his relationship with Joe Gilmore (and by extension with African Americans

generally) and the particular complexity of race in Louisiana (Maycock sees race as an important focus of the play and of course a problem in dealing with the original *Gumbo Ya-Ya*). When Jean attacks the picture he presents of the chimney sweep, he defends the fieldwork behind the book. When she accuses him of being patronizing, he *embraces* the role of *patron* and points out that he gave jobs and money to people in economically depressed times. He brands her an "academic pirate," someone who "pirate[s] the ideas of others" (p. 45) (and, indeed, she has flirted with how her name connects her to Jean Lafitte, and at the very beginning of the act she has been seen as a "treasure hunter"; she even has set out a treasure circle like Tom Plimpton's; the implication is that she too is trying to claim something that belongs or did belong to somebody else).

Thus their conversations develop a discourse across time. Both may be focused on the same subject matter, ultimately folklore, its cultural contexts, and society. But Saxon is the artist (though perhaps a failed one) of the twenties and thirties with the perspectives of his day, his mythologies, and own strong feelings and aesthetic sense. Jean is the academic on the cusp of the third millennium, with her supposedly dispassionate and scholarly view and her own ideological stances—feminist, postmodern, "politically correct." Their dialogue examines the whole process of "collecting," of the appropriation of culture and of ideas and creations constructed or transmitted by others, and examines the relationship of the collector or ethnographer to those studied. Whereas Jean sees Saxon as having appropriated and distorted folklore in a patronizing way, he maintains his approach is the more human one and that she too appropriates—in fact, appropriates him—and does so in the dry and rather lifeless way of late-twentieth-century scholarship. Whereas she may try to be successful in the accuracy of her presentation (though she struggles with this, as Saxon struggled with his fiction), Saxon tries to be more successful in reaching an audience far beyond her limited one (and, it could be argued, like Zora Neale Hurston and J. Frank Dobie, he contextualizes folklore in a way the scholarly folklorists of his day failed to do[17]). Maycock is able to look at the problems inherent in Saxon's "Collection of Louisiana Folk Tales" while also giving pause to the

perspectives of latter-day critics, thus clearing her way for access to the lore itself while providing the play with unity and dramatic tension and an interesting debate.

However, in many ways the original *Gumbo Ya-Ya* is a book about place (an aspect which the slides used in the 1999 production tended to emphasize). Lyle Saxon was much associated with place as the "Mr. New Orleans" of his day and the man Jean disparages as "Mr. Old Louisiana." And Maycock clearly wants to talk about place through the play and through her character Jean, who is at least in part her surrogate (as may be Saxon in quite another way). Whereas Saxon romanticizes the Louisiana he knew earlier in the century, Jean wants to look at disquieting contemporary Louisiana with its problems, pain, and corruption—cultural as well as moral (and of course she resents his earlier vision).

Jean speaks of the "fool's gold" of the gambling the state seems addicted to and reads a newspaper account of Governor Edwin Edwards's vast piles of cash. Edwards later reappears as a character in handcuffs.[18] The chorus carries on about the "money, money, money" which corrupts, and a song tells about the New Orleans–born rapper Master P, who moved into the exclusive Country Club of Louisiana in Baton Rouge, raising questions of another kind of sellout ("He's letting his culture be appropriated," says Jean [p. 69]).

It is particularly in connection with the play's soul-searching about Louisiana that folklore appears in act 2. The folklore in act 1, though presented not without edginess, is full of positive vitality and expresses among other things the hope of discovering hidden wealth and the festivity of both Mardi Gras and the more spiritual Santa Rosalia procession. In act 2 Maycock adopts a different tone in presenting the lore, using it to pose difficult questions about this place, choosing to present the somber traditions of death and the beliefs and rituals of gambling, which stand in for the destructive forces of the state's dark side. Even when Mardi Gras makes a brief appearance it does so in the form of Jean's accusations of the social snobbery inherent in the celebration and her connecting it to economic decline and an implication that a spiritual as well as economic death sometimes curses this place:

New Orleans. The City of the Dead . . . Compare it to
Dallas . . . to Houston . . . to Atlanta. What do you see?
Weeds growing between cracks in the worn down pave-
ments. The stink of garbage. The smell of death.

■ ■ ■ ■

Well, Houston took the port and now old New Orleans
is left with cheap Mardi Gras beads and Rex. The Lord
of *Mis*rule. King of Fat Tuesday . . . Rich white men
playing at monarchy.

■ ■ ■ ■

They rule from office blocks, the Lords and Ladies of
Rule. . . . It's who is who and who does who and who
knows who.

(p. 49)

Jean's musing on Mardi Gras flows into Maycock's use of the folklore
of death. New Orleans, of course, has long been associated with cer-
tain aspects of death in the public imagination—the high mortality
rates of early centuries when yellow fever and malaria raged; the
prominence of cemeteries in the city; jazz funerals; most recently the
vampire "living dead" popularized by the novels of Anne Rice. Jean
having related Mardi Gras and death (perhaps faintly evoking the rev-
elry of the infected during medieval plagues), the chorus reprises the
singing of "Dem Bones"—with which the scene actually began—and
various characters—informants who were quoted in the original
Gumbo Ya-Ya—speak about the customs and beliefs of death:

> The day I died . . . all the clocks were stopped. . . . They
> covered all the mirrors . . . covered the pictures. My
> daughter gathered twigs of orange leaves and sewed
> them to a clean white sheet. The sheet was spread over
> a cooling board and the board was placed on two chairs.
> And they laid my body on the board. It was summer . . .
> mid-summer . . . hot. My sister sprinkled camphor . . .
> put a fresh loaf of bread in a pan of water and placed it
> under the board. To keep down my smell. And some-
> one placed money on my eyes. . . . (p. 50)

The scene ends with a jazz funeral which is described as "antic," "irrepressible," "joyous," but also "mindless" (p. 53). That is, the famous Louisiana ritual has a mixed quality—a combination of rejoicing and something darker—and the scene ends with Jean's implying that in Louisiana—as elsewhere—festivity can be a form of denial:

> [Angry. Unhinged. Manic.] And My oh My! Isn't it fine? Isn't it fun? Hey! Did you hear the news? The Saints'll be here soon. A whole host of them! . . . Any day now . . . any old day now . . . Doncha wanna be in that number? Come on! Lighten up! Laissez les Bon Temps Roullez! This is paradise, ol' sport! Don't spoil the fun! Don't bring me downtown. Let's go to the Quarter! Let's drink! Let's laugh! We're all in this number. We're Saints and we're marching in. (p. 50)

Given Maycock's desire to reveal corners of Louisiana's dark side, gambling was a natural focus for part of act 2. Not only has gambling plagued the state over the last decade, engendering both political corruption and personal tragedies, but it has a notable presence in the original *Gumbo Ya-Ya*, a whole chapter being devoted to the beliefs and customs surrounding it. Maycock is able to mine this chapter for the language and belief systems and folk poetry of gambling, as characters intone:

> Actor/Shelley[19]: If you dream of your husband,
> All: Dreams . . .
> Actor/Shelley: . . . always play six, forty-one and fifty; if it's your sister, play five, fifteen and forty-five.
> All: Dreams . . .
> Actor/Shelley: The Blood Gig is really fine; any time you dreams of blood . . .
> All: Dreams . . .
> Actor/Shelley: . . . be sure to put your money on five, ten and forty.

■ ■ ■ ■

Steve: Look down, rider, spot me in the dark,
When I calls these dice, break the people's hearts.
Roll out, seven, stand back, craps,
If I make this pass, I'll be standin pat.

(pp. 62, 65)

The scene is called "The Lottery of Life," a name which suggests larger issues of fate and fortune (perhaps particularly appropriate in a Latin culture like south Louisiana, where a fatalism foreign to Anglo-American notions of destiny may sometimes prevail). And as the characters re-enact these parts of the original chapter, elements of disquietude creep in here too. Lines from a Twelve-Step program (adapted from the standard Alcoholics Anonymous text) keep getting interspersed with others, suggesting the addictive nature of the mania for gambling, and the scene has begun with Jean's announcing, "Pirates have always operated in Louisiana" (p. 61). But the pirates we are supposed to think of are those who profit from gambling while most of the players just lose. Dreams, of course, play an important role in the folklore of gambling, in that particular dreams are tied into particular combinations of numbers to be played in the lottery. But the scene speaks to the question of shattered dreams — dreams of another sort — and returns to the importance of socially corrupting money, as a prisoner in Angola, the state prison, tells how he was convicted because he could not afford a decent lawyer, and as Jean asks Saxon (p. 66): "Tell me, Mr. Saxon—Gatherer of Souls— who do you think is collecting?"

Act 2 and the play end with Saxon and Jean reaching a sort of detente in a final scene called "Eating the Gumbo." They resume their sparring. Jean accuses rapper Master P of "selling out" while Saxon says he is merely "buying in." She speaks of *Gumbo Ya-Ya* as containing "stolen folklore"; he claims to be folklore himself. She says that "the camera [perhaps referring to modern fieldwork methods generally] never lies" (p. 69); he says "Horseshit!" But when she accuses him of understanding nothing about her world of 1999, he accuses her of not being able to understand his world of the past. That realization—via a digression through famous lines from *Richard*

II which speak of merging brain and soul to beget new thoughts—causes them to finally sit down together to partake of a gumbo of Jean's making (from a recipe of current-day celebrity chef Paul Prudhomme). When she tries to say that it could "use a little more" something, he says, "No more criticism. This is yours. Your gumbo. Your place at the table. Eat." They laugh, he disappears back to the realm of the past and the dead, and she continues to eat. In the end, "She is floating free. And eating" (p. 72). Maycock sees Jean as having found, through Saxon and her dialogue with him, more of her own voice as well as a sense of her vulnerability in knowing less than she thought she knew. Saxon insists that she be less a critic and more an artist, and she softens, no longer needing to play off, to appropriate his work. Now she can go on to her own.

Lucy Maycock did not go looking for folklore to use in a play. She was, in a sense, "presented" with an existing collection of folklore by virtue of its being a Louisiana "classic" ripe for adaptation to the stage. From the outset the collection posed problems for her as a dramatist. Though not a collection at all in the conventional sense of an assemblage of texts, it was nonetheless very loosely structured and certainly lacking in anything like a plot line. Additionally, the existing book came freighted with problems of how the folklore already had been presented to the public. Maycock endeavored to get around both these difficulties in the same manner. She focused upon the creation of the original collection, introducing its principal author as a character who could speak to and for the book. She also introduced a modern-day character, a young scholar who is writing about author and book and who could speak about both. Thus there would be a dialogue throughout the play about cultural issues raised by the book and its folklore. Hence there was unity and dramatic tension. And hence, as a discourse about the book proceeded on stage, material from the book could be dramatized while the problematic matter of its original presentation was brought out into the open, acknowledged and examined.

In the process of doing this, however, Maycock also used the play to work out certain issues of her own having to do with Louisiana

as a place. As a recent "immigrant" both to America and Louisiana, as someone whose professional existence was to be bound up with Louisiana culture on several levels, she felt a need to come to personal terms with this place that she found complicated indeed, which has seemed to many a mixture of the exciting and beautiful, the polluted and corrupt, a place of wondrous festivities and dancing, grim poverty and exploitation. *Gumbo Ya-Ya* gave her an opportunity to lay out some of the strands of Louisiana culture and to look at two, opposing perspectives on the place, one which sees romance and color, the other something dark and thought-provoking (two perspectives which also relate to how culture is perceived and presented by ethnographers and others). In the end there is a rapprochement that implies a perhaps necessary acceptance of place, problems and all (and, indeed, in looking at Louisiana's darker side, Maycock seems not to condemn so much as to explore something which is a puzzling, sometimes disturbing complexity).

Though folklore was a given for Maycock in that a published collection of folk materials was, in a sense, just waiting for her, folklore was also in many ways ideally suited for her purposes. *Gumbo Ya-Ya* included material that could provide theatrical spectacle, like Mardi Gras and the Santa Rosalia celebration, and material that could be adapted to comment on various modes of Louisiana life. But on a broader scale, folklore often has been associated with place, perhaps most especially by cultural nationalists who see in folklore the expression of the "soul" of a country or region.[20] Maycock's utilization of folklore is considerably more sophisticated and subtle than that, yet in somewhat the same spirit. She has made folklore revealing of place and of issues that transcend place as well.

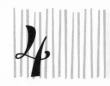

Folk Rhetoric, Literary Strategy

Proverbs in Fiction

Much of the folklore looked at thus far may seem foreign to the personal experience of the average twenty-first-century reader: magical cures and curers, mystical pilgrimage sites, holy image makers, La Llorona, and the fantastic stories we call fairytales—reasonably familiar to us from books but certainly no longer a part of our oral culture. Yet twentieth-century writers have also been attracted to more commonplace, more humble, more ever-present folklore genres, including jokes (such as the one Jay McInerney works from in *Story of My Life*), and proverbs, those pithy, short, sententious sayings which may be so familiar as to seem clichéd and which are the subject of this chapter.

We acquire proverb competence—a knowledge of individual proverbs, how and what they "mean" in certain contexts, and how to utilize them in speaking—by an early age. We are still young when we have learned that watched pots do not boil, that early birds do get worms, and that haste does make waste. Although we do not necessarily ever become active users of proverbs, we continue through life as passive bearers of a stock of proverbial lore. As a result, individual proverbs are widely known throughout our culture, and, even if we do not use proverbs in our speech, we are able to respond to their

meanings when we hear one used. If that were not the case, psychological tests using proverbs could not be devised to assess personality and adherence to conventional mores, nor could a cartoonist like Charles Addams expect a significant number of *New Yorker* readers to be amused by his depiction of a pigpen beside a silk purse factory, proving that, contrary to the proverb, you can make a silk purse out of a sow's ear.[1]

The power and usefulness of proverbs stem from their convenience as a "shorthand" method of flashing a ready-made and presumably easy-to-understand formulation in order to characterize a situation; from their authoritative tone, more illusory than real; and from the versatility which allows us to apply the same simple proverb to a complex variety of human situations, particularly when we seek to depersonalize what we are saying by resorting to the fiction that we are simply invoking ancestral wisdom. Hence we use them as rhetorical modules which we slip into life contexts, to argue, to push home points, to "'name' and suggest an attitude toward a recurrent social situation."[2]

Though proverbs are fundamentally an oral genre, they have proven useful to writers of literature for many of the same reasons they often prove useful to people engaging in spoken communication (and there is a large scholarly and critical literature which comments upon proverbs in literature[3]). For example, Chinua Achebe's widely read novel *Things Fall Apart* (1959) portrays a culture where proverbs are used positively as "verbal strategies for dealing with social situations."[4] Indeed, Nigerian Achebe (one of a number of African writers in English who have achieved notable international literary reputations) comes out of an African cultural context in which proverb use, as numerous folklorists and anthropologists have noted,[5] is of considerable social importance and in which the ability to use proverbs effectively is a valued social skill. Thus the profusion of proverbs used in *Things Fall Apart* illustrates a straightforward re-situation of proverbs to characterize fictional human encounters.

Things Fall Apart[6] is the story of Okonkwo, an important man rising in power and status in the Ibo town of Umuofia in the years

just leading up to the establishment of British colonial control of his region. Haunted by his father, who was weak, carefree, and a failure, Okonkwo fears appearing weak himself. He thus affects what he sees as manly behavior to the point of bullying his family and others and is usually unable to accept compromise. Lest he himself appear weak, he kills—as a sacrifice—a young hostage from another clan who had become like his own son. And he accidentally kills a fellow clan member, an act which necessitates a seven-year exile. While he is in exile, Christian missionaries arrive along with a European colonial administration. The traditional culture and its attendant social order are thus threatened and undermined just as Okonkwo thinks he is emerging from a period of great misfortune to re-establish his position. Finding that the world as he knows it is indeed falling apart, he attacks a messenger of the colonial government and then hangs himself, seeming in the end a tragic figure, both a brave man standing up for his sense of how things should be and a man destroyed by his inability to adapt to new realities.

Through Okonkwo's story, Achebe looks at social and historical processes, at the effects of European political, economic, and ideological expansion into Africa and its effects upon the existing, traditional culture. The novel is full of presentations of the traditional culture, which ultimately comes to be compromised but which is rich and independent in earlier days. In the course of the action, religious beliefs are outlined, stories are told (often in contexts which illuminate their cultural meanings), and ceremonies are performed, giving the reader a rounded picture of how life was lived in a traditional Ibo household and town. A notable feature of traditional life as portrayed in the novel is the use of proverbs in the course of various fictive social interactions.

Achebe, however, re-situates proverbs for several reasons, not merely because proverbs are an important form of communication in the society he describes. The first proverb that appears in the novel is not, in fact, used by a character at all but as part of the omniscient narration. In learning how Okonkwo has gone beyond his father's failing to achieve success and prestige, we read: "As the elders said,

if a child washed his hands he could eat with kings" (p. 12); that is, Okonkwo has paved the way for his own success by "washing" his unpromising origins. Although we might recognize this as a proverb anyway, we are given the additional clue of being told that it is said by the elders; that is, it is marked as a traditional saying. Thus Achebe tells his reader about an important cultural attitude which relates to his main character's position by inserting this formulaic, metaphorical saying into his narration. Because proverbs are seen as statements of moral and social attitudes and positions, the proverb used here serves to indicate that the description of Okonkwo's position is in accord with culturally held attitudes and is not merely the idiosyncratic opinion of a narrator. The proverb speaks for the cultural context and vouches from within that context for the social truth of something. It also helps readers for whom the culture is foreign to view events as the characters see them.

Other proverbs are similarly used. Twice (pp. 29, 121) we are told, for example, that there is a proverb to the effect "that when a man says yes his *chi* [personal god] says yes also," emphasizing that personal ambition and endeavor are important for success; though there are personal spiritual forces that influence a person's success, he must himself activate those forces. This is a cultural commentary on Okonkwo's life and fortunes which represents his own views of himself but which sets them into the context of a cultural judgment. When Okonkwo is forced into exile even though the death he caused was by accident, we are told that "As the elders say, if one finger brought oil it soiled the others" (p. 118), to help explain that even the accidental killing of a clan member brings about the wrath of the earth goddess, affecting all the clan unless the offending member leaves. The proverb states a group attitude toward the nature of the group itself and helps the reader understand why an accident was judged to be a criminal offense.

Thus Achebe uses proverbs in his narration of Okonkwo's story in a way similar to how proverbs are often used in speaking, to provide an authoritative voice to back up his own, buttressing his author's observations with formulaic cultural commentary. In addition, however, various characters in the novel also use proverbs in

their dialogue. For example, when a young Okonkwo seeks help from another, older man in establishing himself as a farmer, he uses proverbs as part of his persuasion and the older man uses proverbs to explain why he will help, saying "as our fathers said, you can tell a ripe corn by its look" (p. 24), meaning that Okonkwo appears to be ready to succeed. And proverbs are also used to point out to Okonkwo later in life that despite his rapid rise to success, he needs to retain humility; an old man at a meeting says (p. 28), "Looking at a king's mouth, one would never think he sucked at his mother's breast."

Such use of proverbs makes clear the social significance of proverb use in this culture and adds to the realism of Achebe's sketching in of the cultural context. Insofar as quite a number of the proverbs relate directly to Okonkwo and his progress in life, they also serve to frame the main character as part of his society, suggesting the restraints within which he must operate and aspects of the background against which he will be judged.

Ultimately Achebe is also offering the proverbs as important statements of traditional values and outlooks (which may be unfamiliar to the reader), as authoritative formulaic presentations of the rules which govern behavior and thus maintain social order and cohesion. In that his novel is about the undermining and collapse of that order and cohesion, the proverbs stand in for a cultural authority which is seriously challenged, undercut, and perhaps in danger of being destroyed. As statements associated with wisdom and with ancestral wisdom at that, proverbs become symbolic of an old order that seems fragile indeed as the novel ends. As the men of Umuofia gather to try to mount a last resistance to the colonial power, one man describes their situation with a proverb: "My father used to say to me: 'Whenever you see a toad jumping in broad daylight, then know that something is after its life'" (p. 186). But this proverb, the last in the novel, only suggests the desperation of the group and the irony that all their traditional values and ways of doing things are now in grave danger of disruption or extinction.

Achebe and his fictional world represent a context in which proverbs are valued and used as statements of truth and value and to

direct human behavior. As a writer Achebe relies upon proverbs as straightforward oral texts which can convey significant meanings. In modern European and American cultures, however, though proverbs certainly are used to convey meaning, they may also be manipulated in such ways that those meanings are undermined through parody or other transformations. Mieder and Litovkina stress that people have never seen proverbs as "absolute truths," and whereas they have "appreciated the didactic wisdom of these sapiential gems, they have certainly also noticed the limited scope of proverbs" and do not see them as "sacrosanct."[7] We might imagine that the twentieth-century rage for experimentation and originality (our "hunger for innovation and novelty"[8]) would in particular limit the acceptance of proverbs in our time. Not only are proverbs old, preexisting verbal formulas, but they are commonly known to everyone and may be viewed as hackneyed "old saws." Such an attitude may indeed be a factor in our creation of proverb parodies, as we play with formulas which have come to seem so familiar as to need lampooning. There are, for example, anti-proverbs (sometimes called "perverted" proverbs), which are plays upon traditional proverbs for satirical or other humorous purposes. Often found in print rather than in oral tradition, frequently they appear in advertising or in cartoons. Thus "good things come to those who weight" advertises weight lifting and exercise at a local gym, while a pompous cartoon general says, "And I say one bomb is worth a thousand words."[9]

There is also a popular visual arts tradition of postcard art which provides humor through the juxtaposition of a metaphorical proverb or proverbial phrase with a picture (a drawing or a staged photograph) that represents a literal rendering of the metaphor. Susan Stewart points out, "Metaphors make 'common sense' so long as they are taken as metaphors and contextualized as such."[10] The postcard illustrations take away the metaphorical context, rendering the proverbs "nonsense." For example, a British card of c. 1908 shows a fallen man whose head has been pushed through the crown of his hat being told by someone else, "You're talking through your hat." Another of the same vintage has a man with his arms around two women, their heads close together, and the caption, "Two heads are

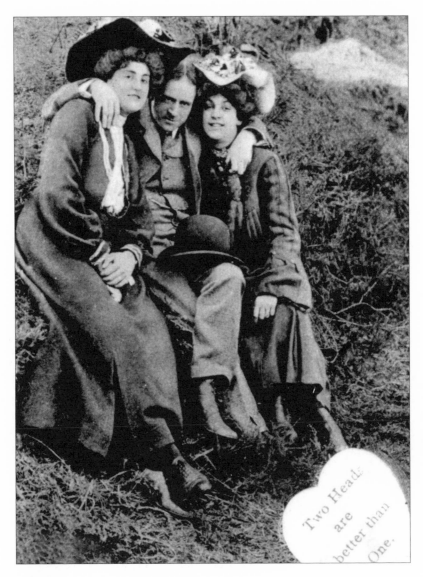

Figure 4 Postcard c. 1908. Collection of the authors.

better than one," thereby shifting the usual meaning of the proverb
from an intellectual reference to a romantic or sexual one (fig. 4). A
third, perhaps from the 1920s, depicts an older man grabbing a boy
by the scruff of his neck; the boy has been sloppily applying black

Figure 5 Postcard c. 1920s. Collection of the authors.

paint to a green door and the man is saying, "Never darken my door again" (fig. 5).

Such parodic play, however, does require a knowledge that implies the vitality of the original sayings. Indeed, a number of important modern American and European writers do in fact re-situate proverbs in novels and short stories, but do so in ways which reveal an ambivalence toward the genre that we simply do not see in Achebe's rather straightforward usage, which assumes that proverbs remain entirely a respected and unselfconscious form of speech communication. Twentieth-century writers may distance themselves from proverb use through irony, alteration of proverb form, or placement in characters' dialogue. But proverbs certainly play significant parts in modern fiction, for example in two very important novels by two of Britain's most sophisticated and elegant writers, E. M. Forster and Graham Greene—in fact, in what may be the best-known novel of each, Forster's *A Passage to India* and Greene's *The Power and the Glory*.

Forster's *A Passage to India* is a work which asks about love and the ambiguity of "reality" and truth. This celebrated novel was first published in 1924 and is based in part on the author's sojourn in India as secretary to the Maharaja of Dewas Senior in 1921.[11] Set, then, in the India of the British Raj, the novel deals with conflict between smug British colonial rulers and their more sympathetically portrayed Indian subjects. Central to the plot is an incident which takes place during a picnic and excursion organized by the Indian Dr. Aziz, whose guests are two English women, the elderly Mrs. Moore and Adela Quested, who is being courted by Mrs. Moore's son, Ronnie Heaslop. In one of the dark, ancient, and mysterious Marabar caves Miss Quested seems to be the victim of vaguely conceived sexual advances. She accuses Aziz of being her molester and he implicates himself through his own unthinking actions. The case bitterly pits the British and Indian communities against each other, with Fielding, principal of the local college and a friend of Aziz, the only Englishman to take a rational view of the situation. Miss Quested withdraws her accusation at a sensational trial, the case is dismissed, and Aziz withdraws to a state ruled by an Indian raja to escape British domination. Later he encounters Fielding again, having in the interim become estranged from the Englishman because of the mistaken belief that Fielding married his accuser Miss Quested. In the midst and the aftermath of a powerful Hindu ritual, the breach between the two men is bridged to some extent, but the novel ends on the note that the two races cannot be reconciled under the prevailing political and social system.

The novel of course has attracted considerable critical commentary,[12] and it is a complex work conceived on a number of levels. Forster is in part concerned with philosophical questions and with Hindu mysticism, and the novel surely can be viewed in political terms. Probably of greatest interest to the folklorist, however, is the theme of culture contact and cultural conflict and of how different cultures may conceive of a given "reality" differently.[13] Proverbs in this novel are used to work out the idea that the two cultures operate with quite different conceptions of truth and language and how truth and language interrelate. The proverbs may not strike the casual

reader as being particularly important to the larger literary whole, and indeed there are elements of traditional expressive culture which are far more striking, such as the Hindu ritual which re-enacts the birth of Krishna, an action which in fact brings about a tentative and tenuous cultural rapprochement. In another noteworthy scene, Professor Godbole, the only Hindu present at a tea party given by Fielding, intones a song addressed to Krishna which remains utterly foreign to the English people and the Muslim present, even after the text is explained to them; the fact that the song immediately delighted Hindu servants outside underscores the gulf between the two cultures. Yet the proverbs are central to the novel. This suggests not only on the author's part an artistry which has tied into his overall thematic strategy even seemingly minor elements, but also that folklore in a literary work need not be overwhelmingly obvious or all-pervading to be of significance to the total structure of that work. Because proverbs are common and sometimes dismissed as clichéd, they may be easily overlooked; however, Forster did not ignore their rhetorical power, and they function to call attention to a major facet of the novel.

Both of the major characters in the novel, the Indian Aziz and the English Fielding, at one point specifically call attention to a proverb or group of proverbs. Fielding, who has missed the train to the place where the fateful picnic and excursion take place, arrives later by car after the incident in the cave, and Miss Quested escapes in the same car he has arrived in. He has no inkling of what has happened, and he and Aziz chat about the excursion. The Indian tries to make light of the great expense he has incurred in hosting the expedition by seeming to use a proverb: "If money goes, money comes. If money stays, death comes. Did you ever hear that useful Urdu proverb?" he asks. But he hastens to add, "Probably not, for I have just invented it." Fielding then ventures, "My proverbs are: A penny saved is a penny earned; A stitch in time saves nine; Look before you leap; and the British Empire rests on them" (p. 160).

Aziz's pseudo-proverb stresses insouciance about extravagance, whereas Fielding's proverbs stress thrift and caution, quite the opposite. However, the exchange of aphorisms goes beyond rhetorical sparring between two individuals. As has often been pointed out,

proverbs are by their nature attempts to draw upon what is perceived to be communal wisdom, and this exchange in fact pits the communal values of one culture against those of the other. This is made clear not only in that Fielding links his proverbs to a social and political system, the British Empire, but also in that he goes on to link Aziz's being taken advantage of in this affair by his fellow countrymen to Indian cultural proclivities. And Aziz himself, in pretending that his aphorism is a real proverb, tries to link it to communal values. The pseudo-proverb in effect becomes a statement of communal attitudes, of the leisurely, aimless extravagance which we also see in the social gatherings of Aziz's circle, attitudes which are very attractive but which are no match for the hardheaded, practical English values that help to control a political empire.

In part, Forster is simply using proverbs, which are presumed to be the value-laden statements of a cultural group, to show how different cultures have different attitudes, and that the attitudes of one may not be at all compatible to the other. However, his use of proverbs goes beyond such a simple design and fits in with his interest in the larger question of the relativity of truth and the role which culture plays in shaping human perceptions of truth and "reality," a theme which he develops in a number of ways.

Because proverbs are assumed to "speak truth," it is easy to see why they would appeal to an author concerned with the parameters of truth, and Forster uses two recurring proverbs in working out his theme, though the first is in fact not a traditional proverb. However, Dina Sherzer has discussed in connection with Samuel Beckett's novel *Molloy* how an author may create aphorisms in the mold of conventional proverbs so that such expressions come to have the gnomic character and functions of traditional proverbs, and Forster seems to be undertaking a similar strategy. The expression he uses is "A mystery is a muddle," and we note that it has the dipodic syntactical symmetry of proverbs, uses alliteration, as do some proverbs, and "states the sort of general truth found in proverbs."[14] Structurally it reminds one of any number of English proverbs which declare that something is something else, and for other reasons as well it evokes "A miss is as good as a mile," a saying which is conceivably its model.

The expression is first spoken by Fielding at a small tea party he gives. Adela, in the context of discussing an incident obviously involving cultural misunderstanding, says that she hates mysteries, Mrs. Moore says that she likes mysteries but dislikes muddles, and Fielding states that "A mystery is a muddle," adding that India is a muddle, thus linking the conversation again to cross-cultural misunderstandings, a point which is re-enforced by the comment that Aziz is "rather out of his depth" (p. 69) in the conversation. Thus there is created in the form of a proverb a statement of what is to be seen as a basic British attitude. Truth and "reality" should be clear, factual, cut and dried; otherwise there is nothing but confusion, muddle. The traditional proverbs that Fielding cites as his and those of the British Empire fit in with such a conception; they are simple, to the point, direct, clear, which is in contrast to a basic Indian attitude; Indians see life and truth as full of mystery, and truth as sometimes shifting rather than simply fixed. The Marabar Caves are associated with ancient truths and are utterly mysterious. Godbole is a mysterious figure who seems to have important knowledge too mysterious to impart. The song that he sings is one of divine mystery (and his explanation of it certainly mystifies non-Hindus). The ceremony commemorating the birth of Krishna which marks the climax of the novel partakes of the same truth that is divine mystery, and in fact one of its functions is said to be the creation of "sacred bewilderment" (p. 287), a notion surely foreign to Western conceptions. Aziz's creation of a "proverb" suggests further a penchant for making up "truth" to fit the occasion. That is, as Forster sees it, to an Indian a statement may be "true" even if it is "false" according to Western logical conceptions of fact, so long as it is appropriate to the social situation or is the polite thing to say. Aziz creates at least some of his own trouble with the British because he follows this proclivity of culture—for example, allowing that his dead wife is alive, "for he felt it more artistic to have his wife alive for a moment" (p. 152). The making up of a proverb and passing it off, however briefly, as traditionally sanctioned truth parallels the cultural process.

Through yet another proverb, however, and through the character who first speaks that proverb, we can most fully see the use of the proverbs so far discussed as part of a unified thematic design. Mrs.

Moore is the character in question, and she is developed as having an instinctive feel for Oriental culture, as sharing in some of the Oriental ways of looking at life. For example, when she finds a wasp in her room, a very Indian-looking wasp, she leaves it alone and even calls it "pretty dear" (p. 35), for in the East not only is there respect for all life, but distinctions between indoors and outdoors break down. Her view mirrors and is amplified by the thoughts of Professor Godbole later during the Krishna birth ritual, when he suddenly remembers a wasp and loves it because to do so is to imitate God, and the vision contrasts with that of the English missionary, Mr. Sorley, who would exclude wasps from heaven despite his liberal views.

In criticizing the British attitude toward India and Indians, Mrs. Moore uses the proverb, "God is love" (from 1 John 4:16). Her son has asserted that the English are not in India to be pleasant but rather to do something "more important," to "do justice and keep the peace." She insists that the English must behave pleasantly toward the Indians because that is God's plan and "God . . . is . . . love," she insists (p. 51). Here we see suggested another fundamental contrast in English and Asian attitudes. The English are attuned to bringing justice and keeping the peace, to which ends they are obsessively devoted in their prosecution of Aziz, and to the practical virtues which enable them to run an empire. The Asians are attuned to love, and it is love—intuitive understanding—they would prefer to receive from the English; English justice and law seem to them only cold and hostile.

However, "God is love" reappears later, during the birth ritual. It is one of a number of inscriptions which appear in the temple and of course is there to indicate that God's universality encompasses everything, even the English language and, by extension, the English themselves. But (p. 285) through "an unfortunate slip of the draughtsman" the expression appears as "God si love," and the novel asks: "God si love. Is this the first message of India?" The message is, of course, that God sees love before God recognizes a cold justice mixed with hauteur and contempt. But there is another message here as well, that in the Asian view words do not matter as much as feelings. The words of the expression "God is love" have been mangled, one of them misspelled, and, in fact, all of the temple inscriptions have

been "hung where they could not be read." Yet feeling transcends mere words, for the whole birth ritual episode is suffused with a spirit of union through divine love. Not only does Godbole love the wasp, but high caste and low caste, even European and Asian, are at least temporarily united through the medium of the ritual.[15]

Yet, the novel suggests, the English are caught up in words alone, in form rather than substance, in a legalism which depends upon cold, logical words, rather than a love which goes beyond. As the novel progresses, Mrs. Moore undergoes a spiritual crisis in which she realizes the powerlessness of mere words. As she sits, following her difficult visit to one of the Marabar caves, she becomes overawed by the experience of the cave and its strange echo, which sends back the sound "ou-boum" whatever is said. In the mystical cave, words are reduced to a single meaningless sound. She is perhaps at heart an Oriental, but culturally she is still of the West and she lacks the means to deal effectively with her experience. She thinks of Christianity, but it is only "poor little *talkative* Christianity," a religion of words, and "all its divine words from 'Let there be light' to 'It is finished' only amounted to 'boum'" (p. 150; emphasis added). Later, when told she is unkind not to say something in a particular conversational context, she responds: "Say, say, say. . . . As if anything can be said! I have spent my life in saying or listening to sayings; I have listened too much" (p. 200). Although by "sayings" she seems to mean here words in general, the term is, of course, a common synonym for proverbs and proverbial expressions. And although she means that she senses that truth goes beyond words, her use of "sayings" returns our attention to the proverbs, the sayings which Fielding has described as the basis of the British Empire. These sayings are practical and commonsensical, but they are also being held up as prosaic, tired, dull, as even British truth, though clearly fixed and tenaciously adhered to, is dull and limited to linguistic formulas, words only.[16]

Forster is, then, working with a particular notion of proverbs. Because proverbs seem to express age-old immutable truths, because their truth "feels absolute," they can be used as vehicles for an author concerned with the nature of truth. But because proverbs may merely *appear* to express such immutable truths, proverbs can also

be used to point to the inadequacy of fixed formulas as statements of the truth. Because proverbs are in part culture-specific and can be presumed to communicate certain values of the culture in which they are transmitted, Forster utilizes proverbs to call attention to how "truth" is culture-bound. He believes that there is a divine truth which cannot be expressed in words—perhaps a curious position for a writer—and points up the ultimate limitations of proverbs and words alone. We can assume that Forster is sympathetic to the sentiments of one proverb, a Western one at that: "God is love." But his most profound sympathies lie with the idea, at least in part realized by Asians, that words alone are not enough, and it is fitting that even "God is love" be misconstrued and hung where it cannot be seen. And fitting that it is through a ritual, which contains words but which goes beyond words to actions, emotions and spiritual outpourings which may not even be rationally comprehended, that the problems of the novel are resolved, however temporarily.[17]

Basing it on his travels in Mexico in 1938 in the aftermath of the fanatically anticlerical Tomas Garrido Canabal's governing of the state of Tabasco, Graham Greene published *The Power and the Glory* in England in 1940, and an American edition (published under an alternate title, *The Labyrinthine Ways*) appeared in the same year.[18] It is the story of a deadly struggle between two antagonists who confront each other only at the end of the novel and whose names we never learn, a priest attempting to evade arrest while the Catholic Church is persecuted, and the police lieutenant tracking him down. The novel deals with the priest's spiritual journey and unorthodox salvation.

Both main characters are seriously flawed, though also admirable in some way. The clergyman is a "whiskey priest," has abandoned many of his priestly obligations, and allowed others to suffer for him. Yet he cannot run away and retains a sense of duty. The lieutenant is dedicated to religious persecution and brings death, yet he is an idealist who opposes Church corruption and seeks a better life for the people of Mexico. Greene is thus able to play with questions of good and evil—who is good and who is bad? In what does wickedness consist? Indeed, both main characters emerge as

heroic, if not in conventional ways. Two of the three proverbs used in the novel, however, relate to subsidiary characters, not the priest or the policeman.

The opening and closing sections of the novel are devoted to several such characters, people who have peripheral connections to the plot. They are uninvolved in the struggle between the main characters, or involved only in oblique ways, even desirous of remaining as uninvolved or ignorant as possible of the reality of the main conflict. Greene in part uses these characters to draw both contrasts and parallels to the priest.

One such character who, in contrast to the priest, refuses to confront the realities of this own life is Captain Fellows, an expatriate Englishman who operates a banana company. His business is down at the heels, his wife depressed and frightened by their living situation; he is unable even to cope with getting his bananas shipped. He can seem happy only when "he felt no responsibility for anyone" (p. 31), and, indeed, a lack of responsibility is at the heart of his character. (His name may be an ironic reference to his caring so little for his fellow humans.) At one point Fellows sits on the bed his wife is lying in and carefully avoids looking out the window; "out of sight, out of mind," Greene writes (p. 38). The words are partly the character's half-conscious thought, partly an omniscient author's conceptualization of a situation, and their meaning seems clear, a proverb's generalized base meaning applied to a particular context.[19] In literally refusing to look out the window and see his sorry surroundings, Fellows is refusing to confront certain responsibilities, blocking from his mind recognition of his life.

A second proverb appears toward the end of the novel. The priest has temporarily escaped to a neighboring Mexican state, where anticlericalism is less virulent. Here he is taken in by the Lehrs, a German American brother and sister who own a prosperous farm. In contrast to that of the Fellows family, the world of the Lehrs is well ordered and well run. Yet they too seem unable to see beyond themselves. They exist "by simply ignoring anything that conflicted with an ordinary German-American homestead" (p. 163). Mr. Lehr, vaguely disapproving of Catholicism, has no idea of the terrible persecution taking

place not far away and virtually no connection to the country and culture he lives in. At one point Lehr and the priest bathe together. Lehr soaps himself and "The priest afterwards took the soap and followed suit. He felt it was expected of him, though he couldn't help thinking it was a waste of time. Sweat cleaned you as effectively as water. But this was the race that had invented the proverb that cleanliness was next to godliness—cleanliness, not purity" (p. 164). The proverb enters the text as the priest has reference to a national stereotype, but what is important is the priest's interpretation of the expression, which suggests a certain falseness in the proverb. Purity and cleanliness, though related concepts, are certainly not synonymous, and the priest seems to be implying that cleanliness can be merely physical, merely a surface manifestation that may have little to do with a deeper purity of the spirit. Mere cleanliness, then, may not be next to godliness. The Lehrs are undoubtedly clean, but Greene suggests that, as cleanliness may be superficial, this is a part of their superficiality and their inability to get beyond the superficial aspects of their lives in this place. (Their name Lehr could suggest the German adjective *leer*, meaning empty, an allusion which certainly fits Greene's conception of them.[20]) Their nationality, which is specifically tied into the proverb, is important, for though the author also plays with a national stereotype of Germans as hearty, clean, and well ordered, what he really means to call attention to is a worldview which cannot escape cultural limits to recognize the realities of another, surrounding culture. Like Fellows, the Lehrs too are unable to see.

Both instances of Greene's proverb use noted thus far might be seen as displaying negative attitudes toward proverbs. In the second instance the wisdom of a proverb is called into question, and Greene may be implying that proverbs are themselves superficial; at any rate, the priest sees the proverb in question as shallow. In the first instance Fellows—insofar as the proverb is part of his thoughts and attitudes— is hiding behind the proverb and using it to excuse his own nonconfrontation and failure to see. Yet, however Greene may view proverbs, he also relies on their power to summarize situations and recognizes their presumed ability to convey values. In doing the latter in particular he draws proverbs and proverb use into the very theme of his novel.

The novel is concerned with the complexities of distinguishing good from evil, and his use of the proverbs reinforces this theme. Proverbs are commonly presumed to be "wise" and to convey positive values. Yet in one case a proverb's truth is questioned; in the other a proverb is used to excuse irresponsible conduct. Greene seems to be suggesting that if even statements which are supposed to convey wisdom and morally praiseworthy values can be questioned or "misused," how much greater the problem of determining what is good, what bad. In doing so, of course, he merely recognizes what scholars have also recognized: that "wise" sayings may only appear wise upon the surface and that proverbs achieve meaning through performance (and that, by extension, a given performance may well suggest a conclusion that some might consider less than moral or uplifting). But Greene deftly ties this recognition in with a central statement of his literary work. Greene may distrust the nature of formulaic communication[21]—whether proverbs or the simplistic formulae to be found in the Lehrs's Gideon Bible which direct readers to certain, preordained passages that fit certain moods—yet he seems to understand the power of formulaic language too. The novel itself has as its title an extremely well-known phrase from the Lord's Prayer. Another of his best-known novels uses a well-known cliché as its title, *The End of the Affair*, and another uses a proverbial phrase, *The Heart of the Matter*. And in *The Power and the Glory* itself Greene uses a third proverb to call attention to another central facet of the novel.

The third proverb is recalled by the priest: "He remembered a proverb—it came out of the recesses of his own childhood: his father had used it—'The best smell is bread, the best savour salt, the best love that of children'" (p. 67). This proverb[22] calls attention to love, simple, basic necessities, and children, and, indeed, there are three important child characters in the novel who relate to the priest's situation—his daughter by a peasant woman; the Fellows's daughter, Coral; and a young Mexican boy, Luis. Each shows a different side of love.

The priest actually thinks of the proverb during a confrontation with his daughter. While in hiding with the girl's mother, he sees his daughter. She is obviously full of a sullen spirit, sniggers at the priest, wonders aloud if he is the Yankee murderer also sought by the police,

and displays "an ugly maturity" (p. 68). He remembers that there was "no love in her conception" (p. 66); he has tried to love her, but has obviously failed; clearly she shows a hostility if not a hatred to him. She represents a failure of love.

Coral Fellows also displays a remarkable maturity for her years, though hers, far from being ugly, is of a responsible kind. Despite her youth, she virtually runs the lives of her parents, puts on her sun helmet to get the bananas to the quay when her father neglects doing so, is clearheaded and decisive while they fumble about with their lives. She is like a loving parent while they are "carried like children in a coach . . . without any knowledge of their destination" (p. 39). She hides the priest and even refuses the lieutenant permission to search their premises. Her mother dreams vaguely of weddings, suggesting the beginnings of loving relationships, but her husband remembers only "his happiness on the river, doing a man's job *without thinking of other people*" (p. 37; emphasis added). But love consists in thinking of others, and it is only the mature child who does this, caring for her parents, caring for the priest. Here there is a sort of triumph of love in the midst of a failure of love.

The boy Luis plays a role in another family drama, though a very low-key one which goes on throughout the novel in a sort of counterpoint to the main action. His mother has been reading to him and his sisters a pious book, smuggled in from Mexico City, which recounts the story of a young man named Juan, martyred by the government authorities for his adherence to his religion. Luis is repelled by the sentimentality of the book, and at one point he flirts with the police lieutenant who is tracking the priest. Yet at the very end of the novel, after the priest has been shot and Luis has heard the story of Juan read yet another time, Luis opens the door of their house to another priest who has just come up the river, and takes this new man into hiding. Thus he puts himself into the role of one who cares for others and who loves the church enough to perform a courageous act.

The proverb, then, calls attention to the love of children and to larger questions of love. As Greene asks about the nature of good and evil in his novel, so too does he ask about the nature of love. Though the priest has failed at love, we must recognize that a kind of love

keeps him going. Though the lieutenant seeks to kill, it is a love, however distorted, which impels him too; he is "a little dapper figure of hate carrying his secret of love" (p. 58). The novel has its share of failed love and love that redeems. The priest goes to his death feeling that he has failed. Yet in a sense he has redeemed himself through love, by caring about the soul of an American bandit also hunted by the police and by going to him despite the danger; the novel ends with Luis's brave action, something which, of course, the priest never sees. Thus the novel ends on a note of hope through love, despite all the hatred and failure.

Obviously the novel could exist without the proverbs, yet Greene has used them to "frame" his thematic concerns in such a way that the sayings call attention to themes and ideas. They fit neatly into the larger work of art and amplify it. Just as proverbs used in speech can be said to "name" recurring human situations, Greene's proverbs "name" recurring themes and call our attention to them.

Both Forster and Greene display a skepticism toward proverbs, Forster using formulaic words to question the power of words, Greene suggesting that formulas are shallow. Yet in part their skepticism is transcended by a recognition of the rhetorical potency of proverbs, which do allow us to draw upon the impact of a widely believed moral "truth." As Abrahams and Babcock comment, "Even when used inversely or ridiculously, proverbs may operate as serious literary devices in characterization, dramatic setting, and plot."[23] Indeed, other fiction writers have worked in this gray area between our recognition of the rhetorical value of proverbs and our mistrust of their supposed wisdom, employing such strategies as using a proverb ironically in a title, or merely alluding to it in a narrative and never actually using it. In the latter case it is up to the reader to supply the full proverb while the writer thus avoids whatever onus may be attached to using it.

A story in which a familiar proverb is merely alluded to, for example, is Katherine Mansfield's "Bliss,"[24] although here there is also an echo of ironic use in the title. It is the story of an upper-middle-class Englishwoman, Bertha Young, whose last name indeed signals her immaturity. She plays at life, not having accepted an adult role.

As the story opens she is experiencing a bliss she cannot explain, though several possible causes are presented to the reader: the charm of her guests at the dinner party which takes up much of the story; her newfound friend, the mysterious and beautiful Pearl Fulton, with whom she is "in love"; the dazzling pear tree in her garden, in full and perfect bloom, which she associates with herself and with Miss Fulton; the fact that during the evening she seems to conceive a sexual desire for her husband, which has hitherto been lacking in their relationship. But the evening ends with the sudden realization that Pearl Fulton is her husband's mistress, and the story concludes with her barely beginning to contemplate knowledge that she previously did not have. She has been ignorant of the true nature of her relationship with her husband, and the reader at least sees she has been ignorant of what is really her position in life. The reader finally realizes the cause of her bliss: this very ignorance which has allowed her to maintain an unrealistic view of the world and her place in it.

Of course the reader also may connect the ignorance and the bliss of mood and title and think of "Ignorance is bliss." Though the writer has merely alluded to the proverb,[25] the proverb has nonetheless become an important element in the thematic strategy of the story, serving in fact as a simplified but nonetheless effective summary of the main character's situation and the focus of the story as a whole.

The allusion to a proverb is even less direct in J. F. Powers's "The Valiant Woman."[26] Like much of his writing, this story deals with the subculture of the American Roman Catholic priesthood, and focuses on the relationship between a priest and his female, live-in housekeeper, the widowed Mrs. Stoner. The priest is Father Firman, whose name mocks the fact that he is not a firm man at all, and his weakness has allowed the housekeeper to expand her influence over the years. Firman secretly desires to be rid of her, yet he is completely unable to unseat her for reasons that become clear to him only toward the end of the story. He enumerates her sins and failings; the only good thing he can find to say about her is that she is very clean. He sits and thumbs through the ecclesiastical regulations governing the employment of housekeepers, hoping to find some rule which will force him to dismiss her. But he cannot find

one and suddenly comes to realize, to his horror, what it is which binds them intrinsically together. They have stumbled into a quasi-marriage, which has produced the tension that sometimes attends the married state, but which can by definition provide no sex, love, or tenderness. Firman is appalled by the realization and immediately represses all thought of it.

The symbolism of the story is fairly complex, and one of the central symbols is a mosquito which buzzes about, tormenting Firman. It is pointed out that only the female of the species bites and Mrs. Stoner notes that female mosquitoes need blood for their eggs, calling attention to procreation, which cannot be a factor in Firman's relationship with Mrs. Stoner. Thus Mrs. Stoner comes to be identified as a blood-sucking female in terms of her relationship with the priest. But one also thinks of a more extended range of the symbolic connotations of blood. There is blood-kinship, another suggestion that there is more than an employer-employee relationship between priest and housekeeper. And there is the Christian religious symbolism of blood; among other things, martyrdom is suggested. But the images of blood and stone combine in another way. The author seems to be hinting at a proverb: "You cannot get blood from a stone."[27] Certainly that saying is a powerful summary of the Firman-Stoner relationship. She may take blood—in fact she "plays for blood" during their card games—but (in part due to the social context of their situation) one cannot get blood—that is, nurturing, love, anything—from this hard-as-stone woman. The alluded-to proverb, then, does not—as seemed to be the case with "Bliss"—serve to encapsulate the full thematic development of the story, but does delineate a major aspect of the relationship that prevails between the main characters.

In Flannery O'Connor's "A Good Man Is Hard to Find" we have a proverb being used as the title,[28] and we have it used again by a character in a perfectly direct manner to comment upon the terrible state of modern society, but it is also used as an ironic point of reference. The story is one which manages to be horribly funny while it deals with chillingly barbarous human actions, the plot involving a bickering and rather unpleasant family who are driving to Florida and

fall into the clutches of a criminal known as "The Misfit." His gang murders the six family members, one by one. In the last pages of the story the proverb-title takes on significance. The grandmother, whose petty, selfish manipulations have caused the family to run into The Misfit in the first place, carries on with the murderer a conversation which is simultaneously bizarre and humorous, horrifying and pathetic. As The Misfit reveals himself to be utterly ruthless and amoral, the grandmother keeps insisting that she knows he is a "good man." She is trying to humor him, but she is really deluding herself as she earlier deluded her family, so that she does not have to face up to the reality of his evil. Although the reader finds it impossible to find a good man in this plainly evil man, the grandmother finds it pathetically easy to do so, and an absurd contrast is created between the reader's perspective and that of the main character, the grandmother.

The proverb/title comes to have a sort of dual usage. On the one hand it can be taken at face value. The reader can agree with the minor character who earlier in the story utters the proverb as a judgment: indeed a good man is hard to find, if the people in the story are to be taken as representative of humanity. On the other hand, O'Connor plays with the proverb, contradicting it, showing how easy it can be to find a good man if one refuses to face the reality of evil. Perhaps O'Connor, as a modern writer, could not use the proverb at face value without also ironic contradiction. Her use of the proverb mirrors the whole tone of the story. Just as the straightforward use of the proverb is countered by the ironic twisting, so are the horrifying events contradicted by the hilarity which pervades the narrative.

Writers can and do re-situate proverbs in several ways. Forster's proverbs are all spoken by his characters and are thus a part of the speech of his fictional lifeworld. Greene's are never spoken, though they are *thought* by his characters, being thus part of their mental lives (though in one instance the proverb is in part an insight by the omniscient narrator). O'Connor puts her proverb out in the open, having a character use it and thus exist as part of the story's lifeworld and plot, but calls greater attention to it by making it her title so that it becomes an important referent of the story's overall meaning. Mansfield and

Powers never use their proverbs at all, merely alluding to them, allowing them to structure aspects of meaning indirectly. But however they are used, proverbs remain a folk genre commonplace in modern life, and certain proverbs at least are known to virtually everyone in English-speaking society. Hence proverbs have a dual existence for us. Their very commonness makes us suspicious of them. If their "wisdom" is so widely known, it must be a very conventional wisdom and so probably shallow, open to question, subject to easy denigration—at least in the formulaic form of the traditional saying itself. On the other hand, proverb use would not be common in the first place if the proverbs did not provide on some level a powerful means of communication, and in effect they offer rhetorical modules which are inserted into an infinity of speech contexts, providing language—often metaphorical language—which resonates with already agreed-upon meaning and an air of traditional authority.

Writers can play upon either facet of this duality inherent in the proverb's modern social situation. They can have recourse to cultural understandings by referencing proverbial language and rely upon the power of proverbs to telegraph meanings related to literary narrative. They can imply the absence of meaning by using proverbs cast as expressions of conventional—and thus supposedly hollow—ideas and attitudes. Or they can—as the writers discussed in this chapter mostly have done—work in the interstices between communicative power and questioned meanings by both referencing the rhetorical abilities of proverbs while also—through irony, through allusion, through indirection—calling into question the presumed social meanings of traditional sayings.

Pageant, Death, Initiation

The Ambiguity of Ritual

R ituals have had great appeal to writers, for ritual provides excitement and mystery and color. Yet just what the term "ritual" encompasses is problematic, increasingly so as we more and more include secular behavior under this term which formerly carried stronger connotations of the sacred.[1] In this chapter we prefer to speak mostly of "ritual public events."

"Public event" is a term used by Don Handelman to encompass a variety of "ritualistic" genres, including ceremony, celebration, rite, pageant, ritual, and spectacle.[2] Handelman suggests that these concepts of genre, in some cases not clearly defined, overlap and that the term "public event" is useful as a kind of general denomination for a broad category of cultural phenomena without constantly having to attempt to draw distinctions between the various aspects of this broad range. He further posits that public events are either mirrors or models. When they are mirrors they function to present or re-present society with a picture of itself. Those which *present* provide society with a more or less literal image. The famous Moscow May Day parades presented a literal statement of the military power of the Soviet state through a selection of military units and equipment. Those which *re-present* provide a more or less distorted picture, through the use of inversion and symbol. Carnival behaviors with their temporary inversions of class status are re-presentations, images

of society being acted out but not in a literal manner (the extent to which social reality is disguised of course varying from event to event). Class privilege may be turned around for a day or longer, but that emphasizes the actual, usual social situation. Those events which *model*, however, do not simply provide a representation of society. They are seen as actually bringing about changes. Initiation rituals are Handelman's prime example, rites viewed as actually bringing about and ensuring transformation of certain individuals, moving them from childhood to maturity or from one status to another.

If there has been popular rebirth of interest in ritual over the past twenty or thirty years, it is because ritual has come to be thought of as emotionally satisfying or psychically or spiritually "empowering." Individuals and small groups invent new rituals—for marking such modern life passages as divorce—and thus a digest-type, general-audience magazine like *Utne Reader* could publish a section called "In Search of Meaningful Ritual," with material from various other periodicals.[3]

Folklorists and anthropologists—however they may have defined the term precisely—also traditionally have viewed ritual as a positive social force, fulfilling functions of integration, identification, and transition. This position is reflected in more general attitudes. In *A Passage to India*, though E. M. Forster casts doubt on the power of proverbs, he affirms the power of ritual, and it is the compelling ceremony that swirls around the birth of Krishna which brings about anything in the novel that might be called reconciliation and good feeling. Trudier Harris discusses at some length how a ritual hunt which becomes a kind of "ritual testing" in Toni Morrison's *Song of Solomon* plays a key role in helping the chief protagonist of that novel to move ahead in his progress toward a more positive situation.[4] And we can also see a belief in the positive power of ritual reflected in some of the visual arts works produced by twentieth-century artists. For example, a whole series of murals painted by Diego Rivera at the Ministry of Education building in Mexico City uses ritual public events as subject matter and is particularly interesting because of the sustained treatment of the subject. Rivera executed the murals at this site between 1923 and 1928 as a vast project which

ultimately totaled 235 fresco panels depicting a variety of cultural and political subjects; the entire project has been called "a vast portrait of the Mexican people."[5]

The Mexican mural movement came out of the Mexican Revolution of 1910 and was part of an ideology which sought both to make art available to the masses by putting it in public spaces and to turn to subject matter that expressed and revitalized indigenous Mexican culture, which was seen as having been repressed in favor of colonialist European models. Mexican artists turned to Mexican folk art for inspiration—a development discussed in more detail in chapter 7—and it is not surprising that Rivera's great Ministry of Education[6] undertaking should include many references to Mexican folk culture, not just ritual events (for example, a series of 26 panels work from stanzas of three *corridos* [ballads]). Indeed in this early project Rivera was himself moving from a fresco style which was Italianate to one which became more his own and more Mexican, so that his re-situating Mexican ritual events in these paintings represents a personal cultural transformation as well as an attempt to use folk materials to project a national cultural identity.[7]

Rivera called the first of the two courtyards that he and his assistants decorated at the Ministry the Court of Labor; his panels there are overtly political. In the second courtyard, which he called the Court of the Fiestas, the panels with rituals appear, and they represent a change in mood from the first courtyard. In these panels, Rivera himself said, "the people turned from their exhausting labor to their creative life."[8] The creativity depicted here, however, is the collective creativity of tradition, and it is no accident that whereas in the Court of Labor murals people appear in small groups, here people appear in great masses, reflective of the reality of public rituals. For example, in a panel depicting *The Ribbon Dance*[9] nearly a dozen musicians vie with an even larger number of dancers and spectators, while in *The Burning of the Judases* the bottom half of the painting is literally packed with a crowd of people who seem scrunched together—like a real crowd at many public events— below the upper half in which the principal activity, the explosion of the Judases, takes place.

Ribbon dances *(las danzas de los listones)*, which are particularly known in southern Mexico where Rivera had visited in 1922 (and which had a powerful influence upon him), have been likened in appearance to English maypole dances. Done by male dancers at religious festivals, they thus have a ritual context, and the dancers' costumes are often adorned with the image of a saint. Perhaps originating in pre-Columbian fertility dances, they involve dancing with ribbons attached to a central pole. The Judases of the other panel are papier maché figures which are blown up by attached fireworks and are thus aspects of a larger Mexican tradition of pyrotechnics, which are often set off as a part of fiestas. The Judases are generally hung in the air from a rope and were traditionally exploded on Holy Saturday after mass. They thus fit into a Catholic ritual context and are conceived as representing Judas, the betrayer of Jesus, a figure appropriately destroyed by Christians during the Easter season, following Christ's death and before his Resurrection. In fact the Judases may be rendered to depict other personages such as the Devil, and since around 1900 unpopular political figures have been an especially popular subject for depiction and demolition. Those in Rivera's mural pick up on political possibilities by representing the church, the army, and politicians in general.

As depicted by Rivera, *The Burning of the Judases* is largely secular despite the larger religious context into which the ritual fits in social and historical reality. The viewer's attention is drawn to the exploding figures that occupy the top half of the frame because they are so prominent and so striking, partly because they are large, grotesque and colorful, partly because they are, after all, exploding. They seem to press down upon the crowd in the bottom half of the frame, a positioning which suggests the social situation in which the Mexican people were oppressed from the "top" of society by army, church, and politicians, while the fact that the figures are now being blown up by the people suggests that those oppressive forces are being destroyed by the Revolution. Rivera re-situates the ritual as image for political reasons, although the image is more gentle in this regard than many of the political murals of the same period. *The Ribbon Dance* is more clearly religious in that Rivera has set a row of

carved saints, probably representing the facade of a church in front of which fiesta dances are often performed, in the space behind some of the musicians. These statues establish an unmistakably Catholic context in which the dancers intertwine their ribbons, as other people participate in other ways.

What is especially striking about the figures in *The Ribbon Dance* is their interconnectedness. The dancers are held together by the ribbons they hold on to, and those ribbons are so interwoven that the viewer wonders if the dancers, presumably having made moves to produce the interwoven effect, will now be able to extricate themselves. In addition, however, there are a number of young girls in the foreground who carry the curved bands of flowers that appear at many Mexican celebrations. The girls too are interconnected, two at a time, by the arcs they hold. And the musicians essential to the other actions hang together tightly, as members of musical groups often do. Through the symbolism of physical ties, Rivera has chosen to emphasize an important aspect of ritual events, their ability to bind people together and to connect them. Traditional Mexican rituals, drawn from the cultural reality that the muralists sought to recognize and glorify, are seen as expressing the unity of the nation, showing its interconnectedness. *The Burning of the Judases* does not provide the binding ribbons and flower arcs of the other painting, but nonetheless is meant to suggest the same connectedness of the people through the density of the crowd, a connectedness which even allows them to change their society and their social position by destroying oppressive forces. These panels suggest that, at least symbolically, ritual has the power to transform society, as the Revolution transformed Mexico. Ritual has the power to, in Handelman's terms, model society, in that it binds people together to make important changes.

Three other panels in the Court of the Fiestas depict different manifestations of the same ritual occasion, one extremely important in Mexico (one which had a considerable presence in the work of Rivera's esteemed predecessor, the influential printmaker José Guadalupe Posada and which has since become significant in the work of many Mexican American artists as well).[10] This is the Days of the Dead, already discussed in chapter 1, a fusion of European and

pre-Columbian elements in a celebration when ancestors are revered and the deceased are honored and communicated with. Two of Rivera's three panels show how the holiday is celebrated in, respectively, the city and the country, thus providing on one level a sociological contrast. *The Days of the Dead—City Fiesta* depicts a large number of people packed cheek-by-jowl into an urban commercial area, probably a market. Some face stalls vending food and drink, while others stream by behind them into another equally packed market aisle. Filling much of the upper half of the image—rather like the Judases discussed above—are gigantic renderings of the wooden, string-manipulated stick puppet *calaveras* (skeletons) which are sold as toys for the occasion, and behind those are piles of the ceramic or sugar skulls which are also sold and sometimes presented to loved ones like Valentines. There are also figures of souls in purgatory, and at the front of the crowd, people try on skeleton masks also being sold. Not only is the scene clearly urban, but it is largely secular and suggestive also of the political in that the stick puppets seem to represent a *campesino*, a revolutionary and an urban industrial worker. In contrast, *The Days of the Dead—The Offering* (fig. 6) shows a group of people in a rural cemetery surrounding a grave mound upon which have been piled greens, wreaths of marigolds, and pottery braziers burning *copal* incense.[11] Village women tend the grave mound while male *campesinos* stretch out behind the women, acting more like reverent spectators. Arcs of marigolds cover the mound and run back among the men, and marigolds also entwine around a cross that seems to be made of vegetation (recalling Mexican colonial crosses carved from stone commonly rendered to look vegetative, a carryover of pre-Columbian ideas). Whereas the city scene is secular and festive, here the cross and tapering, white candles evoke the religious, the mood solemnly reverent.

On one level the two panels contrast, showing on the one hand the teeming urban masses occupied with shopping and festivity and satire (the political stick puppets mirroring the use of the Days of the Dead as a time for political satire through broadsides and newspaper verse with *calavera* illustrations), and showing on the other hand the quiet, religious, reverent villagers who are in tune with the occasion's

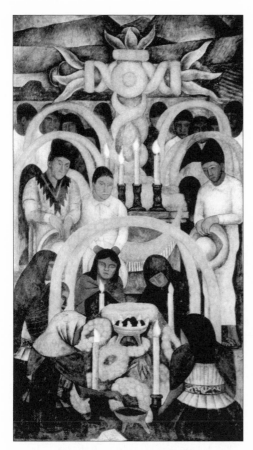

Figure 6 *The Days of the Dead—
the Offering [Día de los Muertos—la
Ofrenda],* by Diego Rivera; mural, Min-
istry of Education, Mexico City; 1923–
1924. © 2003 Banco de México Diego
Rivera & Frida Kahlo Museums Trust
Av. Cinco de Mayo No. 2, Col. Centro,
Del. Cuauhtémoc 06059, México, D.F.
Reproducción autorizada por el Insti-
tuto Nacional de Bellas Artes y Litera-
tura. Reproduced with the permission
of the Banco de México and the Insti-
tuto Nacional de Bellas Artes y Liter-
atura, Mexico City. Photo: Fondo Diego
Ma. Rivera,CENIDIAP.INBA.MEXICO.

central purpose of recognizing and honoring the dead. Rivera cap-
tures something of the variety of Mexico, yet he is primarily using the
ritual to suggest the commonality and connectedness of the Mexican
people. Despite the differences, the great event binds together coun-
tryside and city, homogenous peasantry and diverse city dwellers.
Within each panel too there is a great sense of human interconnec-
tion. In the city fiesta the very mob-scene quality of the depiction, of
people brought together by ritual celebration, if its more commercial
aspects, suggests a kind of oneness, of individuals pressed—happily
enough—into a single sea of Mexican humanity. In the rural scene,
the flower arcs again appear—as in *The Ribbon Dance*—attaching

people to each other but also people to the spirits of the ancestors and, through the flowers around the cross, people to a reality beyond.

For Marxist Rivera that greater reality beyond was more likely a cultural than a spiritual one, and indeed his re-situation of ritualistic scenes in these panels implies a cultural message. The events may in their social reality have deeply spiritual aspects, but the artist means to celebrate that spirituality along with more secular aspects as a statement of a national cultural unity. He does not ignore the spiritual but subjugates it to cultural ideology, recognizing the power of ritual (which also manifests great beauty) to unify and bind a strong social whole. He thus appropriates the power of ritual to model — that is, to bring about great change, consciously using that power in service of a nationalistic agenda. This uses the same ability of rituals to unite a people in support of a nationalistic cause as the Chicano artists discussed in chapter 1 drew upon to unite an ethnic group within American society.[12]

Ritual, however, can be seen in a more negative light, as in the phrase "empty ritual." On the one hand ritual presents something solemn, even numinous, and something deemed socially important, perhaps very much so. On the other hand, ritual presents highly conventionalized actions, the same movements or formulae or modes of costuming being repeated over and over again as occasion demands. Thus the stage is set for a sense of dysfunction in an age that distrusts the conventional structures of tradition, set for a sense that the high purposes of ritual are undermined by a monotony of form. Hence "empty ritual," from the assumption that here is merely form and no substance.

As writers have questioned proverbial language and implied that deep meaning does not inhere in formulaic words, so have others questioned the ultimate power of ritual public events, implying that in formulaic behavior we have only set-piece actions that cannot truly respond to the very human needs of individuals or even of society. We discuss in the rest of this chapter several modern novels which depict ritual public events as an aspect of their fictional lifeworlds, and they suggest ambiguous attitudes towards ritual public events, attitudes which, indeed, may tend toward the negative, although as with A

Passage to India, there may also be recognition that rituals lift the human spirit in transcendent ways.

Ritual public events play key roles in Nikos Kazantzakis's *The Fratricides,*[13] for example, and Kazantzakis seems torn between the power of ritual to inspire and the ineffectiveness of ritual as a force for good.

Death and resurrection—concepts that find expression in many sacred rituals—are central to this novel in the form of passionately held ideas about Christ's death and resurrection and in the form of the Greek ritual through which those events are symbolically enacted in the religious calendar each year. John Cuthbert Lawson gives an ethnographic account of the ritual context central to *The Fratricides,* the vigil and procession of Good Friday, Holy Saturday, and Easter Sunday which he witnessed on Santorini.

On Good Friday night a funeral "drama" is held. A bier is set up at the foot of the altar and the figure of Christ is placed there to lie in state. The people keep a vigil, pray, and sing forlorn chants "as it were in lamentation for the dead god lying" there.[14] The bier is carried out of the church and a procession winds through the town; it is kissed and sprinkled with perfume. The priest and mourners return to the church and place the bier in a sepulchre which the priest alone enters. The mood changes to one of expectancy. At midnight of Holy Saturday the sepulchre doors are reopened and of course the figure, removed by the priest, has disappeared. A new, now joyful procession commences and the people greet each other: "Christ is risen." "He is risen indeed." Lawson comments: "This was no tableau on which they looked, no drama in which they played a part. It was all true, all real."[15] As *The Fratricides* opens, the time for this resurrection ritual is approaching.

Set at the time of the bloody Greek Civil War of 1947, the novel has as its chief protagonist a priest, Father Yanaros, whose village, currently held by the government forces, has been captured and lost several times by communist partisans who daily come down from the hills to fight. Yanaros is depicted as an infinitely strong, deeply Christian man, the only character in the work who is so profoundly distressed by the fratricidal struggle that he is unable to

become caught up in one faction or the other. He is the peacemaker in a violent situation. It is through the priest's memories of ritual that Kazantzakis delineates his personality and emphasizes his greatness of spirit and badly misunderstood love. Though village resurrection rituals, obviously similar to those described by Lawson, animate the current action of the novel, Yanaros was, in his youth, a member of a brotherhood known as the Anastenarides, or "groaners," and he remembers and cherishes their rituals.[16]

The groaners sect originally flourished among the people of Thrace, and when parts of this region were ceded to Bulgaria after the Balkan Wars, many of its members were uprooted and migrated to Greece. The practices of the sect nearly died out, but survived in recent times in some isolated regions of Macedonia, and they have an annual festival. On the eve of the feast the groaners wait in a sort of chapter house where the miraculous icons are kept, until, moved by the spirit, the members jump up to dance to the music of the lyre and bagpipe. On the feast day itself, a bull is sacrificed and then the groaners dance about, holding their icons. A great bed of red-hot coals has been prepared and the participants proceed to dance, walk, and kneel upon this fire in a state of great religious ecstasy and exaltation, clutching the icons all the while. They approach the coals crying out, "Long live Greece," or "Greece will never die."

His memory of these rituals haunts Yanaros as a time of great joy in an irrevocably lost past. Yanaros, who was archgroaner or leader of the sect, has become after years of wandering an exile and a man out of his time. The fire walking symbolizes for him the joys of the spirit he finds lacking in his new people. The fire is associated in his mind with joy, ecstasy, spiritual cleansing, with the whole potential of man for good and with Paradise itself. For him these were rituals that, in Handelman's term, modeled change, transforming the participant.

It is a conception of freedom through love bound up with his associations with fire walking that virtually forces Yanaros to his final action. The total failure of all the other characters to comprehend this concept brings about the ultimate tragedy. Yanaros "betrays" the village to the communists, falsely believing that the Greek brothers

on both sides will unite in love and be free. Of course he is among the first to be executed.

Structurally, Kazantzakis measures the passage of time within the framework of Christ's Passion—that is, within the ritual calendar—and there is a close identification of religion with politics and nationalism. And central to the narrative is the idea of the resurrection, especially as connected to the folk ritual wherein an effigy lies in a bier and is later resurrected by being set upright.

Kazantzakis suggests definite parallels between the divine Passion of Christ which the ritual re-enacts and the political situation. Greece is suffering, Greece is being crucified in the world of Kazantzakis's art. All the characters see the struggle in religious terms, but except for Yanaros they see with a one-sided blindness. For example, two monks wander into the village on separate occasions. One exhorts the government forces to a renewed holy war, whereas the other, just returned from the camp of the rebels up in the hills, declares, "Lenin is the Comforter; God sent Lenin, when wickedness broke out in the world, to prepare the way for Christ" (p. 71).

Only Yanaros is painfully aware of all the complexities of Christ and of Greece and of the intimate relationship between the two, and only Yanaros sees that the ending of the struggle must also be a religious action, symbolically as well as actually. If Greece is being crucified, obviously Greece must be resurrected. It is the idea of the resurrection in his mind, always with the resurrection ceremony as the concretization of this idea in the background, that dictates his subsequent actions. It initially makes him realize that he cannot wait for God to act, but that he must act in the name of God. When the townspeople arrive, expecting the usual ritual, he admonishes them, for he has found a new meaning for the resurrection, at once above and yet associated with the traditional rite. He subsequently refuses to "resurrect" the effigy of the Christ, his refusal tied to this new meaning which makes a sham of the old ritual, unless the meaning of the ritual be internalized in the hearts of men. He has concluded that ritual has lost its power, perhaps only temporarily, to model, to produce genuine spiritual change.

Though he preaches the same to the rebels, he misunderstands what he assumes to be their goodwill:

> Drakos . . . burst into laughter. He turned to his men. "To arms, men! The people have risen!"
> "Truly they have risen, captain," they shouted back, mocking the Easter Resurrection cry, and the hill echoed with their laughter. (p. 207)

And the novel proceeds to its tragic conclusion with Yanaros joyfully anticipating the triumph of the "people" over both factions, and the resurrection of Christ as he conceives it, with the age-old ritual taking on new and meaningful significance. But these are the hopes of one man alone, one who will soon be dead.

Yanaros is inspired by the rituals of his younger days, skeptical of the ritual he is supposed to perform in his present office, and made hopeful by his earlier experience that ritual can still be used to change the world, if that ritual can come to have new, expanded meaning. His participation years before in the fire walking of the Anastenaria group has left him with the memory that ritual can bring about ecstasy and a powerful sense of groupness that can bring about—model, in Handelman's usage—a new spiritual and social sense. Yet when he turns to the resurrection ritual, he finds that he must, in effect, change it by refusing to perform it until a social transformation has taken place, uniting enemies as brothers in resurrection. He has no faith in the power of this ritual itself to model change, while his memories of effective rituals in other days have given him a false sense of the possibility for change in the larger social situation which has brother Greeks killing each other. Kazantzakis, then, though he recognizes the psychic potency of ritual public events to deeply affect the human spirit, implies that they may be impotent in the face of other forces, empty of sufficient meaning for potential participants caught up in other beliefs and more powerful conventions.

Indeed, Kazantzakis stresses this point in his autobiographical *Report to Greco*,[17] where he relates an actual incident. He tells of a priest he knew, or knew of, on Crete. This priest is hurrying about before daybreak on Easter, conducting the resurrection ceremony,

intoning the words, *"Christos anesti* [Christ is risen]." At last he reaches the one remaining hamlet, but there is a difference:

> "Christos anestakas, lads!" he shouts.
>
> The familiar, trite word anesti had suddenly seemed small, cheap, wretched to him; it was incapable of containing the Great News. The word had broadened and proliferated on the priest's lips. Linguistic laws had given way and cracked in the wake of the soul's great impetus, new laws were created, and lo! in creating the new word, this morning, the old Cretan felt for the first time that he was truly resurrecting Christ—all of him, in every inch of his great stature. (pp. 439–440)

In short, we cannot contain the human spirit in the old forms.[18] Ritual public events must often be gone beyond if we are to grow as individuals or as a society. Or perhaps they must be changed to embody new meanings so that they are no longer "empty."

Kazantzakis works with ritual events that are deeply embedded in a profound religious context, coming out of ancient cultural meanings and spiritual traditions centuries old. It is not surprising that when American writers have dealt with ritual public events, those have been from more secular realms and lacking in the sort of spiritual force that lies behind fire walking or rites of resurrection. Nonetheless, these secular ritual events may have profound social importance and can lend themselves to considerations of individual development within the social frameworks where the rituals function as well as consideration of the roles such ritually recurring events play there. Two American novels of the 1960s—Harper Lee's *To Kill a Mockingbird* and Walker Percy's *The Moviegoer*—bring ritual public events to the fore in precisely such ways.

To Kill a Mockingbird[19] was Lee's first novel and over thirty-five years after its publication remains her only novel. It might not be of great interest had it not been a sensational beginning for an author's career. Widely praised, it quickly became a phenomenal best-seller, awarded the Pulitzer Prize.

Like many novels, perhaps many American novels in particular, like *Story of My Life*, it is a coming-of-age tale, a story of a struggle to maturity. The main character and the narrator is Jean Louise Finch, called Scout, six years old as the novel opens. It is principally her route to maturity that the novel chronicles. Her mother is dead; thus she has had no close female guiding force to direct her to a path to maturity socially appropriate to her gender. She lives with her father, Atticus, and her older brother Jem—thus in an immediate environment dominated by males. Much of the humor and some of the pain of the novel stem from Scout's trying to deal with attempts to socialize her as a female as she comes to an age when such gender distinctions are thought to matter by society. The fact that Atticus is, in the view of his children, socially deviant—that is, eccentric—complicates the process as both children grow up in the setting of small-town Alabama in the 1930s, a world which is pictured as simultaneously idyllic and deeply troubled.

The details of Scout's socialization as a maturing female range from the subtle to the highly coordinated. In the early chapters, Jem's statements such as (p. 42) "I swear, Scout, sometimes you act so much like a girl, it's mortifyin'" are indications of the half-conscious awareness that his ultra-tomboy sister is bound to grow up different from himself. Later, as he himself matures and his perspectives change, he yells (p. 117), after an altercation with her, "It's time you started bein' a girl and acting right!" Her revered Uncle Jack takes her to task for using salty language with the admonition (p. 84), "You want to grow up to be a lady, don't you?" In particular her feared Aunt Alexandra is the principal proponent of Scout's growing up correctly female. This proper aunt disapproves of Scout's preferred attire—overalls—and her "vision of my deportment involved playing with small stoves, tea sets, and wearing the Add-a-Pearl necklace she gave me when I was born" (p. 86).

The process of coming of age, however, goes beyond these details of everyday life and is fundamentally centered in the principal conflict of the novel, which comes out of the problematic race relations of the place and time of the novel's setting. Atticus has agreed to defend Tom Robinson, a black man falsely accused of raping a young

white woman, May Ella Ewell, member of a local lower-class family. His dutiful willingness to do so sets much of the community against him. Scout must now deal with her peers' taunts that her father "defends niggers." Worse, she realizes that many of the adults of the community and even some members of the family feel the same way.

It is more than the social pressure that the Finch children feel, however, which works toward their maturation. The course of the Robinson trial itself is a telling and traumatic experience. They witness the attempted, though unsuccessful, lynching of Tom from the county jail. When they go with Calpurnia, their black housekeeper, to attend Sunday services at her church, they at first experience hostility from a member of the congregation who tries to bar their way from attending, asserting that whites have no business in a black church. This experience, of course, brings into focus for them in a powerful new way the racial tensions of the larger community. After they are made welcome by the rest of the congregation, however, they observe how different the church is from their own. The graves in the cemetery are decorated in strange ways with lightning rods and shards of colored glass. The hymns are sung by being "lined" out by a leader because there are no hymnbooks. The preacher uses his sermon to call particular members of the congregation to task. Furthermore, Scout realizes, the beloved Calpurnia has "command of two languages" (p. 128), is able to speak black English as well as the standard English she uses while in the Finch household.[20] These cultural factors all bring home a knowledge that the African Americans of the town live in what is virtually a parallel universe.

The Robinson trial is a particularly difficult and sobering experience for the children. Despite a brilliant defense during which Atticus demonstrates Tom's innocence, the black man is convicted of the crime. After the trial the children endure the death of Tom Robinson—shot while trying to escape from prison in a fit of panic and despair. Then a murderous attack upon them by Bob Ewell, the ne'er-do-well father of Tom's supposed victim, because Atticus's defense exposed the true nature of the situation. The attack is thwarted by Boo Radley, the recluse no one has seen since his boyhood years before.

What Lee establishes throughout the novel, then, is the idea—widely held and widely propounded in modern literature—that people mature as they encounter hard realities, difficult knowledge, traumatic events. Initiation rituals may embody the same underlying idea, for they may include ordeals and the passing on of knowledge that only an adult can handle.[21] The difference, of course, is that the ritual provides for a neat and controlled transfer and transformation. The trials of growing up in the modern world provide a messier, less definitive process.

The ritual public event which actually appears in the course of the novel is, however, not an initiation rite but a historical pageant produced in the high school auditorium in the months after the trial. It comes about as part of an attempt to organize Halloween activities in the wake of a childish prank disturbing to some in the community. Mrs. Grace Merriweather is to organize it and it will be called "Maycomb County: Ad Astra Per Aspera" (that is, "from the mud to the stars").

A new and apparently one-time event, the pageant can nonetheless be seen within the national tradition of historical pageantry which captured the attention of countless American towns between the turn of the twentieth century and World War II. This craze for historical pageantry was in decline by the 1930s, the period of the novel, but the form would have been well known by then and was by no means moribund. The precise format of Maycomb's pageant is not clear, for the account of it the reader receives comes from Scout, who is waiting backstage to play a ham in a segment devoted to local products and who falls asleep and does not see the actual performance. From what she does tell us, however, the pageant seems similar in character to those reported on by David Glassberg in his study of this cultural phenomenon[22]—though actual pageants were more commonly daytime, outdoor affairs, while that in the novel takes place at night, inside a public building. That is, costumed citizens take part in *tableaux vivants* depicting important phases of local history. We get a description of Maycomb citizens in costumes related to several historical periods, and Mrs. Merriweather is droning on about the exploits of the town founder when Scout dozes off. Scout finally wakes up—whether because she hears Mrs. Merriweather repeatedly calling her cue or

because the band has struck up "Dixie" she is not sure—and makes her entrance late at an inappropriate moment, causing much laughter from the audience. As she and Jem return home from the pageant in the darkness, Bob Ewell makes his attack.

Historical pageants had a variety of purposes and multiple meanings depending in part on the differing perspectives of those who produced and attended them. In part the pageants came out of progressive movements, notably those which sought to provide playgrounds and recreation for children and to promote healthy leisure activities. Leaders of the pageant movement saw them as having considerable educational and civic value, as socially and morally useful forms of expression. In reality they often did not work to fulfill such high ideals. Many people who attended or even participated in them probably saw the pageants as little more than a form of entertainment not so different from forms of commercially produced theatrical spectacle. More tellingly, the pageants in actuality served narrow ends. They might be viewed by local leaders as merely a kind of boosterism. Often they were controlled by local elites who mostly sought to express a sense of their own particular social significance and power. The visions the pageants presented of place—and, indeed, as in Maycomb, the pageants most commonly focused upon place ("the place is the hero," says Glassberg[23])—was one which upheld conventional social roles and the status quo, ignored or downplayed the positions of certain groups within the community, and emphasized "Anglo-centric and hierarchical" perspectives. Indeed, one of the first impulses toward pageantry came out of a desire on the part of established, native-born Anglo-Saxons to assert their connection with Elizabethan England, hence the early incorporation of morris dances and maypoles into pageants. Nonwhites were seldom included as participants or as parts of the story—except for Native Americans, who were depicted as there to come in contact with early white settlers. Ethnic and class conflicts were conspicuous only in their absence, only conflict between "humankind and nature" being recognized.

Although Scout's perspective on the Maycomb pageant provides the reader with a limited impression of it, Lee is surely presenting it in terms of historical pageantry's negative possibilities. It

begins with Mrs. Merriweather's "chant[ing] mournfully" (p. 260) about the exploits of Maycomb's founding father, apparently goes through various war tableaus, and winds up with the exposition of the county's products of which Scout plays one. Lee is suggesting the shallowness of vision behind this ritual public event. The community has just undergone another event—the Robinson trial, in its way a "ritual"—which exposed for the children (and anyone else who cared to look) the deepest division of the community, that centering on race, along with the extreme injustice and social blindness that go along with it. Yet when the community elects to present itself, it looks elsewhere for its collective images—to a founder's distant exploits, to conflicts that pitted a united Maycomb against outsiders, to innocuous pork, pine trees, and butterbeans. Though Scout is never explicit on this, we assume that African Americans have no role in the pageant (as, indeed, they almost never played a role in the real counterparts of this fictional event), and certainly race is in no way fit subject matter for the pageant. Though Mrs. Merriweather may think Maycomb has gone to the stars, Lee implies that the place is still in the mud, though the pageant means to say otherwise.

In Handelman's terms, the Maycomb pageant merely mirrors the place ritually, merely gives it a picture of itself, as the white elite would have it. What is needed, of course, is transforming ritual that might model the place into transition to something better. Historically, some leaders in the pageant movement saw the pageants as transformative, as something like communal rites of passage which could refocus a town's attention and sense of purpose and carry it into a new era. Whether or not such transitions ever occurred when real historical pageants were performed, they clearly do not in Maycomb, despite taking place on Halloween, a time of transitions and changes. Lee implies that the ritual, which does sum up the town's reality, however imperfectly, fails and is hence empty. It is the wrong kind of ritual, and this place has no other. Its failure symbolizes the larger social failure that is the novel's subject.

Yet the action following the pageant, Ewell's attack, can be seen as a culmination of Scout's process of maturation. It is her final difficult and traumatic encounter. But in fact Lee actually draws this life encounter in ways at least suggestive both of a rite of passage and

of the closely related pattern of the traditional hero's journey and transformation, as schematized, for example, by Joseph Campbell.[24] Scout speaks of these events as "our longest *journey* together" (p. 256; emphasis added). She is wearing a special costume. What happens is an ordeal taking place in utter darkness. There is a death—Ewell's real, not symbolic one. The closeness of the supernatural world is suggested by the "haints" the children half imagine are haunting the darkness and by the Halloween setting, which is also indicative of liminality and passage.[25] The spirit world is also evoked by the timely intervention of Boo Radley, whose name suggests his ghostliness as, up to this point, an unseen presence who as a recluse has haunted the landscape of Scout's childhood. As the person who actually thwarts the murderous Ewell, he also plays the traditional role of the helper of the hero on his journey. His own emergence as an adult into a world he disappeared from as an adolescent suggests his own growing up, mirroring Scout's passage. Her behavior after the attack solidifies the reader's sense that she has reached a new level of maturity. After first calling him "Boo," she addresses him as "Mr. Arthur" and treats him graciously, almost like a young woman with a gentleman caller, behavior which suggests that, vis à vis gender roles, she has become something of what Aunt Alexandra and society want her to become, yet on her own terms.

Of course Scout's passage might have been smoother if her society had an actual, formalized rite of passage. But of course it is not Harper Lee's point that American society needs some initiation rites. Her point is that insofar as ritual performances only mirror society, they merely replicate that society's pitfalls and evils. They cannot model needed social change. In Lee's vision the South needs waking up—Scout awakens, after all, to the strains of "Dixie." Its people are dimly aware of some need for change—Scout's untimely appearance at the wrong moment in the pageant, disrupting it in a small way, causes amusement among onlookers, who at some level sense the staleness and pomposity of the pageant and hence of their communal ways. The ritual overtones of the children's ordeal in the darkness, holding the possibilities of ritual transformation—of modeling— make the pageant's possibilities seem all the more dismal and doomed, an "empty" performance displaying only limited truths that

cannot be gone beyond. Bakhtin speaks of how in the world of Rabelais, the banquet was where truth could be spoken: "Prandial speech is free and jocular speech. The popular-festive right of laughter and clowneries, the right to be frank was extended to the table. . . . The banquet . . . was the most favorable milieu for . . . absolutely fearless and gay truth." The Maycomb pageant is in fact an anti-banquet, a social gathering of the community where no one eats, where food is paraded before the group in the form of local produce but is never devoured. Its inability to evoke truth is thus heightened. Yet Bakhtin also argues that because labor and food "represented . . . the struggle of men against the world, ending in victory," banquets also evoke "life, death, struggle, triumph and regeneration."[26] Certainly what Scout undergoes in the darkness is struggle involving life and death, and she ultimately triumphs by surviving and undergoes regeneration into a new life phase. Lee presents the actual ritual public event in the novel as wanting force, yet she seems to hold out the possibility that the correct rituals — if they existed — might be powerful.

Despite its violence and concern with racial hatred, *To Kill a Mockingbird* is a sweet novel, even a rather sentimental one. Its vision of childhood progressing into maturity under the guiding hand of an extraordinary adult creates ultimately a reassuring tone, and the narrative ends on a note of definite resolution. More ambiguous in its conclusions, more spare in its emotions, and more revealing of the complexities of the human experience is another novel, a virtual contemporary of Lee's book, which nonetheless also has ritual public events at the heart of its main character's progress through the world: Walker Percy's *The Moviegoer*. Percy's first novel, *The Moviegoer* originally appeared in 1961,[27] and it received comparatively little notice at the time. Although the book was accorded favorable critical attention, Percy's publisher Alfred Knopf personally rather disliked this novel his editors had accepted, and his firm provided virtually no publicity or promotion for it. When *The Moviegoer* won the National Book Award in 1962 many were surprised; Percy's novel was still little known.

Part of the reason for its initial lack of popularity was its spare and introspective philosophical tone, and throughout his subsequent,

acclaimed career Percy—who had mostly published essays in professional journals of philosophy prior to his first fiction—came to be viewed as a writer whose work was suffused with the ideas of the existentialists, including Kierkegaard, Heidegger, and Gabriel Marcel. Though born in Mississippi of ancient Mississippi lineage and living in Louisiana, here was one Southern writer whose novels seemed imbued with European intellectualism, whose characters worked out the obscure concepts of Scandinavian and French thinkers. Thus he might be seen at first glance as a writer in whose work folklore would not find a prominent place. Yet such is hardly the case with *The Moviegoer*, though folklore's importance there has gone unrecognized.

The Moviegoer focuses upon the life passage made by its chief character and narrator, John Bickerson "Binx" Bolling, over the course of nine days—the present action of the novel except for an epilogue which moves to a year later—though also in a sense over the course of his thirty years. During these nine days he undergoes a profound change in his being, though what actually happens to him in terms of his outer life, in contrast to what happens to Lee's child characters, may not seem particularly dramatic. Because of Percy's grounding in existentialist philosophy, Binx's journey has been described by critics in philosophical terms, calling it, for example, a progression through aesthetic to ethical and then religious life stages.[28] Whatever terminology we prefer, Binx does undergo a personal transformation, becoming by the end of the novel a person very different from the one he was at the beginning.

Binx frequently speaks about his sense of detachment from the world through which he moves—the world in both the larger sense of "reality" and in the more limited sense of his immediate environment, New Orleans, where he works as a broker in a firm owned by his Uncle Jules Cutrer and where he both participates in and avoids the milieus of his genteel relations.

As the novel opens, Binx is realizing the depths of his alienation and envisioning the possibility of undertaking a "search." He wants meaning in his life and to find some sense of identity to mark that he is not a "no one." That identity is important to him is suggested by

the almost loving care he takes with his personal identification papers, but these papers merely underscore that he does not know who he is beyond the lost modern man who despairs despite—or because of— his comforts and possessions and material success and family connections. Not that he is unthoughtful, for he constantly muses upon his situation. Nor is he a couch potato, for we learn much about his travels around New Orleans and vicinity, his energetic if unsatisfying love life, and other activities as well. Yet these diversions which have kept him from the fullest despair have also kept him from undertaking his search. They constitute a kind of pseudo-search enabling him to use philosophical concepts—like "rotation" and "repetition," borrowed from existentialism—to characterize his own actions while avoiding what he really needs.

This avoidance is most evident in the obsessive central activity of his life, that which provides the book's title and a metaphor for Binx's state of being: moviegoing. Not only does he constantly attend movies and analyze them and talk about them, he has made moviegoing into practically an art form. Movies even provide "certification," he says; provide, when they show some actual place known to a viewer, a heightened sense of reality; confer a meaning upon that place otherwise lacking in the world beyond the filmed image, though this certification is fleeting. Binx's moviegoing puts into bold relief the truth that he is an observer of life who cannot make real contact with others.

Binx's transformation comes about through his interaction with two women: his aunt Emily Cutrer, his father's last surviving sibling, and her stepdaughter, Kate. Aunt Emily has been his surrogate mother, his own having remarried after his father died and gone home to Mississippi to raise Binx's younger half-siblings. It has been Aunt Emily who has proposed to him over the years a system of values and who stimulated his once-active interest in the life of the mind. She is dismayed by his ordinary life and thinks he should seek greatness, preferably in some sort of vaguely conceived research, though research would, of course, consign Binx still further to the observer's role. She tells him she wants to have a talk with him just after his thirtieth birthday the next week to discuss his future plans.

Binx and twenty-five-year-old Kate have known each other for years and serve as each others' sometimes prickly confidants. She shares in his sense of despair, though in her case there has been a real retreat to emotional instability, pills, alcohol, and regular visits to her psychiatrist. She has better and worse periods of existence and as the novel opens, her stepmother enlists Binx's aid in helping Kate.

Then he is ordered to Chicago to attend an industry convention. At the last minute Kate invites herself along. As they ride through the night aboard an Illinois Central sleeper car, Binx realizes again how his search suddenly has deeply disturbed his ordinary life—which he had constructed to hide his need for a search and his potential for despair—plunging him into malaise. Kate displays her own manic desperation, and her tone of voice causes Binx to be concerned for her state of mind. They speak of various things including suicide and marriage to each other, Kate suggesting that marriage for Binx could be only one more of his "researches," implying she knows that even then he would be the observer. She announces that she could live satisfactorily if she could believe in someone—including Binx—who would tell her what to do, like a directing deity. Then they drift into fumbling and unsatisfactory sex in Binx's roomette.

Chicago turns out to be angst-ridden, but they leave prematurely because they are summoned home by Aunt Emily. Kate had never told her family she was going with Binx, and her apparent disappearance had caused great worry in New Orleans. Aunt Emily blames Binx. The pair return south on a bus, encountering among other passengers a young romantic who thinks he's on his way to New Orleans to spend a little time loading banana boats before shipping out on a freighter. Binx calls him a moviegoer who does not go to movies, indicating an awareness that his own moviegoing is a form of passive escapism.

He has his planned meeting with Aunt Emily but instead of discussing his future plans, she berates him for what she regards as irresponsible behavior. He is too cowed or malaise-filled to even mention that he and Kate have been edging toward marriage, though in the next few days he and Kate agree finally on just that, and he

announces that he will attend medical school—if only because he thinks his aunt wants that.

This would not seem to be much of a personal transformation in modern terms—more like the formulaic marriage that signals the happily-ever-after in fairytales—but it is more complicated than we have made it seem. Earlier in the narrative Kate has announced her discovery that she is free to act, one of the great existentialist truths. Neither she nor Binx has discovered the concomitant truth of accepting responsibility. But by the end Binx has. He accepts responsibility for Kate in becoming the someone who will take her completely in his care. In the epilogue, in fact, we find him giving her meticulous instructions on how to get to downtown New Orleans on the streetcar to do some errand, cutting through her childish fears and hesitations to assist her in finding her own strength. And his sense of responsibility is more general. Earlier he decided: "There is only one thing I can do: listen to people, see how they stick themselves into the world, hand them along a ways in their dark journey and be handed along, and for good and selfish reasons. It only remains to decide whether this vocation is best pursued in a service station or—" (p. 233). His thoughts break off, but we understand that he has begun to reattach himself to others.

But what mechanisms trigger this great if low-key and tentative change in Binx, apparently bringing him out of alienation and despair? Martin Luschei has said that *The Moviegoer* "is a highly elliptical novel, with key elements implied or omitted,"[29] and indeed what propels Binx's transformation may be difficult to pin down precisely. William Rodney Allen argues that it is Binx's rediscovery of his deceased father and a growing sense of who his father was which gives Binx his own sense of identity and thus changes him. Luschei emphasizes that it is a "leap of faith," though one for which Binx has laid the foundations.[30] We would like to suggest that it is this crucial aspect of the novel to which a consideration of folklore brings significant understandings.

The first important folkloric element is one which runs through the novel and which involves a public ritual event: New Orleans's famed annual celebration, Carnival (or, as it is more popularly called,

Mardi Gras). It first appears early on. Fresh from following a movie star around the French Quarter, Binx emerges into the Crescent City's principal downtown shopping street "a week before Mardi Gras" and encounters a parade, one of many which fill the Carnival season. Far from feeling lighthearted in the Carnival spirit, he finds that the street produces only "a fog of uneasiness" (pp. 17–18) for him. At a family lunch a little later Jules Cutrer and Kate's fiancé-of-the-moment try to persuade him to "ride Neptune," that is, to take part in the parade of his own Mardi Gras club. But he has no interest, though the fiancé—an esteemed old friend—takes him aside to extol the excellence of the club and its members. Aunt Emily "looks at me in disgust—with all her joking, she has a solid respect for the Carnival krewes, for their usefulness in business and social life" (p. 32).

As the novel winds toward its climax, Mardi Gras is a constant if understated presence. There is ongoing discussion as to whether Binx will take Kate to a business partner's house to view the Neptune parade. Kate says she will not attend the group's ball, though her fiancé is captain (though she finally decides to attend a supper for former queens, of whom she is one). Binx comments on the slowdown of business as Mardi Gras day approaches, discusses the weather outlook for the day with a newspaper vendor, tells us about the Mardi Gras organizations his business associates belong to, reports on the speculation about who will be king and queen of Neptune this year. Binx and Kate do go to the Neptune parade but wait only long enough to see its "vanguard" of black flambeau carriers, pointedly leaving before Kate's fiancé rides up to where she and Binx stand. It is from the queen's supper that Kate leaves to ride to Chicago with Binx. She has "made up her eyes with a sparkle of mascara" as a "celebration of Mardi Gras" (p. 184), and he offers her his "Mardi Gras bottle" in the roomette. They return to New Orleans on the bus because they cannot get plane reservations in the Mardi Gras rush, finally arriving back in New Orleans just as Mardi Gras night has come to an end, street cleaners pushing the debris of the celebration with their brooms.

A reader might take all this Mardi Gras as simply local color and cultural background, as elements convenient to plot development.

However, Mardi Gras in fact plays an important symbolic role here, and Percy's choosing to set his story precisely in accord with the timing of this ritual season seems a deliberate and significant decision. To understand that, we need to understand something about the centrality of Carnival to New Orleans life and particularly to those of Binx's class.[31]

For New Orleans, Mardi Gras serves as a symbol of collective identity, an expression of local identity to outsiders, a magnet for drawing tourism dollars, a focus for various forms of celebration, and a nexus not only for socializing but for the maintenance of social and economic networks. Munro Edmonson has commented that from "an examination of the Mardi Gras festivities . . . we may infer a great deal about New Orleans's view of itself as a city," an idea seconded by David Draper, who says "the Mardi Gras season, as a ritualistic drama, provides a public statement of the social structure of New Orleans."[32] Local T-shirts offer Mardi Gras motifs; city litter cans use Carnival phraseology to discourage littering. Vast numbers of New Orleanians participate in Mardi Gras in one way or another—if not as members of an old-line krewe, such as Binx belongs to, then as members of a walking club like the Jefferson City Buzzards,[33] as a rider on one of the truck floats launched by family and neighborhood groups, as someone who costumes in the street on Fat Tuesday itself, or simply as someone who attends parades or who parties. People look ahead to upcoming Carnival—participating in the king cake culinary tradition which leads up to the height of the season[34]—and look back on past Carnivals by collecting various forms of memorabilia. An industry of float builders and artists, mask makers, and costume sellers maintains Carnival activity throughout the year. Krewe officers begin planning the next Carnival virtually the day after Mardi Gras.

As Handelman implies, carnivalesque events commonly invert the usual social order in some way, but it is not this aspect of Mardi Gras that is relevant to Percy's novel but rather how social class relates to the structure of New Orleans Carnival—that is, to the social realities behind whatever inversions take place. New Orleanians are generally aware that kinds of participation in Mardi Gras relate to power and status and presume that certain Carnival organizations play a role

in interconnecting local elites. Historically the principal krewes had members drawn from the upper classes, and the balls are highlights of the social season. This is to say that for Binx Bolling's class, Carnival has particular importance and involves its members in a particularly close participation. Indeed though some residents of New Orleans, for various reasons, ignore Mardi Gras or actually try to leave during its enactment,[35] mass participation, often intense, is the general rule.

Binx tells us a lot about his feelings of detachment, yet neither the reader nor the other characters see much of this alienation made manifest. To outward appearances Binx leads a quiet but normal life of the 1950s. In Binx's relationship to Carnival, however, Percy makes his narrator's detachment visible, though this strategy may be lost on readers unaware of the role Mardi Gras has in Binx's local culture. It is through his extreme nonparticipation—his indifference toward his krewe, his desultory parade attendance—in a ritual public event that so thoroughly absorbs the others who inhabit his world that Percy concretizes his character's being so cut off from his place and time, so tenuously attached to existence.

Though ritual public events are collective endeavors, working to absorb individuals into the community enactment, they sometimes fail to do so. This may be because individuals find them inadequate for one reason or another, and writers as diverse as Kazantzakis and Harper Lee have produced novels implying that ritual forms may be too stereotypical and empty of meaning for some people. Certainly Mardi Gras seems empty for Binx and stands as a compelling instance of the failure of a folk tradition to tie an individual to his group or to a meaningful life.

Interestingly, however, Percy also uses folk tradition to signal Binx's tentative re-attachment to others. This occurs during his painful conversation with Aunt Emily on his thirtieth birthday. Significantly, this takes place on Ash Wednesday, the day after Mardi Gras.

What Emily Cutrer (viewed with some lack of sympathy by commentators on the novel) has offered Binx during their long relationship has been the role of honorable Southern gentleman who leaves the world a little better than he found it. "I did my best for you, son,"

she tells him. "More than anything I wanted to pass on to you the one heritage of the men of our family, a certain quality of spirit, a gaiety, a sense of duty, a nobility worn lightly, a sweetness, a gentleness with women—the only good things the South ever had and the only things that really matter in life." She says that people of their class "do not shirk our obligations either to ourselves or to others. We do not whine. We do not organize a minority group and blackmail the government. We do not prize mediocrity for mediocrity's sake" (p. 224).

Though Luschei allows that Aunt Emily's "virtues are admirable," he feels that she addresses the outward forms of life, notably only the forms of "the white Southern aristocracy," when Binx needs "his own decisive act" in order to change. For William Rodney Allen she provides Binx only with "an evasion." For Mary Deems Howland she offers only "stoicism combined with a romantic nostalgia for the bygone days," for Max Webb a "melodramatic historical myth." Janet Hobbs claims that she "inflates" the value of existence, never getting out of an aesthetic vision of life.[36] These critics all suggest that though she offers some sort of values, she cannot give Binx what he can find only in himself, the sense of responsibility he finally realizes by assuming complete care of Kate.

While she and Binx talk, however, a sound from outside the closed world of her servant-staffed, Garden District house seeps through to Binx's hearing. It is a street cry yelled by a black chimney sweep who calls out in French, "R-r-r-ramonez la cheminée du haut en bas"—that is, Sweep your chimney from top to bottom. Emily has seen the man first, before his cry, and she points out the window to ridicule him as "your prize exhibit for the progress of the human race" (p. 224). Binx finally sees him, recognizing the man as "Cothard, the last of the chimney sweeps," describing him as dressed in a "frock-coat" and top hat, noting that he carries broom straw and bundles of palmetto leaves as his tools. He is dressed, thus, like old-time, traditional sweeps in formal attire, like sweeps in England as well as the United States, though his use of palmetto fronds as one of his tools marks his location in the Gulf South.

Sweeps have been seen as colorful figures, their image and their cries incorporated into the literature and art of street characters, in

New Orleans and elsewhere. *Gumbo Ya-Ya,* the Louisiana folklore collection discussed in chapter 3, speaks of them and includes a photograph of two of them from the 1930s. Indeed, Percy may have taken the cry from the book[37] — one of the characters in *The Moviegoer* has even written a book called *Yambilaya Ya Ya.* Yet Percy's use of the cry is no more a touch of local color than is his close tracking of Mardi Gras in developing his plot. That he should have chosen a sweep is, of course, tied to the time frame of Ash Wednesday, when the Catholic community is concerned with the symbolic use of ashes for religious reasons, and Martin Luschei notes how the cry obviously suggests Binx's need to clean himself out from top to bottom in order to effect his transformation.[38]

But in and of itself a street cry is, as an aspect of tradition, as a verbal performance designated for a public sphere and purpose, a communal thing. As Percy has used Binx's avoidance of Mardi Gras as communal festival event to mark his character's detachment from the responsibilities for others inherent in a community, in the end he uses the street cry as a communal coda to signal a re-attachment soon to come, for it signals the sense of responsibility Binx is about to discover in himself. It is a message called from the outside, public world into a shuttered, interior one — the Cutrer household and Binx's own isolated self. Binx's comment that this is "the last of the chimney sweeps" (p. 226) echoes nostalgic assertions about the imminent demise of a tradition, but here Percy also suggests that Emily Cutrer herself is the last of an era, a line, a tradition.

Yet it is Aunt Emily who is, in fact, the catalyst for Binx's change and the one who shows his way — or at least part of his way — and the sudden, incongruous appearance of a folk performer outside the house is hence a particularly appropriate touch. Emily Cutrer's values may be inadequate and too old-fashioned and class-ridden for the modern age. They may not as such offer Binx what he needs to progress to. Yet she very strongly stresses the need for responsibility, the very quality which does bring Binx to his new sense of self. She begins her talk with him by accusing him of failing to be responsible, of acting as though "finding oneself in one of life's critical situations . . . one may simply default. Pass. Do as one pleases, shrug, turn on

one's heel and leave. Exit" (p. 220). Though some of her rhetoric seems disturbingly narrow, her message is still one of the need to accept responsibility for oneself. Her very anger arises out of her feeling that Binx has been irresponsible in taking Kate away to Chicago.

Finally, just as the *ramoneur* gives another cry and then "is gone," Emily challenges her nephew: "What do you live by?" she asks (p. 226), implying that his values, if any, are shallow. Soon after, though he does so haphazardly, Binx reaffirms his engagement to Kate, demonstrating a new sense of responsibility that he has—in a crisis of sorts—plucked out of what Emily has said to him and what he remembers of what she refers to about past talks, relationships, and ideas. It is not a sudden existential revelation coming out of nowhere. She has recalled for him a tradition, that of the Southern aristocracy. Though he has no interest in being the dashing Southern gentleman she wants him to be, though he may have deconstructed any sense of being that if he ever thought he could, he is nonetheless able to reach into that tradition and extract what he does need to finally transform himself. Then that tradition is gone, like the sweep and the sweep's cry—a folk tradition also at the end of its days—and Binx need be haunted by it no longer.

As writers, Percy and Lee and Kazantzakis deal with a diversity of ritual public events, ranging from the profoundly sacred and ancient to the profane and newly invented. Though their approaches and attitudes to ritual vary, all are concerned with how their public events relate to a community (something they share with the painter Rivera) and how they affect particular individuals who could be transformed by ritual acts.

Percy's rituals of Mardi Gras fail a thoughtful individual, the main character, and do not provide the transformative power that he needs to make the transition to new man, responsible in and for his actions. Carnival events, after all, merely re-present society to provide temporary changes which playfully mask realities only to bring them into bolder relief. Such inversions do hold the potential for change in their displaying, however temporarily and lucidly, other social possibilities, but Binx ignores Carnival and whatever possibilities it may

hold for suggesting change. When he finds his way to a new self, it is through his interaction with individuals, Aunt Emily and Kate, though this process does ultimately involve Binx's integration into the community, something which Percy marks by the sudden appearance of the *ramoneur* with his traditional street cry.

Percy leaves us with no definite sense of his vision for ritual. Certainly ritual events do nothing for Binx, though whether this is because Binx, in his alienation, chooses to ignore whatever possibilities may lie there or because Mardi Gras—and by extension other ritual events in the modern world—ultimately is too conventional and too wound up in reflecting the status-quo power structure is unclear. His primary interest, of course, is in using Mardi Gras and Binx's disinterest in it to signal his narrator's alienation.

Lee is more fixed upon showing the failure of ritual public events, bringing into her narrative what is admittedly a kind of event which seems outdated. In many ways the novel is about the failure of community values which allow great injustice to transpire and smallness of mind to prevail. The community's historical pageant is literally a depiction of the community's self-image and, as such, gives the community only what it wants to see, not what it needs to be a better place. A ritual which models is what is needed, Lee suggests, but a ritual event which merely presents is what the town winds up with. Insofar as the book's main character *is*, unlike the community, transformed into something new, Lee is concerned with successful change. And insofar as the traumatic event which plays such a crucial part in Scout's coming of age—the attack by Bob Ewell—suggests elements of an actual initiation ritual, Lee is proposing that effectual rituals are possible (and had they existed in 1930s Alabama they might even have taken the community to Bakhtin's banquet of truth).

Kazantzakis takes us into an ancient spiritual tradition where we might expect to encounter rituals which produce magical results of some sort, but here the view of ritual events is mixed. Concerned with the "resurrection" of the human spirit, Kazantzakis distrusts the power of ritual to lift us above the status quo. His rites of resurrection never take place because they lack power in the face of other potent forces which easily compromise them. Yet the rites of the fire walkers were

infused with some transcendent power that did move human hearts
to a glorious experience (though, indeed, an experience which has,
with disastrous consequences, misled Yanaros into expecting miracu-
lous transformation later in his life).

Much in these novels, then, suggests the inevitable failure of
ritual to truly move modern humanity to a greater spirituality or the
betterment of the group (and is thus at variance with Forster's use of
the Krishna birth ritual and with Rivera's depictions of communal
closeness through rituals which offers the possibility of social
change). Yet in hoping for human transformation Kazantzakis holds
out the possibility for ecstatic transformation, and Lee wishes for the
right rituals in the face of the wrong (even suggesting that her char-
acter's traumatic experience is like one). If Percy's character is trans-
formed by something other than ritual, we must admit that he has
shut the ritual events out of his life very deliberately, and his final
growth is marked by folk if not ritual forms. The possibilities of ritual
power, if dormant, do remain as though the authors cannot really dis-
miss them from their minds, while Rivera's fresco rituals stand as a
reminder that another twentieth-century artist expresses belief in the
beauty of ritual public events and their ability to bind people
together and move them to progress.

6

The Threads of Tradition

Quilts as Multivalent Symbols

Proverbs and ritual public events represent two of the three large areas within which particular folklore genres communicate, the oral and the customary.* The third area is that of material folk culture, which includes a wide variety of artistic and utilitarian objects—ranging, in the American context, from mourning pictures and cigar store figures to split-rail fences and carpenter's planes—and the methods and communal standards used to produce those objects that themselves come down via folkloric processes. Generally speaking, oral folklore as re-situated in literature has received the most attention from commentators. Yet folk art, folk crafts, and the more amorphous folklife[1] appear in literature in abundance. This chapter looks at one genre of folk art especially important in North America, the quilt.[2]

As a traditional folk art form, the quilt had become widely recognized and appreciated in the late twentieth century. Popularly collected—sometimes at considerable monetary expenditure—intensively researched, and frequently exhibited, quilts are the product of a process of creation learned traditionally (at least historically speaking) particularly by women, who in Western society have been the practitioners of the domestic needle arts. The techniques of making these bed coverings, as well as the structures and names of traditional

*Susan Roach is a co-author of this chapter.

patterns, have been passed on by folkloric means for generations. Although not originating in the United States, quilt-making especially flourished in America, and an association with the American heritage as well as widespread positive response to quilts' colorful patterns, bold designs, and salvage ethic were responsible in part for the growth in popularity of quilts in the twentieth century (after a decline in the making and use of quilts when cheap commercial alternatives became more available late in the nineteenth century).

Given the prominence historically of quilts as an aspect of everyday life and a medium of artistic expression, it is hardly surprising that quilts should appear in the lifeworlds of a number of literary works, especially in those written by women and evoking women's concerns. A survey of some of them—novels and short stories—is highly indicative of the appreciation of a folk art form as a multivalent symbol and provides insight into the complexity of the quilt as a cultural symbol, particularly though not exclusively in the woman's sphere. This chapter is, then, in part an overview that looks briefly at a number of literary works—largely prose fiction—which re-situate quilts and quilting in a variety of ways, though more detailed attention is given to several recent novels.[3]

A literary interest in quilting begins early (in this chapter, we begin by considering one nineteenth-century literary precursor) and has been relatively sustained up to the end of the twentieth century. Novelists Harriet Beecher Stowe and Julia Peterkin both develop chapters of their respective novels, *The Minister's Wooing* (1859) and *Black April* (1927) around the quilting bee, describing the women's language and customs of this event. Eliza Calvert Hall's novel *Aunt Jane of Kentucky* (1907) also devotes a chapter to quilts, "Aunt Jane's Album," which focuses on the folk artifact as a means of evoking family memories. Similarly, much later, Alice Walker's "Everyday Use" shows the quilt as a scrapbook of family history and a symbol of tradition. Two other short stories, Susan Glaspell's "A Jury of Her Peers" and Sylvia Townsend Warner's "A Widow's Quilt" focus on the individual quilt maker's making of a quilt, which serves to hide important evidence of criminal acts or thoughts. In the late twentieth century Whitney Otto's *How to Make an American Quilt* brings

quilts and quilting to the absolute center of a widely read novel (also made into a film), while Anne Tyler's A *Patchwork Planet* foregrounds quilting in its title, and Barbara Michaels's A *Stitch in Time* uses as its title a play on part of a proverb and relates an odd story of evil passed down in a quilt. Evil also inheres in a quilt in *Stigmata*, by Phyllis Alesia Perry. Beyond the U.S. context, Margaret Atwood uses quilts and quilting in her exquisitely complex *Alias Grace* (Warner of course also being a non-American author). This fiction gives insight into how folk art provides a challenging and complex trope for literary narrative.

Approaching at least some of these works with a feminist perspective—which seems appropriate, given both the nature of the folklore and the identity of the writers—illuminates the complexities of this special women's craft and reveals the multivalent qualities of quilting and the quilt. Within the lifeworlds of these fictions, the language of quilt making and the quilt itself allow the women characters to disclose private information about the female domestic sphere to other women who are members of this world—and bounded out of the male world. Yet the quilt also hides information from those outside this sphere, thus bounding the domestic sphere from the outsider (men or those women outside tradition).

Catherine Stimpson, in the introduction to *Feminist Issues in Literary Scholarship*, states: "Men, as men, have controlled history, politics, culture. . . . In so doing, men have relegated women, as women, to the margins of culture, if not to silence and invisibility . . . [but] women, if choked, have still spoken. For women, if on the borders of culture, have still smuggled messages past the border sentries."[4] In a number of the literary works discussed here, quilt making, a women's art, is one means of speaking; the quilt and the language of quilt making are a special women's expressive communication.

Feminist writer Barbara Du Bois stresses the importance of feminist social science scholarship addressing women's issues and experiences in their own terms in order to create theory grounded in the actual experience and language of women. She continues that "to see, name, and describe the experience and realities of women," we must see it "complexly, contextually," and "within its matrix,"

which "includes the knower."[5] Thus to understand the complexities of a women's art such as quilting, we must look to women themselves to explain what the quilt says. If quilts and quilting are a mode of women's communication, the ability to understand this "language" here also determines the boundaries of the sphere in which it is "spoken," and quilts in fiction do indeed serve to demarcate boundaries. This function can be seen in literary works through quilts themselves and through the processes by which quilts are made.

One possible step of the quilting process, the quilting bee—that is, communal quilting, a common work method in the nineteenth century, less common today among traditional quilters—is portrayed quite early by Harriet Beecher Stowe in *The Minister's Wooing*, her 1859 novel of manners.[6] Here the quilting serves as a rite to create a quilt for Mary Scudder and her minister husband-to-be to use after marriage. The making of the quilt thus serves as a boundary over which the single girl must cross to become a married woman. The quilting bee is arranged with great care by the town seamstress Miss Prissy. The quilting brings women together and serves as a bonding rite for women, yet at the same time it validates the woman's approaching marriage and gives cover for the marriage bed. Stowe captures the importance and complexity of this process in her description of the preparations for the quilting bee and the quilting:

> The quilting was in those days considered the most
> solemn and important recognition of a betrothal. . . .
> The good wives of New England, impressed with that
> thrifty orthodoxy of economy which forbids to waste the
> merest trifle, had a habit of saving every scrap clipped
> out in the fashioning of household garments, and these
> they cut into fanciful patterns, and constructed of them
> rainbow shapes and quaint traceries, the arrangement
> of which became one of their few fine arts. . . .
> When a wedding was forthcoming there was a
> solemn review of the stores of beauty and utility thus
> provided, and the patchwork-spread best worthy of

such distinction was chosen for the quilting. Thereto, duly summoned, trooped all intimate female friends of the bride, old and young; and the quilt being spread on a frame, and wadded with cotton. Each vied with the others in the delicacy of the quilting she could put upon it. For the quilting also was a fine art, and had its delicacies and nice points, which the grave elderly matrons discussed with judicious care. (pp. 244, 245)

Stowe makes sure the reader understands that men are not welcome at this private women's event until after the end of the quilting, nor are the men capable of sharing the special knowledge of quilting: "The quilting generally began at an early hour in the afternoon, and ended at dark with a great supper and general jubilee, at which that ignorant and incapable sex which could not quilt was allowed to appear . . ." (p. 245).

In addition to her description of the quilting, Stowe comments on how quilt piecing[7] itself is a symbol of women's mastery of the domestic sphere:

Collections of these tiny fragments were always ready to fill an hour when there was nothing else to do; and as the maiden chattered with her beau, her busy flying needle stitched together those pretty bits which, little in themselves, were destined by gradual unions and accretions, to bring about at last substantial beauty, warmth, and comfort—emblems thus of that household life which is to be brought to stability and beauty by reverent economy in husbanding and tact in arranging the little useful and agreeable morsels of daily existence. (pp. 244–245)

Thus the quilting process also tells of women's roles in domestic life: the economic, aesthetic duties of arranging daily life for one's family.

Julia Peterkin's novel *Black April*,[8] a depiction of the plantation life led by Gullah blacks in South Carolina, also details a quilting, though of a different nature, in one of its chapters. Here main

character Big Sue gives a quilting at the house of matriarch Maum Hannah to get some of Sue's quilt tops quilted. Two teams of eight women each are chosen by team captains to quilt on two frames set up in the front room. The two teams compete to see who can finish first. The competition is good-natured, yet some arguments break out. Hannah manages to erase the boundary between groups by bringing out her appliquéd Bible quilt to illustrate Bible stories which she tells:

> She held up one corner and motioned to deaf and dumb Gussie to hold up the other so all the squares could be seen. There were twenty, every one a picture out of the Bible. The first one, next to Gussie's hand was Adam and Eve and the serpent. Adam's shirt was blue, his pants brown, and his head a small patch of yellow. Eve had on a red headkerchief, a purple wide-skirted dress; and a tall black serpent stood straight up on the end of its tail.
> The next square had two men, one standing up, the other fallen down—Cain and Abel. (p. 171)

With each block, Hannah tells a "marvelous story" to which the quilters listen with "rapt attention" and tearful eyes. Thus, the quilt serves to end the quilting on a harmonious, spiritual note.

Peterkin, a white woman writing about black culture, sees Western religion (the Bible) embodied in a quilt as means of bringing harmony (salvation) to blacks, while her vision of how a quilt can "speak" to these ends is almost a literal one.

Eliza Calvert Hall's novel *Aunt Jane of Kentucky*, published in 1907,[9] also devotes a chapter to quilts, "Aunt Jane's Albums," in which the first-person narrator, a young neighbor woman, comes to visit the older matron Aunt Jane, to find her airing her patchwork quilts. The airing quilts provoke Aunt Jane to express her views on quilting and her quilts. She details how her piecing has served to keep her busy, yet has not taken time from her work as it does for some women. For Aunt Jane, the quilts symbolize not only her diligence and skill, but her family as well:

> "You see, some folks has albums to put folks' pictures
> in to remember 'em by, and some folks has a book and
> writes down the things that happen every day so they
> won't forgit 'em; but, honey, these quilts is my albums
> and my di'ries, and whenever the weather's bad and I
> can't git out to see folks, I jest spread out my quilts and
> look at 'em and study over 'em, and it's jest like goin'
> back fifty or sixty years and living my life over agin."
>
> (p. 59)

Aunt Jane proceeds to talk about the pieces in each quilt and the memories and people they evoke. Barbara Kirshenblatt-Gimblett's analysis of synthetic memory objects sees quilts as a quintessential example. She states: "The key to the way quilts work is in the tension between the abstract principles of visual organization . . . and the metonymic nature of the pieces themselves. . . . Scraps are literally parts that stand in a contiguous relation with particular pieces, but according to abstract principles of color and geometry and repetitive patterns. . . . The potential for reminiscence is left wide open."[10]

In addition to seeing quilts as her albums, Aunt Jane also tells her visitor about the hidden language in the quilting stitches, pointing out the stitching done by different women on her quilt: "Now, child . . . you think I'm foolin' you, but la! there's jest as much difference in folks' sewin' as there is in their handwritin'" (p. 64). Aunt Jane's quilts entered in county fairs have also been the means by which she received praise from the outside world; her prizes, silver cups, along with her quilts, she designates as heirlooms for her children and grandchildren. Aunt Jane also sees her quilts as metaphors for living a life and providing much clearer sermons than her (male) minister can deliver: "Many a time I've set and listened to Parson Page preachin' about predestination and free-will, and I've said to myself, 'Well, I ain't never been through Centre College up at Danville, but if I could jest git up in the pulpit with one of my quilts, I could make it a heap plainer to folks than parson's makin' out with all his big words'" (p. 74). She goes on to elaborate how the

quilter gets just so much calico from scraps and friends (predestination) and then she chooses her pattern (free will) and executes it. Aunt Jane realizes that she cannot cross the boundary from domestic world into the male world of the pulpit; nevertheless, she sees her quilts as reservoirs of more valuable knowledge than that held by the minister.

Aunt Jane's lessons are taken to heart by her guest, the narrator, who upon leaving has learned the special language of quilting:

> An hour ago, they had been patchwork and nothing more. . . . The old woman's words had wrought a transformation in the homely mass of calico and silk and worsted. Patchwork? Ah, no! It was memory, imagination, history, biography, joy, sorrow, philosophy, religion, romance, realism, life, love, and death; and over all, like a halo, the love of the artist for his work and the soul's longing for earthly immortality. (p. 82)

While these early works show how quilting operates as a positive means to create harmony and validation of relationships, while helping to draw the boundaries of the traditional domestic sphere, another early work, Susan Glaspell's "A Jury of Her Peers,"[11] uses the making of a quilt as a woman's statement about her oppression by her husband, and other women's interpretation of this private language of the quilt-making process to uncover the woman's motives for killing her husband. In this story the sheriff's wife and a neighboring farm woman accompany their husbands and the county attorney to the home of Minnie Foster Wright, who has been arrested for strangling her husband with a rope while he slept. While the men look for evidence that Minnie Foster indeed committed the crime, the women talk in the depressing kitchen, taking note of Minnie's barren life. In gathering some clothes to take to Minnie in jail, the women come across her sewing basket holding her unfinished patchwork. The find of the quilt intrigues the women, and they delight (p. 371) in the pattern and the aesthetic choices Minnie has made and has yet to make: "Do you suppose she was going to quilt it or just knot it?" This remark is overheard by the men as they pass through

the room. Making great fun of the women's conversation, the men go on out to the barn to look for more evidence.

Upon examining the stitching of the pieced blocks of her Log Cabin design, they find the last block badly sewn, indicating perhaps some nervousness by the maker—an idea which the women ponder in depth. Looking for tools to take with the quilt pieces, the women find instead her dead canary, with its neck wrung, which explains the empty birdcage in the room. The women note that Minnie had always liked to sing, but that over her twenty years of marriage, her husband had stifled her music as well as her outgoing nature. Nor had he allowed her interest to re-emerge through the canary, which the women determine he had killed. While the men are busy with their official search, the women through the language of the quilt find the clues to the crime, clues which they silently decide not to reveal to the men representing the lawful establishment. The story ends when the men have completed their investigation, and upon leaving they refer to the quilting term they have learned from the women's discussion earlier on how Minnie would finish her quilt— by quilting it or knotting it:

> "Well, Henry," said the county attorney facetiously,
> "at least we found out that she was not going to quilt it.
> She was going to—what is it you call it, ladies?"
> Mrs. Hales's hand was against the pocket of her
> coat [in which she had hidden the sewing box with the
> canary]. "We call it—knot it, Mr. Henderson." (p. 381)

Little do the men know that this women's language of quilting is the very evidence for which they have been looking since the man was strangled with a rope knotted in the same fashion as a quilter's knot. The women keep silent, having absolved their sister of any guilt for the murder, feeling that a higher justice than that of the men's world has been served. The quilt in progress speaks to the women, bonds them together in a conspiracy with the murderer, yet closes the men out of their world, which the women know the men can never understand.

Similarly, in Sylvia Townsend Warner's short story, "A Widow's Quilt,"[12] a wife sews a quilt of that type with secret hopes that by so

doing she will be made a widow; thus her husband is also not privy to the special language of the quilt. Set in England, the story centers around Charlotte, a married woman without children leading a bland life. When she visits the quilt room of the American Museum with her sister, she is captivated by a widow's quilt "that stood out from the others, dominating their rich vivacity with a statement of dulled black on white" (p. 128). She decides to make a similar quilt and plans a complex hexagon design in black and white. As she works on it only when her husband is at work, at first the quilt expresses her creativity, giving meaning to her life, and she worries lest she should finish it too soon: "Patch after patch would lessen her private entertainment; the last patch in the border of the black hexagons would topple her over the edge to drown in the familiar tedium. She did not want to make another quilt, or any other kind of quilt. This was her only, her nonpareil, her one assertion of a life of her own" (p. 129). Frustrated because she cannot work on it when he is home, she "told herself that a little publicity would be the surest safeguard of the secrecy which was the essential ingredient in her pleasure" (p. 131); therefore, she decides to let her dependent husband Everard see the quilt, which she ironically tells him is a traditional pattern called a "Magpie" quilt; of course, he, unaware of quilt types, does not realize that it is really a widow's quilt which hopefully prophesies his death. However, when Charlotte's sister Helena drops in, she recognizes the implications with "a momentary gasp" (p. 132); thus the quilt silently relays to another woman Charlotte's wishes to be rid of her husband. As she becomes more and more obsessed with the quilt, Charlotte looks forward "to the time when she would rightfully sleep under it," and thinks about "where she might go as a quiet traveling widow" (p. 131).

With her sister's visit, Charlotte has been reminded that after the piecing she still has to stuff and quilt the quilt.[13] Instead of being only a winter's work, it will go on into the summer. She also realizes that "with the added weight of the backing and the interlined padding, the quilt would be too heavy to handle comfortably, could become a drudgery—another marital obligation, almost another Everard" (p. 132). Thus, no longer the creative projection of freedom she has

anticipated, the quilt has now become symbolic of the despised domestic obligations. Becoming careless in her haste to finish her obsession, she makes mistakes in the sewing and runs out of thread. Braving a March storm, she goes for the thread. However, upon her return, the stress of the wind and the three flights of stairs is too much for her heart. Gasping for breath, she stumbles and falls down the stairs to her death, leaving her widow's quilt incomplete. The story ends with Everard giving the quilt to Charlotte's sister, Helena. Everard says to her:

> "And there's that quilt. What should we do about it? It's not finished, you see. Poor Charlotte, so unfortunate! It's a magpie quilt."
> "Magpie?"
> "Yes, because it's all black and white—like the birds, she said."
> "I see." (p. 134)

Ironically, Everard unknowingly states the truth when he says:

> "I can't very well take it with me. Yet it would be a pity to throw it away. Could you take charge of it, Helena? It would be a weight off my mind if you would. You'd know how to finish it, and I don't suppose it would take you very long. Not that there's any hurry now. And then you could keep it, to remember her by. I'm sure she'd like you to have it. It meant a great deal to her." (p. 134)

The reader is left knowing that the sister shares the secret of the quilt with her dead sister, and that Everard will never know the truth about Charlotte's intentions and her misery over her dull life with him. Again, the quilt speaks only to women and covers up the truth from the outsider male.

In Alice Walker's short story "Everyday Use,"[14] quilts only speak to those inside the rural domestic tradition and bound out not specifically males but anyone outside the tradition. The story involves a visit to Mrs. Johnson and her daughter Maggie from her other

daughter Dee, who has been educated and moved to the city. While her mother is involved in the traditional farming and domestic practices of the rural South, Dee has abandoned her home and its traditions and adopted the ways and values of urban life and the black identity movement, even taking a new name, "Wangero Lewanika Kemanjo." While she was ashamed of her home and their way of life before she left, upon returning, Dee (Wangero) is newly "delighted" by it all, from the handmade benches at the kitchen table to the churn top, which she appropriates to use "as a centerpiece for the alcove table" (p. 56). Her newly found delight in her rural background and its material culture leads her to look for the "old quilts" her mother had "been saving," stored in a trunk at the foot of her bed. When Dee brings them out and asks sweetly (p. 56), "Can I have these old quilts?" Maggie is quietly upset because her mother had promised them to her for her upcoming marriage. Mrs. Johnson tries to persuade Dee to take some of the other quilts, but Dee does not want them because "They are stitched around the borders by machine" (p. 57) while the older quilts are stitched by hand. The older quilts were made from tops pieced by Mrs. Johnson's mother, Grandma Dee, and quilted by Mrs. Johnson and her sister Big Dee. Like Aunt Jane's quilts, these quilts have pieces of family clothing. Remembering how Dee had rejected an offered quilt gift as being "old-fashioned" when she went off to college, Mrs. Johnson tells Dee that she has promised them to Maggie for her upcoming marriage. Dee is outraged (p. 57): "Maggie can't appreciate these quilts! . . . She'd probably be backward enough to put them to everyday use. . . . They're priceless!" To Dee's objection that Maggie would use them and wear them out, her mother reasons that Maggie could make some new ones since she had learned how to quilt from Grandma Dee and Big Dee. When Dee accuses her mother of not understanding "these quilts," her mother asks her what she would do with them. Dee replies, "Hang them" (p. 58).

When Maggie sees that she probably will not get the quilts, she tells her mother, "I can 'member Grandma Dee without the quilts" (p. 58), willing to again play second best to her more blessed sister. With this remark, Mrs. Johnson, in a moment of epiphany, realizing

that Maggie is the rightful heir to the quilts, "snatched the quilts out of Miss Wangero's hands and dumped them into Maggie's lap" (p. 58). Dee leaves, on one hand telling her mother that she does not understand her heritage, and on the other telling Maggie to "make something" of herself. Revealing how she really feels about her family's lifestyle, Dee says, "It's really a new day for us. But from the way you and Mama still live you'd never know it" (p. 59).

In Walker's story, quilts are objects symbolizing family heritage and tradition. Reaffirming the mother-daughter relationship, the quilts function as a birthright which the mother bestows on Maggie, her daughter who still carries on that tradition. Signaling her love and warm feelings for Maggie, the gift of the quilts serves to bind the mother to her daughter who shares her affinity to quilting and the traditional lifestyle.

Yet the mother's giving the quilts to Maggie actually alienates her from her urbanized daughter Dee, who truly does not practice, understand, nor appreciate the quilts and their domestic use. Thus the quilt continues to function as a metaphor for tradition, for traditions not only hold groups together, but also set them apart from other people with different traditions. Dee, who has always set herself apart from the family and the house, cannot be heir to something she was never a part of.

In these works by Stowe, Peterkin, Hall, Glaspell, Warner, and Walker, quilts bind the traditional female sphere much as the binding that finishes the edges of a quilt to make it one piece; as these fictional narratives show, to be able to read the messages of the quilt, one must be part of the women's sphere, yet just being a woman does not make one part of the tradition. One must operate within the tradition, understand its context and its language; otherwise, one is bounded out of that tradition. There are layers of meaning for the quilt and for the quilting process that we can derive from these works, just as the quilt has three layers. The first or bottom layer we may see as representing the female domestic world with its esoteric knowledge and experience. The top layer reveals the quilt as a positive symbol explaining the experience of life and relationships. Yet

between these layers, hidden inside, are other messages that express the demarcations of group membership and identity, or sometimes darker ones of oppression and conflict.

Yet if quilts and quilting are important elements in each of these works, these novels and stories seem almost a mere prelude to Whitney Otto's 1991 *How to Make an American Quilt*,[15] a novel whose very structure is based on quilt metaphor and whose plot and character relationships depend upon quilting as an activity. Indeed, it is somewhat misleading to speak of the novel as having "a plot," for the overall narrative which holds together a number of smaller narratives is really more a frame story used to bind those other stories which make up individual chapters (and spill over into others). It is rather like an album quilt with the sashing holding together the pieces (the smaller narratives). "Bind" seems an appropriate word to use here because Otto clearly wants us to see her novel as a kind of pieced quilt, a series of related stories stitched into a larger whole just as quilt blocks are put together. This metaphor is made obvious, however, by her interrelating the stories through the centrality of a quilting circle to which the main characters belong and through the use of nonnarrative chapters ("Instructions") that ostensibly provide quilting instructions.

The frame story is established through a "Prologue" and an epilogue called "The Crazy Quilt," the only sections of the novel with first-person narration throughout and in which the narrator, erstwhile grad student Finn Dodd, establishes her presence in the lives of her grandmother Hy and great aunt Glady Joe, sisters who are members of the quilting group. Uncertain about her future, she has come to spend the summer in the small California agricultural town of Grasse, near Bakersfield. The quilters meet at Glady Joe's house, so that Finn initially becomes acquainted with the members of the group. She is considering marriage to Sam, and they offer to make her a bridal quilt, though as this is another very uncertain area in her life, she fends them off.

She is particularly drawn to Anna Neale, "my aunt's oldest friend," an African American, and the subtly acknowledged leader of the circle. Anna promises her a long talk and "I am ready to listen"

(p. 6). We are meant to imagine that the subsequent chapters which tell about the lives of the various quilters are in some sense Anna's narration. Though each story involves a variety of personal, human issues (as well as, in some instances, larger historical concerns), each involves some element of love and of relations between men and women and tells of how a woman's life worked out through relationships and through choices made and not made. That is, indirectly they tell of things that concern Finn and from which she may gain insight. Finn, then, is both central to their stories, as the intended audience, and peripheral to them, as someone who does not participate in them as an actor. (The 1995 film of the novel, no doubt to provide more unified plot structure, put Finn more integrally into a more conventional narrative.[16])

Otto establishes in the nonnarrative "Instructions" chapters a certain whimsicality which allows her to skip from the ostensible instructions in quilt making to other issues and musings. "Instructions No. 1" and the appended "More Instructions," for example, begin by almost prosaically setting out the equipment needed for quilting but also introduce by name the members of the circle. But we shift to a statement of the salvage values inherent in quilting which of course evokes the idea of femmage, the idea that women are bricoleurs who put together various kinds of scraps in the interest of avoiding waste and communicating through the creation of a beauty made from the pieces of the everyday.[17] But the idea of the quilt as communication is more explicitly developed as Otto shifts to American history and the period of colonization and the fact of colonial women often remarrying out of economic considerations with the consequence that this frequently was having to make do ("Not unlike fashioning a quilt from scraps, if you think about it" [p. 10]). As time goes on, this section notes, women make quilts tied into the developments of American history, commenting upon Lincoln's assassination or social development or strains upon the American union. As women do not get to vote, they are exhorted to "Say something in cloth," to "Save your opinions for your quilt" (p. 12). Through the comments on colonial marriage, an important connection is made between quilts and love and relationships between men

and women (an important thematic thread throughout the novel and a matter of special anxiety to Finn). And the use of quilts to communicate women's observations and concerns (especially appropriate in the context of the American past, given that quilting flourished in the United States more than anywhere else) is clearly established at the outset.

Thus Otto does begin the novel very much in line with the earlier works considered above, conceptualizing quilts as a form of women's in-group communication, a form shaped by women's having been shut out of other, male-dominated communicative channels. However, though the novel very much focuses upon a world of women and how they relate to and communicate with each other, and though she conceives of quilting as a women's language, Otto is less concerned than the other writers with issues of gender and group inclusion and exclusion. Certainly, male characters fail in their communication with women and female characters outside the quilting circle also fail in communicating with its members, but this is not so much tied to the esoteric language of quilts or to the close ties that hold together the in-group of the circle. Rather, Otto uses metaphors of quilting to establish a complicated structure in which the lives of the characters are mirrored in a variety of ways, with the "Instructions" chapters setting out the terms of comparison.

For example, "Instructions No. 2" speaks of the need for the lone quilter to choose a quilt "subject" carefully, to be a strong person in order to stay with the project by herself, and to keep it under control. A crazy quilt (one in which the pattern of the top is made up of irregularly sized and shaped pieces) is too random for someone concerned with control. The section skips to following in a parent's footsteps—tied to the notion that "quilting is about: something handed down" (p. 39)—and then asks the reader to "think about the perfect marriage or . . . ideal love union" (p. 40), which is, in fact, "as uncommon as any wondrous thing."

This nonnarrative chapter is followed by "Sophia Darling," which narrates the story of the character by that name and which is obviously commented upon by "Instructions No. 2."[18] Though as a girl Sophia wants freedom and adventure (expressed through her

penchant for swimming and in particular her swimming alone at a remote quarry), her mother is nearly obsessed by domesticity and would steer her daughter into a secure marriage. Her mother is delighted when Preston Richards, a "college man," takes an interest in Sophia. When Sophia becomes pregnant (ironically after sex following a swim at the quarry), she marries Preston, and this "fishgirl" once "lusting after rebellion" (p. 45) gives up her dreams and settles into a life of certainty, predictability, and control. She will "do as her mother did," having received an inheritance—like a passed-on quilt or tradition of quilting—of fearfulness, disappointment, and acceptance of defeat. Predictably, when the circle decides to make a crazy quilt, Sophia is disquieted, not "enjoy[ing] the freedom of color and pattern" (p. 61). Her older daughter leaves town for a promising career—having something of what Sophia wanted but leaving her mother behind—while her younger daughter has gotten pregnant out of wedlock—thus having received a sort of negative inheritance—and run away. Her son too hopes to go elsewhere, so that Sophia, somewhat estranged from her husband, with all her desire for control of the domestic sphere, has lost it and may end up a lonely—if not actually a lone—quilter.

Sophia's tragedy is, obviously, a personal one, though it does reflect a larger problem for women in a time before the immediate present of the novel, that of being denied a life outside the home and of being funneled into the centrality of the domestic. "Instructions No. 7" and its related narrative chapter, "Tears Like Diamond Stars," are more directly concerned with larger issues and tie Anna Neale's personal story more fully into American social history. This "Instructions" chapter begins with African stories and with slavery, leading up to the situation of slaves who could sew—a skill which could bring a slave more misery if sewing was added on to field work and other duties or better fortune if on a large plantation that allowed for specialized workers. The section is addressed to a "you" who is clearly Anna, who finds piecing—like slave work—tedious, but who loves designing. Some of her designs are listed and some of the ideas the designs convey explained. One, "Many Shoes," is a statement that no one should trample on the oppressed, another references the civil

rights struggles in Alabama. Others are more personal in meaning ("Broken Star" speaks of Anna's early interest in astronomy). The section ends with mention of Hawaiian quilting, a cultural context in which patterns were highly personal ones, the sharing of which compromised a woman's power. Yet a mainland visitor to the Islands once bought two Hawaiian quilts, brought them home, copied the designs and won a contest with them. Here is a kind of theft of "native" culture by the dominant, white culture of the United States, not unlike the theft of bodies (and culture) that constituted slavery.

"Tears Like Diamond Stars" begins with a brief burst of first-person narration in which Anna declares, "I learned to speak with needle and thread" (p. 133), a further statement of the idea of needlework as women's language as well as of her personal situation as a black woman denied a voice not only because of gender but because of race as well. She grows up with her great-aunt Pauline, who works as a domestic in San Francisco and who owns the quilt called "The Life Before" made by Anna's great-great-grandmother and full of "African scenes . . . before the ships and the block and the coffle" (p. 134). Her employer lusts after the quilt, though Pauline tries to discourage her by explaining that it depicts African stories only and refuses to sell it. Finally she does sell it to pay for Anna's education, telling its stories no more, for its new owner has no comprehension of them any more than the woman who bought the Hawaiian quilts had of those. Anna becomes a maid for wealthy ranchers, takes a white lover, and, pregnant by him, is taken in by Hy and Glady Joe's parents. She begins quilting and, though deeply alienated from American society, finally becomes a friend of Glady Joe and, years later, her daughter Marianna growing up, winds up working for Glady Joe. They quilt together, Glady Joe taking on the more tedious work, Anna doing the top designs. Anna is much aware of her status as black in American society, that she is "the ghostly witness to the American dream" (p. 155), and the quilts in her life relate to that reality, from "The Life Before," which connects her to her ancestral, pre-slavery past to those she makes to comment upon contemporary race relations in America. The sale of "The Life Before" simply mirrors the shallow consumer ethic of American society, the

attempt to appropriate culture as a commodity without understanding cultural meaning, and an attitude toward the importance of possessing property, which once allowed slavery to flourish.

For Anna, then, quilts are very much a form of communication, allowing her both to tie herself to the African past and to make statements about contemporary race-related issues. The special language of quilting is for her one of race more than of gender. Sophia, however, is able only to communicate—through her preference for fixed traditional designs and her suspicion of the randomness of the crazy quilt—her disappointment, her fear of losing control, her loneliness (ironic because tradition draws people into groups). In the case of Anna, Otto works a connection to a larger pattern in American history, using Anna's quilts and Anna to comment upon a history of race relations. With Sophia, Otto is more interested in personal tragedy, though by giving quilting and "tradition" negative value related to inherited patterns of behavior that have been limiting or destructive to women, she does connect Sophia to broader, gender-related issues.

In other chapters Otto similarly uses quilts as metaphors for looking at America or humanity. In "Instructions No. 5" and the related "Outdoors," for example, she comments on how women have used quilts to talk about the wars their men have gone off to fight, and then tells the story of two sons of quilt circle members who respond to the Viet Nam conflict in very different ways. This is to say that, though certainly Otto recognizes quilting as a women's language and though that language is used to comment from a women's perspective, the messages conveyed are wide-ranging. Of course the quilting is also the plot device for bringing the characters together[19] as well as a symbolic statement about the "patchwork" quality of friendship. The characters are all different blocks who are joined by circumstances into some local but also American whole. They differ as to whether they should produce a crazy quilt, but in the end that "which has so divided the women . . . has so joined the women" (p. 179). And from listening to Anna tell about all the quilters and their marriages and other love relationships—Sophia's "snaring" her husband with her pregnancy, Anna's bearing a child by her white lover, plus others—Finn learns something about the nature of marriage and

love and decides to marry Sam. That the quilt being made during her visit is meant for her as a wedding gift with blocks having been made by the various quilters according to their own designs—Otto is either confusing a crazy quilt with an album quilt or using poetic license here[20]—is a final statement about human relationships (marriage too as a kind of bricolage) and messages sent.

Otto's knowledge of quilting seems not to come from personal practice of the craft but rather to be largely based on several sources she cites, notably *Hearts and Hands* by Pat Ferrero, Elaine Hedges, and Julie Silber.[21] Writing in the 1990s, however, she could take for granted widespread interest in quilts—indeed often on the part of readers with little personal experience of quilting themselves—and of widespread enthusiasm for them. By the last decade of the twentieth century, quilts had come to be viewed as significant works of art (an idea reflected certainly in "Everyday Use") as well as important signifiers of tradition and heritage (family, regional, national) if particularly of women's lives and identities. Such a situation is somewhat ironic, given the general decline of traditional quilting as an activity in the twentieth century (though certainly many quilters continue to work, whether they learned their skills through tradition or via classes, videos, and books, whether they use traditional patterns or are "art" quilters). Nonetheless, this contemporary interest in quilts gives writers a wide range of reference points for incorporating quilting into narratives and for using quilts as metaphors and symbols.

Certainly, the quilts in the lives of Otto's characters manifest many meanings. More recently two major North American writers, Anne Tyler and Margaret Atwood, have placed quilts in novels in which they function to express a wide range of meanings as well.

The quilt in Tyler's *A Patchwork Planet*[22] might not strike the reader as being particularly significant had not the author called attention to it by the novel's very title. In Tyler's story there is no quilting circle, the character who quilts is in most respects subsidiary, and the main character is a young man who evinces little knowledge of quilts or quilting. This main character, the narrator, is Barnaby Gaitlin, thirty years old, son of a distinguished Baltimore family. He himself has

become the black sheep who works as a manual laborer for an odd little business called Rent-a-Back, whose marriage has failed, and who lives in a lonely basement apartment. Rent-a-Back supplies young people who do all manner of jobs—string Christmas lights, carry furniture, roll up rugs for storage—for local folks who are genteel but not rich enough to have their own help. The employees "were not particularly successful people," Barnaby notes. "Several might even be looked upon as losers" (p. 24). Perhaps he means to include himself among them, and certainly, a reformed juvenile delinquent once arrested for burglary and confined to a school for problem kids, he initially strikes the reader as a failure, though a likable and thoughtful one.

The novel takes him through what obviously becomes a crucial stage in his life during which he proves his worth to himself, a period which he begins by doubting that "I'm a good person" and ends by asserting "*I am a man you can trust*" (pp. 3, 288). His path through such a transformation takes him through his difficult relationship with his ex-wife, who holds custody of their daughter and has in her second husband the responsible, successful person Barnaby was not; a relationship with a respectable, seemingly mature woman who ultimately comes to doubt him; the sale of his beloved sports car to pay back to his parents the money they spent to compensate his burglary victims in order to avoid his prosecution; and the beginnings of a meaningful romance with one of his "loser" coworkers.

The quilter of the novel is one of Barnaby's elderly customers, Mrs. Alford, who remarks to him early in the narrative that she has "been working on a quilt of our planet for the past three years" (p. 34). The quilt reappears when Mrs. Alford takes Barnaby's daughter to see it, but Barnaby himself never sees it until its maker dies and he is helping her brother clean out her house. It is not as he had imagined it:

> What I had expected was a kind of fabric map—a plaid Canada, a gingham U.S. Instead the circle was made up of mismatched squares of cloth no bigger than postage stamps, joined by the uneven black stitches of a woman whose eyesight was failing. Planet Earth, in

Mrs. Alford's version, was makeshift and haphazard, clumsily cobbled together, overlapping and crowded and likely to fall into pieces at any moment.

"Pretty," I said. Because it *was* sort of pretty, in an offbeat, unexpected way. (p. 261)

Mrs. Alford's vision of Planet Earth is obviously Tyler's vision of human existence in the world of the novel and more particularly of Barnaby's own existence. His life is very much "cobbled together"; it *has* fallen to pieces several times. Yet in the end it holds together like the quilt, in however a mismatched and uneven manner. The pattern his life has assumed by the end of the narrative is as unexpected by him as is the appearance of the quilt (and it too is—to the reader—"sort of pretty, in an offbeat . . . way"). The quilt has been hastily finished, perhaps because Mrs. Alford has suspected her coming demise, suggesting a need on her part to finally fulfill a desire to ensure that the world itself actually hold together. Indeed, by the end of the novel Barnaby's personal world is finally holding together, but Tyler is more concerned about making a statement as to how people hold the larger world together: haphazardly perhaps but through a certain sense of love and caring for, so to speak, the other patches, holding them into the design of life.[23] Barnaby's ultimate success comes out of the love and assistance others show for him—his employer (who believes in him), his clients (who give him extra hours of work when he needs the money), his coworkers, his supportive grandparents. Barnaby is a quilt piece—as are we all—being held in place by the other pieces and the thread that binds.

Whereas Tyler's vision is whimsical and sweet, the quilt symbolizing the patchy, strangely supportive networks of humanity, Atwood's is darker and more complex. Her novel *Alias Grace*[24] takes for its narrative core a celebrated murder which took place in colonial Upper Canada in 1843, when a local squire and his housekeeper/mistress were killed by two servants of the household. One of those servants was a young Irish girl named Grace Marks who, unlike the other convicted perpetrator, was saved from the gallows and spent many years both in insane asylum and prison before being released,

partly at the behest of influential supporters who believed her inno-
cent. Atwood's fictional narrative—told from several points of view—
centers upon the visits which Simon Jordan, a young American doc-
tor interested in mental disorders, makes to study Grace.

During these visits Jordan attempts to probe Grace's inner
being and to determine the truth of her life story leading up to and
including the murders, while Grace—partly out of a superstitious
fear that to reveal oneself is to bring about unfortunate ends—takes
care to keep things hidden from the doctor as she nonetheless nar-
rates much about her life. Atwood uses Simon Jordan's probing and
Grace Marks's defensive strategy to examine the nature of truth and
falsehood, memory and forgetting, sanity and madness, guilt and
innocence, identity and loss of self. While Grace moves slowly
toward a redemption (though it is only years after Jordan's visits that
she gains release and marries someone from the past), Jordan is
unable to cope with the tremendous ambiguities of what he learns or
with his failure to find a satisfying answer to the question of Grace.
In a climactic scene, a hypnotism session attended by a number of
people, Grace reveals another, hitherto unconscious personality—
something which may genuinely account for her seeming inability to
remember the actual murders whatever the extent of her participa-
tion in them (though she may yet be "play-acting"). Jordan is shaken
by the outcome of the hypnosis, troubled already by sexual compli-
cations (both a powerful attraction to Grace and a seedy affair with
his landlady) and flees—back to Massachusetts, then abroad, then to
medical service in the Civil War. Badly wounded in the war, he
winds up being nursed by a fiancée he had tried to avoid and a long-
suffering mother, psychically as well as physically devastated. Years
later, after 1872, Grace herself enters into a new life with which she
is reasonably happy, having made important discoveries about
human existence through her strange passage in life.

As Dr. Jordan's visits proceed, he and Grace sit in the sewing
room of the residence of the prison governor, and Grace, a skilled
needlewoman, is working on quilts for the governor's wife—making
the blocks only, the quilting to be done by others at social gatherings
to which she, as a prisoner, is of course not invited. Her quilt-square

making is not obtrusive to her narrative, but she does make several significant comments on quilting, and it is clear that Atwood means quilts and quilt designs to symbolically reflect some of the novel's concerns.

Each chapter, in fact, receives as its title the name of a quilt design, and each design name echoes events or references in that chapter. For example, "Broken Dishes" tells the story of Grace's early life and coming to Canada from Ireland. She compares her faded memory of her native place to "scraps, like a plate that's been broken" (p. 103) and indeed her memory in general—perhaps like all memory—is being presented as fragmented. However, for the voyage to America, Grace's mother is given a fine teapot and cups by her better-off sister. Her mother dies on the journey and is buried at sea, and the teapot falls from its basket and smashes, literally broken crockery, by extension a broken dish. Though Grace interprets its breaking as effected by her mother's spirit, the event is certainly a forerunner of Grace's unlucky, broken life to come. "Secret Drawers" refers to Simon Jordan's childhood practice of slipping into the "secret world" of the servants' quarters in his parents' house, opening drawers to spy out the maids' "forbidden things" (p. 140) (which perhaps included their underwear, another meaning for drawers; indeed, Jordan is trying to "get into" Grace's "drawers," if not literally). Throughout the novel he is, of course, still spying on the secret world of a maid, Grace Marks, whose secret drawers he is, as a medical researcher, trying to pry open. "Lady of the Lake" relates Grace's flight across Lake Ontario to the United States with her supposed collaborator in murder. Seeing the boat's paddle wheel go around, she realizes that the quilt pattern must be named not for Scott's famous poem but for a boat with such a paddle wheel. This realization on her part suggests her innate powers of observation, intelligence, and ability to reason and foreshadows her eventually reaching a reasoned perspective on her whole, odd life. The chapter in which the hypnotism session takes place is "Pandora's Box," a title indicative of the confusion, uncertainty, and turmoil released by Grace's performance.

At the end of the hypnotism session, one of the unsettled attendees—Reverend Verringer, the most sophisticated proponent of Grace's innocence—uses a comparison which evokes quilts. In the

wake of Grace's performance, Simon Jordan has brought up a theory of multiple personalities with "different sets of memories" and, indeed, different lapses of memory. Appalled by this possibility, Verringer exclaims (p. 406): "We cannot be mere patchworks!" That is, he refuses to see the human personality as being, in essence, fragmentary. Yet Atwood is in part suggesting just that, that we are collections of varied and miscellaneous pieces—memories, experiences, impulses, forgettings, ideas, values, both conscious and less than conscious. Verringer may use the patchwork analogy because—perhaps as a male who cannot really appreciate the quilt tradition—he thinks of only the fragments, not the finished design. Or it may be that we are meant to see a distinction between "mere patchworks"—which could be taken to mean the pieces that have not been joined into a complete design—and the finished design of a completed quilt.

The quilt design chapter titles help to structure the novel— somewhat in the manner of Otto's "Instructions" chapters—but they also suggest something more fundamental to the novel's meaning. When she has finally been released, goes to the States, and marries, Grace acquires quilts made by others (from a poor family who have "failed" and are "moving west" and who thus both mirror Grace's earlier family situation and contrast with the relative prosperity she has achieved). One is a Wheel of Mystery, suggesting the mysterious path Grace has traveled to this stage of her life, the other a Log Cabin, a design which she has earlier explained is indicative of "the home" and which "every young woman should have before marriage" (p. 98) (though she obtains it in the wrong order, the Log Cabin does emphasize that she has finally found that home). More important, however, she is now making a Tree of Paradise quilt, a design which years before she told Dr. Jordan was the one she herself would choose to make. She is making it out of material from three sources central to her story: a petticoat from Mary Whitney (whom she has told us about as the deceased friend who taught her much about life but who may be her alternate personality), her prison nightdress, and a dress worn by Nancy Montgomery, one of the murder victims, a woman with whom Grace had a complex relationship and in whom she has found something of herself.

"And so we will all be together," she says to end the novel (p. 460). Whereas formerly Grace only took care of the quilts of others, or worked on top designs decreed by others, she is finally at the end making a complete quilt, planning out the design, quilting together the layers. She has finally achieved a position in life where she controls the wholeness of the quilt, and Atwood is suggesting that Grace has at last achieved some form of personal integration, has in some way succeeded in pulling together all the disparate pieces of self with its fragments of experience and memory and forgetting. The previous chapters have been the isolated blocks of her life which have finally been put together (though not literally), made into a whole by herself. She states that whereas some quilters make the Tree of Paradise with multiple trees, she will have only one, a factor which further stresses her sense of personal unity. That she will add a "border of snakes entwined" (p. 459) signifies her understanding that the Edenic paradise whose grace she has come to is always near and inextricably connected to the evil which plays a role in forging our existence and which threatens the margins of paradise. That she crafts the snakes so that most who view the quilt will only see vines or "a cable pattern" suggests how little some people have understood her. Just as they have told her "main story right but some of the details wrong" (p. 459), others will miss the detail of the snakes. Indeed, Simon Jordan, despite his intelligence, learning, and inquiring mind, failed to get her story right or to understand his own self and ends up shattered rather than integrated, having fallen from grace and into a minor hell far from Eden.

Thus for Atwood, as for Tyler, quilts do suggest something positive, draw scattered pieces into a resplendent whole. Indeed, this fits with our current societal view of quilts as beautiful, valuable creations that recycle and reformat scraps into useful and aesthetically pleasing things. It is somewhat surprising, then, that two other, recent novels treat quilts as repositories of evil forces or as negative possibilities. One is Barbara Michaels's popular, faintly gothic *Stitches in Time* (1995), the other Phyllis Alesia Perry's *Stigmata* (1998).[25] Both posit that women sew into their quilts powerful feelings and that

quilts, as physical objects which survive through time, carry those feelings with them. In both books those feelings are manifest as supernatural/supernormal forces that reappear in extraordinary ways in the present action of each narrative.

Though *Stitches in Time* is certainly the less sophisticated of the two novels, it is the more self-consciously aware of the idea of quilts as repositories of women's feelings. Its main character, Rachel, is a graduate student writing a somewhat vaguely conceived dissertation on women's magic and needlework, and her supposed awareness of cultural issues relating to quilting—amplified by another character who is an eminent anthropologist who believes in demonic possession—is an important feature of the plot background. Rachel works for an antique textiles dealer who acquires three nineteenth-century quilts under strange circumstances. One of the quilts is an album quilt which may also be a bride's quilt or a friendship quilt made for a bride (that is, each block bears a different design and the motifs of each are romantic ones associated with marriage). Not only is it particularly dirty, covered by gray dust of some sort, but it seems to be associated with Rachel's impulsively and unconsciously being drawn to evil deeds (a brief tryst with her employer's husband seems to be the one which causes her the most guilt). In the midst of various plot complications, including twists in Rachel's love life, the characters trace the history of the quilt and decide that it is the nesting place of a curse. They notice that the romantic images in the blocks are, in fact, "wrong," that almost unnoticeable details make them subtly horrible (a female figure is depicted as blind, a little snake has demonic red eyes), and they decide that the quilt was made to wish evil upon someone at the time of marriage through the incorporation of magical elements (the dust turns out to be graveyard dirt, a bringer of death,[26] and there are hair and fingernail clippings inside the quilt). They finally determine that it was made by a slave (also named Rachel!) for her mistress on the occasion of the mistress's marriage to a man who had been the slave's lover.

Thus the plot is a somewhat silly, if somewhat suspenseful one, but Barbara Michaels does stress both the idea that a quilt has power as it is passed down to later times, and ideas about quilts as forms of

women's expression. The main character is after all "writing about women's work and traditions as a separate culture" (p. 6). At one point she reads: "Denied outlets for their creative talents in literature and the fine arts, women poured their hidden frustration and suppressed need for expression into the spheres delegated to them by the dominant male society. Needlework has been, in most cultures, a traditional female occupation" (p. 26). And another character reads from a published source a quilter's assertion that "My whole life is in that quilt. All my joys and all my sorrows are stitched into those little pieces. My hopes and fears, my loves and hates. I tremble sometimes when I remember what that quilt knows about me" (p. 171). The eminent anthropologist cites something as "a perfect example of the fact that men and women don't share the same cultural traditions" (p. 45), and the young anthropologist who becomes Rachel's love interest wonders about "coded messages in quilts" (p. 86). Of course, the album quilt literally takes its power not from the quilt per se but from magic that has been worked into it, and the message of this quilt is that of rivalries and jealousies that have divided women (though ultimately it draws together and unites characters in the novel's present action). Despite this, Michaels does work from the idea that quilts have been central to women's lives and creative expression—to the extent of expressing malice and ill-will in this case.

Interestingly, *Stigmata* also involves a quilt with slavery connections, though not a slave-made quilt. The principal action of the story involves what is happening in the 1990s with alternating chapters in which the action takes place in the 1970s and 1980s. There are also journal entries from 1899 and visions and memories of earlier events. In the 1990s the narrator Lizzie DuBose is trying to readapt to everyday life after extended stays in a mental institution. The chapters from the seventies and eighties tell the story of how she got there and how she found her way back out. Her troubles begin when, at the age of fourteen, Lizzie inherits a trunk from her grandmother, Grace Lancaster, who had abandoned her family when Lizzie's mother was a young girl; it contains a quilt made by Grace and a journal written by Grace's mother, Joy, but containing the story told to her by *her* mother, Ayo, who was brought to America as a slave. In a letter, Grace says that the quilt also tells Ayo's story.

After sleeping under the quilt and reading the journal, Lizzie begins to have unsettling dreams which become visions in which she becomes both Ayo and Grace. Her medical doctor father becomes concerned as she becomes obviously unsettled by these happenings and drags her to consult psychiatrists. She "sleepwalks" into a stream. She begins to feel physical effects from her visions, dust from the roads walked down in them, pain from the slave shackles that bound Ayo. When she begins to bleed as if from the wounding friction of such fetters, her father assumes the wounds are self-inflicted and, alarmed that she is suicidal, has her committed. She comes to realize, however, that she is the reincarnation of both Ayo and Grace (who left her family because she was herself wracked by visions of Ayo and hoped to spare her husband and children these torments she did not understand) and that her visions are real memories, her wounds like the stigmata a Catholic priest tells her about. In the end she is home, helping her mother, Sarah (who is also Lizzie's daughter since Lizzie reincarnates Grace) heal from her early abandonment, and she is making a quilt that tells Grace's story to bring the cycle of these lives to a conclusion.

The novel can be read on several levels. The reincarnation of Ayo—a slave kidnapped out of Africa—as her own later descendants and the reincarnation of Grace—who is recipient of Ayo's soul—as Lizzie are suggestive of African Americans' dealing psychologically with the whole issue of slavery down through the postslavery generations. Grace is haunted by Ayo's capture and painful shipboard passage and shackling to the extent that her memories torture her to flee from her family to spare them her increasing torments; Lizzie is tormented to the extent that she is thought mad and locked away. Perry means to say that, though socially African Americans have come up in the world over time (Grace enjoys a pleasant, relatively stable rural existence until she flees; Lizzie grows up in a safe, prosperous, upper-middle-class world), they must contend with the terrible scars of slavery in the collective group memory. Joy's diary recounting of Ayo's history passes on such a memory, and it is one generation's attempt to express and to deal with the pain. Grace's quilt, which she makes only after having left the family, is her attempt, and in the quilt she appliqués Ayo's story, telling it again. When Lizzie sleeps

under the quilt, the memory of Ayo's story passes to her with its pain and suffering, as the memory of slavery passes even to the most modern generation of African Americans. Her quilt of Grace's story is a marker of moving on and ahead, of working through painful experience and memories, and telling newer, better histories—her own but also those of black America generally.

Perry is telling her readers that these difficult memories of the black experience in America (though often left conveniently forgotten until something stimulates recollection) are there and are real, causing real pain which may seem to drive people mad and whose origins may not be immediately apparent. A quilt, which preserves past heritage, which can tell a story in several ways, and which can literally enfold us in memories of our forebears and their history, lends itself to being an emblem of memory. If the memories evoked by Grace's quilt are of evil things, they are evil things that finally can be transcended by telling happier stories in thread and by coming to terms with memory, however painful that may be.

In the works discussed in this chapter, a knowledge and appreciation of quilts which the modern reading public can be presumed to have combines with the qualities quilts exhibit which can render them complex cultural symbols for late-twentieth-century (or twenty-first-century) readers. Those qualities include the presumption that quilts emerge from a salvage ethic; their association with being heirlooms and repositories of memory; the fact that they are commonly made up of many pieces which have been joined aesthetically into a unity; the recognition of their ability to communicate; a recognition of their beauty; their emanating a female aesthetic and their integral connection to the domestic sphere of women; and their creation through the force of folk tradition through which are transmitted design patterns and their names, methods of fabrication, and attitudes toward design and aesthetic judgments, and use. Different writers have worked with different qualities in laying out the meanings of quilts in their particular narratives.

Of course, the existence of quilt making as a significant part of the world of women has been particularly important so far as the literary context of quilting is concerned (and it is no coincidence that

quilts come to the fore in writing by women, though in the late twentieth century the appreciation of quilts by men is common-place). Quilts thus can become emblematic of women's culture, of women's lives and values and ideas, of women as members of a folk group with their own world with its own insider norms, texts, and contexts. Conversely, quilts and a knowledge of quilts can be indica-tive of the exclusion of nonmembers of the group (that is, males) from shared understandings. The exclusion of men is perhaps most central to Glaspell's "A Jury of Her Peers" and Warner's "A Widow's Quilt," as the female characters deduce truths unseen by the men of the story and, indeed, as they act in Glaspell's story to protect one of their own from male authority. But the theme is important in other works as well. The men who are obsessed by Grace Marks in *Alias Grace* certainly have little interest in her quilts and no comprehen-sion of the symbolic truths those quilts offer (a fact which mirrors the care that Grace takes in revealing and not revealing herself to the world of the male-dominated establishment). And the research undertaken by Barbara Michaels's protagonist reveals the theme in a more abstract way. But even where the exclusion of men is not explicit, that the quilting context is a women's context is obvious. The lives of Otto's characters intersect primarily in terms of their belonging to the Grasse quilting circle. Stowe's Mary Scudder's pas-sage from single girl to married woman takes place in the world of women bound together by quilting. And the making of a quilt which depicts Grace's life in *Stigmata* ultimately plays a key role in drawing together Lizzie and Sarah as women finally engaged together in undertaking a pursuit traditional to women.

Of course quilting is not merely a women's art form but a folk art form in which not all women participate. It has its techniques, its skills, its understandings which may, in fact, have been shared by fewer and fewer women as quilt making declined from the late nine-teenth century on. Thus a knowledge of this somewhat esoteric crafts tradition can mark a different kind of outsiderness-insiderness, of women who well understand the tradition and those who do not. "Everyday Use" works precisely upon that basic dichotomy. Dee (Wangero) has an outsider's incomplete appreciation for the tradi-tion and hence is ultimately rejected by her mother as next guardian

of the tradition's sacred artifacts. In the process Walker is able to poke fun at a kind of ethnic pride which, though real enough, is shallow and fails to appreciate the culture of the group beyond certain currently fashionable ideas. And it is because Otto's Finn is an outsider to the tradition that she is so important as an audience for the stories and for the "instructions." Though evidently she does not become a quilter, her being drawn into the tradition by association is indicative of her maturing into a woman ready for marriage (an echo of Stowe's story). Also in Otto's novel, Sophia's inability to appreciate an aspect of the tradition—the crazy quilt—points to the failures of her life.

But if some are shut out of the tradition—usually by their own inability to appreciate it—the quilt is nonetheless an emblem of harmony. That in a quilt which brings people together may be its beauty—the graduate student, the art dealer, and others in A *Stitch in Time* unite in their admiration for the strangely obtained quilts— but more likely it is the content of a quilt's message or the communality of quilt production. In Peterkin's story a quilt is used to suggest spiritual harmony. In Tyler's novel a quilt of apparently limited aesthetic worth nonetheless reflects the great harmony human beings are able to construct. Otto's diverse group—and the novel itself—are held together by their quilting bee, by the weekly activity by which they work together to create something shared. In "Everyday Use" the quilts bring together Maggie and her mother, even if they shut Dee out of the family circle. Of course the very nature of a quilt as a whole made up of disparate pieces lends itself to the idea of harmony coming out of division, unity out of diversity. Thus Tyler conceives of her "patchwork planet" and Otto structures her novel as a patchwork of lives. The patchwork nature of quilts, then, has intrigued writers in terms of narrative structures, writers who give us novels put together like pieced quilts. The extent to which a novel can be a work of bricolage is debatable, but the idea that a long narrative can be pieced together clearly has appeal. Thus Otto and Atwood re-situate folklore in terms of formal, stylistic structure, though metaphorically rather than literally.

A quilt is also an artifact which survives through time and which is seen as having considerable power to communicate feelings

and thoughts. That combination renders it an important memory object able to evoke past times and stories, whether the pattern itself was meant to tell a story, or the materials used are literal souvenirs of past generations, or the quilt is merely a tangible connection with its maker. Eliza Calvert Hall's Aunt Jane specifically calls attention to her quilts as a kind of picture album. The quilt which Lizzie's grandmother Grace in Perry's novel has made to tell her slave ancestor's life story has been made to pass on memories also, memories so powerful that they have a daunting effect on later generations. Atwood's Grace Marks's quilts are more loosely related to specific memories, but *Alias Grace* is a novel about the very process and meaning of memory, and the quilt patterns whose names name chapters and which thus help to structure the novel exist in a context in which memory is a central concern.

It may be that feminism and a feminist interest in a bricolage aesthetic have paved the way for the recent popularity of quilts and quilt making as symbols and as structuring devices. Yet the literary interest in quilts long predates such developments. Something inherent in quilts—beauty, the fascination of unity out of fragmentation, a process of collective creation, a thrifty work ethic, their being intimate bedroom furnishings—seems to have exercised a powerful influence upon writers (as, perhaps, upon the rest of us) over a long period of time, and we are still—as writers and as readers—responding to what is special in quilts.

Cultural Objects, Personal Images

Frida Kahlo, Clarence John Laughlin, and Folklore

Though there is little commentary by folklorists on folklore as re-situated by plastic or visual artists, obviously the inherent possibilities for doing so are varied and complex, as we have tried to indicate, however briefly, in earlier chapters. It is not difficult to think of examples ranging from Renaissance paintings and statuary based on myth and legend, to Victorian paintings from fairytales; Winslow Homer's superb 1877 rendering of a costumed John Canoe reveler in the American South; and the work of the twentieth-century artists discussed above—Diego Rivera, Ester Hernandez, Thomas Hart Benton, and others.[1] Clearly, folklore can be used by visual artists for a variety of purposes and meanings, and the exploration of the folklore/visual arts connection is, moreover, a promising one for future research. What we wish to do in this chapter is to examine in some detail the work of two artists, one—Frida Kahlo—Mexican, the other—Clarence John Laughlin—American, whose uses of folklore are striking and extended (if in Laughlin's case not necessarily extensive).

Kahlo and Laughlin were roughly contemporaries, though they never met and probably were unaware of each other's work. Both

have been associated with surrealism, though the extent to which either self-identified with that movement is an open question.[2] Both were interested in producing images which others have found grotesque or fantastic. They worked in different media—Kahlo in painting, Laughlin in photography—and when they used folklore they did so for different reasons. In looking at their respective work here we seek to find additional understandings of how folklore can be re-situated in visual art as it is in literary texts and to explore more intensively some of the ways in which it can function in the visual arts context.

Kahlo, whose work has had tremendous vogue in recent years, used folklore as she did much else: to explore her connection to a nationalist artistic endeavor, its politics, and its aesthetic, and—within that larger aesthetic—to create and re-create her own self through artistic projections of that self. Laughlin used folklore in his photography not to construct any sense of his own identity (though perhaps all art does that for the artist) but rather to express and to comment upon what he saw as a mysterious universe. Folklore offered to him what he conceptualized as certain bizarre and esoteric realities which, as captured and transformed by his lens, gave him images of fantasy and strangeness which could stand as representations of "secret meanings" and "imaginative transmutation."[3] That Laughlin's and Kahlo's approaches to incorporating the folk in the visual are so different suggests something of the range of possibilities for doing so. In the case of Kahlo, her art and the projection of self that it helped to establish have inspired various re-contextualizations by others, and her work—and her image—now appear in numerous folk and popular culture forms, so that her life and work bear an especially intriguing place in considerations of the interactions of folk and nonfolk texts.

Frida Kahlo was hardly alone in her intense artistic interest in her own country and its culture. A celebration of *Mexicanidad,* or "Mexican-ness," had already been embraced by other Mexican artists and writers in the 1920s, following the end of the Mexican Revolution when the rise of a nationalistic spirit stimulated interest in the indigenous art of Mexico. The celebrated mural movement in Mexico—of which

Kahlo's husband Diego Rivera was a leading light—renounced all art divorced from the Mexican scene. Mexico's history, its revolutionary struggle, its indigenous people, and (especially for Rivera) its folklore and popular culture—all these were the subjects of the muralists' work. Less obviously, these subjects also feature significantly in Kahlo's work, although Kahlo (only thirteen years old in 1920, after all) began painting during a somewhat later stage of the postrevolutionary period. She first turned to painting to occupy her time while recuperating from an accident in 1925, using a specially constructed easel that could be attached to the bed where she was confined in a body cast, and she thus began the lifelong task of self-creation through her art. In 1928 she met Diego Rivera and showed him some of her work. They married in 1929.

As is often noted, Frida Kahlo's physical and emotional life is chronicled in her paintings. As a child she had polio, which left her with a slight limp. As a teenager, she studied at the Escuela Nacional Preparatoria, one of only thirty-five women out of two thousand students, until 1925, when at age eighteen she was injured in an accident in which an out-of-control streetcar rammed into the bus she was riding. A metal rod pierced her abdomen; her spinal column, collarbone, two ribs, right leg, and foot were injured, her pelvis was fractured, and a shoulder dislocated. She would spend the rest of her life in a great deal of pain (and often confinement), enduring numerous operations on her spine and leg. (Toward the end of her life her right leg had to be amputated at the knee because of gangrene.) She died in 1954. Emotional blows *not* stemming from the accident centered on her relationship with her husband Diego Rivera, whose infidelities were notorious. She was especially shaken when he had an affair with her favorite sister, Cristina. In 1939 Kahlo and Rivera divorced, but they remarried the next year. The emotional content of these life events—tragedies, losses, betrayals, and physical illnesses—are the raw materials out of which Kahlo's life story is constructed, and these life events are the focus of much of the current commentary and interpretation of her paintings, although some recent criticism argues convincingly for the need to view Kahlo's work in a broader social and cultural context.[4]

Kahlo's work was intensely personal, private, and small, in contrast to the work of the Mexican muralists, which was didactic, public, and monumental. Indeed, self-portraits make up approximately one-third of her relatively small body of work.[5] Kahlo in fact focused much of her creative energy in the self-conscious examination of her life and her personal history, interpreting both in terms of the larger national history and identity. For example, she always gave 1910, the year of the Mexican Revolution, as her birth year, even though her actual birth came three years earlier,[6] in Coyoacán, a suburb of Mexico City. This is just one of many ways in which she deliberately "created herself in mythic proportions."[7] In her choices of dress, hair style, and jewelry; in the environment she created and maintained in her home; in the Mexican meals she cooked and often delivered to her husband Diego Rivera at work on various murals; in the art collections she and Rivera amassed; and in her own body of work as one of Mexico's premier painters, she constructed her identity in terms of connections to Mexico and Mexican roots, using folk subjects among others in her paintings. But although her subject matter was a very personal one (in that it included objects and events from her life — and often her own image), she used it to create art which commented on Mexican political and social institutions, even as she created a persona related to a grander sense of Mexican identity and thus to a larger cultural context.

A very early Kahlo painting, *Pancho Villa and Adelita* (1927), refers to two well-known characters from Mexican history and folklore, both associated with the Mexican Revolution. Adelita is the soldier-heroine of a still popular folksong dating from Mexico's revolutionary struggle, when *soldaderas* like Adelita took up arms and fought in battles alongside Mexican men. Sarah Lowe maintains that this painting shows Kahlo's identification with Adelita and the *soldaderas* and that in it "she not only places herself in an historical relationship with Mexico's revolutionary past but adopts an appropriate foremother."[8] Kahlo did in fact sometimes wear short leather boots like those the *soldaderas* wore, and several photographic portraits show her wearing a *rebozo* draped around her in the manner of a *soldadera*.[9] In the painting, however, Kahlo is not dressed as a *soldadera*,

but in an off-the-shoulder evening gown, while a small portrait of revolutionary hero Pancho Villa hangs over her head. On the left side of Villa's portrait, another picture depicts a military train (mentioned in the song "Adelita") with revolutionary soldiers and *soldaderas* in and on top of it. Lowe refers to this picture as "a painted vignette from the Revolution."[10] To the right of Villa's portrait, another picture depicts a modernistic structure, perhaps made of concrete. Lowe calls this structure "a stage set or bar," while Luis-Martín Lozano describes it as "a modern piece of abstract architecture of fantastic and illusory proportions."[11] Kahlo stands in the center of the painting behind a table where two men in suits are seated; one man has his back to the viewer and the other is faceless. A 1926 sketch of this same scene, however, suggests that the 1927 painting is unfinished; in the sketch a number of figures are shown around a candlelit café table, engaging in a discussion or debate. The idea of a debate is echoed by the contrast in the two paintings flanking the portrait of Villa—one depicting a nationalistic theme and Mexico's revolutionary past, the other a modernistic, almost cubist rendering. Lozano refers to these paintings as "metaphorical images" of the dilemma facing Kahlo the artist.[12] Likewise, the location of Kahlo's image in the center of the painting also suggests a position from which to contemplate and reassess the political implications of the other figures, especially the two mentioned in the painting's title (and thus the revolutionary period they represent).

Feminist critic Margaret A. Lindauer writes about Mexico's *soldaderas* that by participating in battles and in public arenas, they were "blatantly disregarding prerevolutionary gendered codes that presumed women's absence from active political combat." But postrevolutionary regimes interested in re-establishing a stable society promoted the traditional patriarchal family structure and a return to domestic roles for women. As Lindauer notes, "After 1920, accounts of the revolution celebrated women as loyal companions and helpers rather than fierce fighters."[13] *Pancho Villa and Adelita* comments on this shift away from the less restrictive gender codes of the revolution by showing Kahlo as a postrevolutionary woman, perhaps a latter-day Adelita, in feminine middle-class attire contemplating

various competing icons of Mexican culture, the aftermath of the revolution, and the changing status of Mexican women. The portrait of Pancho Villa which memorializes him as a hero of the revolution, the portrait of the fighting men and women, and the bare, modernistic-looking structure occupy competing frames of reference, while the faceless men in suits and the completely black canvas contribute to the enigma of this painting.

After her marriage to Rivera in 1929, Kahlo's re-creation of her own image in terms of Mexican folk and popular culture, in both her art and in her personal life, increased. The now-familiar image of Frida Kahlo wearing native-style blouses and long skirts from various areas of Mexico, her hair braided and arranged on top of her head in the manner of Mexico's indigenous women, appears in a number of her self-portraits. Kahlo dressed in these same costumes on a daily basis, carefully constructing her image in life as in art.[14] Rivera, who "liked to stress the Indian aspect of Frida's heritage,"[15] bought her pre-Hispanic jewelry and encouraged her habit of wearing indigenous costumes and hairstyles, a fashion statement consistent with the political sentiments of both Kahlo and Rivera.

Most often Kahlo dressed as a Tehuana—a woman from the Isthmus of Tehuantepec, a tropical area of Mexico whose women are "famous for being stately, beautiful, sensuous, intelligent, brave, and strong." Tehuana women, it is said, "run the markets, handle fiscal matters, and dominate the men."[16] The Tehuana costume consisted of "an embroidered blouse and a long skirt, usually of purple or red velvet, with a ruffle of white cotton at the hem . . . , and for special occasions an elaborate headdress with starched lace pleats."[17] The Tehuana blouse and skirt appear in numerous Kahlo self-portraits (and photographs).[18]

The Tehuana costume had become popular among urban Mexican women in the 1920s (it also appears frequently in art of that period), symbolizing "not merely a celebration of cultural heritage but an exaltation of continuous pre-Columbian culture and a defiance to cultural assimilation."[19] In other words, wearing the Tehuana costume in the 1920s was a political statement in line with postrevolutionary cultural goals. Kahlo's use of the costume likewise

constituted a political statement in support of a Mexico free from European cultural domination; but because she wore it beginning in the 1930s, long after it was generally fashionable, the dress also became associated with her personal identity. Unfortunately, as Kahlo began to exhibit her work nationally and internationally, commentary often focused on her clothing and on her personal appearance rather than on her paintings, and even today her life story and her exotic appearance distract audiences from more complicated messages in the paintings; the political significance of her dress is diminished in favor of more personal associations. Various commentators have noted that the long skirts she characteristically wore (including Tehuana costumes) also allowed Kahlo to hide her physical defects—a limp and scars from various surgeries—while making herself attractive and charming. That she continued to wear the festive costumes every day even after she was ill and dying is cited as an indication of how much she relied on them to help her maintain a positive self-image in the face of diminishing odds.[20]

Besides native costumes, hairstyles, and jewelry, many other folk cultural items that are specifically Mexican, including especially folk art, appear in Kahlo's pictures, symbolically connecting her with her roots in her native soil. Even as a girl she had delighted in buying Mexican popular toys and folk art from the markets. Rivera shared this interest, and they filled the Blue House with their collections of "rustic furniture, lacquer-painted objects, masks, papier-mâché Judas figures and votive panels."[21] The papier-mâché effigies known as Judas figures often depicted public figures and were strung up in the streets, wrapped in strings of firecrackers so that they could be "blown up" on Saturday of Holy Week. Judas figures appear in several Kahlo paintings, notably in *Four Inhabitants of Mexico City (The Square Is Theirs)* (1938; fig. 7). The four inhabitants are a huge Judas figure, associated with betrayal and soon to be blown up;[22] a pre-Columbian pottery rendition of a pregnant female, symbolizing Mexico's Indian population, broken and partially repaired; a *calavera* or skeleton toy associated with the most important Mexican holiday, the Days of the Dead (a festival which blends Catholic and pre-Columbian ideas about the cycle of life and death); and, approaching on the far right and in the distance,

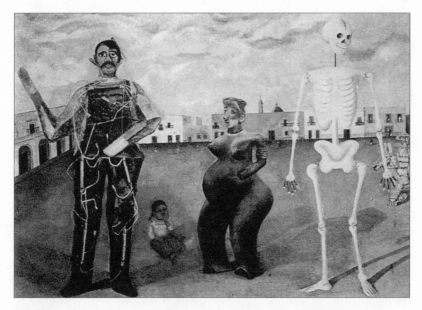

Figure 7 *Four Inhabitants of Mexico City (The Square Is Theirs) [Los cuatro habitantes de la ciudad de México],* by Frida Kahlo; oil on Masonite; 1938. © 2003 Banco de México Diego Rivera & Frida Kahlo Museums Trust Av. Cinco de Mayo No. 2, Col. Centro, Del. Cuauhtémoc 06059, México, D.F. Reproducción autorizada por el Instituto Nacional de Bellas Artes y Literatura. Reproduced with the permission of the Banco de México and the Instituto Nacional de Bellas Artes y Literatura, Mexico City. Photo: Fondo Frida Kahlo Calderon, CENIDIAP.INBA.MEXICO.

a children's toy horse and rider made of reeds, a fragile "straw man," probably representing a revolutionary soldier.[23] Herrera identifies a fifth figure, a little girl wearing a Tehuana dress, as a young Frida and the square as Kahlo's native Coyoacán.[24] Like the Kahlo figure in the earlier *Pancho Villa and Adelita,* this child contemplates emblems of Mexico's cultural heritage: the (Christian) Judas figure, the (pre-Columbian) pottery piece, and the (syncretic) *calavera,* while the reed soldier (representing the revolution) approaches.

Margaret A. Lindauer analyzes this painting in the context of the politics of Lázaro Cardenas's presidency (1934–1940), when the government sought to create a unified national culture through education and economic opportunities. The dilemma created by this approach to ending economic oppression, however, was that bringing indigenous populations into the mainstream would result in the

loss of cultural individualities, and Lindauer thus sees Kahlo's painting as a commentary on the problems of defining "the Mexican" as a unique entity. Instead, she argues, "Kahlo's painting presents 'the Mexican' in a series—pre-Columbian, conquest, revolutionary, mestiza—each of which ultimately is dominated by subsequent characterizations of 'the Mexican.'"[25] The peripheral position of the revolutionary fighter relative to the other figures, she argues, contributes to the painting's message "that without the ideological foundation of the revolution as an economic and ethnic rebellion, the symbols of national identity are superficial."[26]

Herrera, on the other hand, reveals that each of the inhabitants was in fact "modeled after a Mexican artifact that the Riveras actually owned."[27] (They also had their own favorite artisan who made the papier-mâché Judas figures for them—including the one in the painting which is made in Rivera's image and dressed in his overalls.[28]) Thus, despite the dismal vision of Mexico's inhabitants as fragile and ephemeral figures, they nevertheless are familiar companions, clearly identified with both Mexico and Kahlo's own life. An earlier painting, *Tiny Caballero* (1928), painted the year before Kahlo married Rivera, shows the same reed horse and rider, with another folk art item, a lacquer tray, from the same area of Mexico (Lake Pátzcuaro in Michoacán). This comparatively uncomplicated painting demonstrates Kahlo's early familiarity with and interest in folk art, which she used later in more complex paintings such as *Four Inhabitants* to express political ideas.

In addition to depicting folk art and cultural items in her paintings, Kahlo draws on the vision of pre-Hispanic religion and mythology. Images suggesting the tension between opposite forces pervade ancient Mexican indigenous art and persist in contemporary Mexican folk and popular art—images that join life and death in a single face divided down the middle, for example, or that combine human and animal forms. These dualities also appear in various Kahlo paintings, and the theme of a split self-image is developed in several Kahlo double self-portraits, including *The Two Fridas* (1939) and *Tree of Hope* (1946). She painted *The Two Fridas,* her best-known single painting, during the period Rivera was pushing her to consent

to a divorce. There are two full-length self-portraits in the painting, seated next to one another with clasped hands. One Frida is dressed as a Tehuana, representing Kahlo's Indian heritage, and she holds a miniature portrait of Rivera in her lap. This figure is often said to represent the Frida Rivera had loved. The second Frida, supposedly the one scorned by Rivera, wears European-style Victorian dress. Both Fridas have exposed external (anatomically detailed) hearts, and a vein runs from the portrait of Rivera, through the "healthy" heart of the Tehuana Frida, to the broken heart of the European Frida, finally ending in her lap, where blood from the severed vessel has stained her white dress—despite the surgical pincers with which she attempts to hold back the flow, for no image of Rivera is here to complete the circuit.

Like *Four Inhabitants* (painted the previous year), *The Two Fridas* contributes to the national discussion of what constitutes the "paradigmatic Mexican," as it addresses, on the one hand, the subject of Kahlo's personal dual identity as a *mestiza*. That is, like the majority of Mexicans, her heritage is mixed—part Indian and part European—and she thus locates her personal identity in terms of Mexico's history of colonization and *mestizaje* (racial mixing). Her dual heritage—like Mexico's—is part Indian and part European, even though the politics of *Mexicanidad* (especially as interpreted by Rivera) exalts the Indian over the European. On the other hand, as Lindauer points out, noting the European Frida's Victorian dress, during the colonial and post-independence eras, the creole had been held to be the true Mexican. Lindauer thus argues that the two Fridas (representing two views of who constitutes the true Mexican, from the vantage points of two different eras) are nevertheless connected through the larger context of gender politics, which have passed unchanged from one generation to the next.[29] That is, although there were political advances for women during the 1930s, growing anti-feminist sentiments made the passage of women's suffrage seem unlikely, marking the end of the decade as "a time of great defeat" for women. Thus "the concurrence of Kahlo's divorce and women's defeat is inscribed in *The Two Fridas* as differences between *criolla* and *mestiza* are transformed into similarities."[30]

Hayden Herrera points out that Kahlo's practice of painting her own image as reflected in a mirror "must have accentuated [her] sense of having two identities: the observer and the observed; the self as it is felt from within and the self as it appears from without."[31] In *Tree of Hope*, for example, one Frida lies anesthetized on a surgical gurney, the bloody incisions on her back exposed to the viewer, while another Frida, dressed in a red Tehuana costume and holding a banner which reads "Tree of Hope, Keep Firm," takes the role of the strong guardian of her wounded self as she sits tall keeping her vigil. Nevertheless, her loneliness is accentuated here, as in *The Two Fridas*, by her isolation in a desolate landscape, with only herself as company. *Tree of Hope* is also a good example of how Kahlo draws on indigenous mythology in its vision of the universe as constructed of opposing warring forces, a vision still reflected in much contemporary Mexican folk art.[32] The contrast between the wounded Frida and the comparatively healthy guardian Frida is emphasized by placing each in a contrasting environment; the wounded Frida lies under the sun which has parched the landscape, while the healthy Frida sits in a darker space lit by the moon.

In *My Nurse and I* (1937), Kahlo paints herself with a grown-up head and a rather limp infant body, in the arms of a wet nurse wearing a pre-Hispanic stone mask from the Teotihuacán culture. Like many of the seemingly surreal images in Kahlo's paintings, the central figure in *My Nurse and I* was in fact probably inspired by a real-life familiar object, in this case a Jalisco funerary figure of a nursing mother in Kahlo's collection.[33] The white raindrops in the sky behind the nurse figure were inspired by Frida's own Indian nurse's explanation to her that raindrops in the sky were "milk from the Virgin." Herrera comments that the mask "could hardly be more chilling as a mother image; a funerary mask, it evokes the ritual savagery of the Mexican past. . . . Frida appears to be simultaneously protected by the nurse and offered as a sacrificial victim."[34] Nevertheless, the painting does suggest the continuity of Mexican culture, and it validates Kahlo's connection to Mexico's pre-Hispanic past, contributing to her invention of a self in the present. Referring to the nurse in the painting as "a concretization of Mexico's Indian heritage,"

Herrera points to the nurse's "loose black hair and eyebrows that meet" as confirmation that she is "the baby's ancestor or perhaps another side of Frida," and suggests that the painting may in fact be a kind of double self-portrait—like *The Two Fridas* and *Tree of Hope*— in which "one aspect of Frida nurtures the other, becoming the life sustaining half in the central duality of Frida's adult self."[35]

But besides the *items* depicted and the Mexican cultural outlook, or worldview, there are strong connections between Kahlo's work and traditional Mexican art *forms*. For example, the series of paintings recording the important events of her life (an idea suggested by her husband Diego Rivera) has been compared to the Aztec tradition of manuscript painting co-opted by the Spanish colonial government to record native customs and beliefs.[36] Her use of themes that seem morbid or shocking have their parallel in Mexican folk and popular art, in the broadside illustrations of José Guadalupe Posada,[37] and even in colonial art. For example, *The Deceased Dimas* (1937; fig. 8) shows a child's corpse laid out in accordance with Mexican funeral tradition; resting on a reed mat, his eyes open and unfocused, a trickle of blood runs from the corner of his mouth. A somewhat morbid idea to us, perhaps, but Kahlo has in fact drawn on a Mexican tradition of mortuary portraits which has roots in medieval Europe.[38] Dimas was a three-year-old boy, a young member of a family who often posed for Rivera, a family who would not have been able to afford to commission such a mortuary portrait. In the painting, flowers are strewn around the boy's body and a holy card image of Christ being flagellated lies next to his head on a pillow. The boy is dressed to portray one of the Magi, in a silk robe and a crown, holding a gladiola like a scepter. But betraying his social status, his feet are bare and the humble reed mat he lies on is practically synonymous with Mexico's indigenous population. Thus Kahlo has used a traditional art form and transformed it so that it comments ironically and without sentimentality on the high rate of child mortality in Mexico. The banner in the painting reads, "The little deceased Dimas Rosas at three years of age, 1937," but the title Kahlo gave the painting when it showed in New York in 1938 was *Dressed Up for Paradise*.

The popular art form Kahlo most often drew on, however, was the votive painting genre popularly called a *retablo*. The *retablo*

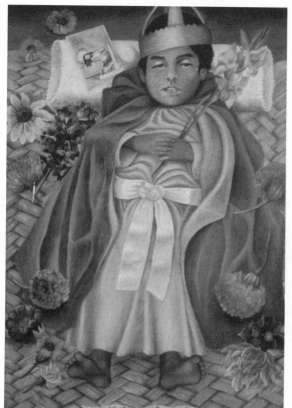

depicts the story of a miracle—the intervention of a saint or other divine power to effect a cure or otherwise save a life. Details of the story are spelled out in a hand-lettered text. Evidence of the influence of *retablo* art on Kahlo is seen in her extensive use of sheet metal as a medium (which Rivera suggested she use[39]), and the relatively small size of her paintings, but also in her use of stylistic features such as explanatory texts, floating objects, and naive primitivism.[40] *Henry Ford Hospital* (1932; fig. 9) was the first painting she did on sheet metal, and like a *retablo* it tells the story of a momentous event, but without the divine intervention: Kahlo's miscarriage while she and Rivera were living in Detroit. Rather than the accompanying narrative text a *retablo* would have had, the bed frame bears the identifying words, "Julio de 1932, FK, Henry Ford Hospital Detroit." Symbolic images (a fetus, a snail, an orchid, and various medical models and machines)

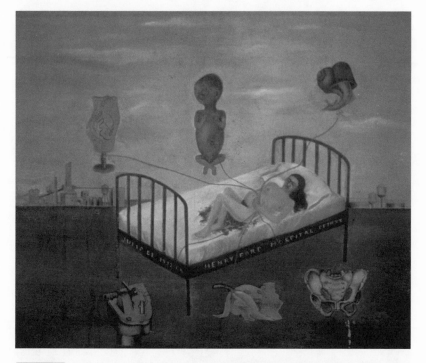

rather than images of saints as in actual *retablos*, float around the bed, attached to the wounded Frida by red ribbons. Explications of the painting point to the distraught figure of the tearful Frida in her bloody hospital bed, to the central position of the male fetus floating directly over her, and to the barren landscape, with the skyline of Detroit factories in the far distance, and interpret the painting as an expression of Kahlo's sorrow over not being able to carry a child to term. Herrera, for example, refers to the floating objects as "symbols of maternal failure."[41] Lindauer, however, looks beyond this surface message and finds in the painting a more covert challenge to the prescribed social roles allowed women "by making explicit the limited realm (motherhood) in which women could be socially esteemed."[42] Moreover, exploiting

the religious uses and associations of the *retablo* format, the painting also makes an ironic statement about the inadequacies of medical "miracles," as Kahlo's medical history even at this point in her life was characterized by misdiagnoses and failures.

Another interesting example of Kahlo's use of the *retablo* format is *The Suicide of Dorothy Hale* (1939; fig. 10), the text of which reads: "In the city of New York on the 21st of the month of OCTO-BER, 1938, at six in the morning, Mrs. DOROTHY HALE committed suicide by throwing herself out of a very high window of the Hampshire House. In her memory, Clare Boothe Luce requested for the mother of Dorothy this retablo, having executed it, FRIDA KAHLO." Durand and Massey identify classic *retablo* features in this painting as:

> a bleak, surreal use of space; the segmentation of time and the condensation of action to highlights (the three phases of the fall); the depiction of images in clouds; the use of bold contrasting colors; the provision of an explanatory text written in childlike grammar; a script that mixes capital and small letters; a deliberate blurring of the border between life and death (dripping blood and an inert body with a composed and beautiful countenance making eye contact with the viewer).[43]

Not being familiar with the form, Mrs. Luce was of course horrified and wanted to destroy the piece, only agreeing to preserve it if the phrase with her name in it was painted over.

Drawing on folk and popular art for themes and formats and even style had several advantages for Kahlo's art. Herrera argues that "their small scale and *retablo*-like style," as well as "their bright color, and charmingly naive drawing," make certain of Kahlo's paintings more bearable to look at, by distancing us from their painful content. "The popular art manner undercuts, and simultaneously underscores, the impact of horrific images—images that the example of popular art emboldened her to present. Works such as *Dimas* and *Henry Ford Hospital* are thus ingeniously ingenuous, and Frida's primitivism is an ironic stance."[44] Lindauer notes, on the other hand, that the integration of popular art and tradition into her work to such a degree may be

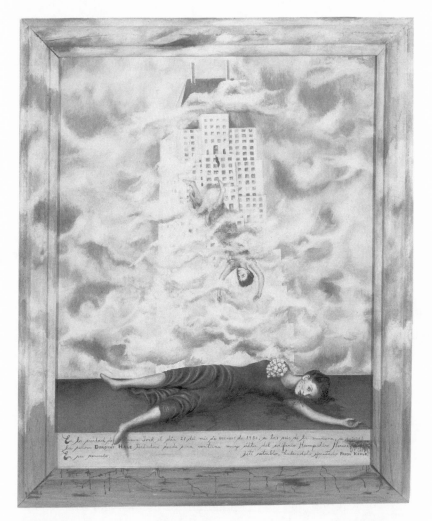

responsible for the fact that scholars tend "to marginalize her work out-side the realm of national politics," preferring to interpret it exclusively in terms of her personal life.[45] Nevertheless, painting folk and popular art objects and indigenous costumes, and drawing on the worldview of

ancient Indian myth and religion still observable in Mexican cultural attitudes, allowed Kahlo to use Mexican artifacts and Mexican themes to explore the meaning of the events of her own life in relation to issues of concern to the nation at large.

Kahlo's dramatizations of her own physical and emotional suffering in her art use specifically Mexican images, occurring within the historical and ideological context of *Mexicanidad*, a nationalist movement which, beginning in the 1920s, championed all things native. It is all the more extraordinary that, as Lindauer notes, "Kahlo's paintings rely solely on female references in setting forth a distinct examination of women's position in relation to [dominant postrevolutionary discourse]," in which women were marginalized.[46] In a feminist analysis of Frida's self-portraits, Paula M. Cooey argues that Frida "identified herself, her body, its appearance, her pain, and her pleasure metaphorically with Mexico; the terms for this connection were not only patriotic, but also spiritual in relation to the natural order. From Kahlo's perspective, her mixed heritage and the events of her life reflected the history of struggle and suffering, as well as the hoped-for destiny of Mexico itself."[47]

Integral to Kahlo's art is the absorption in the folk and popular roots of Mexican culture that she shared with a number of her contemporaries, and her use of folklore must be seen partly as an attempt to connect with and to expose the intricacies of that particular cultural context, even when her subjects are highly personal. Although Clarence John Laughlin's photography is also highly personal, it is so more in the sense of its presenting an idiosyncratic vision than in his having used it to construct or even to reveal himself. And though he endeavored to make connections with other photographers, including Edward Weston and Margaret Bourke-White, and with intellectuals, he was, unlike Kahlo, part of no circle of artists, nor was his use of folklore tied to nationalistic or even regional concerns (though some may see his work as embodying a touch of the Southern gothic). Indeed he remained throughout much of his life a somewhat isolated figure working in provincial New Orleans. Where his work addresses the big issues, it attempts to connect us with the deep-seated concerns of the subconscious and with what he saw as the great mysteries of

existence. Folk art intrigued him when it seemed to emanate some cosmic secret or when it could be manipulated to project such a vision through the images he created with his camera.

Laughlin, though he has received international attention, has retained an anomalous position in the history of photography as a somewhat neglected figure. As John Wood has noted, "the photohistorians' and critics' inability to categorize and pigeonhole Laughlin has again and again led to his being excluded from the history books, neglected or even dismissed as a kind of unsophisticated and curious crank."[48] Or as Patricia Leighton says, "Laughlin was one of a small handful of photographers . . . who continued investigating the expressive possibilities of overtly manipulated photography after the Second World War" and whose "place in the larger international movement was long unacknowledged . . . their work . . . ignored as outside the dominant purist mainstream."[49]

Though one of his images appeared in the Whitney Museum's giant 1999 retrospective exhibition "The American Century," suggesting a measure of his eventual recognition as a photographer of considerable importance, in some respects Laughlin is still better known and more enthusiastically appreciated in his native Louisiana (where the Historic New Orleans Collection maintains an archive of his work) than nationally. He was born in Lake Charles in 1905 (that is, a few years before Kahlo) and while still a young boy moved to New Orleans, where he lived for most of the rest of his life. He had little formal education beyond elementary school, was forced to go to work for local businesses in his teens—coming to dislike "the values and rituals of the business plane"[50]—and did not seriously take up photography until the mid-1930s. In the thirties he began to make a modest living as a freelance architectural photographer, and in 1948 he published a book called Ghosts Along the Mississippi,[51] a collection of photographs of plantation houses. It was very successful, going through numerous printings and bringing him the steady income that enabled him to concentrate more fully on his noncommercial work. Early on he had become an avid reader and book collector, eventually amassing forty thousand volumes on a variety of subjects.[52] He was fascinated by words, and throughout his life he

was an avid correspondent and a prolific writer of disquisitions on photography, aesthetics, and the shape of the universe. More important perhaps, he wrote voluminous commentary on his own images—images which he organized almost obsessively—providing what amount to captions for a great many of them.[53] To approach Laughlin is almost to approach a literary figure.

Laughlin, who died in 1985, left over seventeen thousand negatives—most of them taken by 1965—which he divided into over twenty categories, such as "Early Industrialism" and "The Louisiana Plantations." Thus his artistic output was rather vast (in contrast to Kahlo, who produced probably no more than two hundred paintings). Folklore plays a role in rather few of his images and is certainly not an overriding focus of his work, but where he uses it he does so with a vividness that reverberates in the beholder's eye.

Having worked as an architectural photographer, producing images for clients who simply wanted striking illustrations of their own designs, Laughlin understood documentary photography at its most basic. However, documentary was not what interested him. Indeed, he strongly rebelled against what he saw as the dominant documentary and "purist" aesthetics of his day and against the idea of the photograph as merely "stenciled off the real" (as Susan Sontag was to later put it), of the camera as "no more than a copying instrument" (as Laughlin himself phrased it).[54] In fact, he resented those aesthetics. He wrote to Weeks Hall (painter and photographer as well as the last master of one of Louisiana's plantation house treasures, The Shadows, where Laughlin as well as the likes of Henry Miller and Walt Disney visited): "It infuriates me to see people with the power and position . . . try to stem the development of symbolic or hyper-real photography, and to force conformity upon all photographers."[55] Laughlin's mission was to create photographs that played with the "symbolic or hyper-real."

Commentators on his work consistently invoke such phrases as "vast mythologies" or "all phantasmagoria and gumbo."[56] Poet Jonathan Williams also asserts that Laughlin was "like Claude Monet . . . who told us '. . . try to forget what objects you have before you, a tree, a house, a field, or whatever,'"[57] implying that for Laughlin the

real objects he photographed were stand-ins for other realities. Laughlin sometimes created his effects through deliberate composition of objects, double exposure, and the use of models such as the black-draped figures who inhabit many of his photographs of cemeteries and ruined houses, while he attempted "to use objects as symbols of states of mind."[58] For example, in *The Besieging Wilderness, Number Two*[59] (1938), he uses double exposure to join the facade of the Beauregard-Keyes House, a French Quarter landmark, and a forest of trees, notably a central, moss-dripping live oak. The effect is one of man-made structure engulfed, utterly invaded by a wilderness, or perhaps by the threat that the decay of time and the semitropical environment wreak upon fragile human existence. In *We Try to See through the Mirror of Self*[60] (1941), a shrouded figure holding a mirror stands before the tomb of a New Orleans Italian American benevolent society while other substantial tombs fill in the background in a well-tended, prosperous-looking cemetery. The mirror's reflecting surface may be turned toward the figure's face or it may be turned toward the viewer of the photograph, thus asking exactly who is trying to look beyond the limitations or the surface texture of self. The numbered burial spaces in the tomb and the whole cemetery remind us of the ultimate death of our selves. Over it all a statue of St. Bartholomew—patron saint of the association—stands half naked and seems to laugh as if mocking the whole matter of self. Even a seemingly unmanipulated photograph of the interior of a ruined building—a fireplace overflowing with ashes or perhaps broken plaster or mortar, what may have been wallpaper hanging in shreds—was meant by Laughlin to evoke something more. He calls this image *The Room of Shrouds*[61] (1939), associating his scene with death and the passage of time, which so interested him in the ancient, sometimes half-destroyed houses that drew him as a subject matter.

In such photographs as these, Laughlin sought "instead of dealing with the object as a thing-in-itself, to deal with it as a thing-beyond-itself," to use photographs as "catalysts . . . or projections of my own inner world," to engage in "the use of the object as a symbol, and . . . the camera as a living instrument to probe the intangible psychological jungle in which every object is enmeshed." Photography,

he thought, "is concerned with the psychic content of objects," and helps us "to discover the extension of the individual object into a . . . more significant reality." "Everything," he writes, "everything, no matter how commonplace . . . has secret meanings."[62] Precisely what secret meaning individual photographs may hold, precisely what "hyper-reality" an image might take us to, precisely what psychic content a photographed object held, Laughlin is seldom explicit about (ditto, for the most part, his commentators), but his overall vision clearly saw realities beyond and behind the real, even if those realities remain rather vaguely realized.

Laughlin obviously was intrigued by the commonplace and its supposed "secret meanings." "In the most 'commonplace' objects marvelous new realities lie hidden," he wrote. "I feel that whole new worlds lie about us, sheathed in what we call the 'commonplaceness' of reality."[63] Perhaps this interest in what he saw as the mysterious inner meanings of the ordinary brought Laughlin to folklore, which is after all associated with the "common man" and the "ordinary" world of the non-elite. On the other hand, Laughlin may have thought of folklore as anything but ordinary, for not only was much of the folklore he photographed foreign to his own urban, middle-class world, but he concentrated on folk objects which likely would strike the average viewer of his photographs as exotic even on the surface (though he himself probably did perceive that many of those objects — such as south Louisiana grave boxes — would be ordinary to those who made and used them in the course of their everyday lives, and of course that is a paradox of folklore: what may seem quite ordinary to those who create and pass it on may seem highly exotic to those outside the folk community).

On one level the 1941 photograph called *Anatomical Cascade* (1940; fig. 11) presents a reality which is an ordinary one in the context of the urban culture of New Orleans. It shows the interior of a well-known chapel associated with miraculous healing, ironically located in the cemetery of St. Roch, both being Ninth Ward neighborhood landmarks. To the left side of the image, seeming almost to be merely stuffed in a corner between a wall and the altar, is a stack of wooden crutches surmounted by a metal leg brace, a loosely

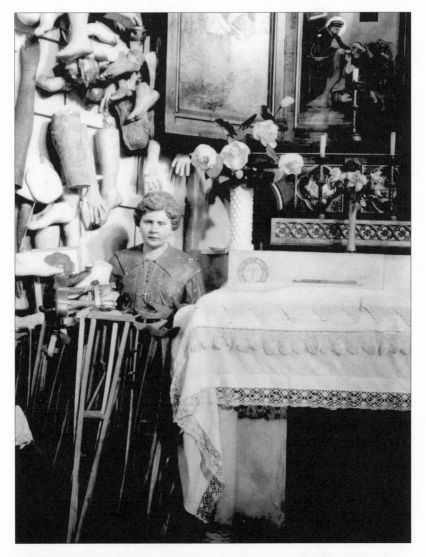

Figure 11 *Anatomical Cascade,* by Clarence John Laughlin; 1940. Copyright 1985, The Historic New Orleans Collection. Photographer: Clarence John Laughlin, #1983.47.2.191.

structured melange. From the wall above this stack hang plaster body parts, mostly arms and legs, the "anatomical cascade." These objects are, of course, *ex votos*, tokens presented by the cured to mark their successes, tokens associated with particular afflicted parts

of the body; they are expressions of both thanks and devotion. They are, indeed, a fairly ordinary feature of certain forms of folk Catholicism and folk ritual practice, though they may seem bizarre to visitors, even many Catholic visitors, to the Crescent City. These St. Roch's objects (which in more recent times have been shifted to an anteroom off the chapel, as though the Church finds them less ordinary than it once did) have been photographed by others with a more documentary bent, and Laughlin's photograph itself could be a piece of documentary. Yet clearly what appealed to him was not the social reality of a folk custom but the fantastic idea of "cascading" body parts, a surreal waterfall that plays with the fantastic while suggesting spiritual realities beyond both the real and the more conventional religion of altar and saints' pictures, as if the body parts are mysteriously appearing out of the wall from some universe beyond.

Laughlin looks at another New Orleans folk ritual in *The Phantom Shoes*, a 1940 image (fig. 12). It shows a different cemetery, St. Vincent de Paul, seemingly on All Saints' Day, November 1, traditionally the day when New Orleanians in great numbers visit family graves, cleaning them, bringing flowers, remaining to socialize. The image catches the cemetery's central avenue through the gate of one section across a city street to another section. Amid the "ovens" (wall vaults) and other tombs which facilitate New Orleans's preference for "above-ground burial," people make their ritual visits. Flowers stand in front of individual wall vaults on small shelves. However, the main point of the image resides in a woman—dressed darkly, as are all of the human figures in the picture—almost perfectly framed by the vaults and the wrought iron above the cemetery gate. Because Laughlin used a time exposure or slow shutter speed, we see the after-shadow of her movement as she must have turned while the shutter was open. There are particularly strong after-images of her shoes, left over from her earlier stances, the phantom shoes of the title. More than in *Anatomical Cascade*, Laughlin suggests realities which just barely appear in the real world, which are caught by the camera as they fleetingly make their presence known on the surface of our existence. Again the religious nature of the scene—a Catholic cemetery, a Catholic folk custom (indeed, one

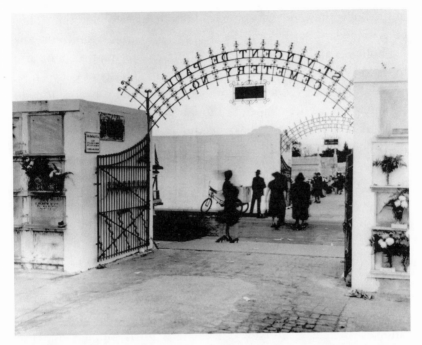

Figure 12 *The Phantom Shoes,* by Clarence John Laughlin; 1940. Copyright 1985, The Historic New Orleans Collection. Photographer: Clarence John Laughlin, #1981.247.3.336.

which might be said to deal with phantoms in that it celebrates the dead)—makes us wonder about the nature of spiritual realities and whether whatever Laughlin has revealed stems from or transcends the Catholic spiritual universe.

Anatomical Cascade could not have been made without the reality of a folk custom. Where else could Laughlin have found a stack of crutches and a wall full of sculpted body parts? And though for *The Phantom Shoes* he might have been able to photograph a woman whose movements allowed him to create an image with shadow shoes in any number of contexts, the cemetery atmosphere makes far more powerful the idea of a phantom reality, and the backdrop of a calendrical ritual for the dead heightens this event even more. The folklore Laughlin has worked with seems essential to each picture. Of course, whether the photographer consciously conceived of himself as re-situating "folklore" in either instance is impossible to determine.

Yet Laughlin certainly was aware of folklore as a concept, as can be seen in the photographs he did of folk architecture and less directly in those of the Louisiana "primitive" painter Clementine Hunter, and of the grave or mourning boxes which have been a feature of rural south Louisiana cemeteries, especially those in coastal areas. He was a consistent recorder of folk buildings, particularly rural churches, and his captions for these photographs certainly indicate his awareness of the concept of "folk." For example, for an image of an African American Baptist church on Louisiana's River Road near Ashland Plantation, he notes: "Churches such as this one are built by the congregation involved, and of any scrap material which can be gotten. . . . [T]hey are the *folk architecture* of La"[64] (emphasis added). The caption (and probably the photograph) dates from 1938, and Laughlin probably was aware of the interest being taken in folk art by some artists and intellectuals, such as Lincoln Kirstein, who had organized the "American Folk Paintings" exhibition at Harvard, and the photographer Walker Evans, who was intrigued by the itinerant "flash artists" who painted signs and murals. Characteristically Laughlin's interest was not in documenting folk culture but in what transcendent realities folk buildings might reveal. About a photograph taken in 1948, a color transparency which shows a Baptist church, he says: "Diagonal view of church, from a distance, with beer and soft drink signs. At left, the symbol of the religion of most people in the times (the religion of money) and at right, the symbol of the religion built on myth (which is now dying out)."[65] The church becomes a symbol of battered spirituality in a time of adversity and of mythic realities and universal mysteries.

Evidently while photographing architecture in central Louisiana in 1951, Laughlin discovered Clementine Hunter, often called a "folk" painter, though generally not by folklorists, who view her paintings as those of an "outsider" artist or an autodidact. Laughlin was very much taken by her and her art, arranged for her to show her paintings at a gallery in St. Louis (a financial failure when few sold despite prices that seem laughably low today when Hunter is an avidly collected artist), bought paints for her, and wrote an essay on her and an article about her he hoped to publish in mass-circulation *Look* magazine. Actually Laughlin appreciated a number of outsider artists during his

life. He took several photographs, for example, in St. Louis of the work of John Dudas, a retired waiter with no art education who started to fantastically paint his room—the walls, the ceiling, then the halls of the rooming house and finally its exterior. Commenting on one of the photographs he took of Dudas's work, Laughlin thought that Dudas was "one of the many inarticulate people in this country who instinctively need to create." Laughlin also took a number of pictures of the so-called Watts Towers built in Los Angeles by Simon Rodia, a remarkable construct of cement embedded with thousands of objects such as broken plates and other crockery. The titles Laughlin gave to his Watts images, such as *The Fantastic Growth* and *The Vault of Lost Dreams*, give some idea of what he saw in the work of such artists: fantastic structures to provide fantastic photographic images. He was not averse to adding his own touches to the Towers. He recorded that while there he "felt constrained to arrange, on two of the shelves, gloves . . . which now suggest [in a particular image] the hands of lost dreams." Clementine Hunter fitted into a similar context in Laughlin's imagination, though unlike Dudas and Rodia, she had a connection to folklore through her quilts (which she began making around the time she took up painting), dolls she made, and through the subject matter of many of her paintings, the folklife of the Cane River region.

Hunter had taken up painting while working as a cook at Melrose, the plantation house art colony on Cane River. At least according to oral tradition, she did her first picture on a discarded window shade after one of the artists who had left Melrose left behind some tubes of paint. By the time Laughlin arrived, however, Hunter had done a number of pictures and was showing her work to whoever wanted to see it, even operating a sort of gallery in an old plantation cabin. Laughlin photographed her beside it, along with her sign, "Art Exhibit Admission 25c Thanks."[66]

Laughlin photographed Hunter and her quilts, one of her dolls, and her paintings in several related contexts. Clearly he was intrigued by her person (as have been other photographers since), and he took several photographs of her in an outside setting. In addition to the image of her next to her makeshift gallery, there is one in which she sits on the steps of another humble dwelling, the only

objects being two chairs on the porch. In a third she sits in front of a quilt that hangs on a frame on an exterior wall (possibly also the art gallery building). Additionally, in a photograph of a doll she made (fig. 13), there is in one corner a photograph of her standing outside a house, possibly with a hanging quilt. His other images relating to Hunter include her in her living room and a hanging quilt or quilt top, seemingly both pieced and appliquéd with a rendering of the Melrose big house and outbuildings (possibly Yucca, the original, smaller main house, and the African House, a structure sometimes said to be derived from African architectural forms and inside which Hunter painted extensive murals).

Laughlin's interest in Hunter's art, whether her paintings or her traditional quilts (and related hangings) and dolls, was not an anthropological or folkloristic one and is, indeed, in line with his interest in the St. Roch's *ex votos* and All Saints' Day. For him she is a creator of fantastic worlds both in her art works per se and in her personal environment; she is someone who brings to the visible level those unconscious secrets that so intrigued him. In his essay on Hunter, he sees her work as "being executed almost completely from the instinctual level of her being." "She paints," he goes on to say, "entirely from within herself, from a deathless world where she has re-awakened the magic of the child's vision."[67] That is, he views her in a manner that is patronizing—she is the childlike figure folk and "primitive" artists often have been viewed as—but also awestruck—she is the shamanlike conduit to other worlds (and, indeed, he says that she told him she began to paint "when the spirit came over me").

How this is borne out in his photographs can be seen, for example, in his image of a doll she made dressed like a nun (*The Nun Doll*, fig. 13). Although the figure could be viewed as embodying a traditional doll motif and simply as reflecting the Catholicism of the Cane River community, Laughlin notes its "almost skull-like face." It is placed between two kerosene lamps (whether by Laughlin or because this was its customary position), and these have been lit to cast an eerie glow that both reveals and hides. A clock, a popular surrealist symbol, peeks out from behind the doll. The photograph of Hunter in one corner injects a note of human presence which seems

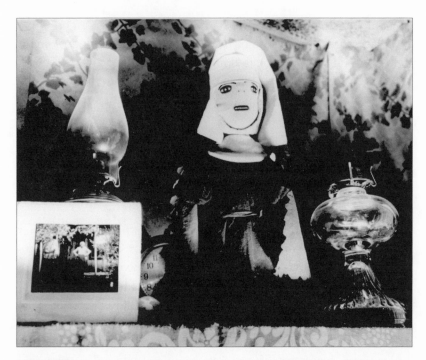

Figure 13 *The Nun Doll,* by Clarence John Laughlin; 1952. Copyright 1985, The Historic New Orleans Collection. Photographer: Clarence John Laughlin, #1983.47.4.2782.

both ordinary and strangely intrusive. For the photographer, this is another assemblage of ordinary objects which projects some vision of the spiritual, the phantom, the bizarre—of hidden realities that lurk in this domestic corner (the domesticity reinforced by homely wallpaper behind the featured objects).

Similarly, Laughlin's rendering of Hunter in her living room *(The World of a Primitive Painter [No. 2])* (fig. 14) is not so much an attempt to document an artist and her work as it is to present a fantastic assemblage that comes out of what is presumed to be the artist's strange interior world as expressed in her unconventional still lifes: landscapes and portraits and hanging collages which may stylistically stem from appliqué quilt tops, but which are something else. Even in the photograph in which Hunter sits outside in front of a quilt she made,[68] the quilt must have appealed to Laughlin because of its strange textures and the swirling vortex of scraps of material which is

at its center, like a many-petalled flower or even a whirlpool. The Melrose quilt-top photograph,[69] on one level a very simple documentation of a folk artifact, may have struck him (perhaps in part because he was unfamiliar with improvisational African American quilt-making traditions) as an almost cubistic jumbling of surface reality (he was also very intrigued that "two charms made of watermelon seeds stringed together" were attached, "a custom going back to the West Indies, apparently"). When Laughlin looked at and photographed Hunter's paintings that depicted local folklife, he again chose to look beyond the everyday reality that could be seen there. A cotton-picking scene "becomes fantastic—with the bags used to collect the cotton in, seeming to propel the figures through space." Her painting of a juke joint depicts not so much the local world of music and dance as it presents "all the figments of a child's dream" with the human figures in the picture having an "implicit tragic quality" because, Laughlin says, they lack freedom.[70]

Figure 14 *The World of a Primitive Painter (No. 2),* by Clarence John Laughlin; 1952. Copyright 1985, The Historic New Orleans Collection. Photographer: Clarence John Laughlin, #1983.47.4.2783.

With Hunter, Laughlin is, of course, playing off those qualities which have attracted others to her and to artists like her, their abilities in interpreting the world in "visionary" terms. What exactly that means depends on a variety of factors, but Laughlin especially valued anything which could help him and his camera establish a connection to those other realities of the imaginative mind that were his own virtual obsession. He may have drawn little distinction between her naive art and her work which was more traditionally folk, though he seems to have thought of folk art as instinctual and by definition in touch with realities missed by the more sophisticated—a view of folklore hardly unique to him. Thus the quilts and dolls have a particular importance as ordinary objects which nonetheless convey extraordinary messages to those who care to read them.

Such was also true of the mourning boxes and other decorations in Louisiana folk cemeteries. Surely he recognized their ordinariness by their very commonness in the local landscape and by the fact of their creation by "ordinary" people. Yet the mourning boxes in particular, which have attracted attention from other photographers, offered objects of a character bound to have special appeal. These boxes, generally about a foot and a half high and a few inches deep, are usually made of wood painted white, have doors with glass panels, and are filled with religious objects or "found" objects of various kinds. The religious objects consist mostly of commercially made statues of Jesus or the Virgin Mary or St. Joseph, though also common—and this is a factor in the interest the boxes generate as unusual to outsiders—is a bird to represent the Holy Spirit. Today artificial birds are usual, but in the past, actual stuffed birds were widely used. Customarily the boxes are set on graves in front of the grave marker, often on the concrete slab that is characteristic of south Louisiana graves, though occasionally they are set into the actual markers. Thus they are self-contained little worlds of the sacred, the box functioning both to protect the objects and to foreground them in a grotto-like or even chapel-like environment.

What seems to interest Laughlin, of course, are the symbolic possibilities of these grave structures (which may indeed seem odd to those not previously familiar with them). He gives his photographs of

them such titles as *From a Sunken Fairyland* (fig. 15, where a disintegrating, beaded *immortelle* has at its center—encased in a globe of glass or plastic—a figure which may represent the Christ child and which seems to float as if about to surface from some undersea realm) and *Bird of Dread (#2)*, also called *The American Albatross* (fig. 16; a stuffed bird hangs from a hook above plaster religious statuary). About another box, in which statues and a crucifix and plastic angels are affixed with particular symmetry and which sits embedded in the grave marker with photographs of the deceased on either side of it, Laughlin comments: "Within the box is a fairy tale world of angels and saints, of the emblems of faith and hope. But despite all its unreality the objects *are* real. On the other hand, the two framed photos . . . acquire a strange kind of unreality because of the intensity of their reality."[71] He is intrigued by what the assemblage suggests philosophically. About a cross covered by colored sea shells in front of which sits an egglike object with writing, the photographer notes: "Here is one of the simple forms of the folk art of the La. country burial grounds. The cross is home made, and set with cockle shells, painted black. And nearby, is a wooden egg. A psycho-analyst would be fascinated by this memorial to a departed wife."[72]

What Laughlin in effect does with these grave decorations and also with Clementine Hunter's work is to transpose objects created according to a folk or visionary aesthetic, repositioning them in photographic images which function according to an elite aesthetic and which are appreciated by a middle- and upper-class, "mainstream" audience. This approach not only de-situates the folk objects, but indeed displaces them, making them seem notably bizarre. The folk/visionary aesthetics create objects—the boxes with their cheap statues and dead birds, the Melrose quilt top with its seemingly unconventional perspectives, the nun doll with its eerie mien, the Cane River folk floating in space—that seem bizarre, jarring, strikingly different to those imbued with the more widely conventional aesthetic. By de-situating objects which are "unusual" creations to start with, Laughlin is able to endow them (or at least try to endow them) with his own meanings (which may be quite at variance with their original, cultural meanings), through the photographs themselves and such

Figure 15 *From a Sunken Fairyland,* by Clarence John Laughlin; 1953. Copyright 1985, The Historic New Orleans Collection. Photographer: Clarence John Laughlin, #1983.47.4.3088.

methods as rearranging the objects and lighting them in a certain manner, but also through his written commentary. If the originals have some sort of spiritual dimension, the re-situating photographs seem all the more imbued with the phantom, the arcane, the otherworldly. But essential to this whole process is the folkness (or visionary/outsider quality) which brings the objects into being in the first place according to an "otherworldly" aesthetic, giving them an appearance which is startling to those who judge according to another, more "standard" aesthetic. The objects, like the St. Roch's cascade and even the All Saints' Day cemetery, would not exist save for the cultural processes of folklore. Because of their provenance, they provide a reality foreign to Laughlin's own world.

On one level, Laughlin's incorporation of the folk very much differs from Kahlo's. As part of a national art movement which celebrated

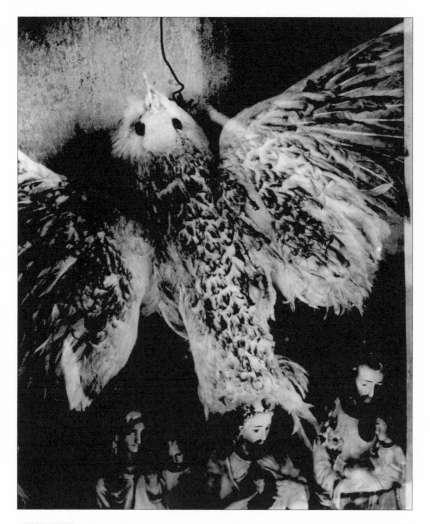

folk culture, Kahlo was in many ways close to the local meanings of the folklore she used. Of course in de-situating it, she and Rivera and others reinterpreted it, but she and they in part sought also to present it as it was, as something not only beautifully evocative of but also deeply functional in Mexican Indian and *campesino* societies. Laughlin had little interest in local meanings, choosing to reinterpret

the folk solely in terms of deeply socio-psychological, often presumably "universal" meanings. Thus, however much he may have respected folk productions in some regards, ultimately he wrenched them from any ethnographic context, whereas Kahlo respected that context in many ways.

Yet Laughlin and Kahlo produced images which bear an eerie similarity in that both created pictures which play with the fantastic and the strikingly bizarre and which seem to plumb the depths of the unconscious mind. Thus both have been associated with surrealism, a connection which was more amenable to Laughlin than to Kahlo. The surrealist fascination with unconscious and thus hidden meanings clearly appealed to the self-educated Louisianian, and he sought to conceive photographs expressive of the fantastic and of the world of the secret imagination. Sometimes folk objects with their air of being from another world suited his conceptions and his art. Kahlo's private purposes—her need to construct her self and her need to comment on painful personal experiences and to express tortured feelings—caused her also to create startlingly dreamlike, fantasy-evoking images. Sometimes she incorporated folk artifacts or references into her personal visions, such that she too sometimes wrenched the folk from original cultural contexts, for reasons rather different than Laughlin's. But whatever their similarities or differences, both found folklore essential to some of their work, re-situating folk objects or processes within visual arts media for appreciative audiences that have been expanding in size ever since.

Finding a Sense of Place

Folk Ideas and the Lore of Place
in Written and Visual Arts Texts

lthough earlier chapters of this book have concentrated on the re-situating of folklore in literary and visual arts contexts, the interconnections of folklore and literature are, of course, more complex. In addition to the literary de- and re-situating of folk texts and folk contexts, the study of folklore has contributed to the study of literature itself, and literary conventions have shaped how folklore has been presented to the reading public.

In the next two chapters, we consider instances of each of these situations. In chapter 9, we consider two important folklore collections of the 1930s from the perspective of their authors' adopting novelistic, fictionalized narrative frames—that is, literary conventions—in presenting folklore recorded in the field. Here in chapter 8, however, we look at how a particular folkloristic concept is useful in studying identity through the examination of literary and visual arts texts.

Bruce Rosenberg has discussed at length "aspects [of scholarship] in which literary criticism and analysis have benefited from theories and methodologies originally developed for folkloric study." He notes that the origin of structuralism, perhaps the most influential approach in literary criticism since the end of the Second World War, is to be

found in the study of folktales. He writes about the work of Milman
Parry and Albert Lord, noting its "importance" and also its relevance
to those "hot topics" in contemporary academic circles: orality and lit-
eracy.[1] Other folkloristic contributions in literary and other culture
studies fields include Mark Workman's readings of a variety of modern
literary texts which work from folkloristic concepts and understand-
ings. In discussions of Pynchon's *Gravity's Rainbow* and work by
Kundera, Kafka, and Philip Roth, Workman foregrounds the concept
of the *folk group* in order to consider ideas of community.[2]

In this chapter we utilize the concept of the *folk idea* and
develop the concept of *lore of place* in considering how literary and
visual arts texts can be usefully examined to illuminate discussion of
sense of place and local identity, areas of interest to more than one
discipline. Thus we are not concerned with folklore and literary crit-
icism as such but rather with folkloristic ideas and literature/art in
the context of broader culture studies.

It is difficult to define both what we mean by "sense of place" as a
concept and what we mean by sense of place in relation to a *partic-
ular place*. What aspects of place *in general* determine our "sense" of
particular places? How do we go about deciding what particular ele-
ments of a place are important in our forming a "sense" of it? How
does sense of place as a concept relate to other concepts of place like
rootedness, local boosterism, local identity, and what the geographer
Yi-fu Tuan simply calls "topophilia"—which he defines as "the affec-
tive bond between people and place and setting"?[3] Can a particular
place have a single "sense" or even a limited range of "senses"
attached to it, or are there as many senses of place for place X, Y, or
Z as there are people perceiving it?

Several commentators have noted how what they may call
"space" or "landscape" becomes place through human consciousness
and interaction. As the falling tree creates no "sound" unless someone
is in the forest to hear it, neither does the forest—or any other geo-
graphical environment—become "place" unless someone is there to
conceptualize it. "Place is created," says folklorist and critic Kent
Ryden, "when experience charges landscape with meaning." The

geographer Eugene Victor Walter suggests that personal history and communal history create place ("We call locations of experience 'place'"). Ryden also puts strong emphasis on the importance of stories in creating place, quoting poet Kim Stafford's line that "A place is a story happening many times," while Lucy Lippard claims "space combined with memory defines place."[4]

If the very idea of place requires consciousness of place, sense of place starts with that basic consciousness, yet the term "sense of place" suggests something more than mere awareness. Indeed, Ryden says that for humanistic geographers the term means: "the strong sense of rootedness in a location, of identification with (and self-identification in terms of) that location, of membership in a unified place-based community, and of a common world view as a result of a common geographical experience."[5]

Such a definition assumes that sense of place is something collective, something had by a community. We as individuals, of course, each have a unique, individual relationship to place, wherever it may be, and our own personal sense of place. Likewise, members of different social and cultural groups will have different ways of conceptualizing the same place. Native Americans, Hispanics, and Anglos no doubt relate quite differently to New Mexico as a place, and so too do whites and blacks to New Orleans. But we may still speak of sense of place as something which is communal, insofar as divergent individuals share common reference points about place. Such reference points—sometimes more, sometimes less consciously conceived—are invoked when someone says something like "Only in New Orleans"—as local "vampire" novelist Anne Rice is said to have remarked in April 1995 after stretching out in a coffin in Lafayette No. 1 Cemetery, to the intense interest of the local media. On such occasions, everyone present smiles or nods in silent agreement.

Sense of place, then, also assumes some sense of uniqueness of place. Uniqueness, of course, is a relative concept. Two villages which may seem prosaically similar to outsiders may be seen as very different from each other by their respective residents, who may even base intense rivalries on such emically perceived diverseness.[6]

But if we all think of our place as unique, another relativity of uniqueness resides in a broader consensus that *certain* places enjoy a *particular quality* of being "different." New Orleans is one of those places whose difference is well recognized by outsiders. This perceived uniqueness is the basis for the city's present-day tourist economy but is also amply attested by visitors throughout the nineteenth and twentieth centuries. For example, numerous travelers, such as Frederick Law Olmsted, George Augustus Sala, and that nineteenth-century English sojourner who identified himself only as "a Rugbean," pointed to what they found as the distinctly non-American atmosphere of this American city.[7] Ryden's definition more than implies that sense of place is limited to *local* perceptions, while he also insists that tourists can have little more than "largely aesthetic impressions."[8] Yet to promote tourism, New Orleanians have certainly projected to outsiders some of the focus points and symbols of local identity, so that *some* aspects of the local sense of place have been absorbed by nonlocals.

New Orleans is a city whose residents do have a strongly and intensely developed sense of themselves and of their place, a cultural perception which is, for example, strongly evoked by John Kennedy Toole in A *Confederacy of Dunces*. Early in this Pulitzer Prize–winning comic novel,[9] the book's bloated, self-deluding, disaster-creating hero, Ignatius J. Reilly, recounts the story of "the only time I had ever been out of New Orleans," on what he calls his "misguided trip to Baton Rouge." On his way to a job interview at the state university there, he recalls, he became sick on a "menacing" Greyhound Scenicruiser, thus beginning a series of misadventures that continue to the end of his trip. "Leaving New Orleans . . . frightened me considerably," he tells his mother. "Outside the city limits, the heart of darkness, the true wasteland begins" (pp. 9–10).

The story of these exploits is an important one to him and he refers back to it several times. His personal narrative of the journey serves as an indicator of Ignatius's character, but it and the incidents at its heart are more than aspects of character development. They act as a statement of the insularity of Ignatius's native place, its sense of itself as a special place which is left only at some peril—cultural and psychological, if not physical. Indeed, many New Orleanians took

quickly to Toole's novel, recognizing in it something of their vision of themselves, finding in its pages an appreciation of their speech patterns and an approximation of some of their ways of life.[10] A statue of Ignatius (modeled by an actor who played the character in a stage adaptation of the novel) placed at the one-time entrance to the department store (now a hotel) where the novel opens is further testament to the book's local resonance.

Though the novel works on more than one level and is certainly a comic tale of personal foibles, vanities, and calamities, its author clearly intended it in part as a statement of the character of his hometown. This intent is made clear in the two epigraphs Toole provides at the beginning of his text, both quotations from the classic *The Earl of Louisiana*, A. J. Liebling's account of the last days of a Louisiana icon, Governor Earl K. Long.[11] The first calls attention to the New Orleans "city accent," pointing out its supposed similarity to the accents of Hoboken, Jersey City, and Astoria, offering the theory that "the same stocks that brought the accent to [the New York area] imposed it on New Orleans." The other suggests that New Orleans is actually part of a "Hellenistic" Mediterranean/ Caribbean world "that never touched the North Atlantic" and implies that a New Orleanian is more likely to feel at home in Italy or Greece than in the rest of the United States. These quotations are meant to tell the reader that the author sees his novel as delimiting locality, as presenting a local American culture and identity as a distinctive reality.

As Frederick Starr has written: "New Orleans is different, as Gertrude Stein learned when she went there to visit Sherwood Anderson. It is a There; it has an identity—several of them, in fact. Its inhabitants know it and they revel in it." And Max Webb, in writing about Walker Percy, goes so far as to say that the coastal South, particularly New Orleans, did not develop a literature rivaling that of the upland South because New Orleans and other coastal writers have been obsessed with explaining their sense of their own uniqueness.[12] How, however, can we tap into that Crescent City mind-set and discover what that sense of place consists of; see what are its tropes, symbols, and reference points; understand what is the particular knowledge needed to prove that one is a bona fide resident of

222 ||||||||||| Finding a Sense of Place

that place? Robert Blair St. George says that sense of place has been "more evoked than analytically explored,"[13] and we have to wonder what data, what documents are available for such analysis to be undertaken.

We might, of course, try to generate such understandings through field interviews. For example, in interviews conducted by one of the present authors for quite other purposes, informants sometimes have expressed a strong feeling that their city is unique. Photographer Matt Anderson has said, "This is a different place," and, half-jokingly, of local cultural events and experiences, "A lot of these things don't happen so much . . . over in America, as opposed to . . . New Orleans." And Larry Bannock, Big Chief of the Golden Star Hunters Mardi Gras Indian tribe, in the context of discussing costume making, said, "There's no place [else] in the world like New Orleans. Where else can you take some paper and some paste or whatever and make a masterpiece?"[14]

One might also try to determine subjectively what are the focus points for the New Orleans sense of place, as Howard F. Stein and Gary L. Thompson have done for Oklahoma,[15] or one might look at some obvious symbols of place such as are projected to tourists. The Walt Disney organization has been the great master in following this latter course, especially in re-creating vivid if shallow or even faux senses of place at their World Showcase section of EPCOT Center in Orlando, utilizing isolated fragments of cultural meaning which have "semiotic potency" and what Tuan also calls "high imageability."[16] Thus the "French" area of EPCOT has an Eiffel Tower which projects the illusion of height from a distance, a simulated sidewalk cafe, and the facade of a *librairie*—in fact a shop, although one which sells souvenirs and sunglasses, not books.[17]

Actually, the folkloristic concept of the *folk idea* promises to be useful in looking at the components of sense of place. Alan Dundes offered this term to folklorists in 1972 because he had noted that folklorists were disturbed by the use of the term "myth" to refer to belief systems or grand cognitive or emotive schemes, as in The Myth of the Frontier. He suggested that folklorists might nonetheless wish to study "traditional notions and conceptions" as a part of worldview.

Dundes defined "folk ideas" as "traditional notions that a group of people have about the nature of man, of the world, and of man's life in the world,"[18] a characterization which could define "worldview" itself, except that the idea of the folk idea allows us to break down vast, all-encompassing worldview into more manageable segments. The folk idea is not a folklore genre but something that may be expressed and communicated in various genres.

In his essay Dundes provides several examples. Though he draws the distinction between worldview and ethos, his examples seem to be folk ideas which relate to, loosely speaking, values, or rules about how society and the larger environment "operate." Yet his overall conception allows for something broader. There can be folk ideas about group identity, about particular places, and about identity connected to place and thus to sense of place, which will be closely related to identity insofar as identity may be based on region, locality, or some other geographic parameter.

Folklorists increasingly have recognized that an important function of folklore is to express identity, and that folklore may, in fact, become symbolic of identity. In a general discussion of the subject, Dundes notes several types of identity that folklore may help to delineate—ethnic, sexual, personal, even temporary.[19] But American folklorists have been principally interested in *ethnic* identity, although Angus Gillespie has dealt with foodways and American regional identity—that of the New Jersey Pine Barrens—as has Paige Gutierrez, who deals with the crawfish as a symbol of identity in Louisiana. More recently Ellen Badone has looked at how Breton villagers identify themselves in contrast to their neighbors through folklore and through traditional stereotypes.[20]

Identity, of course, is expressed not only through folklore, and folk ideas take us beyond concrete expression in folklore. Dundes notes that they might "be found in movies, television, and the mass media generally,"[21] and surely we might look to high art and literature as well, particularly when writers and artists work with some strong component of the local (as does Toole in A *Confederacy of Dunces*).

To return to New Orleans: It is not only a city which visitors find "unique," but a city whose residents have a strongly developed

sense of themselves, a mind-set which stems in part from an aware-
ness of participating in a distinctive urban culture. A *Confederacy of
Dunces* speaks to this awareness and so too do the other graphic and
written texts which are the focus of the rest of this chapter: the car-
toons of Bunny Matthews, which have appeared in several New
Orleans newspapers as well as on calendars and in two books; a col-
lection of sketches by S. Frederick Starr, *New Orleans Unmasked:
Being a Wagwit's Sketches of a Singular American City*; and a col-
lection of poetry by Brooke Bergan, *Storyville: A Hidden Mirror*,
which in turn calls attention to a celebrated group of photographs.[22]

Matthews's cartoons, which feature mostly white, working-class
New Orleanians, have not met with universal favor in New Orleans.
In an introduction to Matthews's second book, Jeanette Hardy—who
had invited him to contribute to the *Times-Picayune*'s Sunday sup-
plement magazine *Dixie* when she edited it and for which he pro-
duced a comic called "Vic and Nat'ly"—writes that, "We have some
readers who don't always share our enthusiasm. . . . They write occa-
sionally to say that the cartoon is a mean joke on New Orleans and
some of its people."[23] Indeed, the cartoon series might be seen as an
attempt by a sophisticated artist to lampoon, however affectionately,
the city's white working class. Matthews's earlier cartoons, which
appeared in the now-defunct weekly *Figaro*, specifically attempted to
reproduce dialogues allegedly actually heard in the city and played
in part on local dialect. The use of dialect, of course, implies an
awareness of a standard language against which it can be measured,
and dialect humor historically has been directed at a group by per-
sons who are outsiders to the group and has suggested condescension
toward the group. Nonetheless, Matthews has an unerring sense of
local symbols, which his cartoons manipulate to call attention to
aspects of culture that loom large in the local culture and that play a
significant role in establishing sense of place.

Certainly Matthews draws attention to insider/outsider rela-
tions. A number of his cartoons depict an awareness of New Orlean-
ians' sense of their own difference as shown specifically in the con-
text of interaction with outsiders, generally tourists. In one cartoon a

waiter serves traditional beignets and coffee to a tourist, a camera around the tourist's neck a badge of his outsider status—and announces: "Lissen, Cap—Not too many people drink dis kinda coffee black . . . so I ain't responsible if ya have a hawt attack or sump'n." The tourist, of course, has asked for black coffee with his beignets, a common "mistake," thus showing his ignorance of the strength of New Orleans coffee and the local practice of eating beignets with café au lait. In another cartoon, "A food critic from Cleveland 'discovers' Vic and Nat'ly's" bar, seafood restaurant, and po-boy emporium in its Ninth Ward neighborhood and exclaims, "Wait'll I tell my readers about this." But owner Vic Broussard replies, "Do me uh favah, Cap—tell 'em ya got ptomaine poisonin' . . . I need uh buncha tourists in here like I need a hole in da *head!!!*" while the Chihuahua who graces many of Matthews's productions chimes in, "Publicity ruint many uh good po-boy jurnt." There is a clear expression here of the ambivalence New Orleanians—and perhaps residents of other tourist meccas–have about tourists, those people who flood their town and their space, bringing with them other mores and an ignorance of the local. They may be accepted in the French Quarter or the Garden District, but not in the Ninth Ward, which is for locals who understand the culture and the scene.

However, in addition to drawing a line between local and nonlocal, Matthews also focuses on details of life which help to define local existence. Consider, for example, Mardi Gras, which is dealt with in a number of his cartoons. Though some of their humor might appeal to anyone vaguely familiar with the festival, some of it decidedly plays on insider knowledge, enjoyments, and anxieties. In one (fig. 17), though the visual interest lies in a lavishly sketched flambeau carrier and motorcycle rider, barely visible parade attendees engage in a discussion not uncommon to the real event, wondering what float a friend or relative is riding, so that they can obtain a larger share of the trinkets thrown to the crowd. In another, Nat'ly tells her sister who has phoned from the Gulf Coast, obviously on Mardi Gras, while fabulously costumed people cavort before Nat'ly's eyes (or perhaps as a backdrop beyond her literal ken): "Nun uh—it ain't no different den any udder Tuesday." What we see here is both pride in a

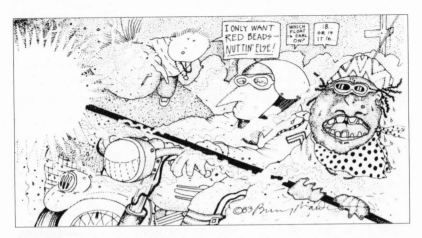

Figure 17 *Drawing by Bunny Matthews.* Reproduced from *Vic and Nat'ly* (vol. 1) by permission of Bunny Matthews.

glorious ritual public event which plays an extremely important role in New Orleans life and a certain blasé attitude toward it—the event is so ingrained in the local consciousness that it is, in a sense, not so different a day after all.

In other areas of local life Matthews also utilizes the symbolic, visually exploring folk ideas that might otherwise remain less consciously expressed. He takes note, for example, of the city's socio-geographic divisions, when "a couple of uptown goils," obviously slumming, visit Vic and Nat'ly's bar, jabbering about their friends Muffy and Sissy and Binky ("Where do they get dem names? Fairy tales?" wonders the cockroach who appears in many of Matthews's cartoons), or when "Mr. Cool discovers the Ninth Ward" and orders a spritzer from Vic, who asks if that isn't some kind of little dog.

Obviously different from Matthews's cartoons, S. Frederick Starr's *New Orleans Unmasked* is a collection of sketches—short, informal essays—on life in the Crescent City, arranged under such general headings as Habits, Death, The Sacred and the Profane, and Politics, the sketches themselves ranging over such topics as nicknames, clubs, All Saints' Day, St. Expedite, wop salad, and families. Starr, a former Tulane University administrator, a jazz musician, and a one-time

research scholar at the Historic New Orleans Collection, is a whimsi-
cal writer, and his tongue-in-cheek essays display his obvious amuse-
ment at the bizarreries and vagaries of New Orleans existence. He
marshals an astonishing array of rather miscellaneous facts and half-
facts. For example, the reader learns that the New Orleans *Times-
Picayune*'s Classified Department maintains "a silver-bound volume
of memorial verses" (p. 69) out of which bereaved relatives can make
selections for the paper's regular "memorials" column between the
classifieds and the obituaries. Or that New Orleans was at the time of
the book's publication represented in Congress by descendants of the
first American governor of Louisiana and of the brother of the man
who negotiated the Louisiana Purchase with Napoleon. Or that dur-
ing a recent economic slump a businessman sought a bank loan for an
entrepreneurial venture; he was turned down but was gladly offered
money should he need it to pay for his daughter's social debut.

But none of this information is passed on as isolated, amusing
bits or as "strangely true" pieces. They are specifically tied into a larger
context of cultural meaning. The refused and proffered bank loans
suggest a society where the Carnival season and an intense love of par-
tying and of social rituals are more important—and hence safer risks—
than new business undertakings. The congressional descendants mark
the continuing centrality of "old families" in the political life of the
city. The memorials show the considerable awareness New Orleanians
have of death—cemeteries, after all, are a looming presence in the
cityscape and even tourist attractions—though Starr also stresses how
the locals "spurn . . . alien imports" in the ready-made funereal verses;
for example, no one ever chooses the one about "your cold and lonely
grave" because "New Orleanians . . . have traditionally buried their
dead not in graves but in tombs, which are never very cold and, due to
crowding, rarely lonely" (p. 69).

On one level Starr and Matthews are deliberate, careful artists
making their own, personal observations about a place. On another,
however, they are simply rendering into texts a local *mentalité*, making
conscious a local self-awareness which usually exists somewhere below
the surface, though not very far below it, in less conscious thoughts.

Toole does something similar in fictional form, and all three are working out in artistic modes folk ideas of local self-recognition found in New Orleans. In fact, much of the humor inherent in the sketches and cartoons arises from a recognition that some shared knowledge of the local suddenly has been made manifest, crystallized into conscious shape by drawings or words.

What Starr and Matthews are doing, however, is considerably more complicated than simply describing or even caricaturing a regional culture. People not only live their cultures but also reflect on them, discuss them, symbolize them, select aspects of them which seem to stand for larger cultural meanings. There are the cultural rules that they unconsciously obey, the attitudes they automatically assume, but there may also be a self-consciousness of the cultural parameters, of the elements which particularly mark the group and its lifestyle, of the symbols which help to define its place in the world. Matthews and Starr are working not only with a singular place, but a place very aware of its singularity. This awareness can be seen, for example, in the popular lists which appear in locally published books (or now on the Internet) which begin with "You know you're from New Orleans when . . ." or "You know you're truly an Orleanian when . . . ," and go on to list such aspects of local knowledge as "you know better than to inhale when eating beignets with powdered sugar" or "every time you hear sirens you think it's a Mardi Gras parade."[24] Matthews works with a more restricted range than Starr, defining local existence rather broadly in terms of comparatively few ideas, including cuisine, Mardi Gras, basic internal divisions, the prevalence of insect life, and gambling. Starr roams through countless facts, though most lead to a recognition of local realities and mind-sets. Even when he notes facts that few New Orleanians would be aware of per se—for example, Brooks Brothers reports that the company sells more formal wear in New Orleans than in New York and Washington combined—he hits upon familiar themes. In the matter of the formal wear, it is an awareness of the importance of Carnival and a love of partying in style.

Toole, Matthews, and Starr are expressing folk ideas of place that are the components of sense of place. It would be possible to break down some of what they express into the form of a series of statements:

From a native standpoint, New Orleans is a place defined by these foods, this language, these celebrations, these forms of experiencing the world. Yet the concept of the folk idea may not encompass the whole situation adequately. The term *lore of place* may be a more appropriate, if more amorphous, designation. Though folklorists, if they use the term "lore" at all, generally use it as a synonym for "folklore," "lore" does have a continuing general use to mean knowledge of a particular sort. It refers to knowledge that is less than formal, scholarly, or scientific, which may also have an arcane or esoteric quality, which centers about one thing, and which may also have emotional associations or a peculiar fascination for people. Matthews and Starr— or, for that matter, John Kennedy Toole—are tapping into a lore of place, not only into discrete folk ideas but also into something more broad: patterns of behavior and cultural knowledge but also a reification of those into a self-awareness and interrelated sets of feelings. For its residents, New Orleans is lived in and lived, experienced, felt, reflected upon. Insofar as aspects of local life become a mental construct and a focus for identity, a basis for a mutual and collective self-recognition and recognition of local shared knowledge, we have a lore of place—an aspect of worldview which incorporates various folk ideas regarding locality and local cultural knowledge. The lore of place is the complex of folk ideas about place and is the basis for our discourse about locality. It is, in a sense, how we talk about place and, more fundamentally, how we conceive of place collectively as a system of identifications, images, recognitions, and symbols.

Lore of place is then rather complicated, an amalgam of overlapping consciousnesses, both collective and personal. Indeed, one can see such overlap in Brooke Bergan's *Storyville: A Hidden Mirror*, a book of poems whose focus is the E. J. Bellocq photographs of prostitutes in Storyville, New Orleans's quasi-legal red light district.[25] A number of the poems remark upon individual Bellocq images (which were taken around 1912) and are keyed by title to particular plate numbers for the photographs, for example, "Plate 27: Girl in a Mask." Four of the images are included as illustrations, one (plate 7) being used on the cover.

That the widely publicized pictures should evoke a series of poems is hardly surprising. They are fascinating images, mysterious

in what we don't know about them, remarkable in that they should exist, evocative of a strange and anomalous world that disappeared rather suddenly. That so little is also known about their creator has only added to their mystique, something most fully exploited perhaps in Louis Malle's film *Pretty Baby*, though also in Michael Ondaatje's novel *Coming through Slaughter*.[26]

The Bellocq images say something to and about New Orleans. They have become so well known that it is difficult to remember that they came to public attention only in 1966, when the noted documentarian Lee Friedlander acquired the glass plate negatives from Larry Borenstein, a New Orleans French Quarter art dealer and real estate investor. Despite the comparative newness of our knowledge of these images, they have a powerful presence in the local mind. They have come to represent Storyville itself in a way no other images or symbols have—perhaps because they seem to be almost archeological artifacts that re-emerged after their own time, perhaps because they give a certain individuality to people who otherwise remain murkily unknown in their generality, perhaps also because the photographs have a quality and a concerted singularity lacking in other visual records of Storyville. Insofar as they represent Storyville, they also represent something larger, a folk idea that looms significantly in the New Orleans consciousness and lore of place: the idea of New Orleans as a place of vice and decadence, of sin easily tolerated and worn lightly if not actually promoted. Such, of course, is in part an outsider stereotype of the Crescent City born of generations of visitors who noted the failure to respect the Sabbath according to Protestant standards, the particular vitality of saloons and poolrooms, and the existence of such scandalous institutions as plaçage and the quadroon balls, all of which aroused such comments as these of the English writer J. Benwell, who called New Orleans "as vile a place as any under the sun."[27] Yet this particular aspect of sense of place also operates in terms of local folk ideas of New Orleans as laid back morally as well as psychologically, as—well, as the Big Easy, a nickname that is surely autochthonous.

Bellocq's photographs might once have been shocking—there was speculation that scratches on some of the plates were attempts by the photographer's priest brother to deface them—but they have

become for us emblematic of a local wickedness of spirit in which we take a certain pleasure and pride, perhaps not unlike that which Louisianians in general take in the exceptional corruption (real or imagined) of their state's politics. This is, in fact, an important pole of New Orleans's self-identity and thus of its lore of place, the pole of wide-open morals which may work in counterstatement to the pole of intense Catholicism, as Ash Wednesday works as a counterstatement to Mardi Gras. (In the realm of photography, perhaps Bellocq's counterstatement is his contemporary, the much less-well-known nun Mother St. Croix, who photographed another closed world, that of the convent and the schoolgirl.[28])

Bergan subtitles her collection "A Hidden Mirror." Although that choice has multivalent meaning, it suggests a recognition that the Storyville images hold up a mirror to New Orleans—that is, reflect a part of its sense of self, though that part may, historically, have been officially hidden. In some of the poems Bergan also stresses the fluidity of the Storyville world. In one poem, for example, a former Storyville woman speaks of going on to a life of married respectability; another poem draws the parallel between the brothels and the community of Ursuline nuns. The world of Storyville is hardly disconnected from the rest of the New Orleans community and hence can be seen as part of its sense of itself. Additionally, Bergan ties herself into the picture through her own family history, thus uniting herself and her respectable Creole family to the larger local world that includes Storyville. In particular she gives attention to establishing the physical location of family property, as though to suggest acknowledgment of shared earth, hence shared identity.

Against this background of the Bellocq photographs, Storyville, and her personal and familial place here, Bergan works with a variety of the local symbols and cultural knowledge that make up a lore of place. Using a variety of repeating and alternating sections which have such indicative titles as "extrapolations" and "voices," and which include and refer to "oral histories, folklore, letters, genealogies . . . material on race laws, Mardi Gras, the Louisiana bayous" (p. 7) as well as fictions drawn from these materials, Bergan piles up a collection of New Orleans and Louisiana reference points: vetiver, calas,

persimmons, *fais do do*, plantation names, quadroons, Mardi Gras Indians, Baby Dolls, and Zulus. One poem incorporates lines from an Indian song, "Meet De Boys at the Battlefront," others such folk legends as the Durand wedding (near New Iberia, when spiders were supposedly loosed to weave a canopy of gold in the live oaks), legendary slave figure Bras Coupé, sites like St. Louis no. 1 cemetery and the French Opera House. Of course it could be argued that Bergan is merely salting her poetry with fragments of local color. However, the totality of her work in *Storyville* clearly indicates otherwise, as do her appendices which outline the bibliography on Creoles, Louisiana architecture, sociology, photographic history, and music. This range indicates a desire to capture New Orleans as a place and to capture the feeling of being connected to New Orleans. And it does so not by evoking a small corner of New Orleans life, as Tennessee Williams, for example, does in *A Streetcar Named Desire*, nor by focusing attention upon social roles and rules, as Kate Chopin does in *The Awakening*.[29] Rather it does so by drawing together a number of recognizably local reference points, some contemporary but some antiquarian — who, after all, makes the rice balls called calas today or sees old-style Baby Dolls outside the pages of *Gumbo Ya-Ya?* — to produce an extended impression of self-identity, a recognition that certain discrete entities and values and events combine to create something of who we are as residents of a place and which we are aware of as constituting ourselves and of forming that discourse on our geographic selves that is the lore of place.

Bergan's reference points noted thus far touch upon one major folk idea of locality: that relating to New Orleans as a place of tolerated sin. Another important to her work is the idea of New Orleans as supremely multicultural and racially convoluted, which she works out by moving from the sexuality of Storyville to the sexuality in race relations ("Argument 3," for example, quotes from the Louisiana Civil Code of 1808 in regard to intermarriage and illegitimate children), to arcane classifications for race ("Argument 1," which begins by speaking of "the homes of the *femmes de coleur*, mistresses of well-to-do white men" [p. 19], and goes on to recite the oft-repeated litany

of French terms for particular racial admixtures, *griffe, mulatto, meti,* and so forth), jazz as metaphor for cultural mixing, and the use of Creole (Creole proverbs are interspersed with the prosy stanzas of "Discourse 6," which is itself a discussion of Creole and creolization). This idea of the multiculturalism of place probably is most fully expressed in "Voices 5," which begins

Jazz is what folks should be.
 African work chants, American folk music, grand opera (p. 88),

suggesting the melange of influences which produced jazz as a musical form (with other musical root sources being sprinkled between later, longer sections). Later the poem breaks up into words and phrases scattered across several pages. Their arrangement is perhaps meant to suggest the loose, improvisational quality of jazz, but many of the individual words and phrases evoke, in addition to jazz, other cultural admixtures: *quadroon, creole, os rouge* to suggest racial mixing; plantation names to suggest another class stratum; *fais do do* for the Cajun element; jazz musicians with Spanish, Italian, French, and Anglo-Saxon names. Other parts of the poem are in French, Creole, German, and an attempt at local dialect, so that the poem as a whole seems to embody cultural melange in its very structure as well as its referential possibilities.

Of course, to discuss Bergan's work in terms of lore and sense of place is to say little about it as poetry. The point of this discussion, however, has been not on aesthetic issues but to suggest something of how in her work Bergan attempts to tie self to place by working with elements of a local discourse on place, to examine how an individual's sense of place relates to the more communal lore of place. As an individual, one draws upon that lore in a variety of ways in realizing and asserting who we are in terms of place and what is that place to which we connect. If we are poets, that lore of place is available for creatively connecting self and place, but in doing so the poet also creates texts which concretize feelings about place and the parameters of the lore which can be examined and analyzed for understanding the components of sense of place.

Sense of place, really, is a collection of feelings about locality, about how we as individuals and as members of a community relate to that locality which ties in with our senses of *identity*. This chapter has suggested that, to understand sense of place, we need to look at *lore of place*, that amalgam of conceptualizations of and discourses about the physical and cultural parameters of place, about insider knowledge and outsider ignorance, about what are perceived to be unique ways of talking, cooking, seeing, and acting which stem from place. It also has suggested that lore of place may consist of many *folk ideas of place*, and that this folkloristic concept can be useful in conceptualizing what ultimately makes up our sense of where we live (or even where we sometimes visit). That lore and these ideas may be looked at through nonfolk texts, through various literary and visual arts documents.

As a place whose residents have a highly developed sense of their own local identity (and whose visitors also are drawn by some strong sense of uniqueness of place), New Orleans is an important city to consider in any larger discussion of sense of place in America. Yet the total picture of that New Orleans sense of place is complex— probably urban sense of place inevitably will be more complex, though not necessarily any more profound, than that of rural places like those considered by Ryden—and open to analysis for those who would try to describe, however imperfectly, the "essence" of the Crescent City as experienced by its people. That "essence" arises from a conglomeration of accents, foods, devotion to festival occasions and neighborhood mores, geographic-social boundaries, and conceptions of the past; ways of celebrating, of burying the dead, of talking the talk, and of knowing about insect life, ethnic divisions, and local legends, among many other things. New Orleans writers and artists like John Kennedy Toole, Bunny Matthews, Frederick Starr, and Brooke Bergan give concrete form to folk ideas about these things, further engage us in the discourse that is lore of place, and enable us to better see and understand the components of a vital city reflected in the mind.

Though singular in many ways, New Orleans of course is not unique in being an interesting place with an interesting self-identity.

Not only is the Crescent City's complex sense of self worthy of further attention, but so is that of many other American cities and regions. We mean to propose New Orleans merely as one example of a larger American phenomenon, and one could certainly look to other cities and regions to suggest how folk ideas relate to sense of place. The American West, for example, is a region—obviously far more vast geographically than the single city we have discussed and thus surely of greater significance—not only with a strong sense of itself but a region whose essence has been discussed by many from a variety of perspectives.

The folklorist John Dorst recently has written at length about how the West has been "seen," in fact literally seen in that his interest primarily has been in defining how the region was perceived through certain modes of looking. Dorst considers various kinds of texts—folklore, literature, historical sites—and prefers to conceptualize his comments in the theoretical language of the problematic field of cultural studies, but some of the texts he examines could certainly be looked at in terms of their projecting particular folk ideas of the West. For example, he cites two oral anecdotes in which inexperienced travelers in the West misperceive distances, thinking that far-off mountains are closer than they really are. He also provides a Wyoming variant of the modern legend of the water-skier who is pulled into a knot of poisonous snakes in the water. Dorst interprets these folk texts as having to do with "patterns of visual practice," that is, with a process of perceiving place. The anecdotes imply the deceptiveness the West imposes upon those who view the landscape; the legend suggests "the misrecognition of a 'reality'" and "the destructive exercise of visual power."[30] One could, however, also frame these texts in terms of their revealing folk ideas about the West as a place, a place of vast distances (inconceivable to those not used to them), or a place of hidden dangers. Likewise the vernacular constructs—namely, yard art—that Dorst examines in one chapter of his book, *Looking West*, could be seen in terms of their presenting folk ideas of the region through the symbolism of discrete objects that are parts of those displays. A found-object, bleached cow skull in one yard, for instance, suggests both that cattle are central to the region's

identity and that death can be close in this potentially harsh environment. The wheel motifs that proliferate through the metal sculpture in another yard evoke the idea of the West as a place of pioneer migration (by covered wagon or handcart), a folk idea which is also reflected in the wheel as an Oregon gravestone motif, as Richard E. Meyer has pointed out.[31]

Western cowboy poetry, a genre which includes both original verse and passed-on "classics" and which consists of "memorized performance of traditional poems," may also be useful in looking at folk ideas of the West. Though cowboy poetry has received some wide attention in recent years, it "sustained itself almost exclusively in ranching communities," though cowboys were not literally the only reciters. The tradition uses poems by well-known, popular poets like James Whitcomb Riley and Robert W. Service and borrows poetic forms from such older poets as Service and Rudyard Kipling, though there are also many locally composed poems, both anonymous and with known authors. Cowboy poetry is, then, written but rather straddles the line between literature and the oral tradition. Hal Cannon suggests that cowboy poetry very much reflects the "shared values" of those who "live that cowboy life"[32] and thus might be seen as reflecting folk ideas of a region and about a region, given the iconic status of ranch life in the West.

Our intention is not to develop a detailed thesis about the many folk ideas that cowboy poetry may call attention to, but we do want to suggest a few of the possibilities inherent in several texts. For example, poems such as "This Was a Harsh and Barren Land" and "Dixie" express the folk idea of the West as a particularly difficult landscape nonetheless transformed by hardy pioneers (in relatively recent memory) into something livable and fruitful. The "harsh and barren land" of the first poem becomes "a refuge of peace and rest" through the "sacred quest" of the settlers, while in the second, land that was said to be "no good" and where "no white man could live" becomes full of "verdant spots" with a "thriving city," though farmers still have to hold a foot on planted seeds until they grow, lest they be whipped away by the furious winds.[33] Indeed, the West as a place of hardship because it constitutes a tough environment only partly

"tamed" is worked out in more personal terms in such poems as "The Great Wanagan Creek Flood" and "Rain on the Range," which deal with the vagaries and power of Western weather. The first of these is a narrative in which "hail was a steamin'" and nine fences wash away in a downpour, while the second poem muses on the general discomforts of rainy weather for cowboys, as bedrolls "go floatin' down the drawer" and "the cook can't build a fire."

The potential for hardship and difficulty may lead to the recognition that in the West comradeship is especially important, an idea familiar to many from the insistence in older Western films that having a "podner" (partner) or sidekick is an essential fact of life, a situation perhaps analogous to needing a "mate" in that other pioneer place, the Australian outback, as John Greenway has noted.[34] In "The Sierry Petes," a cowboy duo working together are powerful enough to defeat the Devil by using their occupational skills. In "The Dude Wrangler," a friend who deserts the narrator and goes to work at a dude ranch is shot by the narrator, but out of friendship—to put him out of his misery. The recognition of the existence of dude ranches suggests, of course, an awareness that the West is not static, and indeed other poems deal with folk ideas about the changing of the region in which the old ways—which are perhaps the essence of the region's identity—linger as newer realities arrive. In "The Last Buckaroo," the title character on "his trusty steed" vies with

> . . . the traffic jam
> I see,
> Beyond the desert's rim

and remains "standing in his place" as urbanites and dollars change the world around him. Even the tradition of ghost towns evoked in a poem like "Jerome" suggests the passing of an earlier West whose remnants are merely "ghostly figures" who perhaps stay on as emblems of an earlier reality that still shapes regional identity.

Cowboy poetry is an unusual genre in being literary yet connected closely to folkloric contexts. Its being popular within the group in which it circulates and its being so intimately regional makes it a particularly likely vehicle for folk ideas that express regional identity,

though here we have merely suggested a few possibilities to supple-
ment our more detailed consideration of New Orleans. Whatever the
place or region, however, literary, artistic, and other texts of various
kinds are important source documents in examining sense of place,
and the concepts of the folk idea and the lore of place are certainly
among the useful intellectual tools for conceptualizing it. Folkloristic
ideas can thus tie literary and visual arts texts to understandings of cul-
ture and show how folk conceptions and characterizations inform
those texts.

Not into Cold Space

The "Novelization" of
Folklore Collecting

The use of a frame narrative for presenting folk-lore in written form is an ancient device, particularly well known from such late medieval works as Boccaccio's *Decameron* and Chaucer's *Canterbury Tales*. In both of these works, the frame narrative provides a fictional presentation of an occasion for storytelling, with fictional characters being turned into storytellers recounting to the other characters stories of course put into their mouths by the author. In both *Decameron* and *Canterbury Tales*, the authors give their characters stories deriving from oral tradition and also stories from other sources. Folk stories are thus given a written existence through a fictional telling, and other stories not orally transmitted are given a fictional oral provenance. The latter case suggests a perspective which sees oral telling as the truest context for stories, which fancies such a context as a more fundamental, perhaps more fascinating milieu for narrative than writing.

This device carries over into more recent literary works. Kipling's "The Man Who Would Be King," for example, features oral narration at its heart, as the working-class adventurer Peachey Carnehan tells a first-person literary narrator how he and his now-dead companion went beyond the Himalayas to establish themselves as kings.[1] As is often the case with folk stories, the tale is told late at night (though in a newspaper office). Joseph Conrad's celebrated *Heart of Darkness* is actually presented as a story told by the character Marlowe while a

yacht waits to pick up wind. Although Marlowe's story is otherwise told according to literary conventions, the initial oral context provides a reason for the story's telling and a suitable immediacy. In "The Man Who Would Be King," Carnehan is "recorded" as if speaking, taking this tale toward an approximation of an oral account. Neither Kipling's story nor Conrad's novel, of course, uses a traditional folk story, unlike "Who Let the Cat Out of the Bag in Austin, Texas," which works from the frame of a gathering of women in an office and uses a contemporary legend.[2] But many modern works use fictional oral narrators or simulated oral narration, ranging from Walker Percy's *Lancelot* to David Madden's *Brothers in Confidence*, to John Barth's *Chimera*, which plays on a classic frame folktale collection, *The Thousand and One Nights*.[3]

Yet two of the most intriguing of modern works which use frame narratives are books that are not presented by their authors as works of fiction at all but specifically as works of folklore. In each the fictionalized (but not necessarily fictional) frame narrative presents the story of a folklore collector in search of oral material, and the folk narrators who are described are performing in the context of the collecting experience. Thus a literary device comes to be used specifically in the context of folk studies, producing books which are hybrids of a sort, neither novels (despite novelistic techniques) nor conventional collections of ethnographic texts. They raise questions about both literary conventions and the needs of folklorists in contextualizing folk texts. In effect, they reverse the function of the narrative frame of a storytelling event. The works in question, both published in 1935, are Zora Neale Hurston's *Mules and Men* and J. Frank Dobie's *Tongues of the Monte*.

Zora Neale Hurston is widely celebrated today as a novelist and interpreter of rural African American folk culture, and J. Frank Dobie is remembered primarily as a regional writer of books about Texas folklore and culture. Hurston's *Mules and Men* and Dobie's *Tongues of the Monte*[4] are both hybrids defying classification: book-length presentations of field-collected folklore materials, but presented in a literary rather than a scholarly format. Both *Mules and Men* and

Tongues of the Monte are based on field research, yet as collections of folklore, neither has won scholarly acclaim from folklorists because both Hurston and Dobie, though presenting folklore, ignored or only partially adhered to scholarly standards. For example, Darwin Turner's 1970 introduction to the Perennial Edition of *Mules and Men*, while reassuring general readers that they need not be "discouraged" by Hurston's academic credentials as anthropologist and as "a major Afro-American folklorist," nevertheless contains a warning for scholarly readers: "The anthropologist will not find here an exhaustive and exhausting description of the traditions, mores, and living habits of a folk; he will not be provided with prescriptions for the future behavior of these folk or suggestions for further studies. The folklorist will not find a cataloguing of the tales with documented references to parallel tales in other cultures and other collections."[5] Dobie, for his part, was openly scornful of so-called scientific folklore methods, especially annotations or comparative analysis; he did not hesitate to improve texts which he felt to be ineffectively related.

Moreover, both of these works employ the fictional or semi-fictional frame of a narrator/folklore collector traveling to a community and reporting on the folklore activities observed there. The fictionalized story of Hurston's collecting adventures in *Mules and Men* begins in part 1, "Folk Tales," with her return to Eatonville, Florida, where she had as a child learned to admire the narrative skills of the African American community.[6] Zora, the narrator/collector character of *Mules and Men*, sets out to find folklore, first in Eatonville, and then in the sawmill camps of Polk County, Florida, where in order to explain her presence to a suspicious community she passes herself off as a bootlegger fleeing the law. From Florida, the narrator/collector goes to New Orleans to study hoodoo rituals, apprenticing herself to five different experienced sorcerers and undergoing a series of initiation ceremonies which are recounted in part 2 of the book, "Hoodoo."[7] For *Tongues of the Monte*, Dobie invents a slightly more elaborate but uninspired narrative thread. His narrator, Federico, although not specifically identified as a folklore collector, nevertheless functions like one. He travels into remote areas of northern Mexico and encounters and recounts a variety of folklore as well: legends,

Märchen, songs, rhymes, prayers, charms, proverbs, games, and count-less details of everyday life and lore, such as rhymes chanted while grinding corn and patting out tortillas, and a complicated method of prognosticating the year's weather.

But despite the use of fictionalized frame stories, neither *Mules and Men* nor *Tongues of the Monte* can properly be called a novel, for the fictionalized context is really a pretext for presenting the folklore, and as characters, the narrators/collectors in both books stay enough in the background to make the folkloric and ethnographic material itself clearly the books' focus. As a consequence, *Mules and Men* and *Tongues of the Monte* seem to fall somewhere between the categories of "novel" and "collection of folklore." Largely because of their uncon-ventional format, however, these two books do offer something that present-day folklore scholars can appreciate as much as general read-ers: a more holistic version of folklore. In dramatizing the presenta-tion of field-collected folkloric materials, these two authors tried (with varying degrees of success) to offer us a vision of the folklore as it exists in its cultural context. In a sense, then, these two books anticipated more recent scientific folklore study which acknowledges the need to include context along with text and textual analysis, although the device for doing so in each case is the adaptation of literary, not anthropological conventions. As contemporary folklorists and anthro-pologists begin to look more reflexively at the process of fieldwork and ethnography, raising questions about the possibility of scientific objectivity and about methods of analyzing and presenting cultural "others," these two early attempts at making readers feel "part of the scene" are instructive,[8] especially when we compare the goals and methods of the two field-workers and the stance each developed in relationship to the communities being studied.

Hurston's folklore collecting for *Mules and Men*, conducted dur-ing the period 1927–1932, came about as a result of her training at Barnard College at Columbia University, where she studied anthro-pology with Franz Boas, who sent her out into the field to "collect Negro folk-lore." Folklorists have faulted the book for what they see as its lack of scholarly apparatus, for its total absence of analysis, and for the fact that Hurston was not above some rewriting and tampering

with texts. And yet Robert E. Hemenway argues that her anthropological credentials were in fact very important to Hurston, and that even though she had come to New York in 1925 as a writer and had become part of the literary movement known as the Harlem Renaissance, her subsequent study of anthropology at Barnard profoundly affected her self-concept. He notes the absence of any creative efforts from Hurston between the fall of 1927 and the spring of 1930 as evidence of her commitment to the role of social scientist during those years. He further notes that she was "extremely proud" of her membership in the American Folklore Society, the American Ethnological Society, and the American Anthropological Association, and that she "made sure that any news stories about her contained mention of these professional memberships."[9] That she wanted her work to be perceived as scholarly is further borne out by a 1929 letter to Langston Hughes in which she communicated her desire for scientific accuracy as well as artistry in her work. She wrote, "I not only want to present the material with all of the life and color of my people, I want to leave no loopholes for the scientific crowd to rend and tear us."[10] She reveals here that she is tampering with texts, but only, she explains, "where the story teller was not clear." This shift in self-concept at least temporarily from artist to social scientist certainly implies a different, more analytical way of looking at the world: a different "use" of experience.

By the time *Mules and Men* was published in 1935, however, Hurston had in practice backed away from her commitment to the scientific approach. She had by that time already published two conventional scholarly articles in the *Journal of American Folklore*,[11] but her ambivalence about the role of serious scholarly publication must have been increased by the emphasis in folklore scholarship of the 1920s and 1930s on a kind of objectivity which centered upon texts and textual analysis and tended to ignore the folk themselves. And it is the folk that *Mules and Men* celebrates, most explicitly in part 1, which dramatizes the performances of the community's verbal artists.

Difficulties in finding a publisher for *Mules and Men* in the trade publishing climate of the day must have contributed to her changing consciousness as well. She wrote in 1934 that "it is almost useless to collect material to lie upon the shelves of scientific societies."[12] She

realized of course that the format she chose in order to make her work more appealing to publishers and to the general public would lessen her credibility with the "scientific societies," and thus she wrote to Boas, who she hoped would nevertheless write the introduction to the book: "I have inserted the between-story conversation and business because when I offered it without it, every publisher said it was too monotonous. Now three houses want to publish it. So I hope that the unscientific matter that must be there for the sake of the average reader will not keep you from writing the introduction. It so happens that the conversations and incidents are true. But of course I never would have set them down for scientists to read."[13] Hurston's decision to jettison the demands of academic scholarship—to omit analysis and annotation and to "improve" texts and present them in a fictionalized format—can thus be seen as a reflection of her evolving consciousness about her own sense of self as artist rather than as scientist, and a reflection of her doubts about the effectiveness of too rigid a scientific approach.[14]

The book's seventy folktale texts are presented, as Hurston explained, "with background so that they are in atmosphere and not just stuck out into cold space. I want the reader to see why Negroes tell such glorious tales."[15] Hurston's premise was that the folklore performance of the uneducated rural Negro was "the greatest cultural wealth of the continent,"[16] and her strategy is designed to reveal the aesthetic significance of that performance while documenting the cultural and social context which nurtures it and endows it with meaning. Together, tales and context reveal a great deal of ethnographic information, teaching us about the details of setting, folk events, and worldview. The characters are constantly performing such items as proverbs, slang, nicknames, greetings, insults, and ritualized verbal routines which are presented not as isolated texts, but as part of a given character's behavior in response to specific events on a specific occasion. In context, these items illustrate how folklore functions to break tension, impress one's peers, forward a courtship, or express feelings of resentment. This information is not given in a separate analysis, however; it is dramatized.[17] Hurston herself noted the importance of dramatization in African American culture when she wrote

in 1934: "Every phase of Negro life is highly dramatized. No matter how joyful or how sad the case there is sufficient poise for drama. Everything is acted out."[18] The "between-story business" in *Mules and Men* becomes, in the final analysis, fully as important as the texts, presenting the context which amplifies the stories' meanings and the place of storytelling in the lives of the community.[19] One comes away from *Mules and Men* with a respect for the rural black community and for the verbal skills of its participants.

A similar interest in performance and context rather than scientific accuracy underlies the work of J. Frank Dobie. Dobie was introduced to the field of folklore study by no less a scholar than Stith Thompson, his office mate at the University of Texas, and Dobie also knew well the work of his friend John A. Lomax. He became the mainstay of the Texas Folklore Society and was the major force in shaping folklore scholarship in Texas during his lifetime, chiefly as the editor of the society's publication series. Because of the wide popular appeal of his work, he has always been associated in the public mind with Texas folklore and culture. Unlike Hurston, however, who wanted approval from the "scientists," Dobie resisted being pegged as a folklorist. Folklorists for their part have largely dismissed his work with very little consideration. Nevertheless, the widespread popularity of his books of Texas folklore and his influence for many years as a dominating force in the Texas Folklore Society suggest that a serious evaluation by folklorists is overdue.

Dobie's methods and aims were deliberately not those of the folklorist, for folklore interested Dobie as a storyteller and as a spokesman for the region, not as a scholar interested in accurate recordings of texts or in the comparative studies popular with those to whom Dobie referred as "the literalists designated as scientific folklorists."[20] He was enchanted with oral storytelling and wanted somehow to capture in written form the essence and the "romance" of a live encounter with folklore and the folk. His dissatisfaction with the written form as a substitute for real experience is reflected in his comment, "It's the despair of a writing man who has known the best of storytellers that he cannot translate their oral savor into print."[21] Dobie realized that the folklorist's insistence on accurate renderings

of texts ran counter to his artistic goals. Writing about "charm" in Mexican folktales he noted, "Somehow it eludes recording machines, whether of flesh or metal. Probably no printed folktale that can be called an example of finished art is a literal transcription of oral telling."[22] Logically, then, he would show no interest in the comparative analysis so popular with folklorists of his day.

On retiring as editor of the Publications of the Texas Folklore Society in 1942, Dobie reiterated his disdain for "the science of folklore," which in his view consisted of "the tedious process of finding out, through comparisons and analogies, that nothing new exists under the sun."[23] He was interested in multiple variants, but instead of relating a story "to similar stories from other times and places," writes Texas folklorist Mody Boatright, Dobie "would find it related to its own cultural setting. Back of this were hours in libraries and archives, interviews with oral informants, and a look at the terrain."[24] His interest in multiple variants, then, was not for the purpose of scholarly analysis, but in order to obtain all the details associated with the tradition so that he might synthesize them into a fuller account, a practice which is still frowned upon by folklorists. For example, early in the fieldwork for *Tongues of the Monte*, Dobie wrote his wife: ". . . I want a ghost story as good as any in *Legends of the City of Mexico*. To have one I might weave several I have into one pattern."[25] And in his autobiography he wrote about collecting the story "Juan Oso," or "John the Bear" (Tale Type 301), from the cook on a ranch he visited in Mexico. The cook's version began with "Juan Oso,"[26] then led into and joined together several other tales. Dobie later extracted the "Juan Oso" segment from its place in the longer story, and put it into *Tongues of the Monte*. The day after hearing it, he repeated it to two American women who arrived at the ranch as fellow guests. This had the effect, he explains, of fixing it better in his memory and of letting him learn "how it could be improved in spots."[27] He thus appropriated the story, not for scholarly analysis, but for retelling and passing on to an audience, much as any good oral storyteller would do.

Dobie summed up the difference between his aims and those of contemporary folklore scholars when he complained to his wife in

a letter written from the field that he wasn't yet finding the wealth of Mexican material he wanted for *Tongues of the Monte*: "If I were writing scientific folklore, I could go home and publish my notes. I'm after, as you know, drama, pictures, romance. I'm going to keep after it until I find it. . . ."[28] This early sparsity of materials may also have motivated Dobie's decision to add plot and characters to provide context for the folktales in *Tongues of the Monte*. Although he later found many more stories, Dobie wrote his wife after only a month or so in the field, "Like you, I think I'll have to modify the book from a pure book of tales to something of a chronicle of observations."[29] This strategy led to a book which captures vividly the sense of place he wanted to convey. Dobie was interested in the physical terrain and, being something of a romantic, in how the folk lived in harmony with the place. What appealed to him about folklore was that in his vision it represented and reflected the flavor of the region and that it belonged to the people closest to the soil. In another context he wrote: "I like folklore because it has color and flavor and represents humanity. . . ."[30] In the preface of *Tongues of the Monte* he writes (p. xiv): "I tried to weave the life of the Mexican earth into a pattern. It is truer, I think, than a literal chronicle of what I saw, whom I heard, and where I rode or slept would have been."

We know less about Hurston's methodology, but despite her desire to be acceptable to Boas and other "scientific folklorists," she apparently was not above tampering with texts either.[31] Certainly, aesthetic concerns mattered to her. In the final analysis, both Hurston and Dobie made conscious decisions to eschew the objective, scientific approach—the "literal chronicle," or "bare texts" and comparative analysis. Instead both *Tongues of the Monte* and *Mules and Men* are fictionalized accounts of folklore fieldwork and compendia of folklore presented more or less within its cultural context.

This narrative manner of presentation used in both *Tongues of the Monte* and *Mules and Men* no doubt appealed to the artist in Dobie and in Hurston while providing a picture of the cultural and social context of the folklore. It allowed Dobie to re-create the sense of place he was after—the "drama, pictures, romance"—and it allowed Hurston to re-create the performances of the community whose artistry

she wished to demonstrate. But although both books contain folklore presented as encountered during the course of a fictionalized, semi-autobiographical journey into the field, there are some important differences growing out of each author's relationship to the community being depicted and in the goals each had in writing about that community. These differences are especially apparent when we look at each of the narrators as a novelistic projection of the author as a field-worker. The narrators of both books are fictionalized versions of the authors themselves, though Dobie's somewhat more elaborate fictional thread makes that connection less obvious. Both books are composed of a series of episodes which take the narrator into settings where various characters tell stories or discuss their customs and beliefs. Thus both books use the narrative frame story to provide skeletal plot lines as well as contexts for the folklore they contain.

Dobie's interest in folklore, like Hurston's, was spawned long before he knew anything about folklorists or folklore study. In his auto-biographical *Some Part of Myself* (1952), he tells of the first taleteller he can recall, a traveler who stopped over at Dobie's father's ranch, whose stories thrilled the young boy. The second storyteller to make a significant impact on him he met some twenty-five years later when, as a young adult, he left his University of Texas teaching post and for a short while managed a large ranch for his uncle, J. M. Dobie. There he developed a friendship with one particular storyteller, "a goat-herder and hunter named Santos Cortez," who, Dobie wrote, "learned me his lore and changed my life. Listening to his talk, I resolved to collect the traditional tales of Texas. . . . I have been listening for and to tales ever since. . . ."[32] He records how this return to ranch life as a young man inspired his life's work as a recorder and interpreter of southwestern folklore and culture: "During the year I spent on Los Olmos ranch, while Santos talked, while Uncle Jim Dobie and other cowmen talked or stayed silent, while the coyotes sang their songs, and the sandhill cranes honked their lonely music, I seemed to be seeing a great painting of something I'd known all my life. I seemed to be listening to a great epic of something that had been commonplace in my youth but now took on meanings."[33] The desire to explore the "great epic" and its newly perceived "meanings" provided the impetus for

much of Dobie's writing, and he inevitably included his vision of Hispanic culture in his explorations of southwestern life. Unlike Hurston, however, who returned to her hometown to document the folk artistry of a group she had once been a part of, Dobie in researching *Tongues of the Monte* traveled to a place where his vision of the past could be recaptured, and he collected the folklore of a subculture to which he had never himself belonged.

Dobie's parents had been "*patron* and *patrona*" to the Mexican cowhands who worked on their ranch and to Mexican families who rented fields from them. Of the cowhands traveling to and from Mexico to work every year and passing through the Dobie ranch he recalls in *Tongues of the Monte* itself: "They sang, played the accordion and the French harp, and were great whistlers. When we killed a beef or a yearling, my father would say at the supper table, 'We'll have singing to-night. . . .' After a big bait of fresh meat, the vaquero songs would go up to the stars. Out in the brush, coyotes would respond with songs crying up to the skies. The long, quavering, rising concert of the coyotes was no more wild and eerie than that of the vaqueros" (p. x). These boyhood memories of vaqueros were a part of "the great epic" that took on new meaning for Dobie as a young man looking back on a world which now held great sentimental attraction for him. In the preface of *Tongues of the Monte* Dobie writes about listening to Santos Cortez's stories and about his childhood experiences on his father's ranch, where Mexicans seemed a part of the cultural landscape, and he traces the impetus for the book to the power of these memories. He writes, "The night that Santos made me believe in the bulto that sat on his chest, I had the idea of a book made up of people like Santos and of their stories" (p. xii).

Like Hurston when she set out to collect African American folklore, Dobie's research for *Tongues of the Monte* sent him on a search for his own past, although we should note this difference: the past Dobie was looking for was one in which he occupied a privileged social and economic position vis-à-vis Hispanics. To find a cultural milieu that duplicated the world of his childhood as he now envisioned it, a world "made up of people like Santos and of their stories," Dobie spent 1932–1933 traveling in northern Mexico, supported by a

Guggenheim grant. The similarity in both the physical and the cultural landscape to the surroundings of his childhood in south Texas drew him to the hot, dry brush country of the Sierra Madre region.[34] This area, says Dobie biographer Lon Tinkle, "in its solitude and space, in simple ways of living and its dedication to ranching, and its 'feel' touched his reservoir of profound early memories."[35] Dobie made several extensive excursions into the back country, putting up at various camps and remote haciendas, tracking down storytellers and stories. He described these field trips and his own empowerment as a result of them in the preface to *Tongues of the Monte*: "I made various trips on horseback or muleback, with pack outfit and mozo (combination guide and servant), wandering through the vast, unpopulated mountains of Mexico, lingering at ranches and mining camps, living the freest times of my life. The written result was this book" (p. xiii). The ultimate sources for the book, however, and a key for understanding what Dobie was trying to accomplish, are described by his wife, Bertha McKee Dobie, who claimed: "The wells of English literature and childhood on a ranch, with Mexicans for playmates and mentors, are for Frank deep, deep wells. It is because those wells are deep that *Tongues of the Monte* is a rich book."[36] A more rigorous look at his relationship to the culture under study, however, and comparison with Hurston's objectives in returning to her "wells of inspiration" highlights some of the strengths and weaknesses of both books.

Dobie doesn't analyze the cause for his early difficulty in locating material for use in *Tongues of the Monte*, although realistically it is not too surprising that locating informants and establishing rapport would take some time, especially when we remember that Dobie was an outsider and a foreigner in the community where he did the fieldwork for the book. Hurston's ties with the communities where she did the fieldwork for *Mules and Men* were of course much closer. Nevertheless, in her autobiographical work *Dust Tracks on a Road*, Hurston reveals that, like Dobie, she didn't find the material she was looking for on her first field trip, and she describes her difficulty in shaking off "the glamor of Barnard College" and establishing a satisfactory identity vis-à-vis the community. Her initially refined manner

and formal approach, the result of her university training and her life in New York City, did not win the confidence of her informants. She wrote in *Dust Tracks on a Road*: "My first six months were disappointing. I found out later that it was not because I had no talents for research, but because I did not have the right approach. . . . I went about asking, in carefully accented Barnardese, 'Pardon me, but do you know any folk-tales or folk-songs?' The men and women who had whole treasuries of material just seeping through their pores looked at me and shook their heads."[37]

On the other hand, the analytical character of ethnography of necessity implies a degree of distance from the community even for the "native ethnographer." Hurston explains in the introduction to *Mules and Men* that a certain distance from the community helped bring a new focus to her vision of it. She likens her native culture to "a tight chemise" when she writes, "I couldn't see it for wearing it. It was only when I was off in college, away from my native surroundings, that I could see myself like somebody else and stand off and look at my garment. Then I had to have the spy-glass of Anthropology to look through at that" (p. 17).

Hurston's comments call our attention to the problem of balance inherent in the construct of the anthropological fieldworker as both participant and observer. As an ethnographer Hurston draws authority on the one hand from her scientific objectivity—the "spyglass of Anthropology"—and on the other hand from her personal, subjective involvement with the culture. And yet the written descriptions of culture which would have been most acceptable to social scientists in Hurston's (and Dobie's) time would have downplayed any hint of the ethnographer's personal involvement with the cultural events she records, to enhance the impression of authority based in objectivity.[38] Thus the very choice of the narrative frame story as a method of presentation for ethnographic data would upset the tenuous, perhaps illusory, balance between these two kinds of authority by making the shaping and selecting hand of the ethnographer more perceptible, weakening the appearance of objectivity. Hurston realized, of course, when she chose the format for *Mules and Men*, that she was reluctantly but necessarily risking the disapproval of the "scientific crowd."

Dobie, on the other hand, never conceived of his work as "scientific." Instead he wanted to convey a vivid picture of the culture he wrote about, hoping that description would be "truer" than "a literal chronicle." Nevertheless, the narrative framework, in emphasizing the personal and the subjective, the antithesis of rigid scientific objectivity, has done much to undercut the credibility of both books with folklorists and ethnographers.

Hurston comes close, however, to finding a balance between the impression of scientific objectivity and the impression of authenticity based on the personal and the subjective. In the early chapters of the book, set in Hurston's native Eatonville, the folklore itself carries more emphasis than the narrative frame story, and the narrator, Zora, is very undeveloped as a character.[39] Zora herself comments early in the book, for example, that she "went into neutral" as she greeted potential informants (p. 23). True, the frame story narrative of the ethnographer's adventures becomes more prominent in later sections of the book as Zora moves out of her native setting and develops as a character in response to her encounters. But in the meantime the muted personality of the Zora of the Eatonville section has helped to establish the impression of some degree of the ethnographic objectivity and authority so important in more orthodox presentations of ethnography.

The dynamics change, however, when Zora leaves the front porches of Eatonville for the turpentine camps and jook joints of Polk County, for this move signifies her entry into a more exotic, foreign world. John Dorst describes her move out of Eatonville, where she could remain the passive observer, and into Polk County, where she was unknown to the community, as a move "into the perilous realm of an alien Other."[40] Cheryl A. Wall also recognizes Zora's journey into Polk County as symbolically significant, although instead of seeing the movement as toward "the alien Other," she sees it somewhat as a move inward, toward self-discovery. She refers to Zora as crossing the boundary down into "an almost mythic space which . . . represents the matrix of Afro-American expressive culture. . . . In Polk County both the narrator and the women of the book grow more assertive."[41] Certainly Zora's character begins to develop at this

point, and her story (the narrator's story, that is, in contrast with the stories told by her informants) becomes more prominent, suggesting less of the "neutrality" she displayed in the Eatonville section. Hurston herself calls attention to the challenge the move to Polk County represents for the field-worker. She notes that starting her fieldwork in her home town had made things easier but adds, "I knew that even I was going to have some hindrance among strangers" (p. 19). To deflect the suspicion from herself as a stranger, she creates an identity which will not be considered threatening, and to establish her insider credentials she joins in a performance of "John Henry." In this way she gains acceptance into "the inner circle" (p. 91). Eventually, however, the jealous girlfriend of one of her male informants tries to kill her by attacking her with a knife in a jook joint, whereupon her savvy and tough female friend Big Sweet comes to her rescue and allows her to escape. In describing the real-life incident which she incorporated into *Mules and Men,* Hurston writes in *Dust Tracks:* "I ran out of the place, ran to my room, threw my things in the car and left the place. When the sun came up I was a hundred miles up the road, headed for New Orleans."[42] This incident, described in detail in *Mules and Men,* is the impetus for taking narrator Zora into her adventures with hoodoo practitioners in New Orleans, the recounting of which forms part 2, the last section of the book.

Miriam Camitta, noting the disappointing results of Hurston's early attempts at fieldwork and her subsequent admission into "the inner circle," argues that Hurston's identification with her informants and their culture enabled her eventually to bridge the gap between them.[43] John Dorst, on the other hand, argues that Zora's adventures suggest the impossibility of bridging that gap. He notes that in order to be accepted in Polk County, Zora invented "a bogus identity, a story that is a real lie, a deception" (in contrast to the fictive lies of her informants), demonstrating what he believes to be the "inescapable scandal and dilemma of participant-observer fieldwork." Dorst bases his argument, however, on a consideration of part 1 of the book only, on the grounds that it constitutes "a narrative unit." As a result the violent conflict and Zora's flight from Polk County become in his analysis the climax of the story. This series of

events, he suggests, demonstrates that "for all her sympathy and rapport, there is a whole world of motivations, alliances, and animosities that she has barely glimpsed, much less penetrated," and adds, ". . . one could read the final scene of *Mules and Men* as the symbolic expression of this inevitable failure fully to connect with the Other."[44]

In contrast to Dorst, Wall sees parts 1 and 2 of *Mules and Men* united by an underlying narrative thread: the "successful quest for female empowerment." She argues that Zora develops from the timid daughter of Lucy Hurston returned to her childhood environment into a more assertive researcher under the tutelage of Big Sweet, "the powerful figure who becomes Zora's guardian and guide" in Polk County,[45] and eventually, in part 2, into a mature person "now prepared to navigate spiritual mysteries" in New Orleans, where her experiences "unlock the key to her personal power, the power of the word."[46] Wall thus sees the story of the narrator as primary, inextricably bound up with the source of Hurston's authority in writing the book.

In part 2, Hurston's focus is no longer the community's narrative performances but its beliefs, practices, and rituals relating to hoodoo. Narrator Zora becomes an apprentice to several hoodoo authorities (as did Hurston the ethnographer). She narrates the story of her contacts with these specialists and describes their practices and the problems various clients consult them about. She also describes (in narration) the initiation process she underwent in order to complete her apprenticeships, as well as other ceremonies and rituals she took part in. She does record a few of the community's narratives in part 2, but since the focus has shifted from storytelling to ritual practices, Hurston no longer re-creates the narrative performance context in detail as she did in part 1. Even so, she retains to some extent a communal perspective through her language and by introducing stories with comments which emphasize connections to the community. She says, for example, "The way we tell it, hoodoo started way back there before everything" (p. 229), and ". . . the following conjure stories . . . illustrate the attitude of negroes of the Deep South toward this subject" (p. 287), thus contextualizing the stories and beliefs. Moreover, Zora's own emotions and her opinions about the events she takes part in remain undisclosed to the reader so that the emphasis on community

is retained.[47] Nevertheless, as narrator Zora's story becomes more central relative to the folklore itself in part 2—or inseparable from it since it is no longer confined to "between stories"—the illusion of an objective ethnographic account (difficult to maintain in a narrative anyway) is further damaged.

It is true, obviously, even for the narrative ethnographer, that one can never fully be both subject (ethnographer) and object (informant), and yet the field-worker's attitude toward her informants helps or hinders her efforts to speak about them with authority. Hurston felt that her apprenticeship and initiation into the practice of hoodoo was an expression of her commitment to an insider's perspective, and she criticizes Robert Tallant's *Voodoo in New Orleans* (1946) for being "totally exterior so far as Hoodoo is concerned."[48] If Tallant "had been 'in' and become a 'Two-Headed Doctor' himself," she maintains, he would have had much greater access to information and could have produced a more accurate and more meaningful study of the practices of contemporary hoodoo doctors.[49] In a recent article about fieldwork methods, Camitta expresses a contemporary shift toward recognizing the importance of personal involvement in fieldwork. She writes that as field-workers "we can see ourselves as either identifying with the object of our research or viewing that object as exotic and different."[50] She maintains that in part 2 of *Mules and Men* Hurston actually "crossed over the boundary dividing the researcher from the informant—she herself became the informant she wished to study."[51] Wall, too, connects the source of Hurston's ethnographic authority to her experiences described in part 2. Zora (and Hurston), she argues, "earns the right to write the words by first seeking the power through which she may invest them with meaning."[52] Again viewing parts 1 and 2 as a coherent whole, she maintains that part 2 was written "in the spirit" and thus serves "to allegorize the journey of the artist who travels both to the matrix of the culture and to the deepest regions of the self. Having completed this dual journey, she is empowered to tell her story to the world."[53]

The connection between Dobie as a field-worker and his narrator persona Federico in *Tongues of the Monte* is less obvious than the connection between Hurston and her narrator Zora, yet Federico

is arguably a fictionalized version of Dobie as well as a character in the book's framing narrative. Some distance between them is created by calling the narrator Federico—Dobie was sometimes called Pancho (a nickname for Francisco, or Frank) in real life, but not Federico—and by surrounding Federico with an air of mystery. Although Dobie and Federico both traveled into northern Mexico and encountered folklore there, only Dobie is identified openly as a writer or as a collector of folklore.[54] Instead Federico dismisses "explanations" as "tedious," telling us that if asked "how I came to be riding alone in this remote part of the land . . . I reply frankly that I am not the first man to have crossed the Rio Bravo del Norte, in either direction, without giving or wishing to give an explanation" (p. 27). The real explanation, of course, is that author Dobie, in the guise of his semi-autobiographical narrator, has set out in search of romance and drama in a setting he identifies with his nostalgic vision of his own youth—the "great epic" of ranch life and Mexican folk culture. In the preface he cites a long association with Mexican people as a kind of "warrant for my right in years long afterwards to write a book about the Mexican people" (p. x).

We have already discussed the sources of Hurston's ethnographic authority in writing about the African American community. A closer look at Federico's interactions with his informants in *Tongues of the Monte*, however, will illustrate an important difference between these two writers in their approach to the people they studied, a difference which bears on their "warrants" to write these books. Both Zora and Federico find themselves involved in situations of conflict and danger spawned by sexual jealousy. It was an incident of this sort which motivated Zora's precipitous departure for New Orleans, where she continued her research. Federico, the more fictional narrator of *Tongues of the Monte*, is attracted to Dolores, the seventeen-year-old ward of the owner of the Hacienda of the Five Wounds, where he is a guest. But since he knows that he will never marry her, he decides to forestall trouble by avoiding contact with her and takes the physically alluring servant girl Lupita for his mistress, even though one of the vaqueros, White Moustache, is in love with her. Occasional chance encounters with the forbidden Dolores continue to torment him, however, while

Lupita "was, as she knew, but an incident" (p. 137). But Dolores, out of jealousy aroused by his physical liaison with Lupita, poisons Lupita, and White Moustache seeks to avenge her death by attempting to kill Federico, who is saved by the intervention of his faithful servant Inocencio, who kills the attacker.

Dobie uses this obviously fictional conflict to add interest to the rather sketchy plot and to provide motivation for Federico's leaving the hacienda for the next stage of his adventures, where he meets yet other characters who perform their folklore for him. Nevertheless, the fictional scenario of his sexual exploitation which resulted in such unhappiness and two deaths seems almost emblematic of Federico's— and by implication Dobie's—relationship to the culture he studied and wrote about. Dobie's creation, his alternate "self," shows no sense of responsibility whatever for the sorry chain of events and calmly walks away, even leaving the dead man to be buried by "others." Dobie uses this incident to begin a scholarly digression on roadside crosses in Mexico before picking up the narrative thread again. Far from bridging the gap between ethnographer and the Other and identifying with the people he studied, then, Dobie as ethnographer remains the outsider writing his "chronicle of observations." The people he writes about fascinate him, but they nevertheless remain romantically exotic—like the vaqueros Dobie remembered from his boyhood. Consequently, Dobie's narrator persona Federico learns a great deal about Mexican folk culture, but he never abandons his position as an elite outsider.

At the end of the book Federico describes his approaching leavetaking from his servant, Inocencio, "the good old man who had served me so well" (pp. 294–295). As a parting gift Inocencio gives him the knife with which he had killed a man to save Federico's life: "I was to keep it as a recuerdo of one who wished to serve me" (p. 299). It is hard not to see the ritual which follows as emblematic of the dynamics of Dobie's relationship to his material:

> As Inocencio stood now, neither of us saying anything, I
> saw him eying the knife. Presently he picked it up. . . .
> He unsheathed the knife, which was polished bright and

newly sharpened, and with it cut a small vein in his left
wrist. He wiped the knife clean, put it back in its scab-
bard, placed the scabbard in my left hand, and then with
a finger took his own blood and marked a cross in the
palm of my free hand. "This sign is more than words,"
he said. "Soy el suyo. I am yours." (pp. 300–301)

However much Dobie (or his narrator persona) may have been moved
by this gesture, it nevertheless dramatizes his stance as researcher in
this project as one of dominance and appropriation, not one of identi-
fication and affiliation.

Dobie's own comments on his goals and methods as a folklorist
support this interpretation of his relationship to his materials. He
regarded himself as an artist and performer, not primarily a recorder
of tradition. As editor of the Publications of the Texas Folklore Soci-
ety, Dobie articulated his vision of the society's goal as not merely the
gathering and recording of regional folklore, but also making "the
people of the region comprehend and enjoy it." The artist/performer
in Dobie and his fascination with the humanistic details of regional
culture thus led him to a preoccupation with the literary presenta-
tion of folklore although not actual performances. For Dobie this
presentation was, as Boatright maintains, an art and not a science.[55]
It was, therefore, the "story" as an aesthetic entity that mattered for
Dobie, and his own aesthetic goals as a performer himself prompted
him to revise texts he considered ineffectively related: "My custom is
to try to tell a tale as the original teller should have told it. Any tale
belongs to whoever can best tell it."[56] Aware of the difficulties of trans-
lating oral storytelling into printed form, he explained, "if the char-
acters in an orally told tale do not talk effectively, the business of any
writer who adopts this tale is to make them talk better—with more
savor, more expressively of both themselves and the land to which
they belong."[57] To capture that "savor" of the land and the people in
Tongues of the Monte, Dobie invented Don Federico and lets the
reader experience the place and the culture through his eyes.
Federico often reports the folklore he encounters directly to the
reader, explaining in detail the cultural background and history
associated with the places he visits and describing the people and

activities he encounters, or he retells the stories he discovers in his own voice instead of letting the storytellers relate them, often adding interpretation and commentary of his own. He becomes the "expert" and the storyteller, and the reader shares his experiences and the knowledge he gains. In Dobie we mostly see the community and the folklore as mediated through the narrator.

Zora Neale Hurston eventually chose fiction over social science—a creative rather than a scientific use of experience, and *Mules and Men* represents in its format a pulling away from the folklore scholarship of its day, and a step for Hurston toward becoming the novelist who would transform her experiences with folklore and folk culture, weaving them into her fiction.[58] But her aim in *Mules and Men* was to demonstrate and claim recognition for the verbal artistry of the humble folk performers of the black community. Thus she returned to the rural South in search of folktales and other verbal performances, and the device of a narrator persona allows the reader to travel with her into the heart of the community, becoming vicariously "part of the scene."[59] The narrator, then, both in *Mules and Men* and in *Tongues of the Monte*, serves as a mediator who (theoretically) makes the exotic culture accessible to the reader. But while in Dobie's book the reader almost always encounters folklore reported on, retold, and interpreted by the narrator Federico, the narrator/collector Zora in *Mules and Men* remains a catalyst and a reporter, not a re-teller of stories herself. Though she often joins in with folklore performances, participating in the "between-story business," her essentially nonintrusive character (especially in the Eatonville segment of the book) keeps her own performances somewhat de-emphasized, pointing the reader instead towards the world and the words of her informants.

Ironically, Hurston succeeds in doing what Dobie wanted to do— she recreates the flavor of oral storytelling—precisely by focusing as much on the performance context (dramatizing actual performances, including the language of the folk community—in the "between-story business") as on the *story text*, while Dobie lets his narrator persona appropriate and tell the stories himself, in his language. Hurston, by contrast, keeps the focus in *Mules and Men* clearly on the community, dramatizing their performances (notably in part 1, "Folk Tales") rather

than letting the narrator give her own. At the same time, *Mules and Men* never becomes a vehicle for the thoughts and observations of the narrator. Despite her increasing development as a character as the book progresses, narrator Zora doesn't discuss, explain, or reflect on the folklore[60] as Dobie's narrator often does. Even in part 2 of the book, which shifts in focus from narrative performance to ritual practices, Zora refrains from giving the reader much information about her own reactions to the hoodoo rituals she is taking part in and describing to the reader. As a result, despite the fact that narrator Zora's adventures in the field form the framework of the book, the folk performances and the community remain its central focus.

This foregrounding of the community performances in *Mules and Men* contrasted with appropriation of the folklore by the narrator in *Tongues of the Monte* is especially significant when we assess their value as collections of folklore. Hurston's move beyond recording cultural context (which is also important to Dobie) to recording performance context is precisely what makes *Mules and Men* such a valuable document for modern folklorists. Dobie's approach to folklore, despite his efforts to reproduce cultural context, is still much more text-centered than Hurston's. Ironically, his frustration with more conventional folklorists of his own day was a result of his appreciation of oral storytelling performances. But while Hurston recorded the performances of African American storytellers, Dobie in all his books presented his own (the writer's) performance and not that of his informants. For the modern folklorist assessing their works, this difference is crucial.

Nevertheless, both Hurston and Dobie sought, in a manner of presentation which was personal and artistic rather than scientific and objective, to go beyond recording texts to the more ambitious goal of entertaining and educating the reader. Both books were published in 1935, a time when conventional academic folklore studies gave little attention to such issues, and in this respect they actually anticipated some of the trends in current folklore research. As early as the 1960s Mody Boatright contrasted what he felt were the two essential approaches to the study of folklore. "One is to consider the lore in relation to its local cultural context. The other is to extract the item

under consideration from its social setting and treat it in one of several ways—as a metaphysical entity, as a psychological phenomenon, or as a variant of an item common to several times and places."[61]

Folklorists today have in fact become less interested in comparative analysis of texts, less satisfied with analyzing items extracted from their social settings—less "item-centered" in general—and more interested in looking at folklore as part of a cultural and social context in the performance of folklore. This shift in the very conceptualization of folklore was described by Dan Ben-Amos in 1971: "Any definition of folklore on the basis of abstracted things is bound to mistake the part for the whole. To define folklore, it is necessary to examine the phenomena as they exist. In its cultural context, folklore is not an aggregate of things, but a process—a communication process, to be exact."[62] It follows from this conceptualization of folklore as a process that the folklorist's vision of material must be holistic: the "texts" that the folklore collector observes cannot be separated from the performer, the audience, or the performance itself. As Mary Ellen Brown Lewis has written, "Folklore in its totality involves a situation, a context, a collectivity of persons interacting with one another."[63]

Hurston's method in *Mules and Men* of dramatizing the setting, the meaning, the function, and the artistry of the folktale community likewise emphasizes "folklore in its totality," or as Hurston put it, "in atmosphere and not just stuck out into cold space." Dobie, in *Tongues of the Monte*, focuses less on the oral performance of his informants, letting his narrator persona become the storyteller in many instances. Nevertheless, he aimed in his writing at creating for readers a picture of the context, however romanticized, emphasizing connections of the lore to the culture and the land. He wrote in *Some Part of Myself*, "I considered that if [the stories of the range] *could be put down so as to show the background out of which they have come*, they might have high value."[64]

Both Hurston and Dobie, in these two books published in the same year, deliberately violated scholarly standards of their day and assumed a more literary format at least partly because the format of folklore collections, which isolated texts from their performance context and from their social and cultural milieu, failed to satisfy their

aesthetic and humanistic demands.[65] On the other hand, these two hybrid books—part folklore collection and part fictionalized narrative—attempted a kind of contextualist, if not an analytically contextualist, approach. Hurston and Dobie each sought to go beyond some of the limitations of the folklore scholarship of their day.[66] They did not choose precisely the path of more recent folklore studies, but they were very much working in uncharted territory. A comparison of the strategies they developed in the absence of scholarly models suited to the needs they perceived reveals the crucial difference between them to be in their attitudes toward the communities they studied and highlights how really ahead of her time Hurston was in developing an approach which, particularly in part 1, "Folktales," would focus on the artistry of the community. In his review of the 1978 reissue of *Mules and Men*, John Roberts writes that Hurston "demonstrated a folkloristic sophistication and sensitivity to folklore processes shared by few of her contemporaries."[67] Because of this emphasis on folklore in the context of not only culture but also performance, *Mules and Men* even more than *Tongues of the Monte* represents an important effort to present the whole folklore process, to pluck texts out of "cold space" and put them into "a situation, a context, a collectivity of persons interacting with one another."

Whereas the use of a story to frame other stories within that larger narrative most commonly subordinates folk material for the purposes of written literature, the opposite happens in the Hurston and Dobie volumes. The folk material is presented as primary, and the frame story—which specifically calls attention to the folkness of that material and its retrieval from a folk context—becomes subservient to its presentation. The more usual folklore/literature relationship reverses to some extent. Literary convention finds a related but new use, suggesting further the fluidity of relationships between oral and written.

Interestingly, though each writer produced work significant to folk studies, both Hurston and Dobie are generally viewed as "creative," not ethnographic writers. Despite her grounding in academic anthropology, Hurston went on to write novels of lasting national and international importance. Dobie, who never saw himself as a

scholar, became primarily a writer of literary nonfiction—much of it folklore-related—whose work is still remembered as evocative of an American region. In their 1935 volumes we get an instructive picture of two writers working with folklore who are poised between folklore collecting and literary storytelling and who were to move on from these works to other literary endeavors and to different kinds of fame. Hurston may have found something of her powers as a narrator in shaping *Mules and Men,* and her lighter touch with her less intrusive narrator is perhaps predictive of her considerable talent as a novelist. Dobie's use of folk materials in *Tongues of the Monte* is very revealing of his attitude toward that which interested him in society and of a romantic vision of culture which in fact pervades his work in general.

Wishing to reveal larger cultural contexts in relation to folklore than the folklore scholarship of their time allowed for, lacking models of how best to do so, both Hurston and Dobie sought solutions in literary conventions and provided novelistic frames for presenting the material they had uncovered in their fieldwork. Neither *Mules and Men* nor *Tongues of the Monte* stands up as a novel as such, and the former is more successful than the latter in finding new ways to contextualize folklore and to produce more vivid presentation of the milieus of folk performance. But both books demonstrate a felt need for holistic presentation of folklore and a notable awareness of the possibilities for interrelating folk and literary narration in a modern context.

Conclusion

Old Meanings, New Meanings

Insofar as "art" imitates "life," art necessarily reinterprets the reality perceived by the artist. In the case of fiction, for example, the writer pulls into the text many reflections of the exterior world—places, relationships, actions, processes, institutions—in creating a written prose narrative. As an aspect of social reality, folklore inevitably is something which sometimes is pulled into that interior world of the novel or short story, whether mimetically or through other forms of reference. In some ways folklore is like any other aspect of culture, such as kinship systems, scientific paradigms, types of architecture, or various modes of socializing and educating, which the artist draws upon and interprets. Yet as a fundamental mode of communication itself, folklore comes with an array of associations and deep meanings, so that in re-situating it in his text, the artist must plot how to redistribute that meaning or must imagine meanings of his own. The twentieth-century artist, often working in a context perceived as removed from or even antithetical to folklore despite the obvious presence of folklore in twentieth-century life, was adept at such re-situations, and folklore is a re-situated part of a great variety of twentieth-century literary and artistic works, for diverse purposes.

For instance, in dealing with quilts and quilt making, the writers discussed in chapter 6 have viewed the quilts in ways which reflect both some of the meanings attached to them by the original

craftswomen and meanings which come from outside that original context, though "insider" and "outsider" meanings may also mesh. Several of the writers discussed in that chapter have focused on quilts as a female genre which is expressive of women's messages, even "subversive" messages, in a cultural context of male domination. Whitney Otto, feminist and nonquilter, is perhaps most committed to such a view and most thoroughly develops it, but even popular writer Barbara Michaels is attracted to the possibilities for "secret" women's messages in quilts (to the extent that her novel, *Stitches in Time*, crosses over into the suspense genre because quilts hold secrets), and she plays with theories about women's culture and women's channels of communication as separate from those of male, "mainstream" society. The idea that women encode in the "female" folk genre of quilts messages unknown to men is also particularly strong (and perhaps particularly disturbing) in Glaspell's "A Jury of Her Peers," as women conspire to further cover up a hidden message, and in Warner's "A Widow's Quilt," where the husband blithely misses a quilted communique.

Yet quilts can have other meanings and suggest social divisions along lines other than those that are gender-based. Both Otto and Phyllis Alesia Perry see racial divisions worked out in quilting (and indeed in reality African American quilt design can be strikingly different from that of white America[1]). In "Everyday Use" Alice Walker works with the gaps that can appear within a single family and between a rural worldview and a "sophisticated," urban one. Her wry and ironic twist certainly reflects an American reality in which quilts may once have been rejected as hopelessly old-fashioned, countrified, and backward, only to be resurrected as charming, beautiful, and chic. Walker's character Dee (Wangero) of course is indicative of a real revival of interest in quilts among the nonquilting classes, and her vision of quilts in part mirrors an attitude which sees quilts as romantic and to be associated with the values of American pioneer life or family togetherness and heritage.

All of this is to say that folklore can be re-situated in literature in a variety of ways to evoke a variety of meanings (even contradictory or contrasting ones), while embodying a variety of relationships

to the original context and meanings of the folklore in tradition. While Tyler uses the patchwork quality of the quilt to suggest a bonding love and mutual helpfulness, in their novels Perry and Michaels have quilts which carry messages of racial separation and oppression. Otto uses quilts to evoke both curative and connective forces and those which divide and produce ill will. For Margaret Atwood, the patchwork of quilts can represent both the fragmentation of memory and the eventual integration of self, the scattered nature of the human personality and the attainment of personal meaning despite our scattered traits. Overall, the writers discussed in relation to quilting find meaning through the forms, the historical contexts, the social uses, and their own re-interpretations of a folk tradition, and other writers re-situating other genres do the same.

As in social interaction, folklore in literature may, then, find its meanings from the contexts where it appears—in the lifeworld of the fictional narrative as in the original context from which it has been de-situated. Meaning is multivalent and the very process of de- and re-situation involves many choices and complexities. For Frida Kahlo, for example, folk objects and folk contexts have both national, cultural meanings and personal ones. In her *Four Inhabitants of Mexico City (The Square Is Theirs)* (fig. 7), for example, the four artifacts which dominate the canvas clearly reflect aspects of Mexican society suggestive of the elements that combine to make up Mexico culturally and politically. Yet the fact that the real counterparts of these re-situated artifacts actually existed in Kahlo's and Diego Rivera's collection makes them a personal reference. Of course artists commonly incorporate both personal and cultural or universal referents and influences into their work, but in the case of Frida Kahlo the tension between the two seems particularly striking.

Despite her use of folklore as personally symbolic, Kahlo participated in a larger artistic movement in which the re-situation of the folkloric was an important element (for example, in Rivera's murals) and whose participants maintained an intense interest in the original folk contexts. In contrast, Clarence Laughlin's re-situations of the folkloric are very different from hers. Whereas Kahlo in some ways retained a connection to original folk contexts and repositioned

those contexts with interest in their original meanings, Laughlin was concerned almost exclusively with imposing his own meanings which he saw as more universal because they reflected aspects of the human mind.

If Kahlo's use of folklore is in part very personal, however, folklore *is* often personal in the sense that individuals have their own repertoires of lore and personal understandings of their lore intertwined with social, group understandings. Insofar as folklorists sometimes have studied individual repertoires, they touch on the issue of the personal use of folklore. And writers of fiction, for example, can certainly work with the folklore of individual characters. That is precisely what Jay McInerney does in *Story of My Life*. His character Alison Poole spends much of the novel trying to remember folklore which obviously she has learned from oral tradition, but which also has personal meanings for her (although of course tradition bearers do forget parts of their repertoires, and McInerney seems well aware of individual memory as a key component in the actual processes of folk tradition). Thus there is interplay between folklore and fictional personality which illuminates the fictional personality, a use of folklore found in other novels.

In *The Robber Bridegroom* Eudora Welty illuminates characters' personalities through her formal/stylistic use of a folkloric form to shape the outline of her narrative. By putting her own characters within the frame of a fairytale, she is able to portray them rather two-dimensionally, like real folktale characters, and thus focus upon them as symbolic representations of duality and as rather simple actors on a stage of Edenic proportion. In *The Robber Bride* Margaret Atwood shapes a key character by referencing her to a particular fairytale character, albeit through a reversal of sex, and Kazantzakis's Father Yanaros's memories of his personal involvement in sacred ritual tell us much about who he is and why he responds to crisis in certain ways.

But folklore is primarily a group possession with social meanings, and inevitably we must look primarily to those collective meanings in literary and artistic re-situations. Kahlo's nationalistic and political uses of folklore fit in with a long line of interest in folklore for reasons of nation building and cultural politics. Likewise, Lucy

Maycock's looking to the lore originally collected for *Gumbo Ya-Ya* to find a collective representation of place assumes a time-honored perspective on folklore. Folklore is often conceived of as highly localized and thus expressive of some definable geographical (though also cultural) entity or some otherwise definable group. Such a view emphasizes the supposed "uniqueness" of some group's lore and thus that lore's symbolic power to define the group itself. Although Ana Castillo re-situates folklore in *So Far from God* for more than one reason, she certainly positions the folklore of an ethnic group as a marker of that group's boundaries within a larger American society in a novel in which she examines the relationship between "ethnic" and "mainstream" cultures.

Castillo, of course, also uses folklore to evoke an otherworldliness, a connection to the divine and the ethereal, and indeed folklore often has been seen as somehow related to the transcendent through the power of myth or ritual, through the archetypes found in fairytales, or through folk belief systems of various kinds. Castillo means to position her ethnic world as on the edge of "normal" American realities in more than just a physical or social sense, and her characters are far from God in one way and closer to God in another. The magical world her characters inhabit is partly a world of folklore. But Eudora Welty, by setting her novel within the frame of a fairytale, also evokes another world, not one of the divine or miraculous, or even, despite her frame, really one of the magic and wonder that infuses many fairytales. What she succeeds in doing, however, is transferring the timeless, placeless otherworldliness of fairytales to a particular historical and geographical context. This enables her to present that context and the actors within it symbolically rather than historically.

In its original contexts folklore does frequently offer links to alternate realities—the magical world of the wonder tale, for example—and spiritual realms, from ghost and miracle legends to sacred mythic narratives to forms of prayer to folk practices like pilgrimages, home altars, and yard shrines. Ritual is certainly one traditional form of religious behavior that proposes links to the divine and even ways of influencing divine forces. Ritual public events

may have transformative power, but even if they simply mirror by presenting or re-presenting social images, they often are intended to move their practitioners closer to some spiritual center or force, and writers pick up on such socially conceived possibilities. Father Yanaros in *The Fratricides* is a ritual practitioner. He believes in the power of ritual to transform spiritually, and he exists in the midst of a horrible situation where transformation is desperately needed. He fails disastrously in part because the rituals are no longer efficacious. Kazantzakis's novel calls into question the power of ritual, though at the same time acknowledging its importance to the human heart. Ritual fails too in *To Kill a Mockingbird*, but Harper Lee seems to wish that the society she depicts did indeed have some effective rituals, especially of initiation, and thus recognizes at least the potential power rituals have to model transformation. But writers' visions of how forms of folklore enable people to transcend the material world obviously are varied and complex.

The potential that ritual in its literary re-situation has to fail reminds us that writers do not necessarily view folklore as a positive force, despite folklore's commonly being regarded positively as an aspect of culture which defines and expresses precious heritage, thrills children and children's librarians, and generally functions to keep society on an even keel. Like those writers who question the efficacy of ritual, others discussed in this book call into question the supposed wisdom of proverbs and the social value of proverbial communication. For E. M. Forster, language itself fails in human communication, and proverbs as fixed-form language are particularly apt to fail, being devoid of real substance. For Graham Greene proverbs may help people to keep from confronting what they should stare in the face. Even in the world of Chinua Achebe, the folk sayings promote the values of a traditional society which itself collapses in the course of *Things Fall Apart*. In sketching out her vision of Louisiana as a place, Lucy Maycock also works with folklore's negative possibilities (the lore of death and of gambling). Margaret Atwood draws upon a fairytale villain for her own villainess, not a reflection of a negative view of folklore but certainly a mining of folk narrative's own propensity for dealing with evil as well as good, indeed for casting good and evil in obvious opposition.

Thus twentieth-century artists take many approaches to incorporating folklore in literary works and other works of art when they adapt plots, imitate folk genres, incorporate folklore into their imaginary lifeworlds, or refer their readers to its meanings less directly. Folklore may have special appeal because meanings inhere in it, both the meanings it is designed to convey by its creators and transmitters and the meanings bestowed upon it by intellectuals and other outsiders to particular traditions. Those meanings make folklore attractive to artists for various reasons. The folklore may seem to convey messages otherwise overlooked, like those sewn into quilts; convey fundamental patterns, like those which inhere in both patchwork and human relations; embody the very soul of a group, whether the nation of Mexico, ethnic subgroups within the United States, or a whole sex; suggest deep truths about the subconscious mind and its creative powers, as in producing grave markers or folk shrines; express personality and connect individuals to social and cultural contexts when they remember or forget, use or do not use elements of their folklore repertoires; express a sense of place, whether Louisiana, the old Natchez Trace country, or somewhere else, even fantasy worlds; enable us to contact supernormal powers and evoke divine solutions, as when we enact rituals, successfully or unsuccessfully; provide a kind of cultural shorthand, as do proverbs, even though we run the risk of communicating ineffectively when we resort to the formulaic. Whatever the motives for recycling lore, the artistic end-product that incorporates folklore inevitably acquires some of the meaning of the original, however refracted through the lens of the artist.

Of course re-situating "real" folklore into a "fictional" lifeworld or otherwise referencing it to literary meaning is not the only act that establishes connections between folklore and the written word. The conventions of literature have shaped how folklorists have presented what they have observed and collected in the field and how written texts (and works of visual art) can be interpreted in terms of concepts originally devised for understanding the oral and traditional. Ultimately the interconnections between folklore and literature or folklore and visual art are merely part of a much larger pattern of interrelations in a culture of which folklore is one communicative form in constant interaction with other forms; this interaction may

be animated by a variety of motives, approaches, and concerns, some of which fall under the heading of folklorism, the "second-hand mediation and presentation of folk culture."[2] That is, folklore is de- and re-situated not only by artists but also by political movements, promoters of tourism, and producers of folk festivals.[3] It is recycled by journalists and other writers of nonfiction, who treat it as news-worthy, as background material, or as quaintly worthy of attention.[4] It is sucked up by the advertising industry and, indeed, siphoned into popular cultural creations of all kinds.[5] Even the ethnographer or folklore collector does, of course, re-situate folklore by observing it or recording it in its context and then describing it in writing or reducing it to a written/printed text. The documentary photographer and the ethnographic filmmaker frame it in more ways than one, giving us cropped and film-edited versions of folk contexts, as do museum exhibitions in related if different ways.[6] When folklore is "revived," as for example during the American folksong revivals of the twentieth century, it is re-situated to serve a number of purposes—romantic, political, social, commercial, countercultural. Woody Guthrie himself, though he used folk and folklike songs to question the political status quo, also produced songs that "echoed the official rhetoric of a state dedicated to economic revival." And Robert Cantwell also calls attention to the various ends folksong reviving and collecting has served, from bridging the gap between New York intellectuals and "the great prewar American south and west" in the 1930s, to providing Bascom Lamar Lumsford "a reservoir of the old-fashioned rural gentility" he sought, to Alan Lomax's thoughts that the Library of Congress Archive of American Folk Song existed to provide material that could be re-situated in some grand "national opera."[7]

Ultimately folklorists need to see how folklore is re-situated in a vast number of nonfolk contexts because it appeals to so many modern and postmodern interests, and to see that re-situation is one great process that places folklore in a central position outside actual folk contexts because folk meanings ancient and less ancient carry over so powerfully into the minds of us all. The folklore/literature relationship has been studied more comprehensively than these other con-

nections, and it is to be hoped that what we learn from folklore and literature as they intertwine can give us insight into the larger process of how modern society views and integrates the folkloric. The study of how folklore is de- and re-situated in literature and art is thus an aspect of our larger investigations of how folklore has been positioned to interrelate with many other forms of modern culture[8] and a significant part of our attempts to integrate our vision of the modern world and its ideas, aesthetics, ideologies, and creative powers.

\bigcapotes

Introduction

1. Ruth Finnegan, *Literacy and Orality: Studies in the Technology of Communication* (Oxford: Basil Blackwell, 1988), p. 64.

2. Marshall McLuhan, *Understanding Media: The Extensions of Man* (New York, Toronto and London: McGraw-Hill, 1964), pp. 22–32.

3. See Barre Toelken, *The Dynamics of Folklore* (Boston: Houghton-Mifflin, 1979), especially pp. 49ff.

4. See Kenneth Pimple, "The Meme-ing of Folklore," *Journal of Folklore Research* 33 (1996): 236–240.

5. And of course folkloric communication will display in varying degrees some of the more subtle characteristics of orality, such as those Walter J. Ong, *Orality and Literacy: The Technologizing of the World* (London and New York: Methuen, 1982), pp. 31–77, refers to as the "psychodynamics of orality," while he contrasts these characteristics with those of chirographic and typographic cultures. On Ong's conceptions of orality and literacy as well as related comments on folklore and literary study, see Eric L. Montenyohl, "Oralities (and Literacies): Comments on the Relationships of Contemporary Folkloristics and Literary Study," in *Folklore, Literature, and Cultural Theory: Collected Essays*, ed. Cathy Lynn Preston (New York: Garland, 1995), pp. 240–256.

6. Finnegan, p. 62.

7. See Tristram P. Coffin, "A Tentative Study of a Typical Folk Lyric: 'Green Grows the Laurel,'" *Journal of American Folklore* 65 (1952): 341–351.

8. Dan Ben-Amos, "Toward a Definition of Folklore in Context," in *Toward New Perspectives in Folklore*, ed. Richard Bauman and Américo Paredes (Austin and London: Univ. of Texas Press for the American Folklore Society, Publications, Bibliographical and Special Series, 23, 1972), p. 13 (emphasis added); William Bascom, "Verbal Art," *Journal of American Folklore* 68 (1955): 245–252. Bakhtin uses the term "verbal art" rather differently, however, to include aspects of the literary; see, for example, M. M. Bakhtin, *The Dialogic Imagination: Four Essays*, ed. Michael Holmquist, trans. Caryl Emerson and Michael Holmquist (Austin and London: Univ. of Texas Press, 1981), pp. 260–261n. 1.

9. Bascom, pp. 246, 251.

10. Finnegan, p. 77.

11. Daniel R. Barnes, "Toward the Establishment of Principles for the Study of Folklore and Literature," *Southern Folklore Quarterly* 43 (1979): 10.

12. Bruce A. Rosenberg, *Folklore and Literature: Rival Siblings* (Knoxville: Univ. of Tennessee Press, 1991), passim.

13. Finnegan, p. 63.

14. Susan Stewart, *Nonsense: Aspects of Intertextuality in Folklore and Literature* (Baltimore and London: Johns Hopkins Univ. Press, 1989), pp. 52, 67, 75, 92.

15. For a conceptualization rather different from that outlined in this chapter, see Neil R. Grobman, "A Schema for the Study of the Sources and Literary Simulation of Folkloric Phenomena," *Southern Folklore Quarterly* 43 (1979): 17–37.

16. Albert B. Friedman, "Tasso among the Gondoliers," in *Folklore International: Essays in Traditional Literature, Belief, and Custom in Honor of Wayland Debs Hand*, ed. D. K. Wilgus (Hatboro, Pa.: Folklore Associates, 1967), pp. 55–66; Louise Pound, "'Monk' Lewis in Nebraska," *Southern Folklore Quarterly* 9 (1945): 107–110; G. Malcolm Laws, *Native American Balladry*, rev. ed. (Philadelphia: American Folklore Society, Publications, Bibliographical and Special Series, 1, 1964); D. K. Wilgus, Liner Notes, "Native American Ballads" (RCA Victor Vintage Series LPV-548); see also F. A. de Caro, "Studying American Folklore in Printed Sources," in *Handbook of American Folklore*, ed. Richard M. Dorson and Inta Gale Carpenter, pp. 411ff (Bloomington: Indiana Univ. Press, 1983). A recent volume, Manuel da Costa Fontes, *Folklore and Literature: Studies in the Portuguese, Brazilian, Sephardic,*

and Hispanic Oral Traditions (Albany: State Univ. of New York Press, 2000), contains several studies documenting the movement from literary to oral forms, and Stephen Nissenbaum, *The Battle for Christmas* (New York: Alfred A. Knopf, 1996), passim, makes a cogent case for the influence of literary works like *A Visit from St. Nicholas* on American Christmas rituals and traditions. For a period of time an aspect of the popular radio show *Prairie Home Companion* was the "Department of Folk Song," which featured a variety of songs from many sources which were deemed to have entered a kind of oral tradition; a survey of this now-discontinued part of the program would suggest interesting insights into the fluidity of printed and oral texts.

17. That is, beyond what happens as oral societies evolve into literate ones, as "literacy . . . consumes its own oral antecedents" (Ong, p. 15). Given our book's focus on the literary re-situating of folklore by modern authors and artists in industrial and postindustrial Western societies, discussion of the early evolution of folk contexts in literary ones is well beyond our scope.

18. See S. B. Hustvedt, *Ballad Books and Ballad Men: Raids and Rescues in Britain, America, and the Scandinavian North since 1800* (Cambridge: Harvard Univ. Press, 1930) and Albert B. Friedman, *The Ballad Revival: Studies in the Influence of Popular on Sophisticated Poetry* (Chicago and London: Univ. of Chicago Press, 1961).

19. Rosenberg, pp. 131–139; see Ong, pp. 20ff for additional comments on the influence of Parry.

20. Roger D. Abrahams and Barbara A. Babcock, "The Literary Use of Proverbs," *Journal of American Folklore* 90 (1977): 415.

21. Stewart, pp. 122, 18, 63, 20.

22. G. Malcolm Laws, *The British Literary Ballad: A Study in Poetic Imitation* (Carbondale and Edwardsville: Southern Illinois Univ. Press, 1972), pp. 8, xi–xii, 3.

23. In addition to Laws, see Frank de Caro, "Literary Ballad," in *Encyclopedia of Folklore and Literature*, ed. Mary Ellen Brown and Bruce Rosenberg (Santa Barbara: ABC-CLIO, 1998), pp. 382–384, for a brief overview of the literary ballad.

24. Toni Reed, *Demon Lovers and Their Victims in British Fiction* (Lexington: Univ. Press of Kentucky, 1988), discusses Bowen's story, passim; Oates's frequently reprinted story first appeared in book form

in her collection, *The Wheel of Love and Other Stories* (New York: Vanguard Press, 1970).

25. Lafcadio Hearn, *Chita: A Memory of Last Island* (New York and London: Harper and Brothers, 1917); originally published 1889.

26. Rosenberg, p. 179.

27. Mary Ellen Brown Lewis, "The Study of Folklore in Literature: An Expanded View," *Southern Folklore Quarterly* 40 (1976): 346.

28. George B. Bryan, *Black Sheep, Red Herrings, and Blue Murder: The Proverbial Agatha Christie* (Bern: Peter Lang, 1993), p. 8.

29. Bryan, p. 12.

30. Carl Lindahl, *Earnest Games: Folkloric Patterns in the Canterbury Tales* (Bloomington and Indianapolis: Indiana Univ. Press, 1987).

31. Lindahl, pp. 11, 3, 61.

32. Mary Ellen Brown, *Burns and Tradition* (Urbana and Chicago: Univ. of Illinois Press, 1984), p. xii.

33. Brown, *Burns and Tradition*, pp. 12, 48.

34. Trudier Harris, *Folklore and Fiction: The Novels of Toni Morrison* (Knoxville: Univ. of Tennessee Press, 1991), pp. 17, 10, 7, 108, 15, 8.

35. Alan Dundes, "The Study of Folklore in Literature and Culture: Identification and Interpretation," *Journal of American Folklore* 78 (1965): 136–137.

36. Bauman and Paredes.

37. Dundes, p. 136.

38. Dundes probably had in mind Richard Dorson's influential comments on folklore and literature, comments which, according to Rosenberg, p. 181, establish the purpose of looking at folklore in literature as "the gleaning of literary texts to locate ethnographic data." Dorson, "The Identification of Folklore in American Literature," *Journal of American Folklore* 70 (1957): 1–8, had argued that to be of interest to folk studies, a literary work needed an author whose knowledge of the folklore in the work came directly from oral tradition. Barnes, p. 14, calls this criterion of Dorson's "rigidly excessive," and, indeed, folklorists who have written on folklore in literary works have not necessarily been overly concerned with documenting writers' sources precisely.

39. Regarding Welty, see chapter 2.

40. Barnes suggests that the process may be more complicated, indicating, for example, the need to give greater attention to the oral performance aspects of the original folklore.

41. Rosenberg, p. 179; Lewis, p. 346.

42. Robert Cantwell, *Ethnomimesis: Folklife and the Representation of Culture* (Chapel Hill and London: Univ. of North Carolina Press, 1993), p. 5.

43. McLuhan, pp. 56ff.

44. Stewart, pp. 48, 76.

45. Kelsie B. Harder, "Proverbial Snopeslore," *Tennessee Folklore Society Bulletin* 24 (1958): 89–95.

46. See, for example, J. R. R. Tolkien, *The Fellowship of the Ring* (London: George Allen and Unwin; Boston: Houghton Mifflin, 1963), pp. 197–198, 203–206. These are but two examples out of many possibilities, but the first is interesting in providing a comment on how the song was learned by the singer from oral tradition and on its fragmentary nature; the second comes with a gloss on its language and historical meaning.

47. For a brief overview of these developments, see F. A. de Caro, "Folklore as an 'Historical Science': The Anglo-American Viewpoint," Ph.D. dissertation, Indiana Univ., 1972, pp. 101ff.

48. Elliott Oring, "Legend, Truth, and News," *Southern Folklore* 47 (1990): 163–177.

49. Kenneth A. Thigpen, "Thomas Pynchon's V and the Alligators in the Sewer Legend," *Southern Folklore Quarterly* 43 (1979): 93–105; Cristina Bacchilega, "Folklore, Fiction, and Meta-Fiction: Their Interaction in Robert Coover's *Pricksongs and Descants*," *New York Folklore* 6 (1980): 171–184. Less well known than Pynchon's famous V is R. Wright Campbell's mystery novel *Hip-Deep in Alligators* (New York: New American Library, 1987).

50. Lewis; Rosenberg; Cristina Bacchilega, *Postmodern Fairytales: Gender and Narrative Strategies* (Philadelphia: Univ. of Pennsylvania Press, 1997); Jack Zipes, *Happily Ever After: Fairy Tales, Children, and the Culture Industry* (New York and London: Routledge, 1997); Mark Workman has published a number of pieces which take somewhat unconventional approaches, as in "Narratable and Unnarratable Lives,"

Western Folklore 51 (1992): 97–107, which looks at folk narratives and literary memoir/autobiography, and the essays in Preston try a number of new approaches. See also Steven Swann Jones, *Folklore and Literature in the United States: An Annotated Bibliography of Studies of Folklore in American Literature* (New York: Garland, 1984).

51. Thigpen; Bacchilega, "Folklore, Fiction, and Meta-Fiction"; Steven Jones, "The Enchanted Hunters: Nabokov's Use of Folk Characterization in Lolita," *Western Folklore* 39 (1980): 269–283; Bacchilega, *Postmodern Fairytales*.

52. Thigpen, p. 94.

53. Mary Ellen Brown Lewis, "Beyond Content in the Analysis of Folklore in Literature: Achebe's *Arrow of God*," *Research in African Literature* 7 (1976): 44–52.

54. Or some "authentic other," as Amy Shuman, "Dismantling Local Culture," *Western Folklore* 52 (1993): 349, puts it; for example, in American culture some ethnic or racial group thought to have particularly strong connections to an oral tradition, such as African Americans or Native Americans. Relevant studies include Kathleen Manley, "Leslie Marmon Silko's Use of Color in *Ceremony*," *Southern Folklore* 46 (1989): 133–146; Carol Mitchell, "*Ceremony* as Ritual," *American Indian Quarterly* 5 (1979): 27–35; and Harris; Harris, p. 2, notes that "African-American folklore is arguably the basis for most African-American literature." That may be correct and certainly much attention has been paid to folk contexts in African American writing, though the importance of folklore in the literature produced by this group which has a specific history in which folklore has assumed particular significance can lead to the false assumption that only writers from such groups emphasize the folkloric. Of course, such studies as these are often insightful, and the groups focused upon may indeed be deeply involved in forms of traditional culture and communication.

55. Mikhail Bakhtin, *Rabelais and His World*, trans. Helene Iswolsky (Cambridge and London: M.I.T. Press, 1968), p. 3. However, as Mary Ellen Brown notes, "Introduction," in Brown and Rosenberg, p. xxxix, for folklorists even "for all its brilliance, Bakhtin's analysis is reductive, limiting folklore" to a restricted range of material.

56. Bascom, p. 246.

57. But see, for example, Barbara Allen Woods, "Brecht, Popular Tradition, and Folklore," *Southern Folklore Quarterly* 43 (1979): 65–70; and

Joseph Patrick Roppolo, "Folklore in Louisiana Drama: A Challenge," *Louisiana Folklore Miscellany* 1, no. 4 (1960): 65–81.

58. In the book as a whole, although we deal with works of visual art and poetry, drama, and nonfiction, we do mostly examine novels, perhaps because the novel is such a central modern genre, or perhaps because, as Michael Holmquist notes in his "Introduction" to Bakhtin, *The Dialogic Imagination*, p. xxxii, "the novel can include, ingest, devour other genres" in a way that other genres cannot.

59. See Jan Harold Brunvand, *The Study of American Folklore: An Introduction*, 4th ed. (New York and London: W.W. Norton, 1998), pp. 11–12 and table of contents.

1. Riddles of Love and Death

1. Jay McInerney, *Story of My Life* (New York: Atlantic Monthly Press, 1988); Ana Castillo, *So Far from God*, paperback ed. (New York: Penguin Plume, 1994); quotations in the text are from the fifth printing.

2. John Sutherland, "End of the Century," *London Review of Books* 10, no. 18 (1988): 22.

3. Including "I love coffee, I love tea. / I love the boys, and the boys love me," which certainly could apply to Alison; "One flew east, one flew west, / One flew over the cuckoo's nest," in itself a counting-out rhyme appropriated by Ken Kesey for the title of his first novel; and "Milk in the pitcher, butter in the bowl, / Can't get a sweetheart to save my soul," which could also perhaps relate to Alison, who runs through guys, unable to stick with any one for very long, and whose inability to hold Dean precipitates her breakdown. See Leah Rachel Clara Yaffie, "Three Generations of Children's Singing Games in St. Louis," *Journal of American Folklore* 60 (1947): 27; Vance Randolph, "Jump Rope Rhymes from Arkansas," *Midwest Folklore* 3 (1953): 81.

4. "Care of the Social Fabric" is a chapter title and refers to a remark made by Dean, p. 73.

5. See Archer Taylor, *English Riddles from Oral Tradition* (Berkeley and Los Angeles: Univ. of California Press, 1951), p. 234; for an important recent study of riddles in film, see Steve Siporin, "Life Is Beautiful: Four Riddles, Three Answers," *Journal of Modern Italian Studies* 7 (2002): 345–363.

6. See Thomas A. Burns, "Riddling: Occasion to Act," *Journal of American Folklore* 89 (1976): 143–144; Roger D. Abrahams, "Introductory Remarks to a Rhetorical Theory of Folklore," *Journal of American Folklore* 81 (1968): 156; F. A. de Caro, "Riddles and Proverbs," in *Folk Groups and Folklore Genres: An Introduction*, ed. Elliott Oring (Logan: Utah State Univ. Press, 1986), pp. 180–183.

7. See Mary Knapp and Herbert Knapp, *One Potato, Two Potato: The Folklore of American Children* (New York: W. W. Norton, 1976), pp. 54, 217.

8. See, for example, *Funny Times* 5, no. 2 (1990): 18.

9. Noah Richler, "Tale of Two Cities," *Punch* September 9, 1988, p. 36; Sutherland, p. 22; Anonymous, Review of *Story of My Life, Kirkus Review* 56 (1988): 1004; David Klinghoffer, "We Are the Children," *National Review* 40 (30 September 1988): 53; David Lehman, Review of *Story of My Life, Newsweek*, 26 September 1988, p. 73.

10. Jay McInerney, *Bright Lights, Big City* (New York: Vintage Books, 1987), p. 138.

11. Mary Ellen Brown Lewis, "The Study of Folklore in Literature: An Expanded View," *Southern Folklore Quarterly* 30 (1976): 351.

12. Richard Bauman, "Differential Identity and the Social Base of Folklore," *Journal of American Folklore* 84 (1971): 31–41.

13. Sofi, of course, suggesting wisdom.

14. Cisneros's comment appears as a publicity blurb on the back cover of the paperback edition of *So Far from God* cited above.

15. For information on the making of *santos*, which may be either statues (*bultos*) or paintings on wood (*retablos*), see Roland F. Dickey, *New Mexico Village Arts*, illus. Lloyd Lozes Goff (Albuquerque: Univ. of New Mexico Press, 1970), pp. 136–186; E. Boyd, *Popular Arts of Spanish New Mexico* (Santa Fe: Museum of New Mexico Press, 1974), pp. 78–169, 327–439, and passim; George Kubler, *Santos: An Exhibition of the Religious Folk Art of New Mexico* (Fort Worth: Amon Carter Museum of Western Art, 1964); José E. Espinosa, *Saints in the Valleys: Christian Sacred Images in the History, Life and Folk Art of Spanish New Mexico*, rev. ed. (Albuquerque: Univ. of New Mexico Press, 1967); Thomas J. Steele, S.J., *Santos and Saints: The Religious Folk Art of Hispanic New Mexico* (Albuquerque: Calvin Horn, 1974); Eluid Levi Martínez, *What Is a New Mexico Santo?* (Santa Fe: Sunstone

Press, 1978); William Wroth, *Images of Penance, Images of Mercy: Southwestern Santos in the Late Nineteenth Century* (Norman and London: Univ. of Oklahoma Press for the Taylor Museum, 1991); Laurie Beth Kalb, *Crafting Devotions: Tradition in Contemporary New Mexico Santos* (Albuquerque: Univ. of New Mexico Press; Los Angeles: Gene Autry Western Heritage Museum, 1994). For the *penitente* brotherhood, see Juan Hernandez, "Cactus Whips and Wooden Crosses," *Journal of American Folklore* 76 (1961): 216–224; Marta Weigle, *Brothers of Light, Brothers of Blood: The Penitentes of the Southwest* (Albuquerque: Univ. of New Mexico Press, 1976); Alberto López Pulido, *The Sacred World of the Penitentes* (Washington: Smithsonian Institution Press, 2000); Marta Weigle, *A Penitente Bibliography* (Albuquerque: Univ. of New Mexico Press, 1976).

16. Thus folklore has often played a role in nationalistic movements; see, for example, Richard Handler, *Nationalism and the Politics of Culture in Quebec* (Madison: Univ. of Wisconsin Press, 1988), and William A. Wilson, *Folklore and Nationalism in Modern Finland* (Bloomington: Indiana Univ. Press, 1976), and "Herder, Folklore and Romantic Nationalism," in *Folk Groups and Folklore Genres: A Reader*, ed. Elliott Oring (Logan: Utah State Univ. Press, 1989), pp. 21–37.

17. On *curanderismo* and related subjects, see Ari Kiev, *Curanderismo: Mexican-American Folk Psychiatry* (New York and London: Free Press, 1968)

18. The Women's Building mural was a collective project done by many hands, but the principal artists were Juana Alicia, Miranda Bergman, Edythe Boone, Susan Kelk Cervantes, Meera Desai, Yvonne Littleton, and Irene Perry, with Olivia Quevedo as calligrapher.

19. See Bacil F. Kirtley, "'La Llorona' and Related Themes," *Western Folklore* 19 (1960): 155–168; Robert A. Barakat, "Aztec Motifs in 'La Llorona'," *Southern Folklore Quarterly* 29 (1965): 288–296; Michael Kearney, "La Llorona as a Social Symbol," *Western Folklore* 28 (1969): 199–206; Bess Lomax Hawes, "La Llorona in Juvenile Hall," *Western Folklore* 27 (1968): 153–170.

20. See Américo Paredes, "Folk Medicine and the Intercultural Jest," in *Spanish Speaking People in the United States: Proceedings of the 1968 Annual Spring Meeting of the American Ethnological Society* (Seattle: American Ethnological Society, 1968), pp. 105–119.

21. Kathryn Annette McDonald, "Ours the Ash: (Re)visions of Death in Contemporary Chicana Literature," M.A. thesis, Louisiana State Univ., 1999, pp. 74–75.

22. "Magic Realism," in J. A. Cuddon, A Dictionary of Literary Terms and Literary Theory, rev. C. E. Preston, 4th ed. (Oxford: Blackwell), p. 487. The term was coined as magischer Realismus in 1925 by Franz Roh. In 1943 the Museum of Modern Art mounted the exhibition "American Realism and Magic Realism."

23. Reproduced in Lo del Corazón: Heartbeat of a Culture (San Francisco: Mexican Museum, 1986): p. 20.

24. See Bea Carrillo Hocker, Ritual and el Día de los Muertos (San Francisco: The Mexican Museum, 1988), p. 11.

25. Chicanos en Mictlán: Día de los Muertos in California (San Francisco, The Mexican Museum, 2000), pp. 34, 40.

26. Reproduced in Tere Romo, curator, Chicanos en Mictlán: Día de los Muertos in California (San Francisco: Mexican Museum, 2000), pp. 122–123; original punctuation (which differs in the title and in the mock press release) has been retained.

27. The authors viewed the installation and video at the Galleria de la Raza in San Francisco, October 2000. The serigraph has been reproduced as a postcard by Fine Art Prints, distributed by Out of Hand Graphics, San Francisco, and also as a button.

28. On Tapia's work, see Kalb, pp. 45–87.

29. For example, Ester Hernandez produced an etching (1976) which shows the Virgin in Asian martial arts attire and pose (The Virgen of Guadalupe Defending the Rights of the Xicanos/La Virgen de Guadalupe Defendiendo los Derechos de los Xicanos); Santa Barraza an oil and enamel on metal which imitates a milagro (El Milagro de mi Hermana/My Sister's Miracle), 1991–1992, reproduced in Amalia Mesa-Bains, curator, Ceremony of Spirit: Nature and Memory in Contemporary Latino Art (San Francisco: Mexican Museum, 1993); Francisco X. Camplis a calavera Virgin of Guadalupe (Virgen de Guadalupe Calavera, acrylic on butcher paper, 1972) (reproduced in Romo, p. 65); in The Source/El Classico: Virgens y Cruces (oil on canvas, 1999), the Mexican painters Einar and Jamex de la Torre use a multitude of vagina-like shapes which mimic the halo which historically surrounds images of Guadalupe (seen by the authors in the "Ultra-Baroque:

Aspects of Post Latin American Art" exhibition, San Francisco Museum of Modern Art, 2001). For images of the Virgin of Guadalupe from Mexican calendars, a tradition of popular publishing which freely mixed sacred and secular, even the sacred and the sexual, see *La Patria Portatil: 100 Years of Mexican Chromo Art Calendars* (Mexico City: Museo Soumaya, 1999), pp. 14–15.

2. Somebody Always Gets Boiled

1. James Joyce, *Ulysses* (Paris: Shakespeare and Co., 1922); Nikos Kazantzakis, *The Odyssey: A Modern Sequel*, trans. Kimon Friar (New York: Simon and Schuster, 1958); Donald Barthelme, *Snow White* (New York: Atheneum, 1967); Angela Carter, *The Bloody Chamber and Other Stories* (London: Gollancz, 1979).

2. Antti Aarne and Stith Thompson, *The Types of the Folktale: A Classification and Bibliography*, 2nd rev. ed. (Helsinki: Folklore Fellows Communications, no. 184, 1961).

3. Quotations from the Grimm version of the tale given here are from *The Complete Grimm's Fairy Tales*, intro. Padraic Colum, commentary Joseph Campbell (New York: Pantheon, 1977). "The Robber Bridegroom" appears pp. 200–204. This edition is based on the definitive edition translated by Margaret Hunt.

4. Cristina Bacchilega, *Postmodern Fairy Tales: Gender and Narrative Strategies* (Philadelphia: Univ. of Pennsylvania Press, 1997). The initiatory factors inherent in these tales are perhaps more central to Type 311 and Type 312, where Bacchilega puts the main emphasis of her discussion, than to Type 955, which she concentrates on much less. Two other, more recent commentators on Angela Carter's short story, "The Bloody Chamber," discuss it in connection with Type 312, Kathleen E. B. Manley, "The Woman in Process in Angela Carter's 'The Bloody Chamber,'" and Cheryl Renfroe, "Initiation and Disobedience: Liminal Experience in Angela Carter's 'The Bloody Chamber,'" in *Angela Carter and the Fairy Tale*, ed. Danielle M. Roemer and Christina Bacchilega (Detroit: Wayne State Univ. Press, 2001), pp. 83–93, 94–106. Renfroe stresses liminal aspects of women's initiation rites.

5. Eudora Welty, *The Robber Bridegroom* (New York: Harcourt Brace, 1942); page references are to the Harvest/HBJ paperback ed. (New York: Harcourt Brace Jovanovich, 1970). Margaret Atwood, *The Robber Bride*

(New York and London: Doubleday, 1993). Both Welty and Atwood are writers whose work has been much commented on. See Victor H. Thompson, *Eudora Welty: A Reference Guide* (Boston: G. K. Hall, 1976); and Judith McCombs and Carole L. Palmer, *Margaret Atwood: A Reference Guide* (Boston: G. K. Hall, 1991).

6. Peggy Whitman Prenshaw, ed., *Conversations with Eudora Welty* (New York: Washington Square Press, 1985), pp. 25–26. The interview originally appeared in *Comment: The University of Alabama Review* in 1965.

7. Eudora Welty, "Fairy Tale of the Natchez Trace," in *The Edge of the Story: Selected Essays and Reviews* (New York: Random House Vintage, 1979), p. 302.

8. See Robert M. Coates, *The Outlaw Years: The History of the Land Pirates of the Natchez Trace*, foreword John D. W. Guice (Lincoln and London: Univ. of Nebraska Press, 1986).

9. Benton was familiar with a number of folk songs and tunes, and he commented on them in some of the literature that accompanied or described his lithographs and other work. The catalogue raisonné of his lithographs includes the texts of the relevant songs, although these were provided by the editor, Creekmore Fath, interestingly enough from his own recollection of song sessions at the University of Texas in the 1930s, where the singers included J. Frank Dobie and other luminaries such as the historian Walter Prescott Webb. See Creekmore Fath, comp. and ed., *The Lithographs of Thomas Hart Benton* (Austin and London: Univ. of Texas Press, 1969), pp. 46–47, for *Jesse James*, which originated as a mural in the Missouri State Capitol. *She'll Be Driving Six White Horses* has alternate titles, including two which place the scene in the Ozarks. Alan Lomax, *The Folk Songs of North America* (Garden City: Doubleday, 1960), pp. 406, 414, presents the song as a railroad song, indicating that it is about the arrival of a train. However, John Cohen, *Long Steel Rail: The Railroad in American Folk Song* (Urbana and London: Univ. of Illinois Press, 1981), p. 41, rejects that idea, especially because of the white horses line which Benton interprets in terms of a stagecoach. For comments on Benton's folklore interests, see Robert Cantwell, *When We Were Good: The Folk Revival* (Cambridge and London: Harvard Univ. Press, 1996), p. 95.

10. Bacchilega, p. 110.

11. Welty, "Fairy Tale," pp. 310–311.

12. Ruth M. Vande Kieft, *Eudora Welty*, rev. ed. (Boston: Twayne, 1987), p. 31.

13. Bacchilega, pp. 129ff.

14. On this form of healing, see Richard M. Dorson, *Bloodstoppers and Bearwalkers: Folk Traditions of the Upper Peninsula* (Cambridge: Harvard Univ. Press, 1952), pp. 150–165, and the corresponding notes. Dorson calls "indispensable" the relevant article in Hanns Bachtold-Staubli, ed., *Handworterbuch des deutschen Aberglaubens*, 10 vols. (Berlin and Leipzig: W. de Gruyter, 1927), I:1452–1465.

15. Bacchilega, p. 130.

16. Karen F. Stein, *Margaret Atwood Revisited* (New York: Twayne, 1999), p. 97, notes that Atwood copyrighted the book as A. W. Toad, anagramatic for her name, which she sees as signaling "the importance of wordplay in the novel."

17. Some early critics of the novel found her mixing of folk traditions confusing. See John Peale Bishop, "The Violent Country," *New Republic* 107 (1942): 646–647; and John Lane, "Southern Allegory," *Times Literary Supplement* 43 (January 22, 1944): 41.

18. Sharon Rose Wilson, *Margaret Atwood's Fairy-Tale Sexual Politics* (Jackson: Univ. Press of Mississippi, 1993), passim. Wilson argues that Atwood has had frequent recourse to many fairytales in a number of contexts. Atwood's short story "Bluebeard's Egg," in *Bluebeard's Egg and Other Stories* (Boston: Houghton Mifflin, 1986), pp. 131–164, is of particular significance in this context.

19. At the end of the novel (p. 450), Roz thinks about her daughters and changing ideas about gender: "fences once . . . in place around the gender corrals are just . . . rusty old wire."

3. Falling in Love with All Its Lore

1. Richard M. Dorson, "The Identification of Folklore in American Literature," *Journal of American Folklore* 70 (1957): 5–8.

2. Dorson, p. 3.

3. Lyle Saxon, Edward Dreyer, and Robert Tallant, comps., *Gumbo Ya-Ya: A Collection of Louisiana Folk Tales*, illus. Caroline Durieux and Roland Duvernet (Boston: Houghton Mifflin, 1945); the play remains

unpublished and quotations from the play are quoted from a copy of the calling script (as revised 9/29/99), a working script used by the stage manager. We are indebted to Lucy Maycock for a copy of this script.

4. Susan Larson, *The Booklovers' Guide to New Orleans* (Baton Rouge: Louisiana State Univ. Press, 1999), p. 161, refers to it as "the basic text for Louisiana folklore." The fact that she gives its subtitle incorrectly as "The Folklore of Louisiana" may suggest that the book is rather taken for granted by Louisianians and owned as a "local classic" rather than actually read (an assessment of the book's status shared by Maycock).

5. Though the field-workers thus sometimes did folklore fieldwork, the term "field-worker" in the Writers' Project referred simply to a researcher.

6. The Louisiana guides appeared as *New Orleans City Guide* (Boston: Houghton Mifflin, 1938), and *Louisiana: A Guide to the State* (New York: Hastings House, 1941). For more information on the Louisiana Writers' Project, see F. A. de Caro, "A History of Folklife Research in Louisiana," in *Louisiana Folklife: A Guide to the State*, ed. Nicholas R. Spitzer (Baton Rouge: Louisiana Folklife Program/Division of the Arts and Center for Gulf South History and Culture, 1985), pp. 23–24, and Ronnie Wayne Clayton, "A History of the Federal Writers' Project in Louisiana," Ph.D. dissertation, Louisiana State Univ., 1974.

7. For recent discussion of the dialect in folkloristics, see Jeffrey Hadler, "Remus Orthography: The History of the Representation of the African-American Voice," *Journal of Folklore Research* 35 (1998): 99–126, and Frank de Caro, "On 'Remus Orthography,'" *Journal of Folklore Research* 36 (1999): 83–85.

8. For discussion of the Spiritual churches within whose context Mother Catherine worked, see Claude F. Jacobs and Andrew J. Kaslow, *The Spiritual Churches of New Orleans: Origins, Beliefs, and Rituals of an African-American Religion* (Knoxville: Univ. of Tennessee Press, 1991); Jason Berry, *The Spirit of Black Hawk: A Mystery of Africans and Indians* (Jackson: Univ. Press of Mississippi, 1995); Claude F. Jacobs, "Spirit Guides and Possession in the New Orleans Black Spiritual Churches," *Journal of American Folklore* 102 (1989): 45–67; and Michael P. Smith, *Spirit World: Pattern in the Expressive Folk Culture of Afro-American New Orleans* (New Orleans: New Orleans Urban Folklife Society, 1984). Mother Catherine ran a New Orleans compound where she ministered to orphans, battered women, and others. Interest in her life and work has grown in recent years, and Jason Berry is completing a

book about her. Berry also discusses her pp. 12–15, 99–100, and passim; Jacobs and Kaslow discuss her pp. 29–31, 150–151, and passim. The relevant material in *Gumbo Ya-Ya* is in chapter 10.

9. Frank de Caro had two discussions in Baton Rouge with Maycock about the play, on January 24, 2000, and July 26, 2000. Neither discussion was tape-recorded; information and quotations from those discussions given here are from notes taken at the time. He also attended a performance of the play at Southern University in Baton Rouge. The authors express their appreciation to Lucy Maycock for her kind assistance and cooperation.

10. For information on Saxon, see James W. Thomas, *Lyle Saxon: A Critical Biography* (Birmingham: Summa, 1991); Cathy Chance Harvey, "Lyle Saxon: A Portrait in Letters, 1917–1945," Ph.D. dissertation, Tulane Univ., 1980; Rosan Augusta Jordan and Frank de Caro, "'In This Folk-Lore Land': Race, Class, Identity, and Folklore Studies in Louisiana," *Journal of American Folklore* 109 (1996): 46–56; Larson, pp. 98–99.

11. Maycock and Barry Kyle, her husband and the director of Swine Palace, felt from the outset a need to work with Louisiana plays, not only from feeling an obligation to the community but also reasoning that local actors could be particularly effective in "local stories." People, Maycock says, are "hungry to see themselves," and Swine Palace has done plays by Louisiana writers Rebecca Wells and Elizabeth Dewberry; Maycock did earlier adaptations of two famous Louisiana novels, John Kennedy Toole's *A Confederacy of Dunces* and Robert Penn Warren's *All the King's Men*.

12. Maycock sees the play as a work in progress which may in fact change for future performance.

13. When she had first come to Baton Rouge, Maycock had been asked to judge a local play-writing contest. Despite the diversity of the scripts she read, she had discovered in them stories that were "curiously similar," with "shared preoccupations" that suggested the influence of a local worldview and local perspectives and interests.

14. The Mardi Gras Indians are organized groups of New Orleans African Americans who costume as Native Americans ("mask Indian") on Mardi Gras and other occasions.

15. Lyle Saxon, *Fabulous New Orleans*, illus. E. H. Suydam (New York: Century, 1928), pp. 3–69.

16. Saxon entitled an unfinished memoir he wrote "The Friends of Joe Gilmore," and in it he talks at some length about his servant, Joe Gilmore. Saxon's collaborator on *Gumbo Ya-Ya*, Edward Dreyer, in effect finished the memoir by writing his own recollections of Saxon and his circle. It was published as *The Friends of Joe Gilmore and Some Friends of Lyle Saxon* (New York: Hastings House, 1948). Saxon's relationship with Gilmore certainly must have been a complicated one and intrigued Maycock.

17. See chapter 9.

18. Edwin Edwards, flamboyant four-term governor of Louisiana, popular and notorious scoundrel, was twice tried and acquitted on charges of corruption and was widely viewed as a "crook." He was under indictment at the time the play was first produced and was, in fact, finally convicted on charges of corruption relating to licenses for riverboat gambling. Edwards was finally imprisoned in October 2002.

19. For this working script Maycock sometimes used the names of the actual actors speaking particular lines in the original production.

20. See also chapter 8.

4. Folk Rhetoric, Literary Strategy

1. See Wolfgang Mieder, "The Use of Proverbs in Psychological Testing," *Journal of the Folklore Institute* 15 (1978): 45–55; Louis A. Berman, "Using Proverbs to Test Readiness for College Composition," *Proverbium* n.s. 7 (1990): 19–36. For the Addams cartoon, see the *New Yorker*, 3 May 1952, p. 31.

2. Roger D. Abrahams and Barbara A. Babcock, "The Literary Use of Proverbs," *Journal of American Folklore* 90 (1977): 417. Or, as Susan Stewart, *Nonsense: Aspects of Intertextuality in Folklore and Literature* (Baltimore and London: Johns Hopkins Univ. Press, 1989), p. 19, notes, proverbs "rely . . . heavily upon situational and social contextual restraints." For basic discussions of the proverb, see Archer Taylor, *The Proverb and Index to the Proverb* (Hatboro, Pa.: Folklore Associates; Copenhagen: Rosenkilde and Bagger, 1962); Peter Seitel, "Proverbs: A Social Use of Metaphor," *Genre* 2 (1969): 143–161; Barbara Kirshenblatt-Gimblett, "Toward a Theory of Proverb Meaning," *Proverbium* 22 (1973): 821–827; F. A. de Caro, "Riddles and Proverbs,"

in *Folk Groups and Folklore Genres: An Introduction*, ed. Elliott Oring (Logan: Utah State Univ. Press, 1986), pp. 175–197; Sw. Anand Prahlad, *African American Proverbs in Context* (Jackson: Univ. Press of Mississippi, 1996); Wolfgang Mieder, *International Proverb Scholarship: An Annotated Bibliography*, 3 vols. (New York: Garland, 1982–1993) and annual bibliographies in the journal *Proverbium*.

3. See Wolfgang Mieder, comp., *Proverbs in Literature: An International Bibliography* (Bern: Peter Lang, 1978); Wolfgang Mieder and George B. Bryan, comps., *Proverbs in World Literature: A Bibliography* (Bern: Peter Lang, 1996), which contains over two thousand entries; and Wolfgang Mieder, "Proverbs," in *Encyclopedia of Folklore and Literature*, ed. Mary Ellen Brown and Bruce A. Rosenberg (Santa Barbara: ABC-CLIO, 1998), pp. 525–528. For a recent selection of commentary on proverbs in one national literature, see Kevin J. McKenna, ed., *Proverbs in Russian Literature: From Catherine the Great to Alexander Solzhenitsyn* (Burlington: Proverbium Supplement Series, no. 3, 1998).

4. Hans-Manfred Militz, "Proverb-Antiproverb: Wolfgang Mieder's Paremiological Approach," *Western Folklore* 58 (1999): 27.

5. See for example John Messenger, "The Role of Proverbs in a Nigerian Judicial System," *Southwestern Journal of Anthropology* 15 (1959): 64–73; E. Ojo Arewa and Alan Dundes, "Proverbs and the Ethnography of Speaking," *American Anthropologist* 66, part 2, no. 6 (1964): 7–85; E. Ojo Arewa, "Proverb Usage in a 'Natural' Context and Oral Literary Criticism," *Journal of American Folklore* 83 (1970): 430–437.

6. Chinua Achebe, *Things Fall Apart* (London: Heinemann, 1958); references in the text are from the paperback ed. (New York: Fawcett Crest, 1989).

7. Wolfgang Mieder and Anna Tóthné Litovkina, *Twisted Wisdom: Modern Anti-Proverbs* (Burlington: Proverbium Supplement Series, no. 4, 1999), p. 1.

8. Abrahams and Babcock, p. 426.

9. Both of these examples are reprinted in Mieder and Litovkina, pp. 35, 163.

10. Stewart, p. 35.

11. E. M. Forster, *A Passage to India* (London: Edward Arnold; New York: Harcourt Brace, 1924); page references are to the paperback edition (New York: Harcourt, Brace and World, A Harvest Book, 1952). Forster,

292 |||||||||| Notes to Pages 101–7

who had also been in India some years before, had gone to Dewas for a period of six months to replace another Englishman who was on sick leave. He writes of his experiences in *The Hill of Devi* (New York: Harcourt Brace, 1953), which is a collection of his letters from India with other commentary. See also P. N. Furbank, *E. M. Forster: A Life* (New York and London: Harcourt Brace Jovanovich, 1978), pp. 67–104.

12. The importance of the novel is underscored by whole volumes of criticism and other materials devoted to it, such as Malcolm Bradbury, ed., *E. M. Forster, "A Passage to India": A Casebook* (London: Macmillan, 1970), and John Beer, ed., *A Passage to India: Essays in Interpretation* (London: Macmillan, 1985).

13. Frederick P. W. McDowell, *E. M. Forster*, rev. ed. (Boston: Twayne Publishers, 1982), p. 102, suggests that "the clash of cultures and modes of life, of temperaments and values appealed to [Forster] as a writer." Malcolm Bradbury, "Two Passages to India: Forster as Victorian and Modern," in *Aspects of E. M. Forster*, ed. Oliver Stallybrass (London: Edward Arnold, 1969), pp. 133, 136, also comments on Forster's interest in "contrasting value-systems."

14. Dina Sherzer, "Saying Is Inventing: Gnomic Expressions in *Molloy*," in *Speech Play: Research and Resources for Studying Linguistic Creativity*, ed. Barbara Kirshenblatt-Gimblett (Philadelphia: Univ. of Pennsylvania Press, 1976), p. 165.

15. The significance of the phrase "God is love" has, of course, been discussed before. See, for example, McDowell, p. 117; K. W. Gransden, *E. M. Forster* (New York: Grove Press, 1962), pp. 90, 101, 104; and Norman Kelvin, *E. M. Forster* (Carbondale and Edwardsville: Southern Illinois Univ. Press, 1967), pp. 138–139.

16. Michael Orange, "Language and Silence in A Passage to India," in *E. M. Forster: A Human Exploration*, ed. G. K. Das and John Beer (New York: New York Univ. Press, 1979), pp. 142–160, discusses Forster's interest in language, noting how (p. 143), "the language of cognition . . . is avowedly insufficient as a means of incarnating mystical experience."

17. Forster discusses the real ritual on which that of the novel is based in *The Hill of Devi*, pp. 158ff. For the proverbs Fielding cites as his own preferred ones, see William George Smith, *The Oxford Dictionary of English Proverbs* (Oxford: at the Clarendon Press, 1935), pp. 23, 28, 276.

18. Graham Greene, *The Power and the Glory* (London: Heinemann, 1940); *The Labyrinthine Ways* (New York: Viking, 1940). Page references in the text are to the paperback edition (New York: Penguin, 1982). Greene wrote of his Mexican experiences in *The Lawless Roads* (London: Longmans, 1939), published in the United States as *Another Mexico* (New York: Viking, 1939). He writes briefly of his Mexican experiences also in chapter 3 of *Ways of Escape* (London: The Bodley Head, 1980). See also Norman Sherry, *The Life of Graham Greene, Volume I: 1904–1939* (New York: Viking, 1989), pp. 669ff.

19. See Kirshenblatt-Gimblett, "Toward a Theory."

20. We are indebted to Wolfgang Mieder for this suggestion.

21. Georg M. A. Gaston, *The Pursuit of Salvation: A Critical Guide to the Novels of Graham Greene* (Troy, N.Y.: Whitston Publishing, 1984), p. 29, appropriately notes that for Greene "salvation does not depend on formulas."

22. This proverb is less well known than the others Greene uses. Morris Palmer Tilley, *A Dictionary of the Proverbs in England in the Sixteenth and Seventeenth Centuries: A Collection of the Proverbs Found in English Literature and the Dictionaries of the Period* (Ann Arbor: Univ. of Michigan Press, 1950) gives it the designation S557. Shirley Arora (personal communication) has advised us that the proverb is found in Spanish, but it is likely that Greene simply knew it from an English-speaking context. For "Out of sight, out of mind," see Smith, p. 350 (the earliest reference to the proverb is 1275), and for "Cleanliness is next to godliness," see Smith, p. 77 (earliest reference 1605).

23. Abrahams and Babcock, p. 424.

24. "Bliss" first appeared in the *English Review* in 1918 and then in Mansfield's *Bliss and Other Stories* (London: Constable, 1920). C. A. Hankin, *Katherine Mansfield and Her Confessional Stories* (London: Macmillan, 1983), p. 143, notes that "Bliss" is "one of Katherine Mansfield's most discussed and controversial stories."

25. J. A. Simpson, ed., *The Concise Oxford Dictionary of Proverbs* (Oxford: Oxford Univ. Press, 1982), p. 118, references the Gray poem and notes that whereas the original source has it that "Where ignorance is bliss, 'tis folly to be wise," "now frequently [the saying is] abbreviated to 'Ignorance is bliss.'"

26. J. F. Powers, *The Prince of Darkness and Other Stories* (Garden City: Doubleday, 1948). The story originally appeared in *Accent* in 1947.

27. Simpson, pp. 21–22, traces the proverb to 1475. As Winifred Lynskey, *Reading Modern Fiction*, rev. ed. (New York: Scribner's, 1957), p. 444, points out, the title of the story references the biblical Book of Proverbs.

28. Flannery O'Connor, *A Good Man Is Hard to Find* (New York: Harcourt Brace, 1955); the story had previously appeared in 1953 in an anthology edited by William Phillips and Philip Rahv. For the proverb, see Burton Stevenson, ed., *The Home Book of Proverbs, Maxims and Familiar Phrases* (New York: Macmillan, 1948), pp. 997–999. Interestingly, the proverb also serves as the title for a chapter of *Gumbo Ya-Ya* (discussed in chap. 3, this volume).

5. Pageant, Death, Initiation: The Ambiguity of Ritual

1. But see Catherine Bell, *Ritual: Perspectives and Dimensions* (New York and Oxford: Oxford Univ. Press, 1997), pp. 93–137, in which she discusses the "basic genres of ritual action" and outlines certain fundamental characteristics of ritual. See also Sally F. Moore and Barbara Meyerhoff, eds., *Secular Ritual* (Assen: Van Gorcum, 1977), especially the introduction, pp. 3–24, which considers ritual outside the context of the sacred. D. I. Kertzer, *Ritual, Politics and Power* (New Haven: Yale Univ. Press, 1988), considers from an anthropological perspective the use of civic ritual in modern society.

2. Don Handelman, *Models and Mirrors: Towards an Anthropology of Public Events* (Cambridge: Cambridge Univ. Press, 1990), especially p. 14. Handelman, of course, is not the only one to use the term "public event" to cover a variety of other genres; see, for example, Rory Turner and Phillip H. Arthur, "Cultural Performances: Public Display Events and Festival," in *The Emergence of Folklore in Everyday Life: A Fieldguide and Sourcebook*, ed. George H. Schoemaker (Bloomington: Trickster Press, 1990), pp. 83–93.

3. *Utne Reader*, November/December 1987, pp. 58–81. Barbara Ardinger, *A Woman's Book of Rituals and Celebrations* (San Rafael, Ca.: New World Library, 1995), is an example of the ongoing interest

in having and inventing ritual. Paul Rich and Guillermo de los Reyes, "Upstaging the Masons: The Promise Keepers and Fraternal Orders," in The Promise Keepers: Essays on Masculinity and Christianity (Jefferson, N.C., and London: McFarland and Company, 2000), p. 35, note in relation to the Promise Keepers movement and the "mythopoetic men's movement" championed by poet Robert Bly, that "The newest idea . . . is the *old* idea: that men should enhance their maleness through collective ritual," and, p. 39, that "Women as well as men have felt a need to rediscover ritual and to use it to maintain gender identity."

4. Trudier Harris, *Fiction and Folklore: The Novels of Toni Morrison* (Knoxville: Univ. of Tennessee Press, 1991), pp. 99ff.

5. Desmond Rochfort, *Mexican Muralists: Orozco, Rivera, Siqueiros* (San Francisco: Chronicle Books, 1993), p. 57.

6. That is, the Secretaria de Educación Pública or SEP.

7. The fresco techniques being used by the muralists were claimed to be similar to those used in decorating pre-Columbian sites, notably Teotihuacán outside Mexico City, so that the use of fresco came to have a nationalistic pedigree. See Rochfort, p. 36, and Jean Charlot, *The Mexican Mural Renaissance, 1920–1925* (New Haven and London: Yale Univ. Press, 1967), pp. 205, 257–258.

8. Rochfort, p. 55.

9. For a reproduction (not in full color) of "The Ribbon Dance" see Rochfort, p. 58. It is also reproduced in Diego Rivera and Bertram Wolf, *Portrait of Mexico* (New York: Covici-Friede, 1937), as plate 131; here it is identified as "The Dance of the Sun: Chalma." Chalma is a major pilgrimage site not far from Mexico City.

10. The third panel, *The Day of the Dead—The Dinner*, is not discussed here. See Rochfort, p. 22, for the urban scene.

11. Rivera also depicts the occasion in a rural cemetery in a painting called "The Day of the Dead" in the collection of the Museo de Arte Moderno, Mexico City.

12. For ribbon dances and judas figures as folk phenomena, see Frances Toor, *A Treasury of Mexican Folkways* (New York: Crown, 1947), pp. 361–362, 65. Toor also discusses the Days of the Dead, pp. 236–244 and passim; although there is an abundance of more recent literature on the subject, Toor's information is of particular interest because of her collaborations with Rivera on the magazine, *Mexican Folkways*.

13. Nikos Kazantzakis, *The Fratricides*, trans. Athena Gianakas Dallas (New York: Simon and Schuster, 1964).

14. John Cuthbert Lawson, *Modern Greek Folklore and Ancient Greek Religion*, 2nd ed. (New Hyde Park, N.Y.: University Books, 1964), p. 575. For additional information on the resurrection ritual, see Alan W. Watts, *Myth and Ritual in Christianity* (London: Thames and Hudson, 1954), pp. 183ff. Robert Graves, *Hercules, My Shipmate* (New York: Creative Age Press, 1945), p. 464, notes a similar ceremony near Mount Pelios and relates it to rebirth and the "White Goddess." Philip Argenti and H. J. Rose, *The Folklore of Chios*, 2 vols. (Cambridge: Cambridge Univ. Press, 1949), passim, refer to this ceremony and note various other beliefs connected with Easter.

15. Lawson, p. 576.

16. Anne Gault Antoniades, *The Anastenaria: Thracian Firewalking Festival* (Athens: Society of Thracian Studies, 1954), is the basis for the account given here.

17. Nikos Kazantzakis, *Report to Greco*, trans. P. A. Bien (New York: Simon and Schuster, 1965).

18. According to the translator's note, pp. 11–12, the priest has added on a suffix indicating great size; that is, Christ has risen "in a tremendous way, suitable to his giant stature." Because this suffix is added to a verb rather than a noun, grammatical rules are fractured.

19. Harper Lee, *To Kill a Mockingbird* (Philadelphia: J. B. Lippincott, 1960); page references in the text are to the paperback ed. (New York: Fawcett Popular Library, 1962).

20. For sources relating to black English, see Ila Wales Brasch and Walter Milton Brasch, *A Comprehensive Annotated Bibliography of American Black English* (Baton Rouge: Louisiana State Univ. Press, 1974). For African American folklore generally, see Alan Dundes, ed., *Mother Wit from the Laughing Barrel: Readings in the Interpretation of Afro-American Folklore* (Jackson and London: Univ. Press of Mississippi, 1990), for the essays and studies reprinted there but more so for the rich bibliographical annotation; and John Szwed and Roger D. Abrahams, eds., *Afro-American Folk Culture: An Annotated Bibliography of Materials from North, Central, and South America, and the West Indies* (Philadelphia: Institute for the Study of Human Issues, 1978). On African American cemeteries, see John Vlach, "Graveyards

and Afro-American Art," *Southern Exposure* 5, nos. 2–3 (1977): 161–165.

21. See Bell, pp. 94–102, where she considers rites of passage, which include initiation rites, as one of the "basic genres of ritual action"; she also discusses various initiation rituals, passim.

22. David Glassberg, *American Historical Pageantry: The Uses of Tradition in the Early Twentieth Century* (Chapel Hill and London: Univ. of North Carolina Press, 1990). That the tradition of historical pageants and even of professional pageant organizers continues into more recent times is noted by Larry McMurtry, *Walter Benjamin at the Dairy Queen: Reflections at Sixty and Beyond* (New York: Simon and Schuster, 1999), pp. 30–33, who writes of the pageant in his own home-town of Archer City, Texas, in 1980.

23. Glassberg, pp. 69–101, quoting William Chauncy Langdon, the fore-most promoter of historical pageantry; "The Place Is the Hero" is the title of Glassberg's third chapter.

24. Joseph Campbell, *The Hero with a Thousand Faces* (Princeton: Princeton Univ. Press, Bollingen Series, no. 17, 1949). Also of obvious relevance is van Gennep's classic formulation of the structure of rites of passage, *The Rites of Passage*, trans. M. B. Vizedom and G. L. Caffee (Chicago: Univ. of Chicago Press, 1960).

25. Samhain (which becomes All Hallows Eve or Halloween in English-speaking tradition) was, as a point in the Celtic year when the dead were passing to the other world, a time of liminality with spiritual enti-ties and even the living poised between the world of life and that of death, with the recently dead making the actual passage. See Jack Santino, *Halloween: The Folklore and Fantasy of All Hallows* (Washington, D.C.: Library of Congress, 1982); and Jack Santino, ed., *Halloween and Other Festivals of Death and Life* (Knoxville: Univ. of Tennessee Press, 1994).

26. Mikhail Bakhtin, *Rabelais and His World*, trans. Helene Iswolsky (Cambridge and London: M.I.T. Press, 1968), pp. 284–285, 281, 283.

27. Walker Percy, *The Moviegoer* (New York: Knopf, 1961); page refer-ences in the text are from the paperback ed. (New York: Noonday Press, 1967).

28. Also a progression from thesis to synthesis through antithesis; and a progression through "increasing intersubjectivity." See Janet Hobbs,

"Binx Bolling and the Stages on Life's Way," in *The Art of Walker Percy: Stratagems for Being*, ed. Panthea Reid Broughton (Baton Rouge and London: Louisiana State Univ. Press, 1979), pp. 37ff; Martin Luschei, *The Sovereign Wayfarer: Walker Percy's Diagnosis of the Malaise* (Baton Rouge: Louisiana State Univ. Press, 1972), pp. 62ff; Mary Deems Howland, *The Gift of the Other: Gabriel Marcel's Concept of Intersubjectivity in Walker Percy's Novels* (Pittsburgh: Duquesne Univ. Press, 1990), p. 35.

29. Luschei, p. 65.

30. William Rodney Allen, *Walker Percy: A Southern Wayfarer* (Jackson: Univ. Press of Mississippi, 1986), p. 24; Luschei, p. 106.

31. On Mardi Gras, especially the sociological implications of the festival, see Munro S. Edmonson, "Carnival in New Orleans," *Caribbean Quarterly* 4 (1956): 233–245; Phyllis Hutton Raabe, "Status and Its Impact: New Orleans Carnival, the Social Upper Class, and Upper Class Power," Ph.D. dissertation, Pennsylvania State Univ., 1973; F. A. de Caro and Tom Ireland, "Every Man a King: Worldview, Social Tension and Carnival in New Orleans," *International Folklore Review* 6 (1988): 58–66; Samuel Kinser, *Carnival American Style: Mardi Gras at New Orleans and Mobile* (Chicago: Univ. of Chicago Press, 1990); Carol Flake, *New Orleans: Behind the Masks of America's Most Exotic City* (New York: Grove Press, 1994); Reed Mitchell, *All on a Mardi Gras Day: Episodes in the History of New Orleans Carnival* (Cambridge and London: Harvard Univ. Press, 1995); James Gill, *Lords of Misrule: Mardi Gras and the Politics of Race in New Orleans* (Jackson: Univ. Press of Mississippi, 1997).

32. Edmonson, p. 234; David Elliott Draper, "The Mardi Gras Indians: The Ethnomusicology of Black Americans in New Orleans," Ph.D. dissertation, Tulane Univ., 1973, p. 8.

33. See Kate Howard, "The Evolving Customs of the Jefferson City Buzzards Carnival Club," *Louisiana Folklore Miscellany* 11 (1996): 1–15.

34. See George F. Reinecke, "The New Orleans Twelfth Night Cake," *Louisiana Folklore Miscellany* 2, no. 2 (1965): 45–54; Janet Ryland, "From Custom to Coffee Cake: The Commodification of the Louisiana King Cake," *Louisiana Folklore Miscellany* 9 (1994): 1–18.

35. See Raabe, pp. 17–19, 183–185.

36. Luschei, p. 66; Allen, p. 28; Howland, p. 30; Max Webb, "Binx Bolling's New Orleans: Moviegoing, Southern Writing and Father Abraham," in Broughton, p. 17; Hobbs, p. 43.

37. Lyle Saxon, Edward Dreyer, and Robert Tallant, *Gumbo Ya-Ya: A Collection of Louisiana Folk Tales* (Boston: Houghton-Mifflin, 1945), p. 40.

38. Luschei, p. 102.

6. The Threads of Tradition

1. Although the term "folklife" can be broadly inclusive, Jan Harold Brunvand, *The Study of American Folklore: An Introduction*, 4th ed. (New York: W. W. Norton, 1998), p. 503, rightly notes that "In most instances, the term 'folklife' as used in American folklore study refers to traditional material culture."

2. In the American context a quilt is a bed covering made by the process of quilting— that is, by sewing together two or most usually three layers of fabric, the top, the backing, and the middle lining or interlining. Quilt tops can be made by *piecing* (see note 7, below) and also by appliqué—that is, the creation of a design by sewing smaller pieces on to the top of a larger piece—or the top design can be created through the pattern of stitchery when the quilting of the layers is done. For information on quilting, see Ruth Finley, *Old Patchwork Quilts and the Women Who Made Them* (Philadelphia: J. B. Lippincott, 1929); Carrie Hall and Rose G. Kretsinger, *The Romance of the Patchwork Quilt in America* (Caldwell, Idaho: Caxton Press, 1936); Patsy Orlofsky and Myron Orlofsky, *Quilts in America* (New York: McGraw-Hill, 1974); Judy Esley, *Quilts as Text(iles): The Semiotics of Quilting* (New York: Peter Lang, 1996); Elaine Hedges, Pat Ferrero, and Julie Silber, *Hearts and Hands: Women, Quilts, and American Society* (Nashville: Rutledge Press, 1987); Barbara Brackman, comp., *Encyclopedia of Pieced Quilt Patterns* (Paducah, Ky.: American Quilter's Society, 1993); Susan Roach, "Quilting," in *Encyclopedia of Feminist Literary Theory*, ed. Elizabeth Kowalski-Wallace (New York: Garland, 1997), pp. 330–331; Susan Roach-Lankford, "Quilts," in *Decorative Arts and Household Furnishings in America: An Annotated Bibliography* (Wintherthur, Del.: Henry Francis du Pont Wintherthur Museum, 1989), pp. 257–265;

Susan Roach and Lorre Weidlich, "Quilt Making in America: A Selected Bibliography," *Folklore Feminists Communication* 3 (1974): 17–28; Francis A. de Caro, *Women and Folklore: A Bibliographical Survey* (Westport, Conn., and London: Greenwood Press, 1983), pp. 40–41. For holdings of actual quilts, see Lisa Turner Oshins and Barbara S. Bockman, eds., *Quilt Collections: A Directory for the United States and Canada* (Washington: Acropolis Books, 1987).

3. We do not suggest that we by any means cover in full the appearance of quilts in literary works. There is even a series of novels by Jennifer Chiaverini about a group of quilters (see, for example, *Round Robin* [New York: Simon and Schuster, 2000]), and a quilting mystery series. See Susan Roach, "Quilting," in *Encyclopedia of Folklore and Literature*, ed. Mary Ellen Brown and Bruce A. Rosenberg (Santa Barbara: ABC-CLIO, 1998), pp. 531–533; Elaine Showalter, *Sister's Choice: Tradition and Change in American Women's Writing* (Oxford: Clarendon Press, 1991), pp. 145–175; and Cecilia Macheski, ed., *Quilt Stories* (Lexington: Univ. Press of Kentucky, 1994), which anthologizes a number of quilt-related literary pieces. We regret that Karen E. Beardslee, *Literary Legacies, Folklore Foundations: Selfhood and Cultural Tradition in Nineteenth- and Twentieth-Century American Literature* (Knoxville: Univ. of Tennessee Press, 2001), came to our attention too late for us to take advantage of its insightful discussion of Stowe's *The Minister's Wooing* and Otto's *How to Make an American Quilt*, or to discuss it in our introduction as a recent, important study of folklore and literature. Beardslee argues that a number of writers engage their characters in folk tradition as aspects of their understanding self and achieving "wellness."

4. Catherine Stimpson, "Introduction," in *Feminist Issues in Literary Scholarship*, ed. Shari Benstock (Bloomington: Indiana Univ. Press, 1987), p. 2.

5. Quoted in Josephine Donovan, "Toward a Women's Poetics," in Benstock, p. 106. Donovan, pp. 101–102, identifies a women-centered epistemology—ways of being in and looking at the world that women share. Among her identification of six structural conditions that appear to have shaped traditional women's experiences and practices in the past in nearly all cultures and that provide themes for women's literature, three especially reflect the thematic and symbolic concerns of many of the present literary works: (1) a knowledge of oppression, (2)

confinement to the domestic or private sphere, (3) the creation of objects for use rather than for exchange.

6. Harriet Beecher Stowe, *The Minister's Wooing* (New York: A. L. Burt, 1859); the novel was first serialized in the *Atlantic*, beginning in 1858. Quotations are from *The Minister's Wooing* (Ridgewood, N.J.: Gregg Press, 1968).

7. The process of sewing together smaller pieces of fabric to make a larger expanse of patched-together material is called "piecing"; there are numerous traditional designs used in creating pieced quilt tops.

8. Julia Peterkin, *Black April* (Indianapolis: Bobbs-Merrill, 1927).

9. Eliza Calvert Hall, *Aunt Jane of Kentucky* (Boston: Little, Brown, 1907); quotations are from the edition of 1909.

10. Barbara Kirshenblatt-Gimblett, "Objects of Memory: Material Culture as Life Review," in *Folk Groups and Folklore Genres: A Reader*, ed. Elliott Oring (Logan: Utah State Univ. Press, 1989), pp. 333–334.

11. Glaspell's "A Jury of Her Peers" originally appeared in *Everyweek* in 1917 and was reprinted in E. J. O'Brien, ed., *Best Short Stories of 1917* (Boston: Small, Maynard, 1918). Arthur E. Waterman, *Susan Glaspell* (New York: Twayne Publishers, 1966), pp. 28–29, calls it her "best known story" and "her finest story artistically." It is based on her earlier play, *Trifles*, produced in 1916, which Waterman, p. 69, notes is "far and away Miss Glaspell's most popular play; indeed it is one of the most popular one-act plays ever written in America," and which Veronica Makowsky, *Susan Glaspell's Century of American Women: A Critical Interpretation of Her Work* (New York: Oxford Univ. Press, 1993), p. 61, calls "justly celebrated." Quotations from the story are from "A Jury of Her Peers," in *American Voices, American Women*, ed. E. Lee R. Edwards and Arlyn Diamond (New York: Avon, 1973), pp. 359–381.

12. Warner's "A Widow's Quilt" first appeared in 1977 in the *New Yorker*, which published a number of her stories over the years, and it was reprinted in the posthumous collection of Warner's stories, ed. Susanna Pinney, *One Thing Leading to Another and Other Stories* (London: Chatto and Windus, the Hogarth Press, 1984). Quotations are from the paperback ed. of this collection (London: Women's Press, 1984).

13. That is, she must assemble the layers of the quilt, including the inner "stuffing" or batting, and sew them together.

14. Alice Walker, "Everyday Use," in *In Love and Trouble: Stories of Black Women* (New York and London: Harvest/Harcourt Brace Jovanovich, 1973), pp. 47–59.

15. Whitney Otto, *How to Make an American Quilt* (New York: Villard Books, 1991). Quotations are from the paperback ed. (New York: Ballantine, 1994).

16. The film version, also called *How to Make an American Quilt*, was directed by Jocelyn Moorhouse and produced by Sarah Pillsbury for Universal Studios, 1995.

17. On the concept of femmage as a particularly female kind of bricolage, see Melissa Meyer and Miriam Schapiro, "Waste Not, Want Not: An Inquiry into What Women Saved and Assembled. Femmage," *Heresies* 4 (1978): 66–69; see also Lucy R. Lippard, "Making Something from Nothing (Toward a Definition of Women's 'Hobby Art,'" *Heresies* 4 (1978): 62–65; and for bricolage see Claude Lévi-Strauss, *The Savage Mind* (Chicago: Univ. of Chicago Press, 1969), p. 17.

18. Each narrative chapter tells the story of a member of the circle, though only this one bears the name of the character, and Finn's grandmother and great aunt are combined in one.

19. And, indeed, a romantic but somewhat unrealistic one, given the general absence of such communal quilting circles in contemporary American culture except for church groups and senior citizens centers.

20. A crazy quilt has a top made up of irregularly sized and shaped pieces (and is very difficult to make despite the "random" nature of its design). An album quilt has a top made up of blocks each made by—and sometimes signed by—a different maker, or made by the same maker but with different designs in each square. Historically, album quilts were made to be presented as a gift to a friend or community figure.

21. Hedges, Ferrero, and Silber; it is based on an earlier documentary film by Ferrero and Silber.

22. Anne Tyler, *A Patchwork Planet* (New York: Knopf, 1998).

23. In her more recent novel, *When We Were Grownups* (New York: Alfred A. Knopf, 2001), p. 107, Tyler compares the lives of her characters to "a kind of crazy quilt of unrelated incidents."

24. Margaret Atwood, *Alias Grace* (New York and Toronto: Doubleday, 1996).

25. Barbara Michaels, *Stitches in Time* (New York: HarperCollins, 1995); Phyllis Alesia Perry, *Stigmata* (New York: Hyperion, 1998).

26. Newbell Niles Puckett, *Folk Beliefs of the Southern Negro* (Montclair, N.J.: Patterson Smith, 1968), pp. 235ff and passim, notes the power of graveyard dust for "goofering" or conjuring in African American magical tradition.

7. Cultural Objects, Personal Images

1. See, for example, Jean Seznec, *The Survival of the Pagan Gods: The Mythological Tradition and Its Place in Renaissance Humanism and Art*, trans. Barbara F. Sessions (Princeton: Princeton Univ. Press, 1953). For discussion of one interesting Victorian fairytale painting, Daniel Maclise's "The Sleeping Beauty," see Cynthia Lynn DeMarcus, "Reawakening Sleeping Beauty: Fairy-Tale Revisions and the Mid-Victorian Metaphysical Crisis," Ph.D. dissertation, Louisiana State Univ., 1999, pp. 88ff. Homer's painting can be seen in Nicolai Cikovsky Jr. and Franklin Kelly, *Winslow Homer* (Washington, New Haven, and London: National Gallery of Art and Yale Univ. Press, 1996), pp. 94, 152. Stephen Nissenbaum, *The Battle for Christmas* (New York: Knopf, 1996), p. 290, notes the painting's significance as a document. Also see, for an example of discussion of folklore in relation to visual art, Harold Schechter, *The Bosom Serpent: Folklore and Popular Art* (Iowa City: Univ. of Iowa Press, 1988); and Archie Green published a series of articles on the "graphics" relating to folk and country music, such as "John Henry Depicted," *JEMF Quarterly* 14 (1978): 126–143.

2. Kahlo's work was included in a notable exhibition in Paris organized by prominent surrealists, but she expressed disdain for the surrealists. Laughlin, isolated in New Orleans, had no direct contact with the movement, but he was actively interested in it, and surrealist publications were part of his extensive library.

3. See Laughlin's introductory remarks to *Poems of the Interior World* (Chicago: Harper Square Press, 1968), p. 34.

4. See especially Margaret A. Lindauer, *Devouring Frida: The Art History and Popular Celebrity of Frida Kahlo* (Hanover and London: Wesleyan Univ. Press and Univ. Press of New England, 1999).

5. Seventy paintings out of two hundred according to Paula M. Cooey, *Religious Imagination and the Body: A Feminist Analysis* (New York and Oxford: Oxford Univ. Press, 1994), p. 95. Kahlo's paintings have been widely reproduced. For those paintings discussed in this chapter but not reproduced here, good reproductions of the following works can be found in *Frida Kahlo* (Boston: Bullfinch Press, Little, Brown, 2000): *Pancho Villa and Adelita* (p. 49), *Tiny Caballero* (p. 96), *The Two Fridas* (p. 148), and *Tree of Hope* (p. 189). See Robin Richmond, *Frida Kahlo in Mexico* (San Francisco: Pomegranate Artbooks, 1994), p. 65, for *My Nurse and I*.

6. Andrea Kettenman, *Frida Kahlo, 1907–1954: Pain and Passion* (Cologne: Taschen, 1993), p. 7.

7. Cooey, p. 95.

8. Sarah M. Lowe, *Frida Kahlo* (New York: Universe, 1991), p. 40.

9. Hayden Herrera, *Frida: A Biography of Frida Kahlo* (New York: Harper and Row, 1983), p. 110; see also photographs in *Frida Kahlo: The Camera Seduced*, ed. Carole Kismaric and Marvin Heiferman, memoir Elena Poniatowska, essay Carla Stellweg (San Francisco: Chronicle, 1992), pp. 28, 49, 91.

10. Lowe, p. 38.

11. Lowe, p. 40; Luis-Martín Lozano, "The Esthetic Universe of Frida Kahlo," in *Frida Kahlo* (Boston: Bulfinch Press, Little, Brown, 2000), p. 50.

12. Lozano, pp. 45–50.

13. Lindauer, p. 23.

14. See photographic portraits in Kismaric and Heiferman.

15. Herrera, p. 111.

16. Herrera, p. 109.

17. Herrera, p. 110.

18. The headdress can be seen in *Self-Portrait as a Tehuana, or Diego in My Thoughts* (1943) and in *Self-Portrait* (1948).

19. Lindauer, p. 126.

20. Herrera, p. 112; Martha Zamora, *Frida Kahlo: The Brush of Anguish* (San Francisco: Chronicle, 1991), p. 78.

21. Kettenmann, p. 26.

22. Richmond, p. 104.

23. Richmond, p. 104, erroneously refers to the straw man and rider as a *piñata*, and various commentators have echoed this incorrect identification.

24. Herrera, p. 17.

25. Lindauer, p. 137.

26. Lindauer, p. 139.

27. Herrera, pp. 16–17.

28. Richmond, p. 104.

29. Lindauer, pp. 146–148.

30. Lindauer, p. 148.

31. Herrera, p. 279.

32. Mary Jane Gagnier de Mendoza, "To Nourish the Soul and Inspire the Spirit," in *Myth and Magic: Oaxaca Past and Present*, ed. Mary Jane Gagnier de Mendoza and Linda Craighead (Palo Alto: Palo Alto Cultural Center, 1994), p. 21.

33. Lowe, p. 48.

34. Herrera, p. 220.

35. Herrera, pp. 220–221.

36. Lowe, pp. 48–50.

37. José Guadalupe Posada (1852–1913) was a maker of popular prints who much influenced modern Mexican painters; on Posada, see Ron Tyler, ed., *Posada's Mexico* (Washington and Fort Worth: Library of Congress and Amon Carter Museum of Western Art, 1979).

38. Lowe, p. 86.

39. Herrera, p. 150. Kahlo and Rivera had a large collection of *retablos*, and oddly enough they owned one which depicted a bus and trolley accident very similar to the one in which Kahlo was injured. She only needed to give the victim her eyebrows, particularize the writing on the vehicles and the details in a text at the bottom to transform it into her own personal *retablo*. That *retablo* and a sketch she made one year after the accident are the only images of the accident she ever made. See Herrera, p. 74; Lowe, p. 65; and Isabel Alcantara and Sandra Egnolff, *Frida Kahlo and Diego Rivera* (Munich, London and New York: Prestel, 1999), p. 20.

40. Jorge Durand and Douglas S. Massey, *Miracles on the Border: Retablos of Mexican Migrants to the United States* (Tucson and London: Univ. of Arizona Press, 1995), p. 38. Use of the term *retablo* in Mexico to refer to a painting of a miracle, traditionally on tin, differs from the use of the term for certain New Mexican *santos* as discussed in chapter 1.

41. Herrera, p. 144.

42. Lindauer, p. 27.

43. Durand and Massey, p. 41.

44. Herrera, p. 223.

45. Lindauer, p. 149.

46. Lindauer, p. 97.

47. Cooey, p. 95.

48. John Wood, "Lost New Orleans," in *Haunter of Ruins: The Photography of Clarence John Laughlin*, ed. John Lawrence and Patricia Brady (Boston and London: Little, Brown, 1997), p. 84.

49. Patricia Leighton, "Clarence John Laughlin: The Art and Thought of an American Surrealist," *History of Photography* 12 (1988): 130.

50. Letter from Clarence John Laughlin to Margaret Bourke-White, 21 July 1936; Clarence John Laughlin Collection, Williams Research Center, Historic New Orleans Collection.

51. New York: Scribner's, 1948.

52. Laughlin's books were acquired after his death by Louisiana State University Libraries Special Collections, catalogued as the Laughlin Collection.

53. Unless otherwise noted, Laughlin's comments on particular photographic images which are quoted in this chapter are from the Laughlin Collection I.D. card file at the Historic New Orleans Collection.

54. Susan Sontag, *On Photography* (New York: Farrar, Straus and Giroux, 1977), p. 153; Clarence John Laughlin, "The Camera as a Third Eye," unpublished lecture, Clarence John Laughlin Collection, Williams Research Center, Historic New Orleans Collection.

55. Lawrence and Brady, p. 57. For an extended portrait of Weeks Hall, see Henry Miller's account of his visit to The Shadows in *The Air Conditioned Nightmare* (New York: New Directions, 1945), pp. 95–115; for Laughlin's portrait of Hall, see Lawrence and Brady, p. 28.

56. Wood, p. 83; Jonathan Williams, "Introduction: The Shadow of His Equipage," in *Clarence John Laughlin: The Personal Eye* (Millerton, N.Y.: Aperture, 1973), p. 5.

57. Jonathan Williams, "An Astonished Eye Looks Out of the Air," in Lawrence and Brady, p. 58.

58. Lawrence and Brady, p. 13.

59. Reproduced in Lawrence and Brady, pp. 94–95.

60. Reproduced in Lawrence and Brady, p. 17.

61. Reproduced in Lawrence and Brady, p. 52.

62. Lawrence and Brady, pp. 51, 38, 72.

63. Lawrence and Brady, pp. 64, 86.

64. The image is Historic New Orleans Collection accession number 1981.247.1.844.

65. See Frank de Caro, *Folklife in Louisiana Photography: Images of Tradition* (Baton Rouge and London: Louisiana State Univ. Press, 1990), p. 164.

66. The image is Historic New Orleans Collection accession number 1981.247.5.1969.7313.

67. "The Work of Clementine Hunter," unpublished typescript dated November 1952, Clarence John Laughlin Collection, Williams Research Center, Historic New Orleans Collection.

68. The image is Historic New Orleans Collection accession number 1983.47.4.2781.

69. The image is Historic New Orleans Collection accession number 1983.47.4.2785.

70. Laughlin, "The Work of Clementine Hunter."

71. De Caro, p. 164.

72. The image is Historic New Orleans Collection accession number 1983.47.4.751.

8. Finding a Sense of Place

1. Bruce A. Rosenberg, *Folklore and Literature: Rival Siblings* (Knoxville: Univ. of Tennessee Press, 1991), pp. 2, 131.

2. Mark Workman, *"Gravity's Rainbow:* A Folkloristic Reading," *Pynchon Notes* 12 (1983): 16–25, and "Folklore and the Literature of Exile," in *Folklore, Literature, and Cultural Theory: Collected Essays,* ed. Cathy Lynn Preston (New York: Garland, 1995), pp. 29–42.

3. Yi-fu Tuan, *Topophilia: A Study of Environmental Perception, Attitudes, and Values* (Englewood Cliffs, N.J.: Prentice-Hall, 1974), p. 4.

4. Kent Ryden, *Mapping the Invisible Landscape: Folklore, Writing, and the Sense of Place* (Iowa City: Univ. of Iowa Press, 1993), pp. 221, 243; Eugene Victor Walter, *Placeways: A Theory of the Human Environment* (Chapel Hill and London: Univ. of North Carolina Press, 1988), p. 117; Lucy Lippard, *The Lure of the Local: Senses of Place in a Multicentered Society* (New York: New Press, 1997), p. 9.

5. Ryden, p. 43.

6. See, for example, J. D. A. Widdowson, "Language, Tradition and Regional Identity: Blason Populaire and Social Control," in *Language, Culture and Tradition,* ed. A. E. Green and J. D. A. Widdowson (Sheffield: CECTAL, 1981), pp. 33–46.

7. See Frank de Caro, ed., *Louisiana Sojourns: Travelers' Tales and Literary Journeys* (Baton Rouge and London: Louisiana State Univ. Press, 1998), pp. 71, 86–88.

8. Ryden, p. 43.

9. John Kennedy Toole, *A Confederacy of Dunces,* intro. Walker Percy (Baton Rouge and London: Louisiana State Univ. Press, 1980).

10. An attitude which has persisted, as is attested by this recent statement from a local publication: "I think John Kennedy Toole was closest, in his book *A Confederacy of Dunces,* to giving an accurate portrayal of life in the Big Easy" (Justice Seeker, "A Confederacy of Failures," *Where Y'at,* March 2000, p. 36).

11. These quotations are taken from a chapter of Liebling's book in which he describes his journey to Alexandria, Louisiana, to observe a speech by Long and in which a New Orleans journalist instructs him about Louisiana regional difference; A. J. Liebling, *The Earl of Louisiana* (New York: Simon and Schuster, 1961), pp. 80–103.

12. S. Frederick Starr, *New Orleans Unmasked: Being a Wagwit's Sketches of a Singular American City* (New Orleans: Édition Dedeaux, 1985), p. 42; Max Webb, "Binx Bolling's New Orleans: Moviegoing, Southern

Writing, and Father Abraham," in *The Art of Walker Percy: Stratagems for Being*, ed. Panthea Reid Broughton (Baton Rouge and London: Louisiana State Univ. Press, 1979), pp. 1–23.

13. Robert Blair St. George, "Mind, Nature, and Art in the Pine Barrens: An Exhibition Review," *Winterthur Portfolio* 23 (1988): 265.

14. Personal communications, January 15, 1987, and October 1985.

15. Howard F. Stein and Gary L. Thompson, "The Sense of Oklahoma-ness: The Contribution of Psychogeography to the Study of American Culture," *Journal of Cultural Geography* 11 (1991): 63–91. Stein and Thompson see such grand themes as the cowboy, football fever, and memory of the Dust Bowl as making up the sense of Oklahomaness. Robert Cantwell, *When We Were Good: The Folk Revival* (Cambridge and London: Harvard Univ. Press, 1996), p. 70, suggests that pioneer folk collector John A. Lomax was inspired by an "idea of Texas."

16. Tuan, pp. 152, 204.

17. See Frank de Caro and Rosan Augusta Jordan, "Strategies of Presentation and Control at Disney's EPCOT: 'Field Notes' on Tourism, Folk Ideas, and Manipulating Culture," *Southern Folklore* 54 (1997): 26–39.

18. Alan Dundes, "Folk Ideas as Units of World View," *Journal of American Folklore* 84 (1971): 95.

19. Alan Dundes, *Folklore Matters* (Knoxville: Univ. of Tennessee Press, 1989), pp. 1–39.

20. Angus K. Gillespie, "A Wilderness in the Megalopolis: Foodways in the Pine Barrens of New Jersey," in *Ethnic and Regional Foodways in the United States: The Performance of Group Identity*, ed. Linda Keller Brown and Kay Mussell (Knoxville: Univ. of Tennessee Press, 1984), pp. 145–168; C. Paige Gutierrez, "The Social and Symbolic Uses of Ethnic/Regional Foodways: Cajuns and Crawfish in South Louisiana," in Brown and Mussell, pp. 169–182; Ellen Badone, "Ethnicity, Folklore, and Local Identity in Rural Britanny," *Journal of American Folklore* 100 (1987): 161–190.

21. Dundes, "Folk Ideas," p. 103.

22. Starr, *New Orleans Unmasked*; all of Matthews's cartoons discussed here are found in two books, *Vic and Nat'ly* (New Orleans: Junawid Press, 1983), and *Vic and Nat'ly Volume II* (New Orleans: Rosina V.

Caselli Press, 1985); Brooke Bergan, *Storyville: A Hidden Mirror* (Wakefield, R.I., and London: Asphodel Press, 1994). As the Matthews volumes are not paginated, there are no page references in the text.

23. Jeanette Hardy, introduction to Matthews, *Vic and Natly*, n. p.

24. The first is from Gaspar J. "Buddy" Stall, *Proud, Peculiar New Orleans: The Inside Story* (Baton Rouge: Claitor's Publishing, 1984), p. 158; the second is from an Internet communication of uncertain origin given to Rosan Jordan by one of her students. See also the Web site http://members.cox.net/ebdraft/alan.htm, which includes "You know you're a native New Orleanian if you aren't puzzled by Bunny Matthews cartoons."

25. For information on Bellocq and his photographs, see John Szarkowski, ed., *Bellocq: Storyville Portraits; Portraits from the New Orleans Red Light District, Circa 1912* (New York: Random House, 1996). Storyville was the quasi-legal district of brothels and associated establishments which existed for a number of years near the French Quarter and which played an important role in the development of jazz. Rather little is known about Bellocq's life or motives or exactly how and when he took his now-celebrated photographs of prostitutes. That the photographs have become internationally known is attested to by the fact that the National Theatre in Dublin used one for its advertising posters for the May 2000 production of Shaw's *Mrs. Warren's Profession*.

26. Malle produced and directed *Pretty Baby* (released in his native France as *La Petite*) for Paramount, 1978; Michael Ondaatje, *Coming through Slaughter* (New York: Norton, 1976). Bellocq's photographs were "discovered" when Lee Friedlander acquired the plates and printed, exhibited, and published images from them. It was virtually unknown that earlier prints had been made, probably around 1950 but possibly as early as 1930. These were exhibited in 2003 at John Stinson Fine Arts gallery, New Orleans.

27. J. Benwell, *An Englishman's Travels in America: His Observations of Life and Manners in the Free and Slave States* (London: Binns and Goodwin, 1853), p. 115.

28. On Mother St. Croix, see Tina Freeman, *The Photographs of Mother St. Croix* (New Orleans: New Orleans Museum of Art, 1982), and Frank de Caro, *Folklife in Louisiana Photography: Images of Tradition* (Baton Rouge and London: Louisiana State Univ. Press, 1990), pp. 32–33.

29. Williams's play was produced at the Barrymore Theatre in New York, December 3, 1947, and published the same year (New York: New Directions, 1947); Kate Chopin, *The Awakening* (New York: H. S. Stone, 1899).

30. John D. Dorst, *Looking West* (Philadelphia: Univ. of Pennsylvania Press, 1999), pp. 35–36, 36.

31. Richard E. Meyer, "Image and Identity in Oregon's Pioneer Cemeteries," in *Sense of Place: American Regional Cultures*, ed. Barbara Allen and Thomas D. Schlereth (Lexington: Univ. Press of Kentucky, 1990), pp. 88–102; Dorst, pp. 119–149.

32. Hal Cannon, ed., *Cowboy Poetry: A Gathering* (Salt Lake City: Gibbs M. Smith, Peregrine Smith Books, 1985), n.p.

33. "This Was a Harsh and Barren Land" and "Dixie" appear in Keith Cunningham, ed., *The Oral Tradition of the American West* (Little Rock: August House, 1990), pp. 176–178, as does "Jerome," pp. 170–171. "The Great Wanagan Creek Flood" and "Rain on the Range" (the latter by the well-known popular poet of the West, S. Omar Barker) appear in Cannon, pp. 117–118, 12–13, as do "The Sierry Petes," pp. 3–4, "The Dude Wrangler," pp. 4–7, and "The Last Buckaroo," pp. 162–165. Dixie is here an area in Utah and "This Was a Harsh and Barren Land" and "Dixie" do come out of a specifically Mormon tradition. See these sources for further information, including authorship.

34. John Greenway, "Folksongs as Socio-Historical Documents," *Western Folklore* 19 (1960): 1–9.

9. Not into Cold Space

1. "The Man Who Would Be King," often reprinted, first appeared in *The Phantom Rickshaw and Other Eerie Tales* (Allahabad: A. H. Wheeler, 1888). E. M. Beekman, "The Whirligig of Empire," *Kipling Journal* 74, no. 295 (2000): 32, suggests that European colonial literature was influenced by "native" oral stories.

2. Frank de Caro, ed., *The Folktale Cat* (Little Rock: August House, 1992), pp. 130–133.

3. Joseph Conrad's *Heart of Darkness* first appeared in book form in *Youth: A Narrative and Two Other Stories* (Edinburgh and London:

Blackwood, 1902); Walker Percy, *Lancelot* (New York: Farrar, Straus and Giroux, 1977); David Madden, *Brothers in Confidence* (New York: Avon, 1972); John Barth, *Chimera* (New York: Random House, 1972).

4. Zora Neale Hurston, *Mules and Men* (Philadelphia: J. B. Lippincott, 1935); page references are from the paperback ed. (New York: Perennial Library, Harper and Row, 1970). J. Frank Dobie, *Tongues of the Monte* (New York: Doubleday, Doran, 1935); page references are from *Tongues of the Monte* (Austin: Univ. of Texas Press, 1980).

5. Darwin Turner, "Introduction," in *Mules and Men* by Zora Neale Hurston (New York: Harper and Row, 1970), p. 8.

6. Robert E. Hemenway, *Zora Neale Hurston: A Literary Biography* (Urbana: Univ. of Illinois Press, 1977), p. 12.

7. The results of Hurston's hoodoo research appear as "Hoodoo in America," *Journal of American Folklore* 44 (1931): 317–418, an extensive monograph. She selected and condensed material from it for part 2 of *Mules and Men*, adding it to her account of collecting tales in Florida; an appendix includes other material. As a term hoodoo refers to certain African-American magical practices; it is related to the better-known term voodoo.

8. Hemenway, p. 164.

9. Hemenway, pp. 207–208.

10. Quoted in Hemenway, p. 207.

11. In addition to "Hoodoo in America," Hurston had published "Dance Songs and Tales from the Bahamas," *Journal of American Folklore* 43 (1930): 294–312.

12. Quoted in Hemenway, p. 207.

13. Quoted in Hemenway, pp. 163–164.

14. Larry Neal, "Eatonville's Zora Neale Hurston: A Profile," *Black Review* 2 (1972): 20, writes that Hurston approached folklore "with the engaged sensibility of the artist; she left the 'comprehensive' scientific approach to culture to men like her former teacher, Franz Boas, and to Melville Herskovits. . . . She would have been very uncomfortable as a scholar committed to 'pure research.'" Nevertheless, we should note her vehement systematic critique of Robert Tallant's *Voodoo in New Orleans*, *Journal of American Folklore* 60 (1947): 436–438. She criticizes Tallant for failure in researching his topic, both in the field

and in the library, concluding, p. 438, that the book "offers no opportunity for serious study, and should be considered for just what it is, a creative–journalistic appeal to popular fancy."

15. Quoted in Hemenway, p. 163.

16. Hemenway, p. xx.

17. Hemenway, pp. 167–168.

18. Zora Neale Hurston, *The Sanctified Church* (Berkeley: Turtle Island, 1981), p. 49.

19. John Roberts, Review of *Mules and Men*, by Zora Neale Hurston, and *Their Eyes Were Watching God*, by Zora Neale Hurston, *Journal of American Folklore* 93 (1980): 464.

20. J. Frank Dobie, *Some Part of Myself* (Boston: Little, Brown, 1952), p. 241.

21. Dobie, *Some Part of Myself*, p. 271.

22. J. Frank Dobie, "Charm in Mexican Folktales," in *The Healer of Los Olmos and Other Mexican Lore* (Dallas: Southern Methodist Univ. Press, Publications of the Texas Folklore Society, no. 24, 1951), p. 7.

23. Quoted in Mody C. Boatright, "A Mustang in the Groves of Academe," in *Three Men in Texas: Bedichek, Webb, Dobie*, ed. Ronnie Dugger (Austin: Univ. of Texas Press, 1967), p. 197.

24. Quoted in Boatright, p. 198.

25. Lon Tinkle, *An American Original: The Life of J. Frank Dobie* (Boston: Little, Brown, 1978), p. 135. Dobie is referring to Thomas Allibone Janvier, *Legends of the City of Mexico* (New York: Harper, 1910).

26. "Juan Oso" or "John the Bear" is widely known in Hispanic tale traditions; for a recent, evocative study of Type 301, see James M. Taggart, *The Bear and His Sons: Masculinity in Spanish Folktales* (Austin: Univ. of Texas Press, 1997).

27. Dobie, *Some Part of Myself*, p. 251.

28. Quoted in Tinkle, p. 135.

29. Quoted in Tinkle, p. 135.

30. J. Frank Dobie, "Muchas Gracias," in *Tone the Bell Easy* (Dallas: Southern Methodist Univ. Press, Publications of the Texas Folklore Society, no. 10, 1932), pp. 5–6.

31. See Roberts, p. 464.

32. Dobie, *Some Part of Myself*, p. 241.

33. Dobie, *Some Part of Myself*, p. 236.

34. There is some historical basis for viewing south Texas and northern Mexico as one culture area, although there are significant differences among Spanish-speaking people in the area.

35. Tinkle, p. 139.

36. Quoted in Tinkle, p. 145.

37. Zora Neale Hurston, *Dust Tracks on a Road* (Philadelphia: J. B. Lippincott, 1942), pp. 174–175.

38. Mary Louise Pratt, "Fieldwork in Common Places," in *Writing Culture: The Poetics and Politics of Ethnography*, ed. James Clifford and George E. Marcus (Berkeley and Los Angeles: Univ. of California Press, 1986), p. 32; John Dorst, "Rereading *Mules and Men*: Toward the Death of the Ethnographer," *Cultural Anthropology* 2 (1987): 314.

39. This muted personality of the narrator is especially interesting in contrast to the lively and outgoing personality the real-life Hurston is said to have projected during that period of her life. But Cheryl A. Wall, "*Mules and Men* and Women: Zora Neale Hurston's Strategies of Narration and Visions of Female Empowerment," *Black American Literature Forum* 23 (1989): 662, observes that Hurston's "shy self-consciousness" is "totally consistent with what the book's Eatonville expects of Lucy Hurston's daughter." Hemenway, p. 164, feels that Hurston's "self-effacing" narrator served "to dramatize the process of collecting and make the reader feel part of the scene."

40. Dorst, p. 310.

41. Wall, p. 667.

42. Hurston, *Dust Tracks*, p. 191.

43. Camitta, "Gender and Method in Folklore Fieldwork," *Southern Folklore* 47 (1990): 21–31.

44. Dorst, p. 311.

45. Wall, p. 661.

46. Wall, p. 672.

47. And yet it seems that a great deal of personal involvement and emotional reaction is implied in her simple comment (pp. 253–254) when she explains how the hoodoo doctor, Turner, asked her to stay on as his partner and heir to his business, "for the spirit had spoken to him that I was the last doctor that he would make, that one year and seventy-nine

days from then he would die. He wanted me to stay with him to the end. It has been a great sorrow to me that I could not say yes."

48. Hurston, Review of *Voodoo in New Orleans*, p. 438.

49. Hurston, Review, p. 437.

50. Camitta, p. 24.

51. Camitta, p. 25.

52. Wall, p. 675.

53. Wall, p. 676.

54. Francis Abernethy, *J. Frank Dobie* (Austin: Steck-Vaughn, Southwest Writers Series, no. 1, 1967), p.21, in a critical study of Dobie suggests that the lack of a clear distinction between the voice of the narrator (a fictional invention) and that of the author is a weakness: "Federico is not involved realistically as a character, and Pancho Dobie never steps in—or out—completely. The story hangs fire between fact and fiction, truth and fancy. I kept getting the feeling that Dobie had created a character and then had gotten jealous of him, so the two of them go through the story trying to elbow each other off the road."

55. Boatright, pp. 197–198.

56. J. Frank Dobie, *Tales of Old-Time Texas* (Boston: Little, Brown, 1955), p. ix; emphasis added. As Editor of the Publications of the Texas Folklore Society, Dobie even admitted to rewriting many manuscripts for contributors, making extensive revisions. See "Twenty Years an Editor," in *Backwoods to Border* (Dallas: Southern Methodist Univ. Press, Publications of the Texas Folklore Society, no. 18, 1943), pp. viii–ix.

57. J. Frank Dobie, *I'll Tell You a Tale* (Boston: Little Brown, 1960), p. xi.

58. Hemenway, p. 133, feels that in *Jonah's Gourd Vine*, published in 1934, Hurston had not yet learned to create "a fusion of folkloric idiom and fictional narrative" as she did later in "her two masterpieces of the late thirties, *Their Eyes Were Watching God* (1937) and *Moses, Man of the Mountain* (1939)."

59. Hemenway, p. 164.

60. See Wall, p. 663.

61. Boatright, p. 197.

62. Dan Ben-Amos, "Toward a Definition of Folklore in Context," *Journal of American Folklore* 84 (1971): 9.

63. Mary Ellen Brown Lewis, "Introduction," *Journal of the Folklore Institute* 13 (1976): 225.

64. Dobie, *Some Part of Myself*, p. 236; emphasis added.

65. It would be instructive to compare in some detail the experience of other creative writers, such as Mark Twain and Joel Chandler Harris, who have for a time taken an interest in academic folklore studies but eventually (for whatever reasons) been alienated from it. See, for example, Eric Montenyohl, "Joel Chandler Harris and American Folklore," *Atlanta Historical Journal* 30 (1986–1987): 79–88.

66. The focus on the personal and the subjective which characterizes both books also anticipated current trends in anthropology which are "altering ethnography's discursive strategy and mode of authority" (James Clifford, "On Ethnographic Allegory," in Clifford and Marcus, p. 109). The revolutionary implications of these alterations led Dorst to consider (p. 305) Hurston's social science work "more important than her fiction from the perspective of contemporary critical theory."

67. Roberts, p. 464.

Conclusion

1. See, for example, Eli Leon, *Who'd A Thought It: Improvisation in African-American Quiltmaking* (San Francisco: San Francisco Craft and Folk Art Museum, 1987).

2. This characterization of the term is by Hans Moser, whose formulation of the concept is the "best known," according to Guntis Šmidchens, "Folklorism Revisited," *Journal of Folklore Research* 36 (1999): 52; see Šmidchens on folklorism (*Folklorismus* in German), but also Regina Bendix, "Folklorism: The Challenge of a Concept," *International Folklore Review* 6 (1988): 5–15; and Lee Haring, "Pieces for a Shabby Hut," in *Folklore, Literature, and Cultural Theory*, ed. Cathy Lynn Preston (New York and London: Garland, 1995), pp. 187–203.

3. See, for example, James R. Dow, "German Volkskunde and National Socialism," *Journal of American Folklore* 100 (1987): 300–304; Demetrios Loukatos, "Folklore and Tourism in Greece," *International Folklore Review* 2 (1982): 65–69; the "Promoting Southern Cultural Heritage" issue of *Southern Folklore* 49, no. 2 (1992); Robert Cantwell, "Conjuring Culture: Ideology and Magic in the Festival of American

Folklife," *Journal of American Folklore* 104 (1991): 148–163; and Simon Bronner, ed., *Folk Nation: Folklore in the Creation of American Tradition* (Wilmington: Scholarly Resources, 2002).

4. The "Folklore in the News" feature which appeared for many years in the journal *Western Folklore*, for instance, provided some basic examples of folklore that interested journalists for various reasons.

5. Wolfgang Mieder and Anna Tóthné Litovkina, in a volume of *Proverbium* entitled *Twisted Proverbs: Modern Anti-Proverbs*, Supplement Series, no.4 (1999), a recent publication which provides numerous examples of folklore in popular cultural sources, particularly advertising and cartoons. See also, for example, Wolfgang Mieder, "Survival Forms of 'Little Red Riding Hood' in Modern Society," *International Folklore Review* 2 (1982): 23–40; Wolfgang Mieder, "Proverbs in American Popular Songs," *Proverbium* 5 (1988): 85–101; Steven Folsom, "Proverbs in Recent American Country Music: Form and Function in the Hits of 1986–87," *Proverbium* 10 (1993): 65–88.

6. See, for example, Julie K. Brown, *Contesting Images: Photography and the World's Columbian Exhibition* (Tucson and London: Univ. of Arizona Press, 1994); Barbara Kirshenblatt-Gimblett, *Destination Culture: Tourism, Museums, and Heritage* (Berkeley, Los Angeles, and London: Univ. of California Press, 1998); Frank de Caro, *Folklife in Louisiana Photography: Images of Tradition* (Baton Rouge and London: Louisiana State Univ. Press, 1990), pp. 1–8, 84–116, 161–172; Mellisa Banta, Curtis M. Hindsley, and Joan Kathryn O'Donnel, *From Site to Sight: Anthropology, Photography and the Power of Imagery* (Cambridge: Peabody Museum Press, 1986).

7. Robert Cantwell, *When We Were Good: The Folk Revival* (Cambridge and London: Harvard Univ. Press, 1996), pp. 135, 131, 33, 52.

8. Such as some of the themes explored by Linda Dégh, *American Folklore and the Mass Media* (Bloomington and Indianapolis: Indiana Univ. Press, 1994).

Index

Märchen. *See* Fairytales
Mardi Gras, 81, 84, 86–87, 91, 140–43,
146, 147, 225, 227, 228, 231, fig.
17; organizations, 141, 143, 222,
232, 289n.14; parades, 141, 142,
225, fig. 17; songs, 232. *See also*
Baby Dolls, Golden Star Hunters,
Zulu
Master P (rapper), 86, 89
Matachines, 51
Material culture, 149. *See also* Folk art,
Folklife
Matthews, Bunny, 224–26, 227, 228,
229, 234, fig. 17
Maycock, Lucy, 74, 77–91, 268–69,
270, 288n.4, 289nn.9, 11, 12, 13,
290n.16
Maypoles, 120, 133
McDonald's (fast food chain), 47
McDowell, Frederick P. W., 282n.13
McInerney, Jay, 20, 23–35, 51, 53, 93,
268
McLuhan, Masrshall, 2, 14
McMuertos, Inc. (group installation),
45
McMurtry, Larry, 297n.22
Media, electronic, 1
Melrose (plantation and art colony),
209, 211, 213
Memory, as theme, 126, 171–72,
177–78, 267, 268. *See also* Quilts
and quilting and memory
Mentalité, 227
Mexican Folkways (magazine), 295n.12
Mexican mural movement, 119,
184–85, 186
Mexican Museum (San Francisco), 46
Mexican Revolution, 119, 120, 184,
186, 188
Mexicanidad, 184, 192, 199
Mexico, 107ff, 184ff, 241ff, 267, 271
Mexico City, 111, 295n.7
Meyer, Richard E., 236
Michaels, Barbara, 151, 174–76, 179,
266–67
Michoacán, 191
Mieder, Wolfgang, 98
Milagros, 48

Miller, Henry, 201
"The Miller's Tale" (poem by Geoffrey
Chaucer), 10
The Minister's Wooing (novel by
Harriet Beecher Stowe), 150,
152–53, 300n.3
Ministry of Education building
(Mexico City), murals in, 118–24
Mirror, as concept of ritual, 117–18,
143
"Miss Mary Mack" (children's rhyme),
26–28, 31; as riddle, 27–28
Mississippi, 137, 138
Mississippi Historical Society, 55, 59
Model, as concept of ritual, 117–18,
121, 124, 126, 135
Molloy (novel by Samuel Beckett), 103
Monet, Claude, 201
Moorhouse, Jocelyn, 302n.16
Moreno, Renée, 47
Mormon tradition, 311n.33
Morris dances, 133
Morrison, Toni, 11–12, 118
Mortuary portraits, 194
Moser, Hans, 316n.2
Moses, Man of the Mountain (novel by
Zora Neale Hurston), 315n.58
Mourning pictures, 149
The Moviegoer (novel by Walker
Percy), 129, 136–48, 221
Mrs. Warren's Profession (play by
George Bernard Shaw), 310n.25
Mules and Men (work by Zora Neale
Hurston), 240–69
Multiculturalism, 233
Museo de Arte Moderno, 295n.11
"My Darling Clementine" (folksong),
67
My Nurse and I (painting by Frida
Kahlo), 193–94
My Sister's Miracle (painting by Santa
Barraza), 284n.29
Mysticism, Hindu, 101
Myth, 53, 191, 193, 199, 222, 268
Myth of the Frontier, 222

Nabokov, Vladimir, 19
Natchez Trace, 55ff, 271

Re-Situating Folklore was designed and typeset on a Macintosh computer system using QuarkXPress software. The body text is set in 11/14 Adobe Electra, with display type set in Bernhard Fashion and Helvetica Neue. This book was designed and typeset by Cheryl Carrington and manufactured by Thomson-Shore, Inc.